CURATING THE FUTURE

Curating the Future: Museums, communities and climate change explores the way museums tackle the broad global issue of climate change. It explores the power of real objects and collections to stir hearts and minds, to engage communities affected by change.

Museums work through exhibitions, events, and specific collection projects to reach different communities in different ways. This book emphasises the moral responsibilities of museums to address climate change, not just by communicating science but also by enabling people already affected by changes to find their own ways of living with global warming.

There are museums of natural history, of art, and of social history. The focus of this book is the museum communities, like those in the Pacific, who have to find new ways to express their culture in a new place. The book considers how collections in museums might help future generations stay in touch with their culture, even where they have left their place. It asks what should the people of the present be collecting for museums in a climate-changed future? The book is rich with practical museum experience and detailed projects, as well as critical and philosophical analyses about where a museum can intervene to speak to this great conundrum of our times.

Curating the Future is essential reading for all those working in museums and grappling with how to talk about climate change. It also has academic applications in courses of museology and museum studies, cultural studies, heritage studies, digital humanities, design, anthropology, and environmental humanities.

Jennifer Newell is the curator of Pacific Ethnography at the American Museum of Natural History, New York, USA. She teaches Museum Anthropology at Columbia University, USA, and convenes the Museums and Climate Change Network. She has partnerships with museums in the Pacific, including in Samoa and Fiji, and is a former curator at the British Museum.

Libby Robin works across the university and museum sectors in Australia, Sweden and Germany. She is Professor of Environment and Society at the Australian National University, research affiliate at the National Museum of Australia, affiliated professor at the Royal Institute of Technology, Stockholm, Sweden, and Board Member, Rachel Carson Center, LMU, Munich, Germany.

Kirsten Wehner is Head Curator of the People and the Environment program at the National Museum of Australia. She is a member of the Humanities for the Environment Australia-Pacific Observatory and a professional associate of the Centre for Creative and Cultural Research at the University of Canberra, Australia.

Routledge Environmental Humanities
Series editors: Iain McCalman and Libby Robin

Editorial Board

Christina Alt, St Andrews University, UK
Alison Bashford, University of Cambridge, UK
Peter Coates, University of Bristol, UK
Thom van Dooren, University of New South Wales, Sydney Australia
Georgina Endfield, University of Nottingham, UK
Jodi Frawley, University of Sydney, Australia
Andrea Gaynor, University of Western Australia, Perth Australia
Tom Lynch, University of Nebraska, Lincoln, USA
Jennifer Newell, American Museum of Natural History, New York, US
Simon Pooley, Imperial College London, UK
Sandra Swart, Stellenbosch University, South Africa
Ann Waltner, University of Minnesota, US
Paul Warde, University of Cambridge, UK
Jessica Weir, University of Western Sydney, Australia

International Advisory Board

William Beinart, University of Oxford, UK
Sarah Buie, Clark University, USA
Jane Carruthers, University of South Africa, Pretoria, South Africa
Dipesh Chakrabarty, University of Chicago, USA
Paul Holm, Trinity College, Dublin, Republic of Ireland
Shen Hou, Renmin University of China, Beijing, China
Rob Nixon, Princeton University, Princeton NJ, USA
Pauline Phemister, University of Edinburgh, Edinburgh UK
Deborah Bird Rose, University of New South Wales, Australia
Sverker Sörlin, Royal Institute of Technology, Stockholm, Sweden
Helmuth Trischler, Deutsches Museum, Munich and Co-Director, Rachel Carson Centre, Ludwig-Maxilimilians-Universität, Germany
Mary Evelyn Tucker, Yale University, USA
Kirsten Wehner, National Museum of Australia, Canberra, Australia

The *Routledge Environmental Humanities* series is an original and inspiring venture recognising that today's world agricultural and water crises, ocean pollution and resource depletion, global warming from greenhouse gases, urban sprawl, overpopulation, food insecurity and environmental justice are all *crises of culture*.

The reality of understanding and finding adaptive solutions to our present and future environmental challenges has shifted the epicenter of environmental studies away from an exclusively scientific and technological framework to one that depends on the human-focused disciplines and ideas of the humanities and allied social sciences.

We thus welcome book proposals from all humanities and social sciences disciplines for an inclusive and interdisciplinary series. We favour manuscripts aimed at an international readership and written in a lively and accessible style. The readership comprises scholars and students from the humanities and social sciences and thoughtful readers concerned about the human dimensions of environmental change.

"I applaud the contributors to this book for their courage, conviction and actions in confronting the reality of climate change. In so doing, this book chronicles a new standard of mindfulness in museum practice, grounded in a commitment to the durability and well-being of individuals, communities and the planet."

– Robert R. Janes, Editor-in-Chief Emeritus, *Museum Management and Curatorship*

"This book documents and advocates for the significance of material storytelling as a resource for addressing the most significant challenges of the Anthropocene – how to acknowledge and manage the impact of climate change on our planet and its people. I cannot imagine a stronger argument for the importance of museums."

– Professor Andrea Witcomb, Alfred Deakin Institute for Citizenship and Globalisation, Deakin University, Australia

"*Curating the Future* is far more than a book about how to exhibit the vitally important, if sometimes contentious, topic of climate change. Instead, it sheds new light by bringing together a myriad of examples and perspectives that show how museums and their relationships with collections, indigenous peoples, and others are being transformed as they find ways to reflect upon and mobilise in relation to the environmental changes that threaten our collective future."

– Professor Sharon Macdonald, Alexander von Humboldt Professor of Social Anthropology and Director of the Centre for Anthropological Research on Museums and Heritage (CARMaH), Humboldt-Universität zu Berlin, Germany

"This collection is a provocative, exciting and pioneering contribution to museum studies scholarship, the environmental humanities and beyond. It offers fundamental, first principles thinking about how museums and communities through their collections and exhibition activities might engage global climate change. It is beautifully written, rich with practical case studies and new theoretical insights – a must read for heritage and museum professionals and scholars."

– Dr Fiona Cameron, Senior Research Fellow, Institute for Culture and Society, Western Sydney University, Australia

"This innovative collection celebrates the reanimated life of objects in many contemporary museums and argues that museums are great places for promoting conversations and actions on the pressing realities of climate change. Through a creative congregation of scholarly analyses, cameo essays, poems and pictures, it reflects on community collaborations, visitor experiences and curatorial practices in mounting exhibitions and performances. It will excite readers' hearts as well as their minds."

– Professor Margaret Jolly, Professor and ARC Laureate Fellow 2010–2015, Australian National University, Australia

CURATING THE FUTURE

Museums, communities and climate change

Edited by Jennifer Newell, Libby Robin and Kirsten Wehner

First published 2017
by Routledge
2 Park Square, Milton Park, Abingdon, Oxon OX14 4RN

and by Routledge
711 Third Avenue, New York, NY 10017
Routledge is an imprint of the Taylor & Francis Group, an informa business

© 2017 selection and editorial matter, Jennifer Newell, Libby Robin and Kirsten Wehner; individual chapters, the contributors

The right of the editors to be identified as the authors of the editorial material, and of the authors for their individual chapters, has been asserted in accordance with sections 77 and 78 of the Copyright,

Designs and Patents Act 1988.

All rights reserved. No part of this book may be reprinted or reproduced or utilised in any form or by any electronic, mechanical, or other means, now known or hereafter invented, including photocopying and recording, or in any information storage or retrieval system, without permission in writing from the publishers.

Trademark notice: Product or corporate names may be trademarks or registered trademarks, and are used only for identification and explanation without intent to infringe.

British Library Cataloguing-in-Publication Data
A catalogue record for this book is available from the British Library

Library of Congress Cataloging-in-Publication Data
Names: Newell, Jennifer, editor of compilation. | Robin, Libby, 1956- editor of compilation. | Wehner, Kirsten, editor of compilation.
Title: Curating the future : museums, communities and climate change / edited by Jennifer Newell, Libby Robin and Kirsten Wehner.
Description: Milton Park, Abingdon, Oxon ; New York, NY : Routledge, 2017. | Includes bibliographical references and index.
Identifiers: LCCN 2016007787| ISBN 9781138658516 (hardback) | ISBN 9781138658523 (paperback) | ISBN 9781315620770 (ebook)
Subjects: LCSH: Museums—Social aspects. | Museums—Environmental aspects. | Museums—Curatorship. | Museums—Collection management. | Museums and community. | Museums and community—Pacific Area. | Climatic changes—Social aspects. | Climatic changes—Social aspects—Pacific Area. | Pacific Area—Environmental conditions.
Classification: LCC AM7 .C88 2017 | DDC 069—dc23
LC record available at https://lccn.loc.gov/2016007787

ISBN: 978-1-138-65851-6 (hbk)
ISBN: 978-1-138-65852-3 (pbk)
ISBN: 978-1-315-62077-0 (ebk)

Typeset in Bembo
by FiSH Books Ltd, Enfield

CONTENTS

List of illustrations xi
About the authors xv
Acknowledgments xxii

 Foreword xxiii
 Michael Novacek

1 Introduction: curating connections in a climate-changed world 1
 Jennifer Newell, Libby Robin and Kirsten Wehner

2 Tell them 17
 Kathy Jetñil-Kijiner

PART I
Welcoming new voices: opening museums 21

3 The Anthropocene and environmental justice 23
 Rob Nixon

4 Cameo: museums connecting 32
 Lumepa Apelu

5 Talking around objects: stories for living with climate change 34
 Jennifer Newell

6 Object in view: *Jaki-ed* mat, Marshall Islands 50
 Kristina Eonemto Stege

7	The Pacific in New York: managing objects and cultural heritage partnerships in times of global change *Jacklyn Lacey*	53
8	Cameo: Connie Hart's basket *Tom Griffiths*	62
9	"Peoples who still live": the role of museums in addressing climate change in the Pacific *Peter Rudiak-Gould*	67
10	Object in view: taking a bite out of lost knowledge: sharks' teeth, extinction, and the value of preemptive collections *Joshua Drew*	77

PART II
Reinventing nature and culture — 83

11	Towards an ecological museology: responding to the animal-objects of the Australian Institute of Anatomy collection *Kirsten Wehner*	85
12	Object in view: Harry Clarke's high-wheeler bicycle *Daniel Oakman*	101
13	Food and water exhibitions as lenses on climate change *Eleanor Sterling and Erin Betley*	105
14	Object in view: a stump-jump plough: reframing a national icon *George Main*	115
15	Telling Torres Strait history through turtle *Leah Lui-Chivizhe*	118
16	Four seasons in one day: weather, culture and the museum *Kirstie Ross*	128
17	Object in view: Nelson the Newfoundland's dog collar *Martha Sear*	139
18	The last snail: loss, hope and care for the future *Thom van Dooren*	145
19	Object in view: hiding in plain sight: lessons from the Olinguito *Nancy B. Simmons*	153

PART III
Focusing on the future 157

20 The reef in time: the prophecy of Charlie Veron's living collections 159
 Iain McCalman

21 Food stories for the future 171
 George Main

22 Shaping garden collections for future climates 181
 Sharon Willoughby

23 Object in view: a past future for the cucumber 192
 Sharon Willoughby

24 The art of the Anthropocene 196
 William L. Fox

25 Object in view: the Canary Project: photographs and fossils 206
 Edward Morris and Susannah Sayler

PART IV
Representing change and uncertainty 211

26 Cameo: The vulnerable Volvo 213
 Sverker Sörlin

27 Museum awakenings: responses to environmental change at the Swedish Museum of Natural History, 1965–2005 217
 Ewa Bergdahl and Anders Houltz

28 Rising seas: facts, fictions and aquaria 230
 Susanna Lidström and Anna Åberg

29 Object in view: the model of flooded New York 240
 Edmond Mathez

30 When the ice breaks: the Arctic in the media 242
 Miyase Christensen and Nina Wormbs

31 Displaying the Anthropocene in and beyond museums 252
 Libby Robin, Dag Avango, Luke Keogh, Nina Möllers and Helmuth Trischler

32 Dear Matafele Peinem 267
 Kathy Jetñil-Kijiner

Bibliography	271
Exhibitions cited	285
Index	287

LIST OF ILLUSTRATIONS

Figures

1.1	In the storeroom: Wayne Ngata and other members of Toi Hauiti (Aotearoa New Zealand), visiting the American Museum of Natural History, April 2013	4
1.2	Exploring the affective dimensions of climate change through theater in museums: Jeremy Pickard in "Flying Ace and the Storm of the Century," using favorite American cartoon character Snoopy, afloat on his doghouse in rising waters. Superhero Clubhouse performance at the American Museum of Natural History, October 2013	7
1.3	*Global Warming: Understanding the Forecast* exhibition, American Museum of Natural History, 1992	8
1.4	Cordell Bank Underwater Reef Installation, Oakland Museum of California, 2015. Visuals collage and design by Olivia Ting	12
1.5	Crocheted coral reef, *Welcome to the Anthropocene* exhibition, Deutsches Museum, Munich, 2014	14
2.1	Kathy Jetñil-Kijiner, Marshall Islands, 2012	19
I.1	Toi Hauiti performing for their ancestor, Paikea the whale rider, American Museum of Natural History, April 2013	21
3.1	eddiedangerous (Sam3), "Deep Rooted," 2008	30
4.1	*Faletalimālō* (house for receiving guests) built by Master Builder Laufale Fa'anū and a team of traditional house builders from Sa'anapu, for the Tiapapata Art Centre, Apia, 2014	33
5.1	Lumepa Apelu with *fale samoa* model, with partial thatch to reveal roof structure. Museum of Samoa, Apia, Samoa, 2014	37
5.2	Erynn Vaeua of Samoa and Maya Faison of New York during the June 2014 workshop, Museum of Samoa, Apia, Samoa	39
5.3	*Meto* (navigation chart), Marshall Islands, c.1850s–1880s, American Museum of Natural History	41
5.4	Maj-Gen. Robley acquisition, American Museum of Natural History, 1908	45

5.5	Owen Wharekaponga's *hongi* with Paikea, American Museum of Natural History, April 2013	47
5.6	Toi Hauiti with their ancestor, Paikea, American Museum of Natural History, April 2013	48
6.1	Kristina Stege in the storeroom of the American Museum of Natural History, with *jaki-ed*. 2015	50
6.2	*Jaki-ed*, Marshall Islands. Donated by Mrs William J. Peters, American Museum of Natural History, 1926	51
7.1	Example of a curatorial note, collection database, American Museum of Natural History, 2016	58
8.1	Connie Hart and her eel trap basket, from A. Jackomos and D. Fowell, *Living Aboriginal History of Victoria: Stories in the Oral Tradition*, Cambridge University Press, 1991	66
9.1	Majuro, capital of the Marshall Islands, Majuro Atoll, 2015	68
9.2	Ocean side sea wall, Majuro Atoll, Marshall Islands	69
9.3	Children playing on a fallen tree, lagoon side, Ujae Atoll, Marshall Islands, 2007	74
9.4	Objects on display in the Tuvalu community exhibition *Waters of Tuvalu: A Nation at Risk*, Immigration Museum - Museum Victoria, 2008	75
10.1	Kiribati warrior, *c*.1890. Pitt Rivers Museum, University of Oxford	78
10.2	Kiribati shark-tooth weapon. American Museum of Natural History	80
II.1	Abandoned vehicles in a winter forest: a Swiss *Autofriedhof* slowly subsides in the leaf litter, 2007	83
11.1	The Australian Institute of Anatomy exhibit in the *Tangled Destinies* gallery, National Museum of Australia, 2001	93
11.2	Visitors to the *Old New Land* gallery, National Museum of Australia, examine the refurbished Australian Institute of Anatomy exhibit, 2013	97
11.3	Preserved young pouch wombat, about 1920, Australian Institute of Anatomy collection, National Museum of Australia	99
12.1	English-made "Cogent" penny-farthing bicycle belonging to Harry Clarke, 1884, National Museum of Australia	101
12.2	Harry Clarke riding his penny-farthing, "Black Bess," in the Melbourne Moomba Parade, 1984	103
13.1	"Science on a Sphere" display in the *Water: H$_2$0=Life* exhibition, American Museum of Natural History, 2007	108
13.2	Clay water pipe from Xoxocotlan, Oaxaca, Mexico, on display in *Water: H$_2$O=Life* exhibition, American Museum of Natural History, 2007	109
13.3	The demonstration kitchen in *Our Global Kitchen* exhibition, American Museum of Natural History, 2012-2013	112
14.1	Eight-furrow stump-jump mouldboard plough, in use 1940s–50s, National Museum of Australia	115
15.1	*Kaigas* mask from Mabuiag Island, Torres Strait, British Museum	123
15.2	Overhead view of the mask showing details of the fish and the *kaigas*	124
15.3	Detail of the rear of the *kaigas* mask showing human figures, the colors on the head of the *womer* and the teeth of the *kodal*	125
16.1	Windy Wellington sign near the city's airport, 2015	129

16.2	*Cloud* by John Reynolds, 2006, installed at Te Papa, 2009	131
16.3	*Wahine Weather Maps* by David Ellis, 2008, displayed at Wellington Museum of City and Sea, 2015	135
16.4	The *maramataka* (Māori calendar) interactive, developed at Te Papa in 2005–2006, shows seasonal and lunar cycles in food planting and gathering, 2006	135
16.5	NZL 32, New Zealand's entry in and the eventual winner of the 1995 America's Cup, c.1995	137
17.1	Nelson the Newfoundland's dog collar, c.1880. National Museum of Australia	139
17.2	An engraving of the rescue and other scenes from the flood, from the *Illustrated Australian News*, 30 November 1881	140
17.3	William John Higginbotham with dog, Nelson, c.1880	141
17.4	"Swanston Street looking S [South] from Lonsdale St.", c.1870–1880	143
18.1	An environmental chamber, University of Hawai'i, 2013	146
18.2	Hawaiian tree snail shell collection, University of Hawai'i, 2013	147
18.3	The last snail: *Achatinella apexfulva*, University of Hawai'i, 2013	150
19.1	The Olinguito, *Bassaricyon neblina*, alive in the wild. Tandayapa Valley, Ecuador, 2013	153
19.2	Specimens of Olinguito, *Bassaricyon neblina*, in a drawer at the American Museum of Natural History	154
III.1	*PHARMAZIE* exhibition, Deutsches Museum, 2000	157
20.1	Charlie Veron dressed for work	162
20.2	Charlie Veron exploring Madagascar corals	164
20.3	Charlie Veron observing bleached corals	167
21.1	Homepage for *The Paddock Report*, a National Museum of Australia online project, created 2012	172
21.2	Children in the kitchen garden at Collingullie Public School, southern New South Wales, 2013	177
22.1	*Cadi Jam Ora*, Royal Botanic Gardens Sydney, 2014	181
22.2	The Australian Garden show garden, Royal Horticultural Society Chelsea UK, 2011	189
22.3	The Australia Landscape created in partnership between the Royal Botanic Gardens Kew and the British Museum, British Museum forecourt, 2011	190
23.1	Cucumber straightener displayed in the historic *Lost Gardens of Heligan*, Cornwall, UK	193
24.1	Alexander von Humboldt, plate from "Geographie des Plantes Equinoxiales," showing a cross-section of Mount Chimborazo volcano, Eucador: flora, topography and altitude mapping, published in *Essai sur la Geographie des Plantes*, A.v. Humboldt & A. Bonpland, Paris, 1805	198
24.2	Frederic Edwin Church, "Heart of the Andes," 1859	200
24.3	Timothy H. O'Sullivan, "Gould and Curry Mill, Virginia City," 1867	201
25.1	Installation view from *The Canary Project Works on Climate Change: 2006–2009*, Grunwald Gallery, Indiana University, 2009	206
25.2	Fossil Study 1, from *A History of the Future*, Sayler/Morris, 2014	209
25.3	Fossil Study 2, from *A History of the Future*, Sayler/Morris, 2014	209

25.4	Fossil Study 3, from *A History of the Future*, Sayler/Morris, 2014	209
IV.1	Polar bear exhibit in the *Climate Change: The Threat to Life and a New Energy Future* exhibition, American Museum of Natural History, 2008	211
26.1	Anorak of seal intestines, Inuit, Central Yup'ik, Tooksik Bay, Alaska. Hood Museum of Art, Dartmouth College, Hanover, New Hampshire	214
26.2	Volvo installation made of cow intestines and aluminum, Swedish Museum of Natural History, 2008	215
27.1	Director Kjell Engström guides visitors in the *Are We Poisoning Nature?* exhibition, Swedish Museum of Natural History, 1996	221
27.2	Flag poster, *Sweden Turning Sour* exhibition, Swedish Museum of Natural History, 1987	224
27.3	A poster presenting the *Mission: Climate Earth* exhibition, showing well-known Stockholm locations flooded by high waters, Swedish Museum of Natural History, 2014	225
27.4	Create your own cloud interactive in the *Mission: Climate Earth* exhibition, Swedish Museum of Natural History, 2004	227
28.1	*Feeling the Heat: the Climate Challenge* exhibition, Birch Aquarium, 2007	233
28.2	Still from *The Drowning Room*, by Reynold Reynolds and Patrick Jolley, 2000	238
29.1	Model of Manhattan, flooded, in the *Climate Change: The Threat to Life and a New Energy Future* exhibition, American Museum of Natural History, 2008	240
30.1	"Arctic sea ice melts to all-time low", (2005 and 2007). NASA/Goddard Space Flight Center Scientific Visualization Studio.	248
30.2	"Satellites witness lowest Arctic ice coverage in history", 2007	249
31.1	Installing the *Welcome to the Anthropocene* exhibition. Placing the "robot" in the *Humans and Machines exhibit*. Curating the crochet coral reef, *Evolution*. Lining up the dogs, *Evolution*. Calligrapher creating the wall. Deutsches Museum, 2014	254
31.2	Three dimensions of the *Welcome to the Anthropocene* exhibition. Artistic interpretation: Victor Sonna's recycled art bike "Guernica," *Cities exhibit*. Publications: catalogue and graphic novel, with curators Nina Möllers and Helmuth Trischler. Participation: *Field of Daisies*. Deutsches Museum, 2014	257
31.3	Various elements of the *Welcome to the Anthropocene* exhibition. Engine block inside object shelf. Brussels sprout growing in shopping trolley. The digital media cube. Planting a tree. Deutsches Museum, 2014	261
31.4	Pyramiden: a coal-mining town above the Arctic Circle, 2012	262
31.5	Ukraine grass planted in Pyramiden, 2012	264
32.1	People's Climate March, London, with hummingbirds, 2014	270

Table

15.1	Totemic Animals of Mabuiag Island clans	126

ABOUT THE AUTHORS

Anna Åberg is a Postdoctoral Scholar at the Centre d'Études des Mondes Russe, Caucasien et Centre-Européen at EHESS in Paris, were she holds the Fernand Braudel fellowship awarded by the Fondatione de Science de l'Homme. She her PhD thesis was on the history of natural gas infrastructure in Northern Europe at the Division of History of Science, Technology and Environment at KTH Royal Institute of Technology in Stockholm. Her current project studies the history of science communication around fusion technology in the former Soviet Union and Russia.

Lumepa Apelu is the Principal Officer and Curator of the Museum of Samoa, in Apia, Samoa, a position she has held since 2011. Her background is in tourism, mathematics and the law. Lumepa holds a Bachelor of Mathematics, Applied Statistics, from Wollongong University, Australia, and the National University of Samoa. She is the former secretary and a founding member of the Samoa Arts Council. She is a board member of the Samoa Voyaging Society and of the Commonwealth Association of Museums.

Dag Avango teaches in the Division of History of Science, Technology and Environment, Royal Institute of Technology (KTH), Stockholm, Sweden. He has worked extensively on industrial heritage in polar environments, including in Svalbard, Norway and in South Georgia, and in Argentina.

Ewa Bergdahl holds a BA in archaeology, theory of science and anthropology. During the last thirty years, she has been engaged in museums and cultural heritage work. Her main research interests concern landscape interpretation and the reuse and transition of industrial sites and landscapes. She has been director of several museums, among others Ecomuseum Bergslagen and the City Museum of Norrköping. In 2004 she was appointed Head of the Division of Cultural Tourism at the National Heritage Board in Stockholm and from 2009 to 2013 she was Director of the Public Outreach Department at the Swedish Museum of Natural History.

Erin Betley is a Biodiversity Specialist for the Center for Biodiversity and Conservation at the American Museum of Natural History and content research specialist for the traveling exhibition "Our Global Kitchen: Food, Nature, Culture." She holds an MA in Conservation Biology from Columbia University and a BA in Biology from Boston University.

Miyase Christensen is Professor of Media and Communication Studies at Stockholm University, Sweden, and Visiting Professor at the Division of History of Science, Technology and Environment at KTH Royal Institute of Technology. She is the editor-in-chief of *Popular Communication* and has published international books and articles on globalization processes and social change; technology, culture and identity; and politics of popular communication. Her latest co-authored and co-edited books include *Cosmopolitanism and the Media: Cartographies of Change* (2015); *Media, Surveillance and Identity* (2014); and, *Media and the Politics of Arctic Climate Change: When the Ice Breaks* (Palgrave Macmillan).

Joshua Drew is a lecturer in Columbia University's Ecology, Evolution and Environmental Biology department where he directs their MA in Conservation Biology. He holds a PhD in biology from Boston University and held a postdoctoral fellowship at the Biodiversity Synthesis Center and the Division of Fishes at the Field Museum.

William L. Fox is founding Director of the Center for Art+Environment at the Nevada Museum of Art, Reno. His many books, which include *Aeriality: Essays on the World* (Counterpoint 2009), concern questions of how human cognition transforms land into landscape. He has held Fellowships with Guggenheim, the Getty Research Institute, the Clark Institute, the Australian National University and the National Museum of Australia. He visited Antarctica in 2001–2 with the National Science Foundation's Visiting Artists and Writers Program and worked with the NASA Haughton-Mars Project, which tests methods of exploring Mars on Devon Island in the Canadian High Arctic. Bill is also an artist who has exhibited in numerous group and solo shows in eight countries since 1974.

Tom Griffiths is the W.K. Hancock Professor of History at the Australian National University and Director of the Centre for Environmental History. He is the author of *Beechworth* (1987), *Hunters and Collectors: The Antiquarian Imagination in Australia* (1996), *Forests of Ash* (2001) and *Slicing the Silence: Voyaging to Antarctica* (2007). His books and essays have won prizes in literature, history, science, politics and journalism, including the Eureka Science Book Prize, the Prime Minister's Prize for Australian History and the Nettie Palmer and Douglas Stewart Prizes for Non-Fiction. His most recent book is *The Art of Time Travel* (Black Inc., 2016).

Anders Houltz is an Associate Professor in the History of Science and Technology. He holds a position as Research Secretary at the Centre for Business History in Stockholm, and teaches at the Royal Institute of Technology and Blekinge Institute of Technology. His research deals with museum practices and politics, industrial heritage, business history and material culture. His most recent book, the co-edited business history, *Svensk snillrikhet: Nationella föreställningar om entreprenörer och teknisk begåvning 1800–2000*, was published in 2014. Currently, he is conducting a project for the renewal of the Observatory Museum in Stockholm for the Royal Academy of Sciences.

Kathy Jetñil-Kijiner is a Marshallese poet, writer, teacher, performance artist and journalist. Her poetry focuses on raising awareness surrounding the issues and threats faced by the Marshallese people. She opened the 2014 UN Climate talks in New York with her poem "Dear Matafele Peinam."

Luke Keogh was international curator for the special exhibition *Welcome to the Anthropocene: The Earth in Our Hands* at the Deutsches Museum, Munich (2014–2016). This position was part of the German International Curatorial Fellowship program funded by the German Federal Cultural Foundation. He currently holds a Gerda Henkel Stiftung Research Scholarship and is working on an environmental history of the Wardian Case.

Jacklyn Lacey is a Curatorial Associate of African and Pacific Ethnology at the American Museum of Natural History. She has a background in virology and medical anthropology, previously working in public health education in Tanzania, HIV/AIDS testing and research at the African Services Committee in Harlem, and in Drew Cressman's immunology laboratory at Sarah Lawrence College. After Hurricane Katrina, she worked in New Orleans with a multi-faith coalition to clear debris from destroyed homes and witnessed both the fragility and determination of coastal communities facing a changing climate.

Susanna Lidström is a Postdoctoral Scholar at the Division of History of Science, Technology and Environment, with the Environmental Humanities Laboratory, at KTH Royal Institute of Technology in Stockholm. Her research examines literary non-fiction and public science writing about oceans and environmental change. Currently she is a guest researcher at Scripps Institution of Oceanography in La Jolla, California.

Leah Lui-Chivizhe is a Torres Strait Islander with family connections to the eastern and western Torres Strait. This chapter draws on research for her doctoral studies (University of Sydney, Australia), examining Torres Strait Islander interactions with the marine environment and the Islander-turtle relationship. The primary focus of this research has involved examining large three-dimensional turtle shell masks, most of them traded or taken from the Torres Strait in the nineteenth century. Along with honoring the cultural knowledge of Islanders, Leah is hopeful her work on these iconic masks will engage the broader community with the long history and cultural significance of Islanders' mask-making practices.

Iain McCalman is a Research Professor in history at the University of Sydney and co-Director of the Sydney Environment Institute. He was born in Nyasaland in 1947, schooled in Zimbabwe and did his higher education in Australia. He was Director of the Humanities Research Centre, Australian National University, from 1995–2002, is a Fellow of three learned academies and a former President of the Australian Academy of the Humanities. He was made an Officer of the Order of Australia in 2007 for services to history and the humanities. His last book, *Darwin's Armada* (Penguin, 2009) was the basis of the TV series, *Darwin's Brave New World* and his new book, *The Reef – A Passionate History, from Captain Cook to Climate Change*, was published by Penguin in Australia and by Farrar, Strauss and Giroux in the United States in May 2014.

George Main is a Curator in the People and the Environment program at the National Museum of Australia in Canberra. He is the author of *Heartland: The Regeneration of Rural Place*, Sydney: UNSW Press, 2005.

Edmond Mathez is an igneous petrologist/geochemist and a Curator in the Department of Earth and Planetary Sciences at the American Museum of Natural History. He was lead curator of the museum's permanent *Gottesman Hall of Planet Earth* (1999), for which he and his team were awarded the 2002 American Geophysical Union Excellence in Geophysical Education Award. He co-curated *Climate Change: The Threat to Life and a New Energy Future* (2008), and curated *The Science of Natural Disasters* (2014), both traveling exhibitions. He holds a PhD from the University of Washington (1981) and adjunct faculty appointments at Columbia, University and the City University of New York.

Nina Möllers is Head Curator of the exhibition *Welcome to the Anthropocene: The Earth in Our Hands* (2014–2016) at the Deutsches Museum and Curator of the Rachel Carson Center. She studied history at Tübingen, Palo Alto and Nashville, Tennessee, and received her PhD in 2007 with a dissertation on *Creoles of Color in New Orleans*. As part of a postdoctoral project at the Deutsches Museum she curated the special exhibition *Cable Tangle* on the history of energy consumption in private households. Her research interests are the history of technology; environmental, gender and museum studies; and the American South.

Jennifer Newell is Curator of Pacific Ethnography at the American Museum of Natural History, New York. She works at the intersection of the environmental humanities, material culture studies and museology. She is pursuing a variety of collaborative projects exploring the cultural impacts of climate change in the Pacific Islands. She has previously worked at the British Museum and as a Research Fellow at the National Museum of Australia. Her publications include works on Tahitian environmental history, Pacific arts, and Samoan responses to climate change. She convenes the online Museums and Climate Change Network.

Rob Nixon holds the Thomas A. and Currie C. Barron Family Professorship in Humanities and Environment at Princeton University. He is the author of four books, most recently *Dreambirds: the Natural History of a Fantasy* and the award-winning *Slow Violence and the Environmentalism of the Poor*. He writes frequently for the *New York Times*. His writing has also appeared in *The New Yorker, Atlantic Monthly, The Guardian, The Nation, London Review of Books, The Village Voice, Slate, Truthout, Huffington Post, Times Literary Supplement, Chronicle of Higher Education, Critical Inquiry, Public Culture* and elsewhere.

Daniel Oakman is a Senior Curator with the People and the Environment team at the National Museum of Australia. He was the Lead Curator for the traveling exhibition *Freewheeling*, which explored the social, cultural and visceral dimensions of cycling in Australia. He has a strong interest in histories of movement and human-powered transportation, particularly the ways in which the bicycle has changed the perception of the landscape and challenged understandings of human power and endurance.

Libby Robin is a Professor at the Australian National University, and an Affiliated Professor at the KTH Environmental Humanities Laboratory, Stockholm. A former curator at the National Museum of Australia, she was a founding fellow of its Research Centre (2007–2015). She is a board member of the Rachel Carson Center for Environment and Society, Munich and is a Series Editor, with Iain McCalman of Routledge Environmental Humanities. She has published over 100 scholarly articles, chapters and reviews, and 14 books including (with Sverker Sörlin and Paul Warde) *The Future of Nature: Documents of Global Change* (Yale 2013). She was elected Fellow of the Australian Academy of Humanities in 2013.

Kirstie Ross is a Curator of "Modern New Zealand," and at Te Papa Tongarewa. She is a graduate of the University of Auckland and has worked as a History Curator at Te Papa since February 2004. Her curatorial projects include Te Papa's permanent environmental history exhibition, *Blood, Earth, Fire,* which opened in 2006. Kirstie's research interests include popular culture and the environment, and issues related to the presentation of social history in museums. Her publications include *Going Bush: New Zealanders and Nature in the Twentieth Century* (Auckland University Press, 2008) which was supported by an Award in New Zealand History, granted by the New Zealand Ministry for Culture and Heritage.

Peter Rudiak-Gould is a cultural and environmental anthropologist who has conducted extensive fieldwork on climate change perceptions and responses in the Marshall Islands. He is the author of an ethnography of climate change (*Climate Change and Tradition in a Small Island State*), an ethnographic memoir (*Surviving Paradise*), a Marshallese language textbook (*Practical Marshallese*), and co-editor of a volume on the reception of climate science in Pacific Island societies (*Appropriating Climate Change*). His applied work focuses on designing environmental communication campaigns and school curricula that are based on hands-on engagement with the local causes and impacts of climate change. He has also conducted fieldwork with Sami communities in arctic Norway. He manages Peter Rudiak-Gould Consulting while maintaining an affiliation with the University of Toronto as Assistant Professor Status-Only in the Department of Anthropology.

Susannah Sayler and **Edward Morris (Sayler/Morris)** are artists concerned with contemporary ecological consciousness. They work with photography, video, installation, open source projects and curation. In 2006, they founded the Canary Project, a studio that produces art and media that deepen public understanding of climate change. They have exhibited work internationally at both science and art museums, including MASS MoCA, the Kunsthale in Rotterdam and the Museum of Science and Industry in Chicago. They teach in the Transmedia Department at Syracuse University. They have been Loeb Fellows at Harvard Graduate School of Design and Smithsonian Artist Research Fellows.

Martha Sear is a Senior Curator on the People and the Environment program at the National Museum of Australia. Her PhD in history from the University of Sydney explored the role played by exhibitions of women's work in the genesis of colonial feminism. She joined the National Museum in 2005, having previously been a curator at Sydney's Powerhouse Museum and with the five museums in Hay, New South Wales. Her research and exhibition work has ranged across many subjects, including taxidermy, the circus,

childbirth, and rural Australians' responses to heat – but enduring interests have been interspecies interactions and understanding the history of exhibition-making. Major projects at the NMA have included the *Landmarks* (2011) and *Journeys* (2009) galleries, and she is the co-editor of *Landmarks: A History of Australia in 33 Places* (2013). Her most recent major exhibition is *Spirited: Australia's Horse Story* (2014).

Nancy B. Simmons is Curator-in-Charge of the Department of Mammalogy. She came to the museum fresh out of graduate school in 1989, and never left because she thinks it is the greatest place in the world to work. Her research focuses on the evolution of bats – the only flying mammals – and includes everything from fieldwork with living animals to studies of 52 million year old fossils. All aspects of her work involve the use of museum collections, including around 60,000 bat specimens and tissue samples in the AMNH Mammalogy collections.

Sverker Sörlin is a Professor in the Division of History of Science, Technology and Environment at the KTH Royal Institute of Technology, Stockholm, and co-founder of the KTH Environmental Humanities Laboratory. Sörlin's research is focused on the role of knowledge in environmentally informed modern societies and on the science politics of climate change, especially as seen through the history of geography, oceanography and other field sciences. He is a writer and a critic and has published autographical narrative non-fiction as well as essays, biographies, journalism and scripts for television and film. He has had a career-long interest in peoples of the circumpolar north and recently published two books on northern topics: *Northscapes* (University of British Columbia Press, 2013; with Dolly Jørgensen), and *Science, Geopolitics and Culture in the Polar Region – Norden beyond Borders* (Ashgate, 2013).

Kristina Eonemto Stege is a community advocate and consultant. She is from the Marshall Islands, has a Masters from the Université d'Aix-en-Provence, and now lives in New York. She has worked for the Government of the Republic of the Marshall Islands, the Pacific Islands Forum Secretariat, and the U.S. Department of the Interior, among others. She has managed projects covering matters as diverse as the role of Marshallese women in contemporary land management and development, immigration issues for islanders entering the United States and community-driven responses to climate change. She also works on climate-change related projects at the American Museum of Natural History.

Eleanor Sterling is the former Director, now Chief Conservation Scientist, of the American Museum of Natural History's Center for Biodiversity and Conservation and has more than 25 years of teaching and research experience globally. She has curated several AMNH exhibitions, including the traveling exhibitions *Water H$_2$O=Life* and *Our Global Kitchen: Food, Nature, Culture*. She received her BA from Yale College and a joint PhD in Anthropology and Forestry and Environmental Studies from Yale University.

Helmuth Trischler is head of research of the Deutsches Museum, Professor of History and History of Technology at Ludwig-Maximilians-Universität of Munich, and co-director (with Christof Mauch) of the Rachel Carson Center. His recent publications include the books *The Anthropocene in Perspective* (2013), *Building Europe on Expertise: Innovators, Organizers,*

Networkers (2014, co-authored with Martin Kohlrausch) and *Cycling and Recycling. Histories of Sustainable Practices* (2015, co-edited with Ruth Oldenziel).

Thom van Dooren is a Senior Lecturer in Environmental Humanities at the University of New South Wales, Australia, and co-editor of the international open-access journal, *Environmental Humanities*. His most recent book is *Flight Ways: Life and Loss at the Edge of Extinction* (Colombia University Press: New York, 2014), www.thomvandooren.org

Kirsten Wehner is a curator and visual anthropologist with particular interests in environmental museology, exhibition design and faunal and botanical objects. She is Head Curator, People and the Environment, at the National Museum of Australia (nma.gov.au/pate), and was previously Content Director for the NMA's *Circa* multi-media experience and the *Landmarks* and *Journeys* galleries. Kirsten holds a PhD in anthropology from New York University, with a specialization in Culture and Media. Her publications include *Landmarks: A History of Australia in 33 Places* (NMA Press, 2013, with Daniel Oakman and Martha Sear). She is a member of the Australia-Pacific Observatory of Humanities for the Environment and in 2015–2016 was a Fellow at the Rachel Carson Center for Environment and Society, Munich.

Sharon Willoughby is currently undertaking research towards a PhD in Environmental History at the Fenner School of Environment and Society, Australian National University. Her thesis, *Gardening the Australian Landscape*, is an environmental history of the development of the Royal Botanic Gardens Victoria Cranbourne. Sharon has worked at Cranbourne since 2003 as Manager of Public Programs and as part of the Landscape Planning Group for the award-winning *Australian Garden*.

Nina Wormbs is an Associate Professor in History of Science and Technology and serves as Head of Division of History of Science, Technology and Environment at KTH Royal Institute of Technology. She has taken an interest in technology and the media, especially broadcasting, where she has also done some policy work. Her present research deals with remote sensing and the efforts to understand and display the Earth at a distance.

ACKNOWLEDGMENTS

This book has benefited from the advice, collegiality and generosity of many people. The workshop held in 2013 in New York to initiate this project was made possible through the support of the American Museum of Natural History, the National Museum of Australia, and the Andrew W. Mellon Humanities for the Environment Australia-Pacific Observatory. The editors would particularly like to thank Professor Iain McCalman, director of the Observatory, for his enabling of this project, just one aspect of his leadership in growing scholarship to address cultural-environmental challenges. The editors would also like to express their gratitude to Karl Harrington at Fish Books Ltd and Rebecca Brennan at Routledge-Earthscan, and their respective teams, for patiently guiding this book through the editing stages.

Jennifer Newell thanks the American Museum of Natural History for supporting the project throughout. Warm thanks to interns Meghan Bill, Brett Creswell Ostrum, Alex Karpa, Andrew Gilkerson, Lily Gutterman, Cecilia Kavara-Verran, Tess Madden and Benita Simati Kumar for their excellent and painstaking work on the manuscript in its various stages. Thanks to Denise Sutherland for professional indexing help. Jennifer is especially thankful to her husband Mark Gunning (gunningdesign.com) for his tireless moral and practical support, image wrangling and design advice.

Libby Robin thanks the Rachel Carson Center, LMU, the Royal Institute of Technology, Stockholm and the Deutsches Museum, Munich for support for research in Europe, and for stimulating partnerships that have made this book far more international than most. She would also like to acknowledge the intellectual support of colleagues at the Centre for Environmental History, Australian National University and its partnerships with the National Museum of Australia and with the Sydney Environment Institute.

Kirsten Wehner thanks the National Museum of Australia for enabling her to commit time to this project and for supplying images for publication. She also gratefully acknowledges the Rachel Carson Center for Environment and Society for enabling her to edit the manuscript while a 2015-6 Fellow. Kirsten thanks Martha Sear for her long-distance assistance with image management, and is especially grateful to Maurice Patten for putting up with late nights and working weekends.

FOREWORD

Michael Novacek

Provost, American Museum of Natural History

In 1990, when a wider appreciation of the evidence for major climate change was just emerging, I journeyed to Antarctica as a guide on an American Museum of Natural History trip meant for tourists. It was the month of January—the Antarctic summer—but the kind of warmth that greeted us was wholly unexpected. We landed on ice-free, sunbaked beaches and quickly swapped our fiber-filled jackets for tee shirts. My mother, who came as my guest on the cruise, had a long-standing familial reputation as someone who always brought sunny skies to all her visits. I idly mentioned her Proserpine powers, and she quickly became the goddess of good weather. Passengers invited her to their dining table and toasted her with expressions of gratitude, as though these offerings would sustain our good fortune. The rituals seemed to work, as the weird but delightful span of Mediterranean weather continued.

Some of us of course were tempted to attribute this stretch of munificent weather to a cause more in the realm of science, what was then coming to light as evidence for global warming. An expert meteorologist on board cautioned against such hasty judgment. True enough, it is important to distinguish climate variation—that is, year-to-year oscillations in dominant weather patterns—from longer-term climate change. That balmy Antarctic summer could have been merely a seasonal aberration. We now know, however, that there are major events in Antarctica, the Arctic, and many other places in the world that clearly point to a global-scale shift in the climate of our planet. A shrinking polar ice cap, unmoored Antarctic ice sheets, receding glaciers, more frequent and more intense heat waves, and rising ocean temperatures and sea level are all symptomatic of the dramatic change in climate we are experiencing. We do not yet understand all the complexities of this trend and its impacts in many regions of the world. But the evidence for climate change is now well established and widely accepted by scientists. What this fundamental change means for life on Earth, including our own species, has come to the forefront as one of the major issues of our time.

This book and the workshop held in October of 2013 that inspired it represent an effort to convene and foster critical conversation on environmental, social, and cultural matters of great urgency. The host institution for the workshop, the American Museum of Natural

History, has been particularly focused on the connections between the scholarship it supports and its responsibility to educate the public on the latest discoveries relating to global environmental change. The Museum in 1998 opened the first large-scale permanent hall dealing with the biodiversity crisis—namely, the rampant loss of species over the last few decades that many scientists compare with the great mass extinction events (including the so-called dinosaur extinction event) of the past. It also has a history of contributing to the public understanding and dialogue concerning climate change. For example, in 1992 AMNH held a major temporary exhibit *Global Warming: Understanding the Forecast*. During its eight-month run it attracted over 700,000 visitors and subsequently traveled to many other venues. In 2008, the Museum offered an exhibition presenting an updated take on the subject: *Climate Change: The Threat to Life and A New Energy Future*. It continues to travel to locations that include the United States, United Arab Emirates, Brazil, Mexico, Spain, Denmark, and Korea.

The Museum has another distinction that means it is a logical place for a workshop devoted to both the scientific realities of climate change and its bearing on human lives, traditions, and cultures. It is widely recognized as the home of modern anthropology, an approach that emphasizes the celebration of diverse cultures inspired by the early twentieth-century work of Franz Boas, and, later, his famous student and curator, Margaret Mead. It is indeed fitting that one of the organizers of the workshop and co-editor of the book, anthropology curator Dr. Jenny Newell, has inherited from Mead the proud responsibility for the Museum's extraordinary ethnographic collection of Pacific peoples. Dr. Newell is committed to better understanding the impacts of climate change, including sea level rise, on the lives and traditions of island cultures in the Pacific. She has also connected her work with the efforts of the Museum's *Center for Biodiversity and Conservation*, an organization devoted to providing sound scientific information about a wide variety of environmental issues in many countries, and to using this knowledge to train in-country expertise and provide guidelines for conservation action.

Dr. Newell, Dr. Kirsten Wehner and Professor Libby Robin designed a workshop that was deliberately broad-ranging—bringing together curators, historians, scientists, educators, and artists to focus on this complex, multifaceted issue. It is clear that the dialogue must draw on not only scientific experts but also on those who can assess the impacts of dramatic climatic change on communities. We are pleased that the American Museum of Natural History has had the opportunity to sponsor this dialogue on a matter of such great importance. Such a role in supporting scientific discovery, education, and engagement will continue and expand. For we are in a time of unprecedented confluence between the work of museums and the needs of society in what must surely be the most important environmental century in the history of the human species.

1
INTRODUCTION

Curating connections in a climate-changed world

*Jennifer Newell, Libby Robin and Kirsten Wehner**

This book springs from the convictions that climate change demands urgent transformations in the ways we think about ourselves and our world, and that museums are effective places for supporting conversation about and action on this issue. This book also responds to the perception that museums need to develop new modes of thinking and practice in order to fully embrace this role. *Curating the Future* considers how contemporary museums are re-shaping some of the conceptual, material and organizational structures that have historically underpinned their own institutions and, more broadly, modes of living in the world that have produced climate change. It explores how diverse museums are engaging with attitudes and practices of 'relationality', tracing how these institutions are, along four key trajectories, building bridges across deep-seated separations between colonized and colonizer, Nature and Culture, local and global, authority and uncertainty.

Curating the Future brings together perspectives from many parts of the world, celebrating how museums can function as spaces that enable the 'coming together' across time and geography of peoples, ideas and stories. The book explores museums as places that foster learning of many different kinds, including through congregation and sharing and in emotional and embodied, as well as analytical, modes. Moreover, it gains impetus from the ways in which museums, despite decades of critical re-evaluation, remain for many of their publics trusted sources of information.[1] These traditions suggest that museums are well placed to enable new forms of collaboration and community through which innovative responses to the frequently highly politicized issue of climate change might be nurtured. The chapters that follow discuss

* Authors are listed in alphabetical order. This introduction, and this book as a whole, reflects our equal and combined intellectual contributions.
1 There has been much discussion of these points in literature surrounding the "new museum." See for instance, Elaine Gurian's "A Savings Bank for the Soul: About Institutions of Memory and Congregant Spaces," in *Civilizing the Museum: The Collected Writings of Elaine Heumann Gurian* (London and New York: Routledge, 2006), and her "Blurring of the Boundaries," *Curator*, 38 (2005): 31–37. Also on museums being still regarded with "trust and respect" by the public, see Robert Janes, *Museums in a Troubled World: Renewal, Irrelevance or Collapse?* (Abingdon, Oxon: Taylor and Francis, 2009), 22; Fiona Cameron, Bob Hodge, and Juan Francisco Salazar "Conclusion: Climate Change Engagement," in *Climate Change and Museum Futures*, ed. Fiona Cameron and Brett Nielson (New York: Routledge, 2015), 248.

a variety of initiatives in this vein, reflecting on interpreting collections in collaboration with communities, engaging diverse visitors with climate-change science, and experimenting with exhibitions and performances that excite people's hearts, as well as minds.

Reflecting their centrality to museums, *Curating the Future* focuses strongly on objects and collections. Many of this book's chapters investigate how collections of diverse types, media and locations, including those held outside museums proper, can be understood as materializing processes of climate change. Short "Object in View" studies sketch out how individual objects can prompt imaginative engagements with this issue. In a sense, this book presents an assemblage of texts through which collections emerge as inter-generational carriers of stories – things that dramatize experiences of cultural-ecological crises and have the capacity to foster cohesion and resilience in the face of them. We hope that it will stimulate museums to consider more fully how they might build new collections, interpretations and collaborations that engage communities and develop their capacities to respond to climate change.

The relational museum

The *relational* museum, a term adopted originally at the Pitt Rivers Museum in Oxford in the United Kingdom, has gathered pace since its inception in 2002, suggesting new approaches to connecting people and artefacts, people of different cultures, human and nonhuman and scales of local and global. As the Oxford project has argued:

> Ethnographic museums used to be seen as "us" studying "them." A more productive approach is to view museums as trans-cultural artefacts composed of relations between the museum and its source communities.[2]

This project considers not just former "ethnographic museums" but also national museums, local museums, art museums and natural history museums that are sensitive to these principles. We do not define a "new museum" as a mold but rather see it as a curatorial practice that enables audiences and collections to be far more "ecological" and interconnected than the old-style museum.[3] A relational museum develops its authority through supporting and curating networks of related things and their significance, rather than delivering knowledge from a single vantage point.

Museums are increasingly open to a flow in and out of the museum's structure, where audiences and collections, curators and designers are all in conversation in a mutually informing way, sharing authority. Museums are no longer restricted to western knowledge conventions, becoming increasingly informed by perspectives of the cultural "Other." Part of this project has been to develop collaborative ways of interpreting and relating to collections, rather than simply putting objects on display. Objects and collections are not merely observed and displayed in the relational museum, but are rather the pathways through which stories can flow. In the twenty-first-century museum, curation is not simply about working

2 Pitt Rivers Museum, "The Relational Museum," www.prm.ox.ac.uk/RelationalMuseum.html
3 See Kirsten Wehner, this volume. See also Fiona Cameron, "Ecologizing Experimentations: A Method and Manifesto for Composing a Post-humanist Museum," in *Climate Change and Museum Futures* ed. Cameron and Nielson (New York: Routledge, 2015), 16–33.

with repositories of inert curiosities, accumulations of the flotsam and jetsam of history and culture, but rather enabling the objects to live again and inform dialogues with peoples from many different backgrounds.

In the era of climate change, museums have begun to think about responsible and creative approaches to respond to the challenges of adaptation. This book demonstrates that museums have been, and can be, effective in contributing to the ontological and social transformations that are urgently needed, around the world, now. It is an experimental book, suitable for a time that demands powerfully creative, lateral, experimental thinking. Its experimental method is "curation," a practice that includes bringing peoples, objects and stories into conversation, and in promoting a safe place to listen to perspectives from the objects and the cultures they subtend.

Engaging responsive communities

A key question for this book is: "how can museums collaborate in building communities able to *engage with* and *respond to* climate change?" Some museums have embraced the importance of public debate in strengthening civil society, seeing their role as providing and developing forums for the coming together of people with different perspectives on a particular issue. For some, this role has been conceptualized in a combative manner, with museum programs operating in a similar mode to television question-and-answer shows, pitting individuals from very different positions against each other. Such debates often result in a narrow scientific framing of the debate about climate change, and very little discussion of human responses to it. They degenerate into discussions of "causes," rather than productive narratives for response.

The context for these discussions in the wider world is just as combative, locked into highly polarized positions, yet, as Mike Hulme has written, there are reasons *why* people disagree about climate change.[4] The science is technical and easily misunderstood, sometimes deliberately, by journalists and those working as "merchants of doubt" on behalf of industry interests.[5] Moreover, the *social meanings of climate* are different in different cultural contexts.

An alternative approach is to focus on how museums can create new communities over time by enabling people from different cultural and social positions to come more gently into relationship with each other, perhaps through the co-curation of objects, or using objects to stimulate events. Some institutions have created spaces and processes to enable community access that invite the performance and strengthening of cultural practices. This has been serving to connect present generations of communities with their ancestors as well as celebrating and sustaining subaltern and minority traditions within larger societies. The focus here is on the human response, putting the debate out of the hands of the polarizing forces of the blame game.[6]

4 Mike Hulme, *Why We Disagree about Climate Change: Understanding Controversy, Inaction and Opportunity* (Cambridge: Cambridge University Press, 2009).
5 Naomi Oreskes and Erik Conway, *Merchants of Doubt* (New York: Bloomsbury, 2010).
6 Museums themselves have to grapple with the question of sponsorship, and particularly where "big sponsors" demand specific messages. This book begins from the premise that the communities need a safe place for discussion, and developing responses to something that is actually happening. There is no possibility for a community led adaptation if the focus is on promulgating doubt.

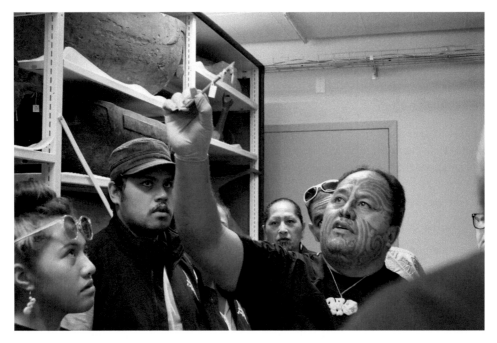

Figure 1.1 In the storeroom: Wayne Ngata and others members of Toi Hauiti (Aotearoa New Zealand), visiting the American Museum of Natural History, April 2013. Photo: J. Newell.

Places of stories and collections

Museums, as places of calm, of reflection and of considered learning, hold considerable potential to open dialogues, where the focus is on the effects rather than the causes of climate change. There is power in a personal visit and in real collections to explore global scale changes at a human pace. Museums are places in which people can wander about at will without immediately being asked for their opinion on something. They are non-confrontational and allow time to absorb information in a way that allows responses to surface without being concerned about what others will think.[7] Museums are institutions that can afford to step aside emotionally from convictions without compromising their identity. They are safe places that can help communities rethink and reinvent themselves better to meet the challenges of climate change.

Museums work through many modes: through the stories they tell, through the collections they mobilize and the exhibitions they launch. Stories are the means through which people make sense of themselves and the worlds they inhabit. Stories encode concepts about personhood, action and direction. They express ideas about value, authority and possibility, about the character of the past and its implications for the present and the future. To borrow a turn of phrase from Appadurai, stories express "the specific gravity and traction of the imagination,"[8] as well as being deeply embodied in often-unconscious habits and practices. Consequently, they define how we act in the world.

7 Gurian, "Savings Bank for the Soul," 88–97; Gurian, "Blurring of the Boundaries," 31–37.
8 Arjun Appadurai, *The Future as a Cultural Fact: Essays on the Global Condition* (London: Verso 2013), 286.

Collections are valuable in many ways, as constructions of knowledge and experience, repositories of cultural memory, agents for cultural creativity, resources for scientific inquiry and records of ecologies. They have the capacity to create unique visual, kinesthetic and affective modes of perceiving and understanding the world. In other words, they create unique forms of *material storytelling*. And in a time where something seems to have gone awry in our human relationships with the world, the materiality of objects and collections seems particularly promising, replete with the capacity to reshape and recreate our place in the physical universe.

Collections, of course, occupy actual locations, they are in and of the world in no uncertain terms. This means that museums are as much about spaces as they are about collections themselves; whether these spaces are collection storage areas dominated by steel shelving and Solander boxes, exhibitions carefully crafted to contextualize and interpret objects in particular ways, entrance halls dignified by a single, keynote display or online environments enabling virtual visitors to find and explore digitized collections.

Exhibitions

Exhibitions remain the most significant and distinctive environments in museums of all sorts. They are, as the American performance studies scholar Barbara Kirshenblatt-Gimblett once wrote, the way in which "museums perform the knowledge they create."[9] Exhibitions are unique, three-dimensional places in which meaning is made as visitors move about within them, encountering and responding to various kinds of carefully positioned and inter-related things, such as artefacts, images, texts, sounds, footage, interactives, pools of light, display cases, walls, seats, windows, exits and other visitors. They are places that enable embodied learning, key to helping audiences develop their sense of how they are inter-connected with physical environments.

Exhibitions are the most distinctive way museums can engage with climate change. They bring together people and objects in ways that collapse past and present, near and far, eliding the linear chronologies of modernist progress. They invite understanding of how localized particularities become interwoven with broader geographies and trajectories.

Exhibitions also promote new modes of thinking and understanding, emphasizing associational and synthetic approaches that build abilities to consider how our choices, actions and lives are entangled with the other species and forces of the planet.[10] Although it is difficult to find single objects that carry ideas on the scale of "climate change," it is worth reflecting on the power of the object and the context of a visit. These are a form of "slow media" – by analogy with the slow food movement. Given the volatility of the other media and its patchy coverage of climate change, appreciating change at a slower pace might be an important alternative way to cope with it. When important long-term discussions dip below sight, there might be a different role for a museum. For example, the media coverage of climate change was strong throughout the first decade of the twenty-first century, spurred on by events such as the sea ice minimum in the polar north in 2007. Suddenly in 2010, after the COP15 talks, media ceased. Coverage in 2010 was down 70 percent from that in 2009. "Merchants of

9 Barbara Kirshenblatt-Gimblett, *Destination Culture: Tourism, Museums, and Heritage* (Oakland, CA: University of California Press, 1998).
10 Deborah Bird Rose, *Reports from a Wild Country: Ethics for Decolonisation* (Sydney: UNSW Press, 2004); Jessica Weir, "Connectivity," *Australian Humanities Review* 45 (2008).

doubt," funded by fossil fuel lobbyists, succeeded in silencing the issue for several years. The implications of this for the Arctic are explored in detail later in this book.[11]

Media outlets shout catastrophe: they are not so able to report on violence that unfolds over longer times, as Rob Nixon reminds us.[12] While the media has plenty of images of New York under water from the Hurricane Sandy deluge, we see few pictures of the victims of the 10-year famine in the Horn of Africa, despite the fact that both are climate-change related. Such events will increase with anthropogenic global warming, but slow tragedies such as the African famine, which claimed more lives than Hurricane Sandy, failed to be noticed. "Slow violence" as Rob Nixon calls it, is a function of the global media cycle, and we need different sorts of media to balance it.[13]

Museum exhibitions are good for the long term, but less good in the short term. In the immediate context, they can sponsor dialogue and host controversial forums, but their galleries, exhibitions and collections are long-term investments. Museum displays cannot afford to be "sensational" in any instant ways. They must stimulate the imagination of visitors in ways that survive the first moment, in ways that invite repeat visits, and encourage participation in discussion sessions, workshops, conferences, and other modes of sustained, shared reflection.

Climate and culture

If the future is a "cultural fact," as Arjun Appadurai describes it, cultural institutions are part of imagining what a climate-changed world is going to mean.[14] As Susan Crate and Mark Nuttall phrase it, "climate change is ultimately about culture," pointing to the "intimate human-environment relations," integral to cultural diversity, that lose place in its wake.[15] Global warming was set in motion by the culture of progressivism that brought us the Industrial Revolution and continues to drive the capitalist culture of consumption. Cape Farewell artists articulate this relationship explicitly: "What does Culture have to do with Climate Change? Everything."[16]

Museums have been creating, mounting and touring exhibitions about climate change for some time. An early exhibition, *Global Warming: Understanding the Forecast* opened at the American Museum of Natural History (AMNH) in 1992, just four years after the establishment of the Intergovernmental Panel on Climate Change (IPCC). It ran for five years. The exhibition toured and was well attended and highly regarded, winning an American Association of Museums Curatorial Award.[17] Curators Eva Zelig and Stephanie L. Pfirman wrote afterwards about the difficulty of displaying the impacts of "colorless gases" and abstract concepts through the exhibition medium.[18]

11 Miyase Christensen and Nina Wormbs, "When the Ice Breaks," this volume.
12 Rob Nixon, *Slow Violence: The Environmentalism of the Poor* (Cambridge, MA: Harvard University Press, 2013).
13 Nixon, *Slow Violence*.
14 Appadurai, *Future as a Cultural Fact*.
15 Susan Crate and Mark Nuttall, *Anthropology and Climate Change* (Walnut Creek, CA: Left Coast Press, 2009).
16 Cape Farewell website www.capefarewell.com and *Carbon14: Climate is Culture,* the catalogue of the exhibition at the Royal Ontario Museum (2013–14); see also Tim Sherratt, Tom Griffiths and Libby Robin eds. *A Change In The Weather: Climate And Culture In Australia* (Canberra: National Museum of Australia, 2005).
17 http://anunknowncountry-movie.com/film_team.php
18 Eva Zelig and Stephanie L. Pfirman, "Handling a Hot Topic: Global Warming: Understanding the Forecast," *Curator: The Museum Journal* 36 (1993): 256–271.

Introduction 7

Figure 1.2 Exploring the affective dimensions of climate change through theater in museums: Jeremy Pickard in "Flying Ace and the Storm of the Century," using favorite American cartoon character Snoopy, afloat on his doghouse in rising waters. Superhero Clubhouse performance at the American Museum of Natural History, October 2013. Photo: Marina McClure.

The pace of exhibiting climate change picked up, as public domain discussions did too, from the early 2000s.[19] Many of these exhibitions were within science museums and museums of natural history, and were primarily directed to explaining the science of climate change. "Scientists" were the main actors employed in the narratives of these exhibitions. There were often minimal discussion of the observations, interpretations or experiences of the majority existing beyond the scientific establishment. More recently, as museums have started to work from the assumption that their audiences are familiar with the basics of climate change science, exhibitions have broadened their reach, becoming more willing to explore the current and future implications of climate change for human societies. Exhibitions are now being staged in a wider range of institutions: national museums, museums of art, historical museums, aquaria, and museums centered on a wide range of specialist subjects. They are reflecting on the implications of climate change on human societies, being more willing to admit and explore the more affective aspects of the issues through artworks, personal stories, and asking local audiences questions such as "what will you miss most in your changing environment?"[20]

19 See the Museums and Climate Change Network (hosted on the AMNH website) for an annotated list of exhibitions. S. Daniels and G. H. Endfield, "Narratives of Climate Change," *Journal of Historical Geography* 35 (2009): 215–404.
20 Yale Peabody Museum of Natural History, *Seasons of Change: Global Warming in Your Backyard*, New Haven, CT, 2012 (see Figure 1.1).

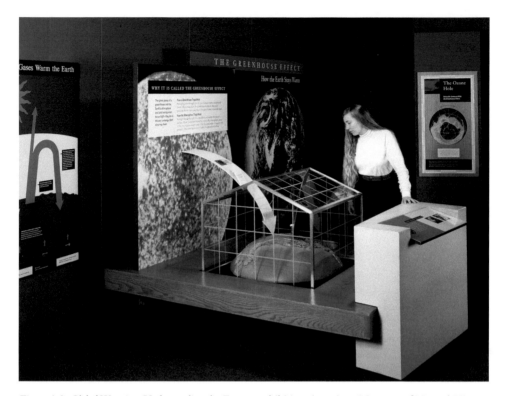

Figure 1.3 Global Warming: Understanding the Forecast exhibition, American Museum of Natural History, 1992. Photo: AMNH. See Plate 1.

The first dedicated museums about climate change are now emerging. The Jockey Club Museum of Climate Change, housed at The Chinese University of Hong Kong, opened in December 2013. It is funded by the Jockey Club Charitable Trust's "Initiative Gaia," and is a place that promotes talks and discussions as well as explaining environmental change through exhibitions and interactives. In New York, The Climate Museum is under development as we write in 2015, with a stated aim of moving "climate awareness to the center of public life." Director Miranda Massie is shaping the museum as an institution that will "catalyze public discourse," and will not present a narrative of "doom and gloom" but will convey the positive achievements of recent years as well; the mission is to "spark the optimism, ambition, and teamwork needed to ensure, in the decades to come, leadership in a climate-safe, vibrant world."[21]

Ethics for museums exhibiting climate change

Canadian Robert Janes lamented in his 2009 book, *Museums in a Troubled World* that museums have largely failed to engage with climate change, and have sidestepped questions of assisting communities to adapt to a changing world, including associated issues such as environmental

21 www.climatemuseum.org; Lisa Foderaro, "A lawyer quit her job to start a Climate Museum in New York," *New York Times*, August 21, 2015; Brian Kahn, "Climate Change is Getting its own Museum," *Climate Central*, August 14, 2015 (www.climatecentral.org/news/climate-change-museum-19341).

degradation, fossil fuel depletion and the social well-being of displaced communities.[22] The result, Janes argues, is that museums as social institutions risk becoming irrelevant. Certainly, museums in general have been slow to take up climate change as a challenge, but there have been significant initiatives and experiments. The contributors to this book, many of whom assembled in New York for a workshop at the American Museum of Natural History in October 2013, explore some of the ways aspects of museum practice are changing. Through increasingly fluid museum practices, some of which bring new people into traditional and non-traditional museum galleries, we argue that museums can reconstruct their social relevance, especially in relation to the great challenge of climate change. Museums can of course do more – but there is a diversity of approaches that engender hope rather than apathy for visitors to many of the museums discussed in this volume.

Kylie Message, in *Museums and Social Activism*, traces curatorial efforts at the Smithsonian Institution to engage with and represent social protest movements from the 1960s, efforts that have continued to grow.[23] She points to museum practitioners and researchers in recent decades showing "museums to exist as sites of public consciousness that are part of the dynamics of cultural change that intersect with both formal and informal spheres of political action." Museums are leading debates about their ethical obligation to contribute to discussions of social justice, protests against human rights abuses and pressure to extend "government policy priorities."[24] Curators in the sector have similarly engaged actively, with varying degrees of success, in issues of environmental justice and environmental change. A handbook for approaching and exhibiting environmental issues was published by the American Association of Museums as long ago as 1971,[25] and exhibitions on environmental degradation and change have at times been willing to be explicit about industrial, corporate and political culprits. Janes's critique of persistent partnerships between museums and sponsors with compromising agendas, however, remains valid. In recent years protests against fossil fuel industry funding of museums such as the British Museum, Science Museum (London), the Smithsonian's National Museum of Natural History, and the American Museum of Natural History have gained momentum, with the recent divestment movement adding impetus.[26] Suggestions that sponsors have censored or limited climate change content have drawn angry public commentary, with critics pointing to the side-stepping, watering down or editing out of mention of the human contribution to the causes of climate change.[27] In

22 Robert Janes, *Museums in a Troubled World: Renewal, Irrelevance or Collapse?* (London: Routledge, 2009).
23 Kylie Message, *Museums and Social Activism: Engaged Protest*. (Hoboken, NJ: Taylor and Francis, 2013).
24 Message, *Museums and Social Activism*, 22.
25 Luke Keogh and Nina Möllers, "Pushing Boundaries: Curating the Anthropocene at the Deutsches Museum, Munich," in *Climate Change and Museum Futures*, ed. Cameron and Nielson, 78–89: 82. The Piggott report for a Museum of Australia in 1975, recommended a gallery of "people and the environment" and commented that "to divorce man from nature in the new museum would be to perpetuate a schism" of the nineteenth century, in Libby Robin, "Collections and the Nation: Science, History and the National Museum of Australia," *Historical Records of Australian Science* 14 (2003): 278.
26 Terry Macalister, "Shell sought to influence direction of Science Museum climate programme," *The Guardian*, May 31, 2015. www.theguardian.com/business/2015/may/31/shell-sought-influence-direction-science-museum-climate-programme.
27 Jane Mayer, "Covert Operations: The Billionaire Brothers Who are Waging a War Against Obama," *New Yorker*, August 30, 2010 (see end of article for discussion of the "David H. Koch Hall of Human Origins" at the Smithsonian) www.newyorker.com/magazine/2010/08/30/covert-operations.

some cases, interpretive panels discussing climate change have been omitted from the final exhibition.[28] In others, exhibitions have constructed evidence for climate change as uncertain,[29] or presented the pressing and deep impacts of climate change light-heartedly through games that suggest that all humans need do to cope is to wait to evolve more sweat glands or gills.[30]

Taking up the challenge of climate change depends upon museums not simply moving to encompass a new theme or topic within existing galleries, but rather developing significant, multi-pronged modes of museological practice, and doing so with creativity and courage. Collections, spaces, communities, institutions and audiences are all implicated, in different ways, in these efforts.

Four trajectories

Recent innovations in museum practice have motivated and given structure to new practices responsive to the challenges of climate change. This book is structured in four parts, each a trajectory that reflects the new relationality that museum practice needs for a climate-changed world. Rather than looking back at what museums have done (or not done) so far, this book aims to stimulate new directions and reflections on museum projects, considering a range of museums and museum-like institutions that bring communities and climate change together in innovative ways. This is not a "how to do climate change in museums" book. This book instead presents conjunctions, resonances and contradictions between perspectives that might stimulate the museum field in its broadest sense, as each local place, each community comes to terms with its own uncertain future. The process of bringing the book together reveals that different voices and experiences might, paradoxically, share future trajectories. Comparisons and contradictions can be creative for those planning new initiatives.

The approach of this book can best be described as *curatorial*. We have curated a series of reflections and representations into thoughtful assemblage, in order to provoke new discoveries of inter-connections, resonances and meanings. Curatorial approaches have value that have generally been overlooked. Ross Gibson wrote of the value of curation when thinking about a city: "What might happen if we stopped *developing* Sydney and commenced curating the place instead, caring for it and encouraging transformations in the city?"[31] The assemblages of reflections and representations here may suggest new ideas and opportunities for discussion, rather than reducing possibilities into defined principles and instructions.

28 Anna Kuchment, "Museums tiptoe around Climate Change," *Dallas Morning News*, June 15, 2014: "Visitors to the Perot Museum of Nature and Science can stand beside an enormous rotating drill bit, take a virtual ride down a fracking well…" but see no clear references to the human contribution to global warming. A panel referring to this was left out of a recent redevelopment of the climate and weather exhibit. This was apparently an oversight. The Director has stated that board members and funders (who include gas industry representatives and ExxonMobil) have no say in content.
29 Jonathan Jones, "Science Museum: Close Your Climate Change Show," *The Guardian*, Nov. 18, 2009: on *Prove it!* at the Science Museum in London.
30 Joe Romm, "Smithsonian stands by wildly erroneous climate change exhibition paid for by the Kochs," March 23, 2015, climateprogress.org.
31 Question posed on the back cover, Jill Bennett and Saskia Beudel, *Curating Sydney: Imagining the City's Future* (Sydney: University of New South Wales Press, 2015).

In the curatorial spirit, this book is punctuated with a series of *objects in view*, intended to enable artefacts – the core of museum business – to carry stories and provoke imaginings that expand our sense of how we relate to the world. Objects are agents of meaning (not just items to caption). They are observed and the observation process itself is part of the multiplicity of museum experiences. Multiple stories coalesce around and explode out of artefacts, opening out possibilities for shared, production of new narratives of community.

This approach resonates with the current interest in interdisciplinary environmental studies, and we are fortunate in this book to be able to bring together biologists who center key parts of their research on museum collections, environmental historians, a philosopher of extinction, and curators who are conservation biologists, anthropologists and artists who have placed relationships with environment at the core of their work and their exhibitions. The four trajectories of museums' engagement with climate-change structure the parts of this book.

Part 1: Welcoming new voices: opening museums

Museums have a history as former participants in colonial practices, disempowering subaltern subjects, collecting and displaying the other, and presenting knowledge in a single, authoritative voice. Decolonized museums include multiple viewpoints. They authorize and bring into relationship multiple, diverse forms of knowledge and experience, particularly in terms of valuing subaltern communities, and empowering the voices of those who have suffered injustice. In the case of climate justice, museums have an opportunity to provide leadership and space for the voices of those already contending with changes that are the result of actions they have had no say in. As Rob Nixon reminds us in his contribution to this book, climate change is deeply implicated in social injustice. Can museums offer a bridge to better build climate justice?

Lumepa Apelu's story is about a connection to a particular place that is changing rapidly, reminding us of the importance of local expertise, as well as western, scientific knowledge in understanding the changing world.

Jennifer Newell explores how, in opening up a museum, people can come together around objects to help expand each other's horizons – powerfully enriching each other's concepts of what is possible. Kristina Stege's "Object in View" demonstrates just how powerful this can be through her *jaki-ed* mat. The *jaki-ed* mat sparks memories and learning that enable new connections between people and communities.

Jacklyn Lacey writes of the responsibility of the museum worker to establish partnerships that enable members of communities to connect with significant objects, and to think of their own relationships to those collections with similar framings, being sensory, place-based, and with predecessors providing particular connections of "lineage." Historian Tom Griffiths tells the story of an object from the past that became important in the future: Connie Hart had not had the opportunity to learn weaving from her grandmother, but when she found an eel trap in the Museum of Victoria, she learned again a lost cultural skill, to teach to her grandchildren.

Anthropologist Peter Rudiak-Gould considers climate change in the Marshall Islands, and argues that islanders on low-lying atolls deserve to live well – to thrive, not just survive – on their islands. He takes the example of the Melbourne Immigration Museum's exhibition on Tuvalu to demonstrate how museums can help those leaving a homeland behind to create

Figure 1.4 Cordell Bank Underwater Reef Installation, Oakland Museum of California, 2015. Visuals collage and design by Olivia Ting. Photo: Kirsten Wehner. See Plate 2.

new places of significance for themselves, assisted by objects and representations of selves and communities within museums. Also considering atoll life, Joshua Drew's "Object in View" is a shark-tooth sword from Kiribati. The teeth on this sword disclose past species distributions, revealing lost species that were once part of the i-Kiribati world.

Part 2: Reuniting nature and culture

Kirsten Wehner urges a turn in museums "towards an ecological museology," a way of thinking with nature and culture together that celebrates connections. Climate change affects all living creatures on Earth, creating change across the planet's biosystems. As such, it demands we re-consider deeply held convictions about human exceptionalism, about the division of "Culture," the realm of people, from "Nature," the world of everything else, and develop new understandings of the inter-weaving and inter-reliance of human and nonhuman worlds. Wehner's ecological museum develops new forms of knowledge, exhibitions and interpretive practice that together foster embodied, empathetic and imaginative, as well as analytical, engagements between peoples and non-human species and forces.

These embodied practices are explored by Daniel Oakman, whose "Object in View," "Harry Clarke's high wheeler bicycle," exemplifies an extraordinary moment in mobility history which resonates for a world beyond fossil fuels. The body theme continues with

Eleanor Sterling and Erin Betley's, "Food and Water Exhibitions as Lenses on Climate Change." Questions of clean water and food security are closely linked with climate change: they are also at the heart of community and cultural life all over the world.

The question of growing food in new environments is explored by George Main, whose "Stump Jump Plough" technology enabled wheat to be planted in places where formerly forests grew. It is a historical object from a settler society that battled the land to sustain itself in a different climate.

With Leah Lui-Chivizhe's "Telling Torres Strait History through Turtle" we return to the sea, and its stories. So often the stories of "environment" are about land, but climate change is about the planet's global systems, the sea and the atmosphere in particular. Lui-Chivizhe tells of the sea, through the lens of Turtle. It is the wonderful turtleshell masks that have survived in museums that allow her to re-tell Torres Strait history afresh.

Kirstie Ross takes us to the Land of the Long White Cloud, New Zealand, where weather is culture. She discusses the principles behind talking about "weather" in an exhibition in New Zealand's National Museum, Te Papa. Martha Sear brings us a dog collar as her "Object in View," a material object that evokes an extreme weather event from long ago. Through his collar, we meet Nelson, who rescued people from sudden, swirling floodwaters in downtown Melbourne city.

What are the ethical responsibilities to individuals of passing species? Thom van Dooren explores the last snail of its species, and the science and moral dilemmas of extinction. Of all the threats from climate change, the greatest is that extinctions will ultimately destroy the integrity of the life-support systems of Earth. But very occasionally, extinction is not forever, as Nancy Simmons' "Object in View" – the long-lost Olinguito – reveals. The Olinguito also suggests a special role for museums: for it is through museum practice that it was found again.

Part 3: Focusing on the future

If we are seriously to consider the future in museums, we must also imagine the collections that will be important to future museum visitors, and start collecting now. Charlie Veron realized this some decades ago, and as Iain McCalman relates, his coral collection is now extraordinarily important as the oceans acidify, and the worlds' reefs change beyond recognition.

Future food is another big question, here tackled by George Main. Agriculture connects us all to the rest of nature in intimate ways, he argues, and yet as the global climate warms and shifts extreme weather events undermine the viability of agricultural systems that emerged over the last 10,000 years, during the relatively stable climatic regime of the Holocene. Main's "Paddock Report" is the story of one museum's efforts to engage the local agricultural community with the big issues of global food security. It is a project of a museum, yet not a traditional exhibition: rather it is about building the community into the practice of the museum. But it is very much about the materiality of change and the objects beyond collections that can be incorporated into the museum's span.

Sharon Willoughby's role at the Royal Botanic Gardens Cranbourne is equivalent to a curator's role in a museum: she tells the stories and interprets the plants for visitors. She relates some of her practice in developing gardens with ideas for the future, and in her "Object in View," the unlikely "cucumber straightener" she explores a historical, then futuristic, garden tool.

Figure 1.5 Crocheted coral reef, *Welcome to the Anthropocene* exhibition, Deutsches Museum, Munich, 2014. Photo: Alex Griesch. See Plate 3.

The final section of this part moves to art museums exploring the idea of the Anthropocene, the proposed new geological epoch that suggests that humans are a biophysical force on the planet. There is no doubt that climate and other global changes have reached a point where we are moving towards a "no analog" world, where the rules that applied in the Holocene no longer apply.[32] The Canary Project, described in the "Object in View" by Ed Morris and Susannah Sayler, is just one of the artist projects in the collecting campaign at the Nevada Museum of Art which Director of the Center of Art+Environment, William L. Fox calls Art for the Anthropocene. Fox's essay explores some of the history of the Anthropocene concept, and how it can be translated into art objects, particularly photographic works.

Part 4: Representing change and uncertainty

Creators of museum exhibitions and programing have been engaging in the dynamics of change within human societies and in our wider ecologies, moving away from asserting static absolutes and universal truths. The entry-point to this, the book's fourth trajectory, considering change, is framed by two objects. One is a protective, delicate Inuit anorak of seal gut held in the Hood Museum, the other an artwork by Sverker Sörlin and Gunilla Bandolin, also of animal gut, stretched over the frame of a symbol of the fossil fuel-driven inequalities of global exchange: a Volvo.

32 Will Steffen *et al.*, "The Trajectory of the Anthropocene: The Great Acceleration," *The Anthropocene Review* 2 (2015): 1–18.

Staying north in Sweden, Ewa Bergdahl and Anders Houltz look historically at museum exhibitions that engage with environmental change at the Swedish Museum of Natural History, Stockholm, in the period from 1965–2005. The last of the exhibitions dealt directly with climate change, and this chapter gives climate-change exhibitions a lineage in one the cities leading discussions of global environmental change. In 1972, Stockholm hosted the United Nations Environment Programme Conference, and at the time the Intergovernmental Panel on Climate Change (IPCC) was established, chaired by a Swede, Bert Bolin, the Swedish Government hosted the International Geosphere Biosphere Program (IGBP) where the Anthropocene was first mooted by atmospheric chemist, Paul Crutzen.[33]

Susanna Lidström and Anna Åberg explore the fish museum and the responses of aquaria to the stories of Rising Seas. Their piece is paired with a "Model of New York Under Water," an object that showed the effects of rising seas at the AMNH exhibition on Climate Change. Edmond Mathez, curator of the exhibition, reflects on the model and a missed opportunity to speak to climate justice.

The book concludes with two reflective pieces: the first is on media beyond museums – especially the fast and furious news media of radio, television and print journalism, and the reportage around the story of diminishing polar ice. Miyase Christensen and Nina Wormbs write of the international comparisons (United States, Britain and Sweden) and what is lost as well as what is gained by the grind of the daily news cycle. This is a timely reminder of the very different time scales and pressures in museums and other "slow media."

The final chapter is about presenting the Anthropocene within and beyond museums. It begins with the project of the Deutsches Museum, Munich, the largest science and technology museum of the world, which developed the exhibition *Welcome to the Anthropocene* (2014–2016). Its curatorial team included Nina Möllers, Luke Keogh and Helmuth Trischler. We also explore the complex landscape scale gallery of the Anthropocene in Svalbard through Dag Avango's cultural heritage advice around the coal-mining village of Pyramiden – a story that spans over a century, but has become a tourist attraction and resource for climate science since 2013. Libby Robin, Dag Avango, Luke Keogh, Nina Möllers, and Helmuth Trischler together show a range of ways that the materiality of museums allows the abstractions of the Anthropocene to be made concrete for audiences.

In conclusion

In many ways, it is the *change* in climate change that most deserves our attention, and the dynamism and uncertainty are the challenge to a museum. To ensure that humanity, and non-humans, can flourish, we need new stories to make sense of how our world is changing and to imagine possible new ways of living in and shaping it.[34] Moreover, these narratives need to move beyond simply expressing measurements of conditions like atmospheric carbon dioxide and more variable weather patterns, to grapple with what these might mean for communities, physically, culturally and affectively. The narratives we share help people cope

33 Will Steffen, "Commentary: Crutzen and Stoermer on The Anthropocene," in *The Future of Nature: Documents of Global Change* eds. Libby Robin, Sverker Sörlin and Paul Warde (New Haven, CT: Yale University Press, 2013), 486–490.
34 Appadurai, *Future as a Cultural Fact*, 287.

with the experience of climate change, and its conflicted emotions of loss, grief, disorientation, confusion, resolution, opportunity, hope and care.

Our aim is for the conversation to develop a global network of museum professionals and other scholars addressing climate change within their communities.[35] We also hope that it will support the development of new conceptual frameworks and discursive directions for museums to use in engaging with the challenges of climate change in all its scientific, cultural, physical and emotional dimensions.

35 The Museums and Climate Change Network, established in 2013: www.amnh.org/our-research/anthropology/projects/museums–and–climate–change–network.

2
TELL THEM

Kathy Jetñil-Kijiner

I prepared the package
for my friends in the states

the dangling earrings woven
into half moons black pearls glinting
like an eye in a storm of tight spirals
the baskets
sturdy, also woven
brown cowrie shells shiny
intricate mandalas
shaped by calloused fingers
Inside the basket
a message:

Wear these earrings
to parties
to your classes and meetings
to the grocery store, the corner store
and while riding the bus
Store jewelry, incense, copper coins
and curling letters like this one
in this basket
and when others ask you
where you got this
you tell them

they're from the Marshall Islands

show them where it is on a map

tell them we are a proud people
toasted dark brown as the carved ribs
of a tree stump
tell them we are descendants
of the finest navigators in the world
tell them our islands were dropped
from a basket
carried by a giant
tell them we are the hollow hulls
of canoes as fast as the wind
slicing through the pacific sea
we are wood shavings
and drying pandanus leaves
and sticky bwiros at kemems
tell them we are sweet harmonies
of grandmothers mothers aunties and sisters
songs late into night
tell them we are whispered prayers
the breath of God
a crown of fuchsia flowers encircling
Aunty Mary's white sea foam hair
tell them we are styrofoam cups of koolaid red
waiting patiently for the ilomij
tell them we are papaya golden sunsets bleeding
into a glittering open sea
 we are skies uncluttered
majestic in their sweeping landscape
we are the ocean
terrifying and regal in its power
tell them we are dusty rubber slippers
swiped
from concrete doorsteps
we are the ripped seams
and the broken door handles of taxis
we are sweaty hands shaking another sweaty hand in heat
tell them
we are days
and nights hotter
than anything you can imagine
tell them we are little girls with braids
cartwheeling beneath the rain
we are shards of broken beer bottles
burrowed beneath fine white sand
we are children flinging
like rubber bands
across a road clogged with chugging cars

tell them
we only have one road

and after all this
tell them about the water
how we have seen it rising
flooding across our cemeteries
gushing over the sea walls
and crashing against our homes
tell them what it's like
to see the entire ocean___level___with the land
tell them
we are afraid
tell them we don't know
of the politics
or the science
but tell them we see
what is in our own backyard
tell them that some of us
are old fishermen who believe that God
made us a promise
tell them some of us
are more skeptical
but most importantly tell them
we don't want to leave
we've never wanted to leave
and that we
are nothing without our islands.

Figure 2.1 Kathy Jetñil-Kijiner, Marshall Islands, 2012. Image: Courtesy the author (jkijiner.wordpress.com) © Kathy Jetñil-Kijiner, 2012.

PART I
Welcoming new voices: opening museums

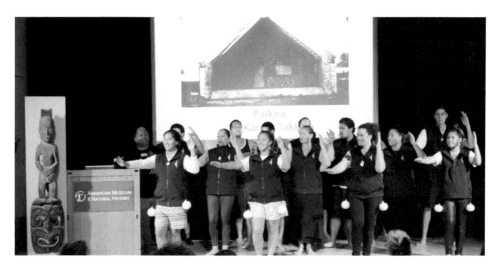

Figure I.1 Toi Hauiti performing for their ancestor, Paikea the whale rider, American Museum of Natural History, April 2013. Photo: J. Newell.

3

THE ANTHROPOCENE AND ENVIRONMENTAL JUSTICE

Rob Nixon

That things are "status quo" is the catastrophe.

Walter Benjamin

I

Giving the Anthropocene a public resonance involves choosing objects, images, and stories that make visceral those tumultuous geologic processes that now happen on human time scales. How can we most effectively curate and narrate the Anthropocene, an idea that can seem, by turns, dauntingly compendious and elusively abstract? What objects, images and stories can best express the imaginative politics of the Anthropocene as an ascendant planetary story, speaking simultaneously to the promise and potential pitfalls that that the idea contains? To approach such large questions requires straddling two of the most pressing challenges of our time: the environmental crisis and the inequality crisis. Over the past thirty-five years—and ever more acutely in the twenty-first century—we have witnessed, in society after society, a widening divide between the super-rich and the ultra-poor, between islands of walled off privilege and ecologically ravaged sacrifice zones of human abandonment, zones stripped of the resources necessary for sustaining life. For if accelerating, anthropogenically-driven planetary change is a definitive feature of our age, so too is an intensifying disparity, the gulf between the haves and the never-will-haves that mars social mobility and scars social cohesion. In Timothy Noah's phrase, we are now living through "the Great Divergence."

So a crucial imaginative challenge facing us is this: how do we articulate the story of the Great Divergence to the story of the Great Acceleration? How do we find the material objects that will bring into emotional focus two large stories that can often seem in tension with each other, a convergent story and a divergent one? First, the story of how a single sentient species has become, for the first time in Earth's history, a quasi-geological force, above all during the post-World War II Great Acceleration that has seen an exponential increase in the globalization of human institutions, trade, and environmental and geological

impacts. This collective story expresses an increasingly widespread awareness that humanity's geomorphic and biomorphic impacts will be legible in the Earth's geophysical systems for millennia to come, that our accumulating, accelerating and durable impacts are being written in stone. To recognize the full force of this morphology entails asking far-reaching questions, like how can we, as a species, pool our creative energies to produce some viable mix of adaptation, resilience, and sustainable endeavor in the name of an already compromised, but best possible planetary future? Can the grand Anthropocene story, which highlights humanity as an exceptional actor in planetary morphology, help provoke a greater sense of human responsibility? For if the Anthropocene is, in both senses, an epochal idea, it achieves that force by shaking the very idea of what it means to be human. The perceptual and conceptual jolt that the Anthropocene delivers is indissociable from a yearning for innovative ways to reframe human power and planet-wide human policies. Environmental historian Libby Robin puts the matter succinctly: "The question is how people can take responsibility for and respond to their changed world. And the answer is surely not simply scientific and technological, but also social, cultural, political and, above all, ecological."

Against this epic species story, which positions and invokes *Homo sapiens* as a collective force, we need to remain alive to a more divided story. The species-centered Anthropocene meme has gained traction in the twenty-first century, which has seen, in most societies, a hollowing out of the social middle alongside intensified resource capture by the most affluent and intensified resource depletion that leaves the most vulnerable ever more exposed. This deepening schism is evident in nations as diverse as the United States and China, India and Russia, South Africa, Spain, Nigeria, Indonesia, the Philippines, Jamaica, the United Kingdom, New Zealand, Bangladesh, Costa Rica and Italy. Yet in the most influential articulations of the Anthropocene, environmental justice considerations have remained marginal, giving at best incidental attention to unequal access to resources and unequal exposure to risk.

This chapter is an effort to help spur us to think through the implications of the Anthropocene's ascent as a grand explanatory story during a plutocratic age. As we take the Anthropocene deeper into the public realm, as we search for material ways to release its imaginative potential, a critical creative challenge is this: how to unearth stories that disturb conventional assumptions about the temporal and physical limits of humanity's planetary agency, while also disturbing the idea of a unitary species actor in terms of impact and responsibility.

It may be helpful here to add a more personal note about what prompted me to begin to address the Anthropocene from an environmental justice perspective. After I had finished writing *Slow Violence and the Environmentalism of the Poor*, I sensed that I wasn't finished with the politics of environmental time as it bears on environmental justice. But I also wasn't sure exactly what direction the new work would take. Then in 2012 I was invited by the Smithsonian Institution to participate in one of their Great Ideas Consortiums, in this case, a brainstorming two-day workshop on the Anthropocene. The plan was to test run the viability of a vast projected Smithsonian exhibit on the Anthropocene that would span all nineteen of the Smithsonian's museums.

At the consortium, which had some thirty participants, just a smattering of whom were from the arts or humanities. I was keenly aware that scientists were driving the Anthropocene conversation. I also soon learned that not only the Smithsonian, but the American Museum of Natural History, the Deutsches Museum, the Venice Biennale, the National Museum of Australia, Duke University and institutions from Stockholm to Leiden were all gearing up

for Anthropocene exhibits or events over the next couple of years. I felt it was critical that perspectives from the arts and humanities become an active part of the mix as influential international institutions started to stage the Anthropocene as a planetary story with the potential to reshape environmental publics. As makers of stories and scholars of storytelling we have powerful roles to play, particularly at this historical juncture. During the first decade of Anthropocene thinking—since atmospheric chemist Paul Crutzen and ecologist Eugene Stoermer coined the term in 2000—the exchanges about its implications remained largely scholarly, interdisciplinary affairs. But, as evidenced by the 2013 conference at the American Museum of Natural History, Anthropocene debates have taken a decidedly more public turn. So how can we most effectively animate this charismatic, planetary, but divisive story—in our writing, our image making and our curation—in ways that speak not just to the global environmental crisis, but also to the global inequality crisis?

II

Let me give these thoughts a material grounding in two thematically connected, but contrastive environmental videos. At the heart of both videos is a quintessentially Anthropocene technology, the handheld chainsaw. The chainsaw was originally a medical, surgical instrument, a product of the Scottish Enlightenment that contributed profoundly to the Industrial Revolution. Indeed, the chainsaw's prototype was devised by two Scottish doctors, John Aitken and James Jeffray, in the 1780s, the very decade when that more famous Scot, James Watt, invented the steam engine, the event commonly cited as marking the Anthropocene's beginnings. But not until 1925 would a corporation, the German company Festo, find a way to manufacture the portable chainsaw—by now much refined, and with trees in mind not human bones— on an industrial scale. This implement would soon become a pivotal technology in the shaping of the Great Acceleration, one deeply implicated in rapid planetary transformation: in deforestation, habitat fracture, biodiversity morphology, the ascent of industrial-scale monocultures, the globalization of food, and attendant changes in the nitrogen, carbon and water cycles.

The portable chainsaw thus weighs something in the annals of the Great Acceleration. As a technology, the chainsaw is particularly resonant—in the fullest sense of that word—for settler societies founded on violent contests over the land and large-scale clearances in the name of civilizational progress. We know the chainsaw, above all, through its distinctive voice: like certain widespread, but secretive forest-dwelling birds, it is more often heard than seen. Thus, from a curatorial perspective, the chainsaw song offers a particular multi-sensory reverberation: as a soundtrack, as an image, and as a tactile, handheld instrument suggestive of human impacts on Earth's character, prospects and morphology.

Two videoclips available on YouTube[1] provide very different environmental angles on the chainsaw as Anthropocene motif. The first clip is from a BBC documentary by David Attenborough on the vocal prowess of Australia's Superb Lyrebird (*Menura novaehollandiae*). Here we are privy to the lyrebird in full display, parading its plumage and melodic powers at the height of the courting season. What we witness is a concert platform on which two male

[1] www.youtube.com/watch?v=VjE0Kdfos4Y Attenborough: The Amazing Lyre Bird sings like a chainsaw!' www.youtube.com/watch?v=hx3zAXnlf4s Youtube video, "Israeli soldier destroying Palestinians olive trees", uploaded August 7, 2011.

soloists are performing, the superb lyrebird and the superb David Attenborough, both prinking males in the business of seduction. The lyrebird is in full-throated priapic song, while Attenborough warbles his excitement sotto voce, as he lurks operatically half hidden behind a tree. The bird proves to be an artful mimic: imitating a kookaburra, a car alarm, a tourist's camera, then a camera with a motor drive, and finally foresters with chainsaws.

This scene has evident powers of enchantment: it has racked up 12 million YouTube hits. That enchantment, I would suggest, resides in more than the bird's mimic versatility. The scene's power and pathos derive principally from the chainsaw soundtrack. We can't see the chainsaws, but we can hear them, if only indirectly through an improbably, poignantly mediated form, via the bird's beak. What we hear is a fracture in the bird's mating song, a crack in its superb voice—the cracked note of habitat fracture. From one perspective, we can recognize the lyrebird as an exemplar of adaptation: driven by territorial impulses and procreative urgings, it invents new music by sampling the technological sounds bites that human culture sends its way. However, from another perspective, the male lyrebird is enfolding into its melody presentiments of its own demise. If this is adaptation, it is adaptation as dirge. So the bird's mimic sampling sets up a tension between two environmental time frames: the spring renewal, year after year, that courtship singing connotes, and the intimations of mortality announced by the chainsaw, a premonition perhaps of some ultimate silent spring. I want to underscore a few features of the kind of environmental story telling that Attenborough partakes of here.

First, the lyrebird scene is located in southern Australia, a part of the planet that is unusual for how sparsely populated it is. The only human we see in the documentary is Attenborough himself, a passerby, a transient witness, not a resident. Second, the chainsaw is audible but it is also abstract. We do not know who wields the chainsaw or why: we lack a political or cultural context for the ragged roar that the bird has heard and imitated. Consequently, this scene functions as a kind of planetary allegory, setting up a Manichean showdown between a threatened nonhuman world and an encroaching humanity, humanity as generalized collective actor in ways that are compatible with the Anthropocene as a unitary grand species narrative.

I want to bear these thoughts in mind in consideration of another chainsaw videoclip. It is set in a Palestinian family's olive grove, beside their home.[2] In this clip, the Israeli Defense Force is wielding chainsaws to obliterate a Palestinian olive grove and to make way for the Wall. This is part of what some Palestinians call the second Nakba, the second catastrophe, after the expulsion of 1948. In this harrowing scene the chainsaw resonates very differently. First, this is no remote, solitary encounter between the human and the nonhuman in a lightly populated corner of the Earth. This is a crowded, shouting environmental scene—contested and congested—replete with weaponry. The humans are not itinerant observers but long-term residents: they're fighting for the survival of their trees and through the trees, their economic and cultural survival. At stake is everything the olive trees represent: food security, land rights, cultural dignity, deep-rooted memory and all hope of persisting into the future. This scene foregrounds environmental justice, concerns, inequalities in access to environmental and technological resources as well as unequal vulnerabilities to risk. In this scene, the dead metaphor of an uprooted community is restored, root and branch, to its material, arboreal meaning.

2 www.youtube.com/watch?v=hx3zAXnlf4s

It makes no sense here to speak of humanity as species actor: that perspective sacrifices too much of the story's vital texture. Nor is the chainsaw's roar allegorical: the scene is not centrally a coded way of dramatizing big-H Humanity's encroachment on the nonhuman. Unlike in the lyrebird clip, here we can see the hands that hold the chainsaw and they belong to the Israeli Defense Force. One soldier wields the portable chainsaw in his right hand and, as an olive tree falls, pumps the air with his left fist, triumphantly. Beside him, the owner of the grove drops to his knees, imploring.

What we witness in this video is a scene from a geopolitically and historically specific resource war, a drama of dispossession between human communities in which the more heavily militarized group has the power to destroy trees in an act that doubles as a cultural assault. We are reminded that the handheld chainsaw is a two-edged implement: an ally of advancing cultures clearing wilderness, but also a technology that settlers have wielded again and again during the Great Acceleration for territorial seizure.

Crucially, this olive grove scene speaks in compressed form to a violent, widening human inequality. The clip portrays resource capture by the powerful and resource depletion of the poor who, through acts of dispossession, are driven toward deepening desperation. In other words, the environmental crisis dramatized here is inseparable from the crisis in disparity. Together, the lyrebird and olive grove clips illuminate a central tension in Anthropocene storytelling, between a centripetal species-centered perspective and a centrifugal sociopolitical perspective more attentive to unequal risks and impacts.

III

The Anthropocene's rising appeal as a story form results in part from mounting frustration over climate inaction at successive climate summits, frustration over the well-funded culture of anti-science in the US, and frustration over government inertia across the globe. But the Anthropocene also offers a response to a widespread exhaustion with the imagery and rhetoric of apocalypse. As Eddie Yuen has remarked, the terrain of catastrophe is "a crowded field"; "Environmentalists and scientists must compete in this marketplace of catastrophe, and find themselves struggling to be heard above the din."[3] In 2013, Elizabeth Kolbert noted in the *New Yorker* that CO_2 levels in Earth's atmosphere have surpassed 400 parts per million, a threshold last crossed 2½ million years ago. Kolbert noted, too, that this extraordinary planetary event "started out as terrifying and may now be described as terrifyingly predictable."[4] In an apocalypse-weary world, the crossing of that dangerous threshold mustered, at best, muffled media coverage and no discernable policy changes.

If we live in times that are sated with apocalypse and drowning in data, what forms of newness, what surprises can Anthropocene narratives deliver? They can help defamiliarize catastrophe's banality by shifting the window of time through which we view planetary change, and by encouraging us to reconceive of humans (appropriately disaggregated) as simultaneously organic and inorganic actors. The Anthropocene, moreover, offers a broader prism and a fresh language for thinking about earth's morphology, one that accommodates

3 Eddie Yuen, "The Politics of Failure have Failed: The Environmental Movement and Catastophism," in *Catastrophism: The Apocalyptic Politics of Collapse and Rebirth*, ed. Sasha Lilley, David McNally, Eddie Yuen and James Davis (Oakland CA: PA Press, 2012), 20.
4 Elizabeth Kolbert, "Lines in the Sand," *The New Yorker* (May 27, 2013).

Mike Hulme's observation that, however critical rising CO_2 levels may be, "the future cannot be reduced to climate change."[5]

However, in some influential quarters, this new story of exceptional species responsibility can revive disturbing forms of hubris, the kinds of enlightenment overreach that have contributed to the environmental and the inequality crises in the first place. Simultaneously, as science writer, Kennedy Warne cautions: "there is a risk that naming this epoch the Anthropocene can legitimize a self-involved anthropocentrism." In other words, in trying to curate and narrate the Anthropocene, we need to guard against both elevating and isolating humanity as some kind of super-agent; we need to make room within our Anthropocene story telling for the vast tangle of imperfectly understood intersections between human impacts and nonhuman actors, operating on macro and micro planes and across enormously variable time scales.

Foregrounding geological perspectives, as the Anthropocene turn does, can engender humility. After all, the 230 years of the Anthropocene so far—even the 11,000 years of the Holocene—is no more than a cheese paring of time. Such scales can seem overwhelming—even anti-human—and can engender (in Clive Hamilton's phrase) a kind of paleo-fatalism. This is one reason why, across history, so many religious leaders have resisted any geological deepening of time.

But within the popularizing of Anthropocene thought, paleo-fatalism has proven less of a pervasive problem than paleo-hubris, as mandarins associated with the Breakthrough Institute and beyond have teamed up to extol humans as the new planetary gods. In these terms, the Anthropocene becomes little more than a spur to humanity's infinite—and infinitely powerful—creative ingenuity. For geographer Erle Ellis, a prominent, gung-ho voice in Team Technofix, "the history of human civilization might be characterized as a history of transgressing natural limits and thriving ...We must not see the Anthropocene as a crisis, but as the beginning of a new geological epoch ripe with human-directed opportunity." Astrophysicist Lowell Wood likewise is blithely optimistic: "We've engineered every other environment we live in—why not the planet?" For Mark Lynas, author of *The God Species*, "Nature no longer runs the Earth. We do. It is our choice what happens here." This set never tires of quoting as their core maxim and inspiration Stewart Brand's grand pronouncement: "We are as gods and we HAVE to get good at it." When I read those words I see the wax melting from Icarus's wings as he plummets from sky to sea.

Far preferable to such naked hubris is anthropologist Harry Ruffles' sobering uncertainty. It is "starkly apparent," he suggests, "that new formations in the age of climate change are unlikely to produce linear outcomes. The future is deeply marked by the inevitable irruption of non-predictable phenomena on startling scales. Forget 'homeland security.' Time itself has changed." That is Anthropocene thinking without delusions of Earth mastery.

The Anthropocene mandarins who populate the Breakthrough Institute make a fundamental error in confusing human impact with human control. Changing the Earth—and leaving a trail of long-lasting, geologically legible effects—is not the same as commanding the Earth. In terms of gender, race, and empire, the Breakthrough Institute's Earth-mastery talk is redolent of the selective enlightenment underpinnings of imperial ambition, of those

5 Mike Hulme, "Reducing the Future to Climate: A Story of Climate Determinism and Reductionism," *Osiris* 26 (2011): 245–266.

exclusive conceptions of hyper-rationality that got us into this fix in the first place. It is as well to recall that the U.S. Department of Defense also views climate change as an "engagement opportunity." But if the object is to secure the Earth, the question remains: for whom? This returns us to the entanglement between the environmental and inequality crises. A certain style of Anthropocene species thinking, infused with biological-technological hubris, screens from view the shaping power of immensely variable cultural practices and forms of governance including those that have exacerbated inequality. A faith in technological innovation should be informed by an awareness of how well—or poorly—such technologies have been distributed historically. After all, 40 percent of humanity still lacks access to latrines, a rather venerable technology. Geo-engineering stripped of geopolitics is likely to be more moral hazard than help.

Historically and in the present century, how have social institutions, cultural practices, and forms of governance affected the way diverse communities have exercised radically different levels of geomorphic and biomorphic power? *Homo sapiens* may constitute a singular actor, but it is not a unitary one. Seventy billionaires now call New York City home, the same city where 30 percent of children live in poverty. Oxfam reports that in 2013 the combined wealth of the world's richest eighty-five individuals equaled that of the 3.5 billion people who constitute the poorest half of the planet. And a 2013 study concluded that since 1751—a period that encompasses the entire Anthropocene to date—a mere ninety corporations have been responsible for two thirds of humanity's greenhouse gas emissions. That's an extraordinary concentration of Earth-altering power.

In such a riven world, will Anthropocene adaptation to geomorphic change be adaptation by the rich for the rich? Will the poor, by contrast, be disproportionately burdened with expectations of resilience? Will we be left, once again, with a selective definition of humanity, but this time, at least in the U.S., with corporations included in the "Family of Man," corporations that have been granted legal personhood, while the outcast poor are dehumanized?

So within our Anthropocene story telling a crucial challenge is this: how to simultaneously dramatize the morphing of geological and social strata. The stratigraphers who are central players in the Anthropocene story are specialists at reading layers of rock. But in studying the human contribution to those sedimentary layers, we also need to conduct another kind of reading, a reading of social stratification. We would do well to acknowledge that even in terms of geological and atmospheric records, different strata, both historical and contemporary, have exerted unequal impacts on the planet's physical systems. Any representation of the Age of the Human should acknowledge the unequal planetary impacts of rich and poor communities, as well as the unequal fallout for those communities of accelerating global change. We are talking here of the Anthropocene as a shared geomorphic story about increasingly unshared resources. As we examine the geology of the human, let's also examine the geopolitics of geology's layered assumptions.

IV

I began this piece with reference to a soundtrack of trees being felled by chainsaws. And I want to end with another falling tree, this time as imagined by Spanish street artist, Sam3, as a stratigraphic event.

Sam3's "Deep Rooted" makes visible, in the fullest sense of the phrase, the body of environmental time. His vertical cross section of embodied environmental time reveals the

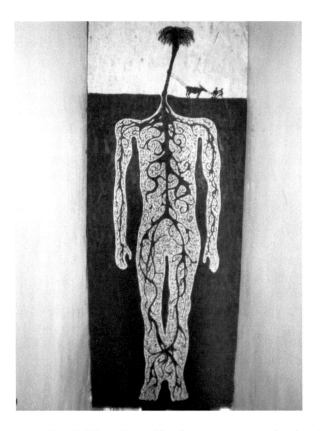

Figure 3.1 eddidangerous (Sam3) "Deep Rooted," color screenprint on hand-made Khadi paper, 94 × 40cm, edition of 40, 2008.

hidden long perspective wherein human agency, geology and biology converge. What we have here is a radical reading of time, in the etymological sense of radical: the image traces environmental time down to its buried roots. The environmental dissociation depicted involves a particular type of dismemberment, namely, decapitation: the land's living body has been rendered headless through, in every sense, a mindless surface act. Severance from connectedness is also a severance from the environmental—and geological—*longue durée*. To be mindful of the future, Sam3's mural suggests, demands that humans remain alive to the subsoil of memory and to life's hidden, yet vital long-term prospects, which are being written in the layers below by our casual surface acts.

V

The Anthropocene will continue to foment controversy, particularly now that the large public exhibitions are underway. In the words of paleogeologist, Jan Zalasiewicz, "The Anthropocene has the capacity to become the most politicized unit, by far, of the Geological Time Scale—and therefore to take formal geological classification into uncharted waters. Geologically," he concludes, "this is the most remarkable episode in the history of the planet." By politicized, however, Zalasiewicz means something quite different from my take here: he

is referring to the political controversy among geologists as to when exactly the Anthropocene began and whether the stratigraphic evidence is sufficiently decisive to mark the onset of a new epoch, and the end of the Holocene.

The Anthropocene politics that I have sought to highlight is rather different. This politics returns us to the question with which I began: What does it mean to promulgate the idea of the big-H human as grand geological actor in an age when the idea of the human is rupturing economically, especially under the deregulatory, globalizing pressures of neoliberalism that have incrementally, over the past thirty-five years, deepened disparity, separating people economically rather than bringing them together as anything approaching a cohesive biological actor? In this world, democracy gives way to plutocracy, and the sacrifice zones, ecological and human, grow ever wider.

Compared to forty years ago, when scientists dominated many of the first university environmental studies programs, we are witnessing a new appreciation of the power of the arts and humanities to create intellectual bridges between imaginative, narrative and ethical issues on the one hand, and, on the other, more data-driven fields. In a world awash with data, narrative can play a critical role in shaping environmental publics and environmental policy. And more and more scientists are acknowledging this role. Stories matter. And they matter immeasurably, their distinctive effects not reducible to metrics.

For this reason, for all my reservations about certain influential strains of Anthropocene thought, I believe it essential that we engage this grand, epochal gesture that has international, interdisciplinary and intergenerational implications. For official ratification as to whether the Anthropocene exists officially, we have to at least until 2016, when the International Stratigraphy Commission of the Geological Society will assemble and discuss whether the Holocene is officially over.

But the public realm moves more rapidly, with less deliberation than geologists. Through museums, TV series, blogs, Ted Talks, tweets, podcasts, and public symposia, the Anthropocene is entering the liftoff phase. As environmental humanists, artists and activists we cannot afford to remain bystanders and let scientists alone shape the emergent sphere of the public Anthropocene. I do not doubt that the mega-corporations, including the oil majors, will try to buy this story too and bend it to their interests. For this reason, we need to tease out the complex connections between rising atmospheric CO_2 levels, the rising oceans, and rising levels of inequality, connections that are not reducible to a centralized species story. In the inimitable words of Urban Studies scholar Eddie Yuen, "beware of plutocrats speaking of spaceship earth."[6]

6 Eddie Yuen, "Reply to 'The Myth of 'Environmental Catastrophism'", *Monthly Review: An Independent Socialist Magazine* 65 (2013).

4
CAMEO

Museums connecting

Lumepa Apelu

The "Museums Connect" project brought together two groups of people, one in New York and one in Samoa, to talk about personal effects of climate change. It focused on the impacts of climate change on our homes.[1] Home and houses are being challenged by more severe storms, in New York and here. The *fale samoa* is a simple traditional hut made of wood, woven string and leaves, circular or oval in shape depending on its significance to the family and the village.[2] In a *fale samoa* live over a thousand years of people and their goings and comings, beginning with the roosters in the mornings and ending with the full moon covering half their skies. But simplicity is ingenuity too. When you look into a *fale samoa*, you notice the weaving of strings across and through each other, binding the posts of the house, leaving no stick untouched because the art of binding is specific. Its authenticity is worth pursuing but like all things authentic, it has also become rare.

When Dr. Newell wrote to me suggesting a project about climate change between our two museums, I read her email and sensed through the detailed logistics a connection. It is an invincible link between people, the act of faith and believing in what is good. Dr. Newell's email was long, but I read it and it made sense to talk to her some more. Now, after meeting her, I see what she does, through our displays, our sciences, mostly hers not mine, our historic representations, our sacred task to give meaning to life, I see love and I feel sunlight. I see the hope of creating a meaningful space for the eyes of those whom we reach out to, together and in kind. The logical drawing up of the project was the skeleton but our hearts combined gave birth to the humane side of it, and that is why this project will sustain and survive. It carries the story of humankind at its best.

The *fale samoa*, in its truths is a miracle house made of raw local materials. The miracle is in the intelligence of its making. Its intelligence is definitely not of this world and as Samoans so truly believe, these skills are God given.

1 "Museums Connect" is a grant program funded by the US Department of State's Bureau of Educational and Cultural Affairs and the American Alliance of Museums to enable a US museum to work with an international museum on a community-based project.
2 The *fale samoa* is extensively written about. This chapter looks at what it means for this project and to me.

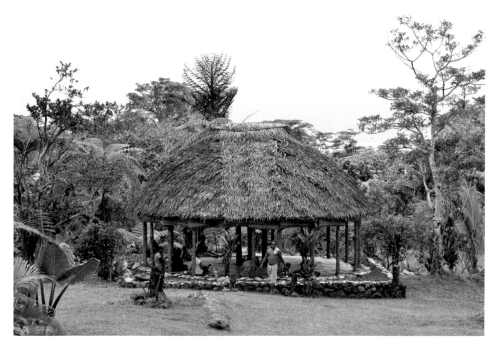

Figure 4.1 Faletalimālō (house for receiving guests) built by Master Builder Laufale Fa'anū and a team of traditional house builders from Sa'anapu, for the Tiapapata Art Centre, Apia, 2014. Photo: Galumalemana Steven Percival. See Plate 4.

When asked whether they would revive the *fale samoa*, the young people in our group more than not opted for the modern houses. Their time is challenged by the threats of climate. Cyclone Evan recently flooded our capital Apia and cost lives of many loved ones. Samoa felt the pain and still suffers the cost of living on a small vulnerable island next to all the other Pacific islands in the Southern hemisphere. Today as I write this, heavy rain falls, inspiring a poem for my dead child, taken by the tsunami, but I do not blame the young people. Their fear of death is easier to walk with than the lonely search for the meaning in life.

But the *fale samoa*, the idea that thousands of years ago, people like us built these houses, were resourceful, were economical, and also died, is proof that we can and always continue regardless of our choices. Nature compounds us profoundly because we are not sole owners of the planet. The challenge for our young people is to find love in the midst of the chaos. If love eventuates after years of suffering, we may connect deeper with ourselves, our neighbors near and far and we may solve the problems of our time. Without these connections, I think, the human spirit cannot move on and forward. We simply live and die.

When looking at New York, their people, their pace of life, the emptiness felt when their homes were damaged by Cyclone Sandy, I felt the hugs of Samoans reaching over to each participant in the room, daring to share their stories. We became one with our homes, our lives, our sorrows and our challenges. We became mankind. God bless all of us and our journeys in this life. May you reach out for as long as you shall live so that the fires within remain with us to comfort, and to bind.

5
TALKING AROUND OBJECTS

Stories for living with climate change

Jennifer Newell

I have three stories to tell that connect objects, people, and museums. Each story involves the museum where I work, the American Museum of Natural History (AMNH), and community groups from the Pacific. Each story frames the museum as a place where objects draw people together, creating connections between places and across generations past and future. Museum spaces can support creative, helpful and healing meetings, rich with powerful moments that hold the potential for addressing disruption and displacement in a climate-changing world.[1] The effects of these meetings can be surprisingly deep and long-lasting.

Objects of significance often operate as lodestones – magnetic things, pulling in people, stories, around them, connecting and creating new stories and relationships that then radiate influences outward. Whether a hand-held chart of the sea made of sticks and shells, a human-sized carving of an ancestor on a meeting house, or the house itself, fast-changing environments re-value lodestone objects, which may become more dear to us as their circumstances of creation move beyond reach. A sudden disaster may suddenly take away things of significance, and even our capacity to renew them. As people move around the world in response to rising sea-level, rising temperatures, intensifying storms, and loss of food sources what happens to the objects of cultural significance for the place that is left behind?[2] Can a migrating family travel with the essence of their place by bringing lodestone objects with them? My conversations with Pacific Islanders living in America, Australia and New Zealand over the past few years suggest that objects from home are important to maintaining a sense of connection with the old place and feeling at home in the new. Whether this connection will still feel effective in coming decades, as some low-lying homelands are no longer there to be re-connected with, is something that has yet to unfold.

1 Laura Peers, "'Ceremonies of Renewal': Visits, Relationships, and Healing in the Museum Space," *Museum Worlds: Advances in Research* 1 (2013), 136–152.
2 Islanders from the Carteret Islands near Bougainville, and various villages in Fiji have relocated in recent years for reasons directly attributable to climate change. On this subject see for instance Kirsten Hastrup and Karen Fogg Olweg, eds, in *Climate Change and Human Mobility: Global Challenges to the Social Sciences* (Cambridge: Cambridge University Press, 2012).

Artefacts that have been placed within museums operate on a different register. Although they lack some of their former connections, they can still be lodestones for communities, and carry important learning for new-generation communities in new places.[3]

Three things are revealed in the stories that follow. The first is about how museums create bridges between people who are separated by time and place. The second explores how a lodestone object can support people displaced by climate change to keep culture strong in new places. Finally, I consider how a lodestone object might create conceptual tools for managing life and culture in a changing world.

Overall, these stories showcase the ways that museums are beginning to enable people to engage with climate change. Moving beyond presenting the science of climate change in an abstract and scientific way, museums are finding a role in creating spaces for people to develop their own culturally sensitive, local ways to live with our global predicament. Museums can play a key role in what environmental anthropologist Ashley Dawson calls "putting a human face on climate change."[4]

I

The first story is about a collaboration between two museums in 2014: "Rethinking Home: Climate Change in New York and Samoa."[5]

Samoa is being struck by increasingly damaging cyclones. New York is being struck by increasingly damaging hurricanes. Both are coastal communities with increasing awareness of the vulnerability of their homes. In early 2012 I moved with my family from the quiet inland city of Canberra to the rather less quiet island city of Manhattan, in order to take up Margaret Mead's old curatorial post. I was busy researching the cultural impacts of climate change in the Pacific when October rolled around and Hurricane Sandy hit. Life in New York felt risky – even more so than before. Just six weeks later, December 13–14, Cyclone Evan pummeled the islands of Samoa.[6]

The parallels struck me anew when the American Alliance of Museums offered a collaborative grant called "Museums Connect." Here was a chance to link people and museums in the two places, comparing people's storm experiences from two different cultural and ecological vantage points. The collaboration had a sense of historical connection, for better or worse, as Margaret Mead – Pacific curator at the AMNH from the 1920s – carried out her first fieldwork in Samoa. The principal curator of the Museum of Samoa, Lumepa Apelu, responded warmly to the idea (see her Cameo preceding this chapter). Lumepa wanted to encourage more local interest in the museum, and to encourage members of the community to think through the ways that climate change is threatening a key part

3 For a range of commentaries on the potencies of museum objects when reconnected with communities, see Raymond Silverman, *Museum as Process: Translating Local and Global Knowledge* (Oxford and New York: Routledge, 2015).
4 Ashley Dawson, "Putting a Human Face on Climate Change," in *Climate Change and Museum* Futures, edited by Fiona Cameron and Brett Neilson (New York: Routledge, 2015), 207–218.
5 "Rethinking Home: Climate Change in New York and Samoa," was funded by the "Museums Connect" granting program of the US State Department's American Alliance of Museums (http://exchanges.state.gov/non-us/program/museums-connect). The project ran from September 2013 to July 2014.
6 Samoa is made up of an archipelago in the central Pacific: the main islands are Upolu and Savai'i comprising Western or Independent Samoa, and American Samoa to the east, with several islands, the capital Pagopago being on Tutuila.

of Samoa's heritage: the *fale samoa*, the traditional Samoan open-sided house (see Figure 4.1). Our project thus centered on homes and houses.

The idea of the project was to explore, capture and share the personal impacts of climate change – not the measurable, millimeter-by-millimeter, degree-by-degree changes, but the emotional changes that are taking place in peoples' heads and hearts. Although personal responses are less easy to measure and therefore attract far less attention from governments, funders and researchers, these are the basis for the wellbeing of individuals and communities.

Our team of Lumepa Apelu in Apia and Jacklyn Lacey, Shelby Pykare and myself at the AMNH won the grant in September 2013. Two diverse groups of about fifteen people each in New York and in Apia volunteered for the project. They included academics, students, retired Peace Corps workers and practicing artists. Some were Pacific Islanders living in New York, particularly interested in the project's Pacific angle; some were students of environmental studies exploring climate change in a very different frame. The conversations inspired new thinking about all of these things, and our homes. We held workshops, a video conference, talked over email, Facebook and the phone, and two participants from each of the two groups traveled to meet with the other.

The focus on the materiality of our homes, what part their material form plays in our own identities, how they reflect and support our cultural structures, and what is at stake when they are threatened, gave structure to our activities. When the groups met at the museum for workshops, we asked participants to bring in a photo of home, or objects that spoke to them of home, and these were useful for sparking reflection and sharing. When we held a "story party" in the Hall of Pacific Peoples at the AMNH one night, one of the New York participants shared her story and an object: the *ula sisi* seed and shell necklace her uncle in Samoa had given her. It represented for her the fluid connections she maintains with Samoa, New Zealand and America, and the ways they are all interlinked.[7] The way she spoke about the *ula sisi* could not help but stand in marked contrast to the object labels in the museum cases around us, with their bare text: "Necklace. Samoa" – labels that completely lacked affective context.

It was fitting that the project permitted the creation of a museum object: Lumepa wanted to commission one of the remaining master *fale* builders, Faanu Motusaga, to make a large model *fale* for the Museum of Samoa. It was constructed during the course of the project. With this model, Lumepa was able to keep discussions circulating around the form of the Samoan house during the workshops, and she continues to use it as a centerpiece for her programing on cultural traditions. Lumepa, with Mata'afa Autagavaia, a respected orator and chief, spoke with passion during the project of the value of the *fale*. At one point in a workshop one of the Samoan students said that it was a pity, but she and others of her generation were going to have to do what they could to survive. They would need strong walls for shelter, and they were going to have to give away traditions like the *fale*.[8] Mata'afa countered these statements with gusto, talking about the value of *fale samoa* for maintaining Samoans' cultural strength in the face of change, as well as keeping them physically safe. He pointed out that people are able to shelter in the village church during storms. In gale force winds,

7 See Dr Anne-Marie Tupuola Plunkett's blog on the "Rethinking Home" website, "Home is Transient and Fluid," September 15, 2014.

8 For more on this exchange, see Jennifer Newell, "Weathering Climate Change in Samoa: Cultural resources for change," in *Appropriating Climate Change: Pacific Reception of a Global Prophecy* (De Gruyter Open, forthcoming), eds. Tony Crook and Peter Rudiak-Gould.

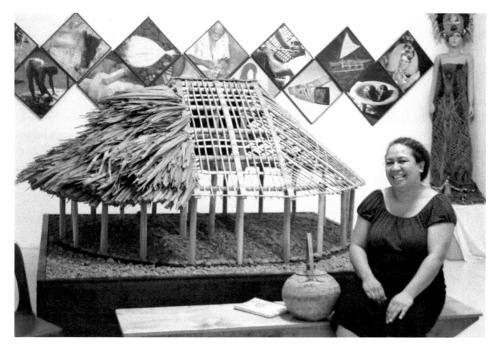

Figure 5.1 Lumepa Apelu with the *fale samoa* model, with partial thatch to reveal roof structure. Museum of Samoa, Apia, Samoa, 2014. Photo: J. Newell.

it is better to have palm leaf thatch being blown about than sheets of metal that cause fatalities.[9]

Near the end of the project we gathered the New York group at the southern tip of Manhattan one Saturday morning and, together with two group members who had joined us from Samoa, took a field trip to the Midland Avenue Relief Center in Staten Island. A local man, Aiman Youssef, was still running this charity center eighteen months after Sandy, on the foundations of his former home.[10] We gathered in the relief center's tent. Aiman and others told us their stories of clinging to light fittings above the street to keep them from being swept away in the storm surge and of the struggles to find ways pick up and start again while waiting for insurance payouts that might never arrive. Many of us gained a new depth of awareness for what people in the same city as ourselves had been living through.

Through all these discussions we were often stuck by the parallels between the New Yorkers and Samoans – how often we heard reflections like "for me, home means family." Many of us were also surprised at how often talking about home, putting what it means to us into words, and thinking about the ways our special places are under threat, uncovered a depth of emotion, caused an unexpected catch in the throat. The potency of our homes, even for those of us who have moved from country to country, is something that often goes unacknowledged. Homes contain parts of ourselves that matter; self-definitions and our

9 Mata'afa Autagavaia, "Rethinking Home" workshop, Museum of Samoa, November 14, 2013.
10 See www.midlandavenuereliefcenter.org; Denis Hamil, "Staten Island man loses home to Sandy, pledges year to Jesus as thanks for his family's life," *DailyNews*, May 4, 2013. www.nydailynews.com/new-york/amazing-act-charity-article-1.1335346; www.change.org/p/build-a-home-for-hurricane-sandy-hero-aiman-youssef

living connections and memories are centered there. It was houses in both places: *fales* in Samoa and homes in the Rockaways, Staten Island, Manhattan – that became the project's lodestones, drawing out people's stories and swirling them into conversations. Dionne Fonoti, anthropology professor at the National University of Samoa (NUS), joined us from Apia for a week in New York, and during a "story party" she talked of her experiences of storms. She said she never follows evacuation orders. She didn't evacuate as Cyclone Evan approached or as the flood waters hit, because she felt her duty was to care for the home of her *'āiga*. The *'āiga* is the extended family, the lineage, and it is the *'āiga* that forms the building blocks of Samoan society. For better or for worse, as Dionne pointed out, "Samoans don't do anything alone": the *'āiga* is the ever-present support, a web of obligation and support for very individual, where ever they might be in the world, no matter what disaster has just been weathered.[11]

The contrast with the ways the nuclear-family-centric households in New York were able to cope with disaster were apparent to all the participants. One Staten Island resident reflected:

> There have been two times in the last fifteen years where the walls of personal space have been eroded away and we have actually come together as communities. Right after 9/11, which lasted only a short time, and then after Sandy … It'd be great to have examples in Staten Island of us not having to center our community activity around tragedy. It'd be great if we were a lot more civic-minded populace. But that's the way it is.[12]

Climate change is already changing conceptions of the future. The places and people we care about are being changed not only in the form they take physically, but in their imagined form. Imagining the future informs our personal environments now. Our future cityscapes, landscapes and seascapes drive the small decisions we take every day. As one of the student participants, Maya Faison, said: "I never thought it will be me and my neighborhood the newscaster would be reporting on … I believe Hurricane Sandy was a push, a push to a future where we recognize climate change and don't push it to the side…".[13] Erynn Vaeua, a student in Samoa, decided to study environmental science after experiencing Cyclone Evan, and aims to work for a climate change organization, so she can explain to people, even tell her elders, how to stop contributing to the problem. "It is exciting but kind of scary as well":[14]

> If we continue living without making changes I am worried about the future. There will be nothing, no more Earth for us to live on, there will be no shelter, no food or water. Everything we need to survive will be gone … That is why right now we need to do something, we need to do more and more to warn the people.[15]

11 Dionne Fonoti, NUS, at the AMNH, June 2014. For more on the ways that the *'āiga* enables Samoans to bounce back from the challenges being brought by climate change, see Newell, "Weathering Climate Change in Samoa."
12 Seth Wollney, pers. com, Staten Island, May 23, 2014.
13 Maya Faison, "The Unfamiliar and the Unpredictable," blog post, "Rethinking Home," posted Jan. 29, 2014, www.amnh.org/our-research/anthropology/projects/rethinking-home/blog
14 Erynn Vaelua, interview, recorded by Jacklyn Lacey, Museum of Samoa, Apia, June 11, 2014.
15 Vaelua, interview, June 11, 2014.

Museums now enable processes that support the creation of imagined futures. I say "now" because they have not always done so. The New Museum is a place that is more conscious of social responsibility and engagement in current issues concerning many constituencies, and a willingness to step back from the need to present information in a voice of singular, absolute authority, as we discussed in Chapter 1. Museums are more willing to encourage dialogic – and even *trialogic* – programs[16] that enable wall and label texts to ask questions, to include multiple voices and to present open-ended musing about potential futures. Projects

Figure 5.2 Erynn Vaeua of Samoa (left) and Maya Faison of New York during the June 2014 workshop, Museum of Samoa, Apia, Samoa. Photo: J. Newell.

16 Fiona R. Cameron, Bob Hodge and Juan Francisco Salazar, "Conclusion: Climate Change Engagement – a Manifesto for Museums and Science Centers," *Climate Change and Museum Futures*, edited by Fiona Cameron and Brett Neilson (New York: Routledge, 2015), 248–268: 260–261.

like "Rethinking Home" are examples of this approach. The AMNH is not alone in drawing enthusiastic public participation in new offerings around climate change such as free evening classes, online courses, podcast lectures and online material for teachers. Such programs encourage active engagement in the current and potential experience of climate change.

The "Rethinking Home" project has continued its conversation beyond the initial grant, developing further ways to make positive and reduce negative contributions to this global crisis through lived experiences of climate change. I continue to work with colleagues in Samoa, and many of the participants remain in Facebook contact with each other. When the next cyclone or hurricane hits, our circle of supporters is bigger than it used to be, and we already know the sorts of material and emotional support our fellow "Rethinkers" will seek.

II

Story two begins with an object: a frame of sticks lashed with fine vegetable fiber into a flat frame, studded here and there with cowrie shells (Figure 5.3). Standing looking at it, through the glass of the case tucked away at the back of the Hall of Pacific Peoples, is Tony de Brum, Minister of Foreign Affairs of the Marshall Islands. I am next to him, along with his aide and the embassy staff, and we are all just gazing. It is a lovely object. Looking at it, you can imagine holding it, arms slightly outstretched to encompass its width, the structure light but firm.

I have been using this artefact as an entry point in classes and tours on the subject of climate change at the museum. It opens up the existence of a set of atolls in the middle of the Pacific and nature of life there. It conveys some of the key conceptual foundations of the place, and introduces the ways climate change is changing these foundations. It is enigmatic. I ask people to guess what it is: someone usually suggests "a net?" I say no, but it does have something to do with the sea. There is usually a pause, then someone might venture "a map?" It is a map. It is called a *meto*.[17] It is a chart of the ocean swells and currents around the Marshall Islands. Hearing this, there is always a reaction from the audience: gasps of surprise, pleasure at happening across this method of reading an environment that would be, for them, "empty" sea. I explain what I have learned from Marshallese colleagues and books; that the shells are the islands of the Republic of the Marshall Islands, and the elegantly curving sticks show ocean pathways that can take you between them. I explain that a master navigator would have stood on the beach with his apprentice, and used this mnemonic device to teach the ways of reading the ocean.[18] He would teach the way the swells feel as they intersect and rock the canoe in a particular way, that they can be better felt if you lie down with your chest against the surface of the canoe. He would talk of the scent in the air that blows from an island, the leaves you can expect to see on the surface, and birds that mark distances out from land. All of these are carried in this woven chart in his hands, before the apprentice leaves the shore. The embodied knowledge of this chart became the mental map the new navigator took with him, beyond sight of land, that enabled him to travel safely to his destination, and home again.

17 *Meto* are charts of specific places, another type, *mattang* or *rebbelib*, are generic models for teaching the principles of how ocean swells move around islands and in open seas. W. A. Davenport, "Marshall Islands Cartography," *Expedition* 6 (1964): 10–13; Adrienne Kaeppler, *The Pacific Arts of Polynesia and Micronesia* (Oxford: Oxford University Press, 2008).
18 Historically, navigation was a skill taught and practiced by men.

Talking around objects **41**

Figure 5.3 Meto (navigation chart), Marshall Islands, *c.*1850s–1880s, American Museum of Natural History, New York, Anthropology Division, 80.0/3317.

Tony de Brum glances over at me and smiles. "It is hung sideways. You need to turn it 90 degrees to the right." When we finish laughing I promise to see what I can do. This *meto* was once owned by Robert Louis Stevenson, on another island, Samoa.[19] We do not know what story he, Tusitala, teller of tales, might have told about the *meto*, nor do we know how Stevenson acquired it, but knowing the author of *Treasure Island* was one of its owners adds

19 *Meto*, Marshall Islands, probably mid- to late 1800s. Previously in the collection of R. L. Stevenson, who lived in Samoa 1889–1894. The AMNH purchased the chart from Stevenson's estate in 1914. reg. number 80.0/3317.

another connection for Western audiences. This *meto* has not helped create navigational mental maps of the ocean over the past 150 years of its existence, but it is fulfilling another role, prompting new mental mapping for people unfamiliar with Marshallese culture. Understanding the histories and current lives of these people who are increasingly needing to navigate their way to America is important both for those arriving and for the receiving community.

Most AMNH visitors – local, national and international – have no previous conception of the Republic of the Marshall Islands: no concept of the coral sands, the thin strips of low-profile land, studded with palms, the vibrant reefs, the pounding waves on one side, lagoon on the other; no sense of the eroding edges, the cemeteries falling into the sea, the tumbled concrete rubble, old cars and rusted metal piled up to create sea walls and a sense of protection, no feeling for the heat, no sense of Enewetak's empty beaches and concrete waste containment dome, no sense of the sunset over the water off the beach at Rita as the kids jump off palms into the water, fathers and uncles finish cleaning the day's catch, mothers soon calling out to come and eat. No concept yet, and no way to care, yet, that these people are losing the atolls that have been their home for some 2,500 years.

Most people who come to the Pacific Hall have come to see and take their photo with one of the AMNH's "destination objects": a life-size replica of a Rapa Nui *moai*, similar to the "Dum Dum" character in the "Night at the Museum" movie. If people turn to the left after taking their selfies, they will see the Micronesian case and the *meto*. If they were to go and peer into the case they will not learn much as there is as yet no supporting text. In the interim, there is still the capacity to talk around the object. Tony de Brum tells me more about *meto*, as several of his compatriots have done too, when we go downstairs to the storeroom, and see the five drawers that contain several more.

Kristina (Tina) Stege is one of the people who has come to see the Marshalls collection. Having grown up in the Marshalls, studied in France, and now living and working in the United States, she has multiple connections with these objects (see her reflections on a *jaki-ed* textile in the "Object in View" following this chapter). Tina has a *meto* on her wall here in New York. She says this is what you take with you when you leave the islands, to hang on your wall to declare your heritage, what you bring to navigate the very different terrains beyond the Marshall Islands. In the Marshalls traveling by sailing canoe and boat is now usually done with GPS, but the *meto* are still part of who Marshall Islanders know themselves to be. They are proud of their canoe construction, sailing and wayfinding traditions, knowing themselves to be among the world's finest navigators. A *meto* chart expresses this. There are modern *meto* in the AMNH collection too.

Tina is a consultant to the Marshallese Educational Initiative, based in Springdale Arkansas. Springdale is a landlocked city but since the 1970s, when islander John Moody moved there for education and employment and encouraged others to join him, Marshallese now comprise some 10 percent of Springdale's population.[20] Education is a key strategy for wellbeing for this community: as the Initiative states on their website, a lack of information means that "the non-Marshallese population in the region is generally unaware of Marshallese culture and history and the challenges facing Marshallese residents. Stereotypes

20 www.meius.org

and misinformation persist."[21] The population of the Marshall Islands was 53,100 in 2011. A 2010 Census recorded 22,400 Marshallese living in the United States, primarily in Hawai'i, Arkansas and Seattle.[22] The Marshallese Education Initiative also works on explaining why America is the destination of choice for most migrating Marshallese. This means raising awareness about the legacy of US nuclear testing (1946 to 1958); encompassing the loss of irradiated homelands, ongoing health issues, and a continued association with America.[23] Political independence was won in 1986, but the Republic of the Marshall Islands has an ongoing connection with the United States through the Compact of Free Association. Marshall Islanders may live and work in the States without a visa.

Young Marshallese growing up in the States have often little ongoing access to the sorts of material things and practices that many in the community value as part of being Marshallese.[24] Having a clear sense and pride in one's heritage is, as is well known, important for strong senses of self, especially in contexts where saying that one is Marshallese or Micronesian or Pacific Islander can be expected to draw either a blank stare or straight out prejudice.

Tina Stege wants to do something about these gaps in connection, and has been developing an idea for a traveling exhibition. She has in mind buying and displaying objects like *meto* that are being made for walls, not oceans, and exquisite *jaki-ed* mats Marshallese women have started making again (inspired and informed by historic museum collections). Her idea is to design an exhibition, with curators at the Alele Museum in Majuro, Burke Museum in Seattle and the AMNH, to bring the tangible and intangible heritage, and the stories that surround them, to Marshallese diaspora communities. As the pace of out-migration increases as life in the islands gets harder to manage, the potential need for and impact of these objects in the United States, out in church halls, schools and community centers, supported by local elders and arts practitioners, is growing.

Tina and I have been working together for some time on a variety of projects, including "Rethinking Home." She is helping me to see climate change, and important dynamics like relationships to changing seas, from Marshallese perspectives.[25] When we first talked about the Western conception of a separation of sea and land, she said that in the Marshalls,

> there is one world view: you look out and you see one environment – people are a part of it, not separate. You cannot get away from the sea on an atoll…It is always there, right there, steps away, no matter where you are.[26]

The perspective Tina and other Marshall Islanders are introducing via the museum is the one of crucial importance for Western audiences: the simple point that we are part of nature.

21 S. Jimeno and A. Rafael, *A Profile of the Marshallese Community in Arkansas*, Vol. 3, Little Rock and Fayetteville, AR: Winthrop Rockefeller Foundation and University of Arkansas (2013): 8,10.
22 Jimeno and Rafael, *Profile of the Marshallese Community*, 3; Office of the *2011 Census* (Republic of the Marshall Islands, 2012), www.doi.gov/sites/doi.gov/files/migrated/oia/reports/upload/RMI-2011-Census-Summary-Report-on-Population-and-Housing.pdf
23 Holly Barker, *Bravo for the Marshallese: Regaining Control in a Post-nuclear, Post-colonial World* (California: Wadsworth Publishing, 2012).
24 For more on these points, see Rudiak-Gould, Chapter 9, this volume.
25 Kristina Stege and Jennifer Newell, "Thinking about the Sea in a Changing World: Views from the Marshall Islands," (conference paper, European Society for Oceanists, Brussels, June 28, 2015).
26 Kristina Stege, pers. comm., New York, May 2015.

Her sense of immediacy around climate change is important too: changes are dire, right now, and "coming soon to a shore near you." In our "SciCafe" presentation in October 2014, Tina said:

> In the Marshalls, climate change is very much the day-to-day reality, it's something people talk about, it is a word everybody knows, it's not something that is far off in the future, it is something that is our present, and we're facing now, and we're trying to figure out how to respond, and deal with it.[27]

Many people responded that this was the first they had heard that things were already so serious. Maintaining urgency remains difficult. Tina's brother, Mark Stege, is councilman of an outer island they spent summers on as children. We caught up at an UN workshop on climate change, and he commented that most people are still wanting to be hopeful; that they cannot yet countenance the idea of losing their homeland. "It seems too soon to think such things," he said. "It is like we're living in a burning house. Many of us world wide are living in that burning house, but are not ready to accept it."[28]

People like Mark and Kristina Stege, and poet Kathy Jetñil-Kijiner, who are seeing, hearing, reading and talking about the crisis, and who understand the complexities and sensibilities of people around them, are powerful communicators and activists for all, not just the Marshallese. Tina's exhibition, our museum-based talks, hall tours, our talking around *meto* and other objects from the Marshalls helps broaden audiences to comprehend this place in the middle of the Pacific, and to recognize the ways that it demands Western attention and our support. Museum work can be the work of activism.

III

My third story is about an ancestor carved of wood. Paikea, the whale rider, is an ancestor of a Māori iwi (tribe) of Uawa (Tolaga Bay), the east coast of the North Island of Aotearoa New Zealand. Paikea is the pinnacle of the ancestral line of the iwi named Te Aitanga a Hauiti. Once Paikea had been carved in the 1860s as a *tekoteko*, a gable figure, on the revered meeting house Te Kane a Takirou, he was embodied and made tangible. For generation after generation he was the focal point of the community's thoughts, prayers and activities. Later, when the house was dismembered and dispersed overseas, they addressed him in oratory, song and dance, *in absentia*.

In April 2013, members of Toi Hauiti, a group of scholars, artists, dancers and other cultural practitioners of Te Aitanga a Houiti came to the American Museum of Natural History.[29] No one from the community had been with the Paikea *tekoteko* since the late

27 Kristina Stege and Jennifer Newell, "Islands at the Edge: Climate Change, Globalization and Island Culture," "SciCafe" (presentation, AMNH, October 1, 2014). www.youtube.com/watch?v=BjQOPzPy3ls
28 See M. Stege, "When it Hits Home," *Huffington Post*, April 22, 2012.
29 A more detailed account is provided in Billie Lythberg, Jenny Newell and Wayne Ngata, "House of Stories: The Whale Rider at the American Museum of Natural History," *Museums and Society* 13 (2015), 195–202.

Figure 5.4 Maj-Gen. Robley acquisition, American Museum of Natural History, 1908. Photo: T. Lunt, courtesy of the AMNH.

1880s, when it was shipped to England and entered the possession of a well-known collector of Māori artefacts, Major General Horatio Robley (1840–1930).[30]

The museum's story about Paikea begins in 1908, when the carving was bought as part of a set of thirteen Māori artefacts. Some, including Paikea, were photographed on arrival (Figure 5.3). The carvings were displayed in the small South Seas Hall on the fourth floor. Once Margaret Mead's new Hall of Pacific Peoples opened in 1971, Paikea was placed in storage. A renovation of the storage facility from the 1980s–1990s resulted in the installation of a state-of-the-art compactus storage system, digital documentation and web-accessible catalogue system. Paikea went online.[31] Then, in April 2013, one hundred and five years after his arrival, the museum's sparse data about the *tekoteko* became suddenly a much richer, living story.

30 Robley had been in Tuaranga, Aotearoa, with the 68th Battalion during the land wars in the 1860s, had developed an attachment to things Māori, particularly tattooing, and amassed, among other things, the largest collection of *toi moko* (preserved, tattooed heads) outside of Aotearoa. This collection, donated to the American Museum of Natural History 1907–1908, was repatriated December 2014.
31 http://anthro.amnh.org/pacific : Search for 80.0/615.

The Toi Hauiti group asked me, in the lead up to their arrival in New York, if Paikea could be brought out from storage, and put on display. They wanted not only to reconnect with him themselves, but to introduce him to his current community in New York. We set up with the museum's Education Department to run a week of presentations for school groups and the general public. So Toi Hauiti's time of "inreach" at the museum, as James Clifford terms it, was also an effective outreach.[32] One of the AMNH carpenters made a mount with wheels. On the morning before their first performance, when the students and elders of the Toi Hauiti group assembled in one of the museum's theaters, our collections management team wheeled Paikea into the room. Toi Hauiti greeted Paikea with a *haka*, and spent time speaking with him, crying for him, warming him with hands, exchanging *hongi* (breath) in greeting.

Wayne Ngata, chairman of Toi Hauiti, then spoke to those of us from the museum there in the room. He talked about the *whare korero* – house of stories – that Paikea had come from. He said that they were there to greet him, tell his story, bring him to life. On stage, Toi Hauiti performed dances and the *haka* for Paikea and the audience (Figure I.i). As Wayne said, they had been learning and performing these dances for Paikea all their lives. One of the students said to us, just after meeting Paikea, "now my life makes sense."

Toi Hauiti helped us to see how this *taonga* – this treasured, ancestral object; surpassing that: an actual ancestor – connected to them through time that spirals up and back, making distinctions like past and present not distinct at all. Distant ancestors and current people can inhabit the same space. The concept of *taonga* applies to treasures that are exchanged, moving through generations, and between people, creating connections and obligations, and are not only material. As Amiria Henare explains in *Thinking Through Things*:

> A taonga might equally be a historic whalebone weapon, the Māori language, a native plant or a body of knowledge; distinctions between the material and the ephemeral are not relevant here. Nor are ideas about animate versus inanimate entities: women and children may be exchanged as taonga, and taonga such as woven cloaks are often held as ancestors or instantiations of ancestral effect.[33]

Seeing objects as ancestral, as objects situated in a long personal and community continuum that is intricately connected to place, offers those of us thinking within a Western tradition about the life and potency of material things a highly valuable paradigm shift. The ancestral mode of thinking provides a *longue durée* that surpasses the usual few generations that we tend to use as our frame for object histories. It was ancestry that Wayne Ngata introduced to the children at the museum. He taught volunteers from the audience to say the name of an ancestor, standing them in order and having each call out their name and "who had…" in turn, calling out the lineage from Paikea down to the meeting house, Te Kane a Takirau.

Wayne's term for the meeting house, "House of Stories," struck me. I cannot think of a better term to highlight the significance of both the *whare* in Uawa (Tolaga Bay) and the museum in New York. What better way is there to underline the link between the two

32 James Clifford, *Routes: Travel and Translation in the Late Twentieth Century* (Cambridge, MA: Harvard University Press, 1997), 192–193.
33 Amiria Henare, *Thinking Through Things: Theorizing Artefacts Ethnographically* (London: Routledge, 2007), 47.

Figure 5.5 Owen Wharekaponga's *hongi* with Paikea, American Museum of Natural History, April 2013. Photo: J. Newell.

48 Newell

Figure 5.6 Toi Hauiti with their ancestor, Paikea, American Museum of Natural History, April 2013. Photo: Billie Lythberg.

houses? They are so different in so many ways, deeply at odds in important respects, but united in wanting to (as Māori scholar Paul Tapsell expresses it[34]) *cloak* objects with the stories that give material things their context, make clear their changing meanings, their active role in world of the living.

George Main and others in this volume have written that we need to look beyond our everyday boundaries – our usual comfort zones – in seeking out the "stories that matter."[35] And within museums we have a responsibility to look for those stories that matter not just to us, but to those people whose cultural and ecological heritage we hold within our walls. There is real value in seeing individual *taonga* (of any culture) as placed within a longer durée. To see them as not just starting from their moment of being carved or woven or written, but as part of a longer continuum, with responsibilities – including environmental responsibilities – and knowledge being passed along with them.

We with our access to "slow media" museums are uniquely placed to work against the "specter of short-termism" as global historians Jo Guldi, David Armitage and Iain McCalman

34 Paul Tapsell, "The flight of Pareratutu: An investigation of taonga from a tribal perspective," *Journal of the Polynesian Society* 106 (1997), 323–374: 335.
35 This is Tom Griffiths' phrase, www.australianhumanitiesreview.org/archive/Issue-December-2007/Eco Humanities/Griffiths.html

have recently advocated.[36] We need the long-term view to perceive the environmental calamity facing us, and to comprehend the implications of that calamity for ourselves and for generations to come.

Museums are most effective when, to use Eleanor Sterling's term (see Chapter 13) they foster "informed engagement" around critical issues. With some imagination as well as dedication of thought and resources, a museum can be an effective "house of stories," an ideas mill, or a place of debate. As many of my colleagues in other museums have also noted, museum collections can offer comfort. Whether it is members of the Pacific Islands diplomatic corps being heartened to find familiar things here, or a visiting exhibition installer coming to the storeroom to spend time with things from home on hearing of the death of a loved one, the AMNH collection has provided solace, despite and in amongst the complex of feelings of sadness and discomfiture at finding so many things from home being on shelves here instead. Laura Peers, Carla Krmpotich and their colleagues have written about the tensions and rewards for everyone involved in a sustained community reconnection around Haida collections at the Pitt Rivers Museum.[37] Peers has also demonstrated the capacity for starting the healing of deep-seated scars when ancestral objects are able to spend time back with their communities, especially when those objects were taken in contexts of colonial dispossession and violence.[38]

Museum theorist Ben Dibley writes about current claims for modern, cosmopolitan communities and the absence of any actual shared "cosmos"– citizens demonstrably still feel, think, and operate in scales that are primarily local.[39] Dibley argues that the "unfolding crisis of anthropogenic climate change" demands that within our newly inclusive museums, decisions can be made with those previously "disqualified by borders of nation, species, and animation"; "decisions that once seemed to have nothing to do with Kiribati, polar bears, glaciers, the gulf stream…" must now be made in their presence, "if we are to work toward the composition of a common world", towards a "liveable, breathable 'home' on planet Earth."[40]

Museums are now well situated to see how sharing narratives and the understandings that flow from them will be able to develop the museum from the productive concept of a contested, negotiated "contact zone" into a zone of real collaboration and supportive engagement across boundaries we cannot afford to keep in place. Engagements around a Samoan *fale* and a Staten Island relief center, a Marshall Islands *meto* and a carved ancestor offer real opportunities for bridging otherwise divided ways of knowing. Sharing stories around objects enables us to reach out across old boundaries, and start to think and work together in the ways the world needs us to. These are the kinds of stories we all need to hear.

36 Jo Guldi and David Armitage, *The History Manifesto* (Cambridge: Cambridge University Press, 2014); Iain McCalman, (presentation at the symposium "Collecting the Future: Museums, Communities and Climate Change," American Museum of Natural History, New York, October 2 2013).
37 Carla Krmpotich and Laura Peers, *This is Our Life: Haida Material Culture and Changing Museum Practice* (Toronto: UBC Press, 2013).
38 Peers, "Ceremonies of Renewal."
39 Ben Dibley, "Prospects for a Common World: Museums, Climate Change, Cosmopolitics," in *Climate Change and Museum Futures*, edited by Fiona Cameron and Brett Neilson (New York: Routledge, 2015), 45–46.
40 Ibid.

6
OBJECT IN VIEW
Jaki-ed mat, Marshall Islands

Kristina Eonemto Stege

The *jaki-ed* mat sits alone on a white table in the archives of the American Museum of Natural History. The tans and browns and blacks of its geometric designs are an earthy contrast to the sterility of the archives. I lean in, wishing I could run my hands over its tiny, tightly-woven intricacies. My hands hover instead a breath away, and I am lost for a moment

Figure 6.1 Kristina Stege in the storeroom of the American Museum of Natural History, with *jaki-ed*. 2015. Photo: J. Newell. See Plate 5.

in memories: the feeling of soft, supple, fragrant pandanus fibers tickling my toes; my grandmother's capable hands turning and tucking individual strands into patterns; the sight of completed wallets and cigarette cases, bundled up nearby and ready to go to a shop for sale.

The fineness of Marshallese weaving work has always amazed me. I was a clumsy child, never the best at any task involving superior hand-eye coordination. I marveled at my grandmother's ability to weave a cigarette case in a matter of days. In comparison, this *jaki-ed* must have taken months to complete. The mat is labeled late nineteenth century, a time when imported fabrics were already displacing clothing mats as the dress of choice in the Marshalls. Even with the waning of the *jaki-ed* tradition, weaving remained an integral part of Marshallese culture. Our mats (*jaki*) and handicrafts (*amiṃōṇo*) continue to be a source of pride. And yet, as familiar as I am with beautifully woven objects, the richness of the *jaki-ed* stuns me.

Geometric patterns surround a square of creamy space that serves as the box-shaped heart (*jouj*) of the mat. The patterns that border this heart are arranged in ever expanding boxes. It is rather like a two-dimensional version of Russian matryoshka dolls, with each border adding another layer of design and meaning to the whole. There are dancing triangles reminiscent of sails on an outrigger canoe. Alternating black and white squares-within-a-square form another border, lending a three dimensional aspect to the mat. A set of four diamond-shaped sequences adorns the widest of the border-boxes to provide a counterpoint to the

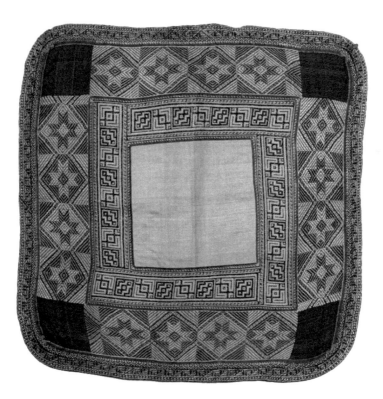

Figure 6.2 Jaki-ed, Marshall Islands. Donated by Mrs. William J. Peters, 1926. ANMH 80.0/4652. See Plate 5.

square-centric design. At the outer corners, reddish-brown, filled-in squares anchor the piece and lend it strength.

The borders each bear a name and a meaning that reflect the importance of land and family in Marshallese tradition. The *ḷōḷō* ("wreath") represents children of the clan, or *jowi*, who inherit primary rights and title to the land through their mother. The *tiltil* ("embroidery") signifies clan offspring inheriting secondary rights through their father. Clan heads and chiefs are seen in the *joor* ("pillar") borders. Toward the outer edge of the mat, the *iñiñ* ("to intertwine") reflects the tie connecting maternal and paternal lineages. Finally, enclosing the whole is the *bọkwōj* ("to embrace") border, which signifies the parental embrace "tightly safeguarding the valuable bond of love, peace and harmony among all members of the clan."[1]

The complexity of the finished *jaki-ed* belies the basic simplicity of the materials used to make it. Marshallese weavers would have gathered and prepared the few materials available to them in a coral atoll environment: pandanus leaves (*maañ*), hibiscus fibers (*ḷō*), and beach creeper vines (*atat*). The different fibers lent varying shades of brown and tan to the design. Black was the only color added artificially, by coating fibers in the dusty embers of cooking fires. So simple and yet so complex, the *jaki-ed* is a testament to Marshallese artistry and ingenuity.

In 2006, master weavers and cultural leaders came together with the support of institutions like the University of South Pacific (USP) to revive this artistic tradition. Women participating in the project fashion contemporary *jaki-ed* that incorporate design elements both traditional and modern. These talented and enterprising women are the epitome of *kōrā im an kōl*, a Marshallese saying that celebrates female creative expression and skill. However, there are a precious few traditional *jaki-ed* left in the Marshalls to look to for inspiration. The American Museum of Natural History (AMNH) likely has more *jaki-ed* in its archives than we have in the entire Marshall Islands. The digital access to the archives at AMNH represents one step in righting this imbalance, but there is much more yet that can and should be done to reconnect Marshallese to their heritage.

I imagine the possibilities. The *jaki-ed* could go on the road as part of a photographic exhibit intended not only for weavers back home, but Marshallese living in the United States. There are large communities scattered throughout the United States – in Springdale, AR, Portland, OR, Honolulu, HI, and other places – that would both embrace and be empowered by these treasures. The museum must also bring more people into the archives. So much of the power and meaning of an object lies in its physical presence. I can only imagine the depth of communion that occurs when a Marshallese weaver is able to see and smell and even perhaps touch a traditional *jaki-ed*. How wonderful it would be to have a group of weavers invited to come commune with and create *jaki-ed* at the museum itself?

For now, I am blessed to be in the presence of this beautiful object. The *jaki-ed* speaks to me, to my values, and to my memories. For a moment, here in the midst of Manhattan, I was a child once more, sitting on a porch with my grandmother surrounded by the work of her hands. *Koṃṃool tata* (thank you).

1 Dirk Spennemen, "Marshallese Dress." In *Essays on the Marshallese Past: Marshallese Dress* (Albury, New South Wales: 1998), http://marshall.csu.edu.au/Marshalls/html/essays/es-ed-1.html

7

THE PACIFIC IN NEW YORK

Managing objects and cultural heritage partnerships in times of global change

Jacklyn Lacey

Global citizens and cultural collections

Each of us increasingly belongs to multiple places, histories, and communities. So do museums. In this chapter, I explore underlying historical tensions framing encounters between museums, creator communities and their objects in my own work practices at the American Museum of Natural History (AMNH), in the Margaret Mead Hall of Pacific Peoples and behind the scenes working with the Pacific Ethnology Collection. Reflecting on my own labor, particularly with respect to professional activities between museums and communities, I consider how objects themselves may foster practical cultural heritage partnerships for the future, which go beyond their original collecting context.

Climate change is global, but its effects are highly localized. Peoples of the Pacific have already begun to move away from low-lying atolls where water supplies are compromised, and from situations following extreme storms, tsunamis and weather events, some of which have been aggravated by anthropogenic climate change. Some of these people are now the "local" (New York-based) museum audience for the AMNH Hall of Pacific Peoples. When Margaret Mead collected many of the objects the museum now holds in its Pacific Ethnology Collection, the Pacific was an exotic place far from New York. The scholarship of Margaret Mead's day focused on "saving" cultures untouched by Western ways.[1] So much has changed in anthropology and museum practice in the second half of the twentieth century, as has the Pacific community, now a worldwide diaspora. At the same time, there has been a Great Acceleration of anthropogenic changes to the atmosphere, the oceans and the lands of

1 Margaret Mead and Franz Boas, *Coming of Age in Samoa* (New York: Penguin, 1973). Mead's work has been subject to a particularly robust amount of critique. For examples of Mead's work assessed and recontextualized by scholars from the Pacific, Foerstel, Lenora, and Angela Gilliam. *Confronting Margaret Mead: Scholarship, Empire, and the South Pacific* (Philadelphia, PA: Temple University Press, 1994) is a notable volume, as it both illuminates the history of critiques on Mead and injects the discourse with Pacific commentaries that are significant in both number and scope. Paul Shankman's work on the subject is a more linear historical narrative and analysis that particularly takes up the now-notorious charges about Mead by Derek Freeman, her most vocal critic. Paul Shankman, *The Trashing of Margaret Mead*, *Anatomy of an Anthropological Controversy* (Madison, WI: University of Wisconsin Press, 2009).

the planet. Together, these changes suggest to earth scientists that the Earth has moved beyond the Holocene, and entered a new geological epoch, the Anthropocene, a "no analogue world."[2] Anthropocene changes, including climate change, are already forcing the migrations of peoples. And in a world beyond the Holocene, the epoch in which most world civilizations have grown up and thrived, there is a demand for new cultural responses, and careful thinking about the collections and objects that will bring cultural heritage to enrich displaced and disrupted lives.

The relationship between museums and diaspora communities is under particular examination in this chapter. In much of the social science literature about climate change and in the positioning of museums in climate changed futures, the space and time that a diaspora (or migrants or a community[3]) occupies are framed in an anticipatory context, implied to be designed to hold the populations who have not yet, but will be, displaced or dispossessed of their land, material heritage and intangible culture due to forces related to climate change.[4] It is difficult to write about a form of climate-catalyzed migration that has not yet become pervasive, but which ecological forecasts clearly suggest will become more and more commonplace in the twenty-first century and beyond. When a writer discusses something that "may" or "will" impact climate-linked diasporas, there is not yet a fully clear definition of who, specifically, and when, specifically, someone might find themselves becoming part of this anticipated diaspora and what their options will be when forms of dispossession occur.[5]

2 Paul J. Crutzen, "Geology of mankind," *Nature* 415 (2002): 23–23; Will Steffen, Wendy Broadgate, Lisa Deutsch, Owen Gaffney, and Cornelia Ludwig, "The trajectory of the Anthropocene: the great acceleration," *The Anthropocene Review* 2 (2015): 81–98.

3 Rafael Reuveny, "Climate change-induced migration and violent conflict," *Political Geography* 26 (2007): 656–673 anticipates the groups who will face migration and dispossession and discusses the scope of a cultural community both prior to dispossession and in the wake of relocation, but does not identify that a community in the process of anticipating a future relocation—in the text, a process described as navigating varying degrees of choice and force—might take a distinct form with its own present needs and concerns. The potential for conflict is described speculatively and does not account for forms of conflict and concern that are already recognized within communities. Rob Nixon's work on slow violence provides a useful frame for looking at the many historical factors over a long period of time that have catalyzed the creation climate change-related diasporas. The greatest impacts on communities may be in the future, but the drivers of these impacts have long histories. Rob Nixon, *Slow Violence and the Environmentalism of the Poor* (Cambridge, MA: Harvard University Press, 2011).

4 Heather Lazarus articulates the lack of certainty that currently exists with respect to what shape these climate-associated migrations will take and who will play a role in determining that shape. The progression of questions echoes a sense of "things-to-come" that do not yet have recognizable form. "Will islands become uninhabitable as a result of the effects of climate change? Where and when will people go? How will relocation be financed? Who should make relocation decisions? How will the cadre of citizenship rights be configured for people relocated across national borders? How will cultural continuity and integrity be impacted?" Heather Lazarus, "Sea change: island communities and climate change," *Annual Review of Anthropology* 41 (2012): 293.

5 This is not to suggest that there are not populations who are aware that they will likely face land dispossession due to climate change, or that there are not researchers who are working with these populations in order to better understand how they are preparing for and conceptualizing of these future dispossessions. A thorough example of social science research in partnership with an island community bracing for climate change migration in the future can be found in Colette Mortreux and Jon Barnett, "Climate change, migration and adaptation in Funafuti, Tuvalu," *Global Environmental Change* 19 (2009): 105–112. The type of uncertainty to which I am referring here is the anxiety of when individual displacements will occur and what specific options and opportunities will be available to individuals and communities when relocation becomes necessary.

At this point in the twenty-first century, more dispossessions of lands of significant to ecologically vulnerable populations will occur in the future than have already happened in the past and present. This future tense of the term differentiates between people of diasporas-yet-to-be that are more readily connected to climate change, from those that are already identified and are less directly connected to climate change-associated dispossession. The popular media usage sometimes paints "victims" of climate change in contrast to "perpetrators." Many Pacific peoples resist the "victim" image, and seek to build resilience in communities through strong museums and cultural heritage practices, and through story-telling.[6]

In the context of rapid global change, physical, social and cultural, ethnographic museums have a particular obligation and opportunity to think about how ethnographic collections might provide temporal, spatial and conceptual links between the groups of people finding themselves separated from their places and senses of home, family, and ancestral belonging due to forced migrations, and in seeking new employment and education opportunities. Pacific people and heritage objects have found themselves displaced together in New York, for example. Here new cross cultural linkages are being built with old collections, and new sharings between communities of people affected by anthropogenic climate change have created other partnerships.[7]

Reflecting on museum practice

In the work that I have been doing with the Margaret Mead Hall of Pacific Peoples and the Pacific Ethnology Collection as curatorial associate of African and Pacific ethnology at the American Museum of Natural History, the common thread that runs through discussions is how to bring communities and audiences into contact with material culture in ways that allow the new stories of the people and the older objects to converge. My job as a museum practitioner in this mix is to open up ways of finding new meanings and contexts. One point of departure is to recognize the democratic potential of approaching artifacts as ethnographic *participants*, subjects rather than objects with new readings by present communities bringing objects from back cupboards to life anew,[8] and presenting some of these readings in the Hall of the Pacific, enabling the museum's Pacific Ethnographic Collection to be creative for present and future audiences, not just part of a frozen, colonial past. Disseminated in a digital form, there are particular opportunities for reaching audiences in the Pacific, even being part of Pacific museums, as well as those audiences (including the Pacific diaspora) who visit the New York museum. Some ethnographic information and meaning-making cannot be captured by digitization. Digital entities have identities wrapped up in tangible notions of place, just as physical objects do and digital formats should not attempt elide the frictions of place-based interactions. Digital formats cannot escape the laws of physics. Some meanings

6 Newell, Chapter 5, this book.
7 Ibid.
8 This is work that is being taken up in a wide array of cultural heritage work partnerships that vary in the length of their duration and intensity, but seek to connect objects and communities, as Amiria Salmond puts it, in "meaningful ways": "Anthropologists, for example, are increasingly involved in developing digital archives and research environments of the kind mentioned above, often working collaboratively with indigenous colleagues. Similar initiatives are proliferating in museums seeking to engage in more meaningful ways with "source communities" and in tribal museums and cultural centers run by community organizations. Amiria Salmond, "Digital subjects, cultural objects: special issue introduction," *Journal of Material Culture* 17 (2012): 214.

remain always in a place that is read very differently by different people, and in different historical contexts. An object in place works differently from an object in a natural history museum far from its origins. The digitization process cannot replace a "located nature of subjectivity."[9]

In environmental psychology, "subjectivity and place cannot be separated without foreclosing an understanding of the located subject and the agency of the place."[10] In the museum context, the objects themselves add another layer, creating interpersonal relationships in cultural heritage partnerships. While place-identity provides a frame through which the subjectivity of individual cultural heritage work partners can become for each other assets rather than roadblocks in the pathway to locating areas of mutual understanding, the sense of place itself is layered and more complex in a globalizing world, and particularly in diasporic communities.

The role of museum professionals in supporting cultural heritage work can itself introduce disruption and dissonance. The formal distance that is introduced by expectations of relationship-making, particularly when the museum is conceptualized as a business or professional environment more than as a cultural repository or meeting place can result in mismatches between individual and collective needs and desires. Museum professionals, perhaps, can help by reflecting on their own place-identity—both personal and professional, as they build cultural heritage partnerships with the special communities associated with their objects. Recognizing that everyone has their own "ecological conception[s] of self and personality"[11] will aid in bridging personal, local, and global scales of cultural heritage partnerships.

If what disconnects museums from community interactions is that westerners often have little insight into their own kinship, generational linkages and genealogies of knowledge, space and power, it is little wonder that museum agents are ill-prepared to work with communities that prioritize these ways of being as part of their collective identity. The formalization of place-identity is sometimes asymmetrical, with large Western museums like the AMNH displaying "global knowledge" or knowledge that is outside place, while local museums (within the United States and beyond) explore the defining cultural elements of their special place. Climate change presents a challenge to both: it is both global and local, and its effects, especially the diasporic communities whose migration has been forced upon them, require a nuanced understanding of both global change and fundamental cultural continuities, that many westerners have either lost touch with, or constituted as "global citizenship."[12]

Collections as places

The Pacific Ethnology Collection comprises 26,000 objects, only 4 percent of which are on display to the public in the Margaret Mead Hall of Pacific Peoples. This, along with the fact

9 John Dixon, and Kevin Durrheim, "Displacing place identity: a discursive approach to locating self and other," *British Journal of Social Psychology* 39 (2000): 27.
10 S. Pile and N.J. Thrift, "Conclusions: spacing and the subject," in *Mapping the subject: Geographies of Cultural Transformation* (London: Routledge, 1995): 380.
11 Kenneth H. Craik and George E. McKechnie, "Editor's introduction: personality and the environment," *Environment and Behavior* 9 (1977): 155–168.
12 Pico Iyer, *The Global Soul: Jet Lag, Shopping Malls, and the Search for Home* (New York: Vintage, 2011).

that the objects in ethnological halls at AMNH are not under constant rotation, creates a particular *privilege* for museum professionals like myself. The process by which we gain this access through employment is likely a markedly different process than the one by which intimate access is granted in constituted. This degree of constant and private accessibility can be described as intimate—perhaps almost irresistibly so, as the stillness and silence of a collections storage area might invite comparisons to a cloistered monastery, inviting an up close and personal study, bent over objects the way in which a monk might have labored over an illuminated manuscript. This intimacy can be both exhilarating and humbling, yet it may not always be appropriate.

The collection space is itself a relational place, with its own silent, and silencing atmosphere.[13] An artifact's existence in darkness, in silence, or in one's own presence might run counter to its intended social life. Community collaborations open up the opportunity to find ways of holding objects in museum collections that feel more dignified, mindful, and respectful to their communities of belonging, and can re-enliven the stories that the object carried in other places. Rather considering the "quality of life" of a collection in sum, I try to work on a case-by-case basis, affording each community and individual the opportunity to be welcomed, heard, and consulted on the basis of their own history, story, needs and specific objects, rather than trying to cope with "the collection" which of course is an invention of museums, not the original communities.

I must acknowledge that I have been fortunate in joining the work of my institution at a point in time when more than a decade of grant work had been completed in imaging and digitally publishing the catalog entries for nearly the entire ethnographic collection—along with cross references for thousands of objects with field notes for significant collections and expeditions, as well as scans of the original handwritten catalog pages. This is a tremendous resource and was accomplished largely through the grant writing efforts of the Collections Management team at the AMNH. Around the time I started at the museum, there was an initiative, catalyzed by the grant support of the National Endowment of the Humanities, which called for each geographically oriented department within the Division of Anthropology to create short narrative texts for about 50 key objects in each ethnological collection. We created teams of two interns for both the Pacific and African collections and were excited to see that the project provided a useful structure for giving interns a rich cross section of museum life—the collections, the halls, the archives, the research library, the literature, and, whenever possible, directly engaging with cultural practitioners, communities and researchers.

In the fall of 2011, the African and Pacific Collections Research Lab started with two interns working through the list of 50 objects. As of summer 2015, nearly four years later, we have had more than 40 interns and students researching over 2500 objects in the African and Pacific collections and working on crafting 250 to 1000 word narratives to accompany the photos and catalog information on the AMNH collections website. Only about a third of these texts are on the website so far, as we have instituted, almost accidentally, a procedure that is helping us create a more consistent final product in terms of voice and tone, depth of

13 Dvora Yanow's article about the narratives of museum spaces provides language for understanding museum spaces as both storytellers and "part of the story being told." Dvora Yanow, "Space stories: studying museum buildings as organizational spaces while reflecting on interpretive methods and their narration," *Journal of Management Inquiry* 7 (1998): 215.

information, citation format as well as navigating the balance in the text of broad cultural context and specific object history. One of the biggest lessons I have learned along this road has been to let the research material dictate the final form of the narrative and to be a little less anxious about uniformity. Sometimes the story that the object tells on the Ethnology Collection page pulls most heavily from archival or expedition records. Sometimes is it material we have collected by interviewing cultural practitioners and academics. These collections are not uniform. Life is not uniform. Objects evoke many different types of stories. The part where we seek to inject the greatest parity is in balancing histories of objects deriving from their communities of origin with the stories of how they have been collected, entered into collections and studied.

When we have discussions in the offices here about the curatorial notes project, we frequently use the term "scaffolding" in reference to how we think about the way the scales of the stories we tell fit together. What do these object histories build toward? What are the stories that these objects are specially "qualified" to tell? How can this object help illuminate histories and stories that are inaccessible to many of the museums' visitors through other forms of media? There is knowledge to impart but there is a sense of soulfulness that I think the best of our curatorial notes are able to impart in some way. When I first started working on this project, I thought it made sense to focus on objects that were not on display—this was motivated by my obsession with the democratizing potential of the digital dissemination—I want people, both in the general public and in cultural heritage communities, to be able to experience the objects that the public are not usually able to access. Over time, I have begun to approach this differently, both conceptually and pragmatically. I have turned the focus toward the objects that are on display to the public—the Pacific Peoples Hall opened in 1977 and the Hall of African Peoples opened in 1968 as part of the museum's centennial celebration.

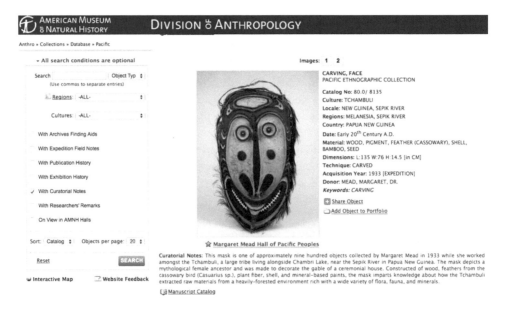

Figure 7.1 Example of a curatorial note, collection database, American Museum of Natural History, 2016.

I look at the physicality of the hall as a point of departure—the digital world, I think has the space and imagination to support virtual halls—interactive experience that photographically presents the halls as they continue to exist—the slow media form, as Libby Robin might put it—that presents fresh contextualization alongside the original label copy, while inviting users to click on the photos of the individual objects and be pulled into the digital catalog pages which include object narratives listed in the curatorial notes section. The most meaningful aspect of this effort for me is the possibility of amplifying the voices that are not often heard by the members of our museum public—voices from the historical record or from places far away from our spot in Manhattan. It is crucial that Pacific voices and stories be heard in New York. In recognizing that collection spaces typically privilege institutional preservation above community access, one can create opportunities through field visits and digitized objects returning to places of origin that temper that bias.

Storage of course can even hide objects from curators for generations. But this need not be the only possibility. Architecture itself matters far less than the way in which those working within collections develop personal political orientations toward them. By conceding the notion that there is a spatial ethics that exists within the collection space and that it is far from neutral, an important step can be taken toward "disclos[ing] the links between constructions of place-identity and relations of power."[14] Open-shelving and specialist community visits are an increasing practice in newer museums of the post-colonial era. For example, Indigenous communities in Australia regularly visit "back of house" open shelving to work with objects. Such objects are more amenable to community connection and use and interpretation "out in back" than they are in public visitor spaces.[15] If spatial infrastructure enforces normative orderings of objects and people to place, the individuals who are tasked with working with people and "their" objects have continually renewed opportunities to acknowledge the historical ordering and consciously embark on a more closely-examined and inclusive place-identity in collection spaces. Recognizing that the space out the back can be more fluid is an important opportunity for building partnerships.

This orientation asks cultural heritage work partners to hold each other, the space they are sharing (particularly collection and office spaces, but others as well) and the objects encountered in mutually-accountable empathetic present tense. New social imaginaries[16] can to be applied to collections spaces in particular, and also to all the points of relationship-building—preliminary emails, meal-sharing, paperwork, and so on. The efforts that several cultural institutions have undertaken to make zones within collections able to spatially and temporally subvert the balance of power and expectation around object encounters during community visits mark a positive move towards decolonizing museum practice. They do not yet address the way in which the underlying dynamics that are created and perpetuated well before anyone enters these appointed community spaces. How might spatio-temporal markers of these spaces be extended to subvert "the conception that places are fixed, empty and undialectical backgrounds to or containers of social action"?[17]

14 Dixon and Durrheim, "Displacing place-identity," 33.
15 Christine Hansen has discussed this subject at length in "Telling absence: Aboriginal social history and the National Museum of Australia," History Program, PhD thesis, Research School of Social Sciences, Australian National University, 2010, http://hdl.handle.net/1885/9328.
16 Charles Taylor "Modern social imaginaries," *Public Culture* 14 (2002): 91–12.
17 Dixon and Durrheim, "Displacing place-identity," 27.

On the museum side of the equation, holding our professional ancestors in somewhat of the manner than we hold our own family's lineage might help rebalance the scales of power in favor of community partners. First of all, this approach acknowledges institutional continuity that is perceived externally but often overlooked internally within institutions. While it may be problematic to consider oneself in the twenty-first century a professional descendant of say, Franz Boas or Mead, their legacies continue to shape the museum where I work, and much of the collections with which I work. To deny this legacy is to fail to come to terms with the way such legacies shape public perceptions, for better and for worse. Often they are remembered with particular acuity by the communities whose families interacted with them and passed down oral histories of their visits and fieldwork. This continuity of memory, which is often stronger in the Pacific places than in New York is bittersweet.[18]

Legacies like those of Boas and Mead come from a particular historical context.[19] If I, like my grandmother, had been born in a small town in Eastern Massachusetts in 1927 to first generation Italian immigrants who moved to the United States in pursuit of the prospect of financial security of working in the textile mills along the Merrimack River, would I have found my way to New York City and been employed by the still-young American Museum of Natural History? I don't think this would have been possible in this era. My own stories and the choices that unfolded for me, my own family, labor, class and political economy has a history too. I have been privileged to hear these personal accounts from many of my colleagues and project partners whose heritage in represented in the collections I work with, including many Indigenous scholars, activists, artists and community leaders.

How would my life have been different?

These questions share overlaps with the questions that emerge from our special "behind the scenes" visitors during object encounters in the ethnological collections; sometimes they are expressed in the collection space itself and sometimes they come forth later, in the process of decompressing in a different space, such as an office or over lunch. "What would my life had been like if I had lived in my community at the time these objects were made and used?" "How would my view of my world been different?" It is a question that is particularly interesting because it involves an accounting of the role that various forms of modernity have on identity formation. These are loaded questions, but important to ask. It is a tremendous privilege to be allowed to ruminate with community stakeholders about how the objects that are in the collections catalyze questions about how much we can still be ourselves in

18 This was particularly the case when my colleague Jenny Newell and I worked in Margaret Mead's footsteps in Samoa in a cultural heritage partnership in the fall of 2013. For more on this see Newell Chapter 5, this volume.

19 Lenora Foerstel takes on the project of contextualizing Mead in both historical and cultural perspectives in an article that she subsequently republished in the volume in which she was an editor, discussed in the first footnote. It is one of the most revealing sources available for embarking on the project of understanding Mead in the more intimate context I describe here. I acknowledge there is no dearth of either archival material or academic discourse about Mead, the institutional ancestor I describe here and that the project of thinking about these connections across generations may be more challenging for scholars and curators for whom there is little material preserved. Lenora Foerstel, "Margaret Mead: from a cultural/historical perspective," *Central Issues in Anthropology* 8 (1988): 25–31.

markedly different circumstances. How much of our personal or collective value systems are experientially-honed and how much innately shaped and ineffable? How useful is past knowledge to future generations? The story of Connie Hart's visit to Museum Victoria in the 1990s is retold by Tom Griffiths in the next "cameo" chapter. Hart's encounter with a traditional eel trap re-created a culture that has a new relevance in 2015 as the Indigenous stone eel trap landscapes of western Victoria are under consideration as World Heritage. Collections can recover past lives, and build future ones.

Part of the task of environmental humanities undertakes is rendering more visible the processes by which colonization and industrialization and the broad projects of empire injected both intentional and consequential disruptions in beliefs and practices to peoples with deep relationships to their places. Such disruptions generate lasting impacts on place-making and how it is able to be created and perpetuated. Drawing connections that these historical displacements would deny brings a new communion of person, place and object. A co-existence may be possible to momentarily foster and there is healing power in those moments, but we must remain deeply mindful that these moments do not and cannot erase the histories and futures of displacements. Deeply personal answers deserve to be heard in the words and voices of those who have taken on the tremendous task of thinking through them in the context of their ancestral peoples and places.

8

CAMEO

Connie Hart's Basket

Tom Griffiths

This essay was first published as an Epilogue to the book, *Hunters and Collectors: The Antiquarian Imagination in Australia* (Cambridge University Press, 1996), which was written at a time of rapidly changing sensibilities about the curation of Aboriginal culture in museums. The book explored the roots of Australian popular historical consciousness through a study of archaeology, collecting, museums, commemoration, memory, monuments, landscape, preservation, heritage and the writing of history. It analysed the culture of collection of Aboriginal artefacts by white settlers such as R E Johns, a clerk of courts and police magistrate in central Victoria, Alfred Kenyon, an engineer and amateur ethnologist, and Stan Mitchell, a mineralogist and stone tool collector. R E Johns' collection of wooden Aboriginal hunting implements was sent as a colonial contribution to the Paris International Exhibition of 1878 and was placed there at the very beginning of an evolutionary display. This essay explores the paradox and potential of museums through a reading of a 1992 exhibition where the work of the collectors was subtly subverted by Aboriginal people themselves.

– Tom Griffiths, April 2016

At times the past forces itself shockingly upon the present, like an intrusion across a geological fault line. I remember in 1968, at the age of eleven, attending a meeting of the Hawthorn Junior Field Naturalists Club, an association formed in 1943 by Stan Mitchell. When it came to show-and-tell time and members produced exhibits of the past month's collecting, a boy aged precisely fourteen got up and showed us his birthday present. It was, he explained with some pride, an Aboriginal skull. It was a gift from his parents. He kept it in his bedroom. But for that evening it took its place on the display between the rock specimens and the beetles. At home that night, and for some time later, my family joked about it. What were we amused or scandalized by? That a human was a nature exhibit? That it was an Aboriginal skull that was so treated? That someone should live so intimately with it? That a boy should be given a human skull for his birthday?[1]

1 Report of meeting and list of exhibits, 29 November 1968. *The Junior Naturalist. Journal of the Hawthorn Junior Field Naturalists Club of Victoria*. (1969): 4.

When I began this study I was myself a collector. I was employed as a field officer for the State Library of Victoria, a job that involved the acquisition of historic manuscripts and pictures for the library's Australiana research collections. It was known as the "cup of tea" job, for it took one into the lounge rooms of Victoria to discuss the future of family papers, and the likely public uses of quite personal pasts. That work exposed me to the politics of the past, to the dilemmas of collection, possession and preservation.

Perhaps I first thought of the subject of this research when, in 1986 while I was working for the library, I was told that the daughter of Charles Barrett was unsure what to do with her father's papers and photographs. I learnt then that Barrett was a journalist and nature writer who had died almost thirty years before. As well as letters and photos, his daughter showed me boxes that had not been opened since his death in 1959. In them were Aboriginal artefacts wrapped in newspaper; some of them were sacred objects that Barrett had collected on trips to central Australia. Even parcelled in a dusty box they were, I suspected, still full of power. Barrett's daughter asked that I take the artefacts to the Museum of Victoria where her father had donated material many years before. During the long drive back to Melbourne I felt increasingly conscious of the boxes in the back of the station-wagon enclosing the secret/sacred objects. Whose were they? What meanings did they hold? What process had brought them here, a process that now implicated me? I thought of a scene at the end of *Raiders of the Lost Ark*, a film about the archaeologist-adventurer Indiana Jones, where the immensely powerful ark of the covenant is casually wheeled into the vaults of a state museum. Was I participating in the dispossession of a people and the disenchantment of the world? It was while driving the sacred stones across Victoria that I first thought of doing this research.

Now, at the close of it, I visit the museum and its new exhibition called *Keeping Culture Strong: Women's Work in Aboriginal Australia*.[2] As I enter the gallery, I hear bird calls, haunting music and Aboriginal voices. The exhibition seeks to balance the anthropological preoccupation with men in Aboriginal society, and it does so by portraying women at work as food gatherers, artists, makers of clothes and utensils, organizers of ceremonies and custodians of community.[3] The cultural focus shifts from hunting to collecting. The introductory boards tell me:

> This exhibition celebrates the cultural heritage of Aboriginal women... Today Aboriginal people have successfully resisted pressures to totally assimilate to the wider community. Women are at the forefront of many community and cultural programs aimed at maintaining and reviving Aboriginal and cultural identity.

Here I encounter some of the main themes of the exhibition: it is about the here and now; it is about continuity and survival. But not just passive survival; it is about resistance and re-creation. Today the silences are different. Koories prefer the museum not to emphasize and isolate the ancient past or "human evolution" because they still carry the weight of the nineteenth century and conjure images of "the primitive". And for legal and moral reasons,

2 Another reading of this exhibition, and the nearby "Koorie" exhibition at the Museum of Victoria, has been offered by Helen Verran in "Othered Voices," *Arena Magazine*, February/March 1994, 45–7.
3 Aboriginal Studies Department, *Women's Work: Aboriginal Women's Artefacts in the Museum of Victoria*, (Melbourne: Museum of Victoria, 1992). The book was produced before the exhibition, which was opened later the same year. In what follows I have quoted occasionally from exhibition captions and texts, and I have drawn on discussions with staff in the Aboriginal Studies Department.

taking into account Aboriginal values and sensitivities, I was asked not to use any pictures of skulls in this work, however ancient, from whatever country.

Textures and colors in the exhibition are strong, the artefacts are beautiful: a dilly bag spills open showing its contents, a woman's tool kit; there are carved emu eggs and gorgeous decorative flowers made from bird feathers. There are grass and string baskets of a surprising variety of designs. There are makeshift dishes: the one that I look at with a mixture of horror and wonder is the car hubcap that has been hammered into a dinner dish. As I walk around, the thing that surprises me is just how many of these artefacts have been recently made and acquired. And I know who made them because there are names on the captions. These artefacts of beauty have mostly been made during and since the killing times; they are largely from the post-contact period. They proclaim not just survival but wilful, dignified, innovative adaptation.

There are some familiar photographs on the wall, blown up to huge size. I know some of these photos well, or I think I do. They are photos from the missions, tourist postcards depicting the sad remnants of a "dying race". They are photos that make me, as a non-Aboriginal Australian, both curious and uneasy. But when I approach the photos and read the captions I get a shock: the black people are named, quite precisely, their relationships with one another explained, and my attention drawn to the craft work in their hands. The photo I thought was exploitative becomes instead affirmative, its sinister dimensions are cleverly, lightly undermined.

There are some grass baskets in a cabinet here, and there is a video running alongside. I crouch down and listen. The film introduces me to Connie Hart. She is shown walking among native grasses, fingering them, plucking them, twisting them. She is a basket-maker, and one of her grass baskets is on display. The caption says: "Coiled basket by Connie Hart. Acquired in 1992 from maker, Portland Victoria". The caption and the film give me some more information and I learn a little of Auntie Connie's story.

Connie Hart's mother, Frances Alberts, lived on Lake Condah Aboriginal Mission Station. It was established in 1867 in the stony rises between Hamilton and Portland. I know that R. E. Johns had dealings with the last manager there, the Reverend J. H. Stähle. Johns, to add to his collection, commissioned some craft work from Stähle and asked for some artefacts to be made by the Lake Condah Aborigines.[4] With a leap of faith, I suddenly realize that one of the baskets made for R. E. Johns may have been made by Connie Hart's mum, or she may have watched them being made. She was the Reverend Stähle's maid and housekeeper in the early 1900s. She was on the spot to be asked, one of a dwindling number of Indigenous people remaining after the 1886 Aborigines Act dispersed the mission communities. As Connie grew up, she watched her mother select the grasses and make baskets. This is what Auntie Connie remembers:

> No one taught me to make my baskets. I used to watch my mother do it and when she put her basket down and went outside, I'd pick it up and do some stitches. When I heard her coming back, I would shove it away real quick and run away. I was a great one for sitting amongst the old people because I knew I was learning something just

[4] From 1893 onwards, Johns recorded many instances of commissioning, and often paying for, artefacts from the mission. He always dealt through Stähle, although on one occasion he "paid the half-caste who brought them 7/-": Johns, Diary, Australian Manuscripts Collection, La Trobe Collection, State Library of Victoria, 28 April, 19 May, 29 May, 16 December, 23 December 1893, 5 January 1894, etc.

> by watching them. But if I asked a question they would say, "Run away, Connie. Go and play with the rest of the kids".
>
> They didn't want us to learn. My mum told me that we were coming into the white people's way of living. So she wouldn't teach us. That is why we lost a lot of culture. But I tricked her. I watched her and I watched those old people and I sneaked in a stitch or two.[5]

Connie did not make a basket herself until her mother died, over forty years later. She was, in a strange way, freed to rediscover her heritage. She remembered the stitch, she remembered the *puung'ort* grass, but she was "frightened to do it".[6] But she did do it, and she taught others to do it. In the exhibition, I found that Connie Hart taught Grace Cooper Sailor, who taught Sharon Edwards, and their baskets are on display, too. You can see a modern lineage of revived craft there. Connie wanted to make an eel net, but no one seemed to remember how. So she came to the Museum of Victoria and she looked carefully – like no one else had looked before – at the one in the museum cabinet, the one collected by R. E. Johns from Lake Condah in 1902, and she went home and made one herself and it stood as tall as she did.[7] Did we expect – or even dare to hope – that museums might operate in this way?

With that thought in mind, I walk around the exhibition again, and I look more carefully at the captions. And there was something I should have noticed before. Here is a fishhook made from a small straight piece of bone, acquired in 1910 from the estate of R. E. Johns. There is a bone implement from a fibula of a grey kangaroo, acquired in 1927 from A. S. Kenyon. The magnificent possum skin cloak, made of eighty-three possum skins sewn with animal sinew, many with fine designs engraved upon them, is from the R. E. Johns collection. The forehead band made of string, the bark container from Ouyen, the grinding stones, all these are from the collection of A. S. Kenyon. They are displayed alongside the contemporary crafts and acquisitions, symbols of continuity, evidence of the continuing vitality of Aboriginal people. The European collectors would not recognise their collections here. Something fascinating had happened in the meantime.[8]

I am intrigued by the way culture works, by the way it is "kept strong." Connie's craft survived because she "tricked" her mum and her elders. They were trying to protect her from prejudice, from the brand of foreign skills, but she – as children often do – knew better. So, too, are the intentions and purposes of collectors undermined and subverted. R. E. Johns, who thought he was memorializing a dying race, whose collection went to Paris as proof of Aboriginal evolutionary doom, was at the same time unwittingly participating in, even encouraging, a process of local cultural renewal. Perhaps I am unfair, perhaps he was not unwitting.

5 Alick Jackomos and Derek Fowell, *Living Aboriginal History of Victoria: Stories in the Oral Tradition*, (Cambridge and Melbourne: Cambridge University Press and the Museum of Victoria Aboriginal Cultural Heritage Advisory Committee, 1991), 74. For biographical information about Connie Hart and her family I have also drawn on Merryl K. Robson, *Keeping the Culture Alive: An exhibition of Aboriginal fibrecraft featuring Connie Hart, an Elder of the Gunditjmara people with significant items on loan from the Museum of Victoria*. (Hamilton: Aboriginal Keeping Plane and Hamilton City Council, 1986).
6 Jackomos and Fowell, *Living Aboriginal History*.
7 Artefact X 16265, Museum of Victoria; Robson, *Keeping the Culture Alive*.
8 The Museum of Victoria has a blog post with an Aboriginal reader telling the story http://museum victoria.com.au/about/mv-blog/jun-2011/budj-bim-rangers/lake-condah-video/

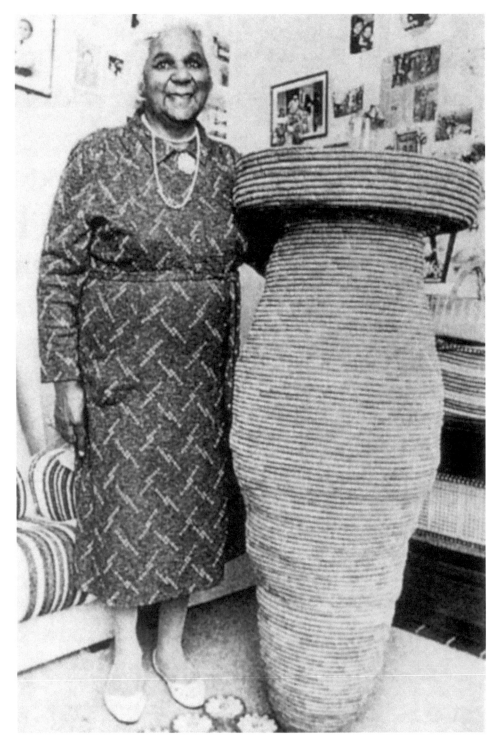

Figure 8.1 Connie Hart and her eel trap basket, from A. Jackomos and D. Fowell, *Living Aboriginal History of Victoria: Stories in the Oral Tradition*, Cambridge University Press, 1991.

9

"PEOPLES WHO STILL LIVE"

The role of museums in addressing climate change in the Pacific[1]

Peter Rudiak-Gould

Introduction: living and surviving in the Pacific

"The end of the Pacific" – that is the rather dramatic title of a recent article in the *Singapore Journal of Tropical Geography* by geographer Patrick Nunn.[2] It sounds sensationalized, but Nunn's article is scholarly and staid. For many communities of Pacific Islanders, this century may indeed be the last in which they can call their ancestral territories home. With UN negotiations at an impasse and new fossil fuel reserves coming under exploitation through fracking and enhanced tar sand extraction techniques, it is being seen as increasingly doubtful that global warming can be limited to the 2°C that is considered the threshold of "dangerous" climate change. Even 2°C, the "ambitious" target, will spell severe impacts for Pacific Islanders. Oceans may rise by 1m or more by 2100. It takes little imagination to appreciate the damage this could deal to flat coral islands, already hardly above sea level at the year's highest tides, in the Marshall Islands, Kiribati, Tuvalu, Tokelau, the Tuamotu Archipelago, the Federated States of Micronesia, and elsewhere.

Equally endangered are the region's many coastal cities and villages and its well-populated river deltas in Fiji, the Solomon Islands, and Papua New Guinea. But sea level rise is just the most obvious impact. Typhoons, historically capable of wiping small atoll islands off the map,

1 A note on sources: For effects of climate change on the Pacific, see the Intergovernmental Panel on Climate Change Fifth Assessment Report, available at www.ipcc.ch as well as Patrick Nunn's "The End of the Pacific?" (ref below). For traditional Pacific disaster relief, see John Campbell's "Traditional disaster reduction in Pacific Island communities." For general perspectives on museums and colonialism, see Sally Price's *Primitive Art in Civilized Places*, James Clifford's *Routes*, and Laura Peers and Alison Brown's edited collection *Museums and Source Communities*. For references specific to Oceania, see Nicholas Thomas's *Entangled Objects*, and Michael O'Hanlon and Robert Welsch's edited collection *Hunting the Gatherers*. Examples of colonial collection techniques in this chapter were taken from *Primitive Art in Civilized Places*, *Entangled Objects*, Lissant Bolton's chapter in *Museums and Source Communities*, and Michael Quinnell's and Rainer Buschmann's chapters in *Hunting the Gatherers*. Mark Lynas' pessimistic take on the possibility of cultural survival in Tuvalu can be found in his book *High Tide*. My work on Marshallese views of climate change can be found in the monograph *Climate Change and Tradition in a Small Island State*. Carol Farbotko's view of the media's "ecocolonial" use of Tuvalu is best expressed in her article "Wishful Sinking."

2 Patrick Nunn, "The End of the Pacific?" *Singapore Journal of Tropical Geography* 34, no. 2 (2013): 143–171. Doi: 10.1111/sjtg.12021

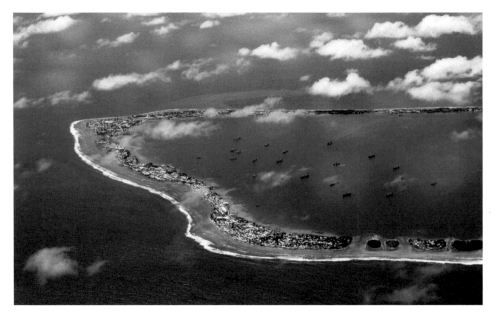

Figure 9.1 Majuro, capital of the Marshall Islands, Majuro Atoll, 2015. Photo: Alex de Voogt. See Plate 7.

may increase in intensity. Coral reefs may die en masse as the sea warms and acidifies. Nunn predicts that within the next two or three decades in the Pacific, villages and cities along the coastline – which are the great majority of settlements in this region – will need to be partly or wholly moved, or protected with massive seawalls. These enormously expensive and disruptive responses are not solutions to the problem, so much as one of the problem's worst effects. By the middle of this century, forecasts Nunn, even those Pacific communities that have managed to remain by the ocean will no longer find it possible to depend on off-shore marine resources for a living. It is not that one day the islands will sink and everyone will leave, but that, gradually, life will become more dangerous, difficult, and unpleasant, until many people decide that their emotional and economic attachment to the homeland is no longer worth the fear and danger of continuing to occupy it.

These looming tragedies are often expressed like so: some Pacific homelands will become "uninhabitable" and people will have no choice but to leave. But we ought to ask, first, exactly what "uninhabitable" means. There is a wonderful quote that speaks directly to this. At a public hearing of the World Commission on Environment and Development in São Paulo in 1985, an indigenous speaker from the floor said:

> You talk very little about life, you talk too much about survival. It is very important to remember that when the possibilities for life are over, the possibilities for survival start. And there are peoples here in Brazil, especially in the Amazon region, who still live, and these peoples that still live don't want to reach down to the level of survival.[3]

3 Speaker from the floor, WCED Public Hearing, São Paulo, 26–29 Oct 1985, quoted in Our Common Future, Chapter 1: A Threatened Future, From *A/42/427. Our Common Future: Report of the World Commission on Environment and Development*. www.un-documents.net/wced-ocf.htm

To take this statement seriously – and I believe we should – we must stop speaking of *inhabitability* and speak instead of *survivability* and *livability*. Survivability is a cold biological concept. A Pacific homeland ceases to be *survivable* when not enough children are born to replace those who drown in storm surges or starve from failed gardens, as well as those who die more prosaic deaths. Unsurvivability may not become a widespread condition in the Pacific for many decades to come. Anthropologists, geographers, and others have documented the boundless resourcefulness of Pacific Islanders, who have survived – if not as individuals then at least as communities and societies – through all manner of drought, typhoon, storm surge, world war, and nuclear testing. Techniques of food preservation, risk sharing, agricultural diversification, knowledge of last-resort famine foods, ecologically informed taboos, rituals of redistribution, extensive trading networks, traditional weather forecasting, and typhoon-resistant house construction are just some of the strategies. Even on coral atolls, often considered the Pacific's most fragile environment, it will probably be many decades before it is truly impossible to survive.

But survivability is too low a bar to set. We would not be content with mere survival in our own lives, so it would be unfair to ask Pacific Islanders to settle for such a meager existence. *Livability* means survival with meaning and pleasure. While unsurvivability may still be a long way off in the Pacific, unlivability, for many communities, may be just around the corner. This distinction between living and surviving will be important as we consider the role of museums in addressing the Pacific climate crisis. First, though, we must query the very idea of a museum.

Figure 9.2 Ocean side sea wall, Majuro Atoll, Marshall Islands. Photo: Skye Hohmann Photography.

Museums and the Pacific colonial legacy

If one asked a well-educated museum patron in a Western country what an ethnographic museum is and what it is for, the answer might go like this: "It is a place where valuable objects created by different cultures around the world are kept safely so that they can be studied by specialists and viewed by the public." This is an innocent enough statement. Undoubtedly the gathering, safeguarding, study, and viewing of objects are valid elements of a museum's mission statement. But we must realize that hidden in that description are certain ideas about the normal and proper relations between objects, those who created them, those who keep them, and those who study them. Once these implicit assumptions are brought to light, the common-sense understanding of an ethnographic museum no longer seems so innocent.

The situation is captured brilliantly in Sally Price's *Primitive Art in Civilized Places*, which begins with a subversive Dedication: "to those artists whose works are in our museums but whose names are not." The reader is immediately made to feel that there is something odd and unjust about the separation of "art" museums, where the pieces are called "works of art" and are mainly European, from "ethnographic" museums, where the pieces are called "artifacts" and hail from societies considered exotic, remote, primitive, threatened, or extinct. Why is it that in the "art" museums the artists' names are displayed, while in the "ethnographic" museums only the culture of origin is noted? Why do "art" museums call artistic change "innovation," while "ethnographic" museums call artistic change "loss"? Price makes it clear that the separation is, at heart, between the colonizers and the colonized – and the curatorial double standard is the natural outcome of this. Artists from societies that colonize are presented as individuals with the agency to innovate, while artists from societies that are colonized are presented as faceless enactors of a timeless tradition, for which change can arrive only through outside (Western or colonial) intervention.

Sally Price, along with anthropologists Nicholas Thomas, Laura Peers, and others, have laid bare the many ways in which museums have traditionally reflected and justified colonial structures and attitudes. As locked storehouses in colonizing countries, they bar less powerful societies from accessing their own cultural heritage. Historically, some museums used their exhibitions as transparent attempts to excuse imperial intervention. As Nicholas Thomas writes, in the nineteenth century the Missionary Museum of London wanted to make the case for pacifying and Christianizing Pacific Islanders, so they preferentially displayed the islanders'"savage" weapons and "crude" religious idols. European and American collectors became obsessed with alleged "cannibal forks" from Fiji, playing into Western images of South Pacific heathens. Museum artifacts were often collected through an abuse of colonial power. Luigi d'Albertis, the first European to travel up New Guinea's Fly River, gathered artifacts on his 1884 expedition by scaring villagers away with guns and then plundering their houses. In the 1920s, Australian filmmaker and photographer Frank Hurley traveled into remote areas of New Guinea, stealing objects from huts when their owners were away. In 1930, the National History Museum in Vienna hired Māori men to steal mummies from their own people to put on exhibition. Over 1,500 Papuan artifacts in the Queensland Museum in Australia were "collected" by Sir William MacGregor and his men in 1891 from a defeated Marind-anim war party. The "salvage paradigm" – the notion that Indigenous societies were primitive fossils destined for extinction and that therefore their material culture had to be collected before it was too late – sometimes became a self-fulfill-

ing prophecy (see also Lui-Chivizhe, essay, this volume). Historian Rainer Buschmann narrates a chilling case in point from turn-of-the-century Oceania. German profiteers extracted artifacts from the islands of Wuvulu and Aua off the north coast of Germany's portion of New Guinea. The trade began peacefully, with locals willingly manufacturing artifacts for sale. But the presence of Europeans caused outbreaks of malaria that cut the native population by more than half. With artifact production thus declining, the German collectors resorted to raiding islanders' graves. The locals retaliated by killing one of the traders, then, fearing reprisal, fled in canoes. Almost half of them died on the stormy sea.

As Sally Price writes, "these are the encounters that have supplied our museums, from the Musée de l'Homme to the Metropolitan Museum of Art, with the great bulk of their non-Western artistic treasures."[4] In the growing postcolonial and indigenist zeitgeist of the 1970s, abuses of this sort could no longer remain unchallenged. In 1970, UNESCO passed the Convention on the Means of Prohibiting and Preventing the Illicit Import, Export, and Transfer of Ownership of Cultural Property, which states that "cultural property" belongs to its "traditional owners" or their descendants. The global indigenous movement gained strength and native cultural revival movements began to flourish in Hawaii, New Zealand, and elsewhere in the Pacific. By the end of the 1980s, most Pacific territories had won political independence. The traditional model of the ethnographic museum was increasingly questioned. National museums sought the repatriation of artifacts that had been bought or stolen in colonial times. The items collected from the Marind-anim war party were repatriated to the Papua New Guinea Museum at their request. The Vanuatu Cultural Centre chose to rely on volunteers from various ethnic groups around the country, rather than on foreign staff; the museum has downplayed object-based displays in favor of grassroots efforts to revive local rituals, arts, and languages. In the Marshall Islands, the Historic Preservation Office and the Alele Museum are staffed mainly by Marshallese. In 1994, anthropology students at Stanford University raised money to invite Kwoma and Iatmul woodcarvers from Papua New Guinea to sculpt stones and tree trunks on the Stanford campus. The artists were personally known individuals rather than anonymous outlets of an unchanging culture.

A role for museums

It would be a shame if climate change-induced exodus from the Pacific ended up reviving some of the old bad habits of museums. But such backsliding is a real danger. The idea of sea level rise could resurrect the salvage paradigm and precipitate a frenzy of insensitive eleventh-hour collecting "before the islands sink." (Already there is a tourism industry aimed at visiting climate change-threatened sites "before it is too late."). The very real cultural damage associated with forced migration could inspire exhibits that present Pacific Islanders in the past tense, as though they were no longer living *or* surviving; as though their cultural identities were too fragile to withstand change or transportation; as though their "extinction" were the inevitable result of the marching-forward of time, rather than the avoidable result of large countries' inaction on climate change. Some journalists have already made exactly these mistakes when reporting on climate change in the Pacific – Mark Lynas' portrayal of Tuvalu comes to mind – and it is important that curators avoid them.[5]

4 Sally Price, *Primitive Art in Civilized Places* (Chicago, IL: University of Chicago Press, 1989).
5 Mark Lynas, *High Tide: How Climate Crisis Is Engulfing Our Planet* (London: Harper Perennial, 2004).

How can this be achieved? Ensuring that more Pacific Islander curators are on staff would be the first, most crucial shift. Allowing significant intervention into museum programing, acquisitions, research and publications by diaspora communities is part and parcel of this decentralizing of control. In museums whose constituents include exiled Pacific communities, the opportunity to support traineeships, internships, and guest curatorships by community members should not be passed by. Community-curated exhibitions can serve to expose non-Pacific Islander visitors to insights from the community that are unavailable through other means.

Second, when the opportunity arises for a museum to represent an exiled Pacific community, care can be taken to address not only what has been lost in the move, but also what has been retained, creatively adapted, reinvented, or even gained. The equal use of past, present, and future tenses in labels, educational materials and other language around the exhibition would encourage thinking on this time horizon. Museums need to portray the tragedy of forced relocation without implying that it entails the evaporation of all identity, distinctiveness, and community.

Third, as discussed elsewhere in this volume, a museum can be more than just a prison for objects. It can be a meeting place for an exiled community of Pacific Islanders, a "lending library" for periodic ceremonial use of valued cultural artifacts. It can, at its very best, be a place of healing, solidarity-building and place-making. As Laura Peers has pointed out, putting objects back into contact with the people to whom they are most meaningful also has an academic and pedagogical function: it opens access to the wealth of information that these people possess about the objects, and ensures that the objects are no longer radically decontextualized as they tend to be in traditional displays.[6]

Undoubtedly, such institutions could play a useful role for Pacific communities negotiating their new lives abroad. But I would add some words of caution. First, we should not naively suppose that such institutions could prevent significant cultural upheaval. In the Marshall Islands, a low-lying Micronesian society where I conduct fieldwork, people give a number of compelling reasons why certain important aspects of their society could not survive the destruction of the homeland. It is not just an ineffable spiritual connection to the islands, but rather very specific practices that require the existence of the physical substrate of the islands. Traditional Marshallese social structure revolves around a hierarchical system of land tenure and stewardship. Without the land, that hierarchy would – say many Marshallese – become purely symbolic or nominal. Marshall Islanders also emphasize the importance of subsistence to their sense of cultural identity. An exiled Marshallese community in Hawaii might manage to cultivate breadfruit and taro, but even there one cannot simply go out on the reef with a spear and return with dinner; it is hard to imagine any serious role for subsistence for Marshallese communities living in Arkansas or Oregon. A museum displaying and lending out pandanus mats, shell necklaces, books of legends, and so forth cannot prevent those losses.

Second, if we invest all of our thought in what "post-exodus" museums might look like, we risk making an assumption of inevitable relocation, giving up on both adaptation and mitigation. While it is probably too late for certain Pacific homelands to remain livable or survivable, it is emphatically *not* too late for others; it still depends on the decisions of citizens

6 Mark Lynas, *High Tide: How Climate Crisis Is Engulfing Our Planet* (London: Harper Perennial, 2004).

and political leaders in large industrial nations. With that in mind, I feel that for now, and perhaps for many decades in the future, the museum community ought to focus its energy on education for non-Pacific Islanders *before* uninhabitability occurs, rather than cultural continuity for exiled Pacific Islanders *after* uninhabitability occurs. We need to make it clear to non-islander museum-goers why most Pacific citizens reject the idea that mass resettlement is a "solution" to climate change. It may seem an obvious point that people do not want to wholly depopulate their homelands, but I have met some Westerners who do not seem to get it. (One British man told me, "If people in the Marshall Islands have lived there for two thousand years, then surely it is time for them to leave, even without climate change.") To drive the point home, climate change exhibits ought to help the public visualize what unsurvivability and unlivability would look like in their own communities or homelands, where presumably the injunction to "just move" would be no better received than it is in the Pacific Islands.

I am optimistic about the ease of attracting attention to such exhibits. The idea of "disappearing islands" holds a special poignancy to Western audiences: it feels like the spoiling of the last pristine wilderness, the touching of the last untouched tribe, the end of childhood or innocence. Comparisons to the book of Genesis, the disappearance of Atlantis, and so forth are inevitable. These powerful, centuries-deep associations can help to draw attention to Pacific climate change-themed exhibits, but they also carry heavy ideological baggage that must be unpacked if these displays are to be successful. Curators must, for one, counteract the lazy fatalism and sense of inevitability that pervades so much discourse on Pacific climate change. Exhibits need to make it clear that it is not too late to slow some of these effects and make it easier for Pacific Islanders to still *live*. Museum-goers, I feel, should be encouraged not simply to change their buying habits, but to band together to participate in change. To put it differently, to act as *citizens* and not just *consumers*. A student of mine once wisely remarked, "We get stuck on the huge solutions and the tiny solutions. The huge solutions, like dismantling global capitalism, feel impossible. The tiny solutions, like taking shorter showers, feel too small to matter. We should focus instead on the medium-sized solutions." Medium-sized solutions, like campaigning to make biking safer, easier, and more fashionable in a metropolitan area, are the kinds of actions that curators can usefully suggest.

These exhibits need to emphasize *livability*, not just *survivability*. Climate change can be shown impacting an island feast or a Pacific child's beach game, as much as eroding a beach-side house or ruining a taro patch with saltwater. Above all, the exhibits must avoid a pitfall described lucidly by geographer Carol Farbotko in her article "Wishful Sinking." Tuvalu, writes Farbotko, is the darling of climate change sensationalists. Portrayed as a "paradise lost," "Atlantis," "Eden," or "canary in the coal mine" by countless documentary filmmakers, journalists, bloggers, and tourists, the island nation has been transformed into a cautionary tale. According to Farbotko, this creates a "perverse impatience … for the first islands to disappear" for "only after they disappear are the islands useful as an absolute truth of the urgency of climate change, and thus a prompt to save the rest of the planet."[7] A living nation has become an allegory. The essential problem with this strategy, well-intentioned though it is, is

7 Carol Farbotko, "Wishful Sinking: Disappearing Islands, Climate Refugees and Cosmopolitan Experimentation" *Asia Pacific Viewpoint* 51, no. 1 (2010): 47–60.

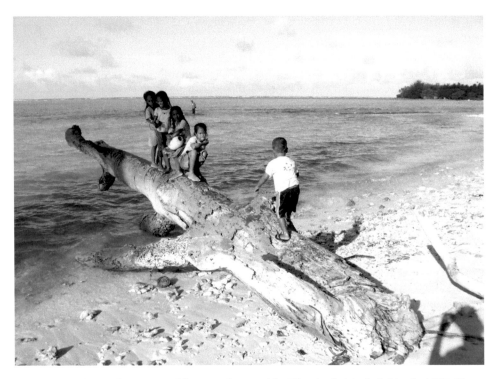

Figure 9.3 Children playing on a fallen tree, lagoon side, Ujae Atoll, Marshall Islands, 2007. Photo: Peter Rudiak-Gould.

that it violates Kant's famous categorical imperative: Tuvalu is being treated not as an end unto itself (a threatened society that has the right to exist) but purely as a means to an end (a way of raising concern about climate change). This appropriation of a nation's tragedy is insensitive and counterproductive.

Case study: *Waters of Tuvalu*

In 2008, the Immigration Museum in Melbourne, Australia opened an exhibit called *Waters of Tuvalu: Nation at Risk*.[8] The curators and organizers were members of the Tuvaluan community in Melbourne including Tito Tapungao, Fikau Teponga, and members of the Melbourne chapter of the Tuvaluan expat organization Kaiga Tuvalu. Geographer, television weather presenter and environmental activist Rob Gell also contributed. The intended audience was both Tuvaluan immigrants and the Australian public. The exhibit featured "traditional" and contemporary artifacts including handmade fans and mats, a model canoe, canoe-making tools, and fishing implements, along with photographs of the country's cultural life, and information on the clear and present danger that climate change poses to this low-lying Polynesian nation of coral atolls.

8 Photographs of the Immigration Museum's *Waters of Tuvalu* exhibit can be found here: www.whitecube.com.au/watersoftuvalu.html. The brochure can be found here: http://museumvictoria.com.au/pages/5996/pdf/IM_Tuvalu_brochure.pdf?epslanguage=en

Figure 9.4 Objects on display in the Tuvalu community exhibition *Waters of Tuvalu: A Nation at Risk*, Immigration Museum - Museum Victoria, 2008. Photo: Rodney Start. © Museum Victoria. See Plate 7.

To my mind, this exhibition got several things right. First, with Tuvaluans themselves intimately involved in the project, this was a truly participatory endeavor, far beyond mere tokenism. Second, *Waters of Tuvalu* effectively portrayed the people of that country *living* and not merely *surviving*. The visitor is shown creative works such as woven mats, not just implements of survival such as fishhooks. Photographs depict children's games, communal feasts, dances, and other ways that Tuvaluans still *live*. Third, the exhibit did not fall into the trap of portraying Tuvalu as primordial, primitive, and untouched: it shows Christian churches and acknowledges Christianity as an important aspect of Tuvaluan identity and society. Fourth, the exhibit gives Tuvaluans agency, portraying ways in which Tuvaluan immigrants to Australia are working to maintain some semblance of identity and community cohesion, and how Tuvalu's government is implementing climate change adaptation measures. Fifth, the organizers made every effort to make the exhibit a good example of sustainability itself, and provided informational resources to visitors as to how they might reduce their own carbon footprints.

At the same time, *Waters of Tuvalu* focused too much, it seems to me, on traditional practices, making the country seem at times like a relic. While it displayed contemporary handicrafts made of synthetic materials, it displayed only traditional canoes and fishing implements – as though people in Tuvalu never used motorboats or fiberglass fishing spears, or could not do so without compromising their authentic selves. Great emphasis was placed on moribund aspects of Tuvaluan culture: "Like other hand-crafts such as canoe making, weaving is becoming a dying art only remembered and practiced by Tuvaluan elders."

Though loss must be acknowledged and mourned in such an exhibition, I believe it ought to be balanced by celebrating adaptability, innovation, and reinvention. The exhibition reflected assumptions that the destruction of Tuvalu and its culture is inevitable: "the geography, sovereignty and cultural heritage of Tuvalu are destined for extinction." Furthermore, the resulting exodus is presumed to spell the end of Tuvaluan nationhood ("Their culture and identity will be taken away, surviving only as memories") and self-determination ("Undoubtedly, the people of Tuvalu will come to depend on the generosity of world communities for their survival."). There is a spectrum of feeling within communities about the relative resilience or threatened status of cultural practices in the face of climate change.[9] While it is understandable that some members of the Tuvaluan community and exhibition planners would want to convey this interpretation, curators need to recognize that expressing these fatalistic sentiments unwittingly reinforces, at best, a valuing of stasis in indigenous cultures, and at worst reproduces the old colonial refrain: that "primitive" cultures are fossils, utterly fragile to outside influence, who cannot change without losing their essence. It is never doubted that Americans can be both very different from what they were in 1776 and yet still be American, that French people can be cosmopolitan and mobile but still French, or that Japanese people can drive cars and wear jeans while still being Japanese – but we find it hard to believe the same for "primitive" cultures. Museums can help to challenge this double standard, and the case of climate change in the Pacific is a good place to start.

I feel there is a way to go towards making the most of museums' opportunity to engage with climate change in the Pacific. But it is absolutely possible to do this and to do it right. We can create institutions and exhibitions that are genuinely participatory and of service to islanders. We can depict climate change both realistically and hopefully. We can honor traditional practices without casting islanders in the role of Stone Age vestiges. We can mourn the tragedy of forced migration without assuming the death of culture. We can provoke visitors to take responsibility rather than to indulge in passive guilt. We can show Pacific Islanders as people who still live, not just people who still survive. Above all, we can look not only to the dead past but also to the living present and the still-to-be-born future.

9 Stuart Kirsch, "Lost Worlds: Environmental Disaster, 'Culture Loss,' and the Law," *Current Anthropology* 42 (April 2001): 167–198.

10
OBJECT IN VIEW

Taking a bite out of lost knowledge: sharks' teeth, extinction, and the value of preemptive collections

Joshua Drew

> In the inter-*maneaba* [tribe] warfare each side normally marched in three groups, with the main party in the centre of the islet flanked by supporting groups on the lagoon and ocean beaches. Once the parties met, the outcome depended on the result of individual challenges made by warriors armed with *unun* [long sharks-teeth spears], who were normally preceded by the henchmen armed with *taumanaria* or *ie* [branched lances] who engaged each other and at the same time helped to assist the spearman by fending off his opponent's toothed spear with the branches of their own.
>
> *Gilbertese warfare as reported by Grimble (1921)*[1]

The Gilbertese people live along a chain of small archipelagos called the Gilbert Islands, now part of the country of Kiribati. Traditionally they had a close association with the marine environment, the oceans providing a source of nutrition, building materials and trade goods. The vivid splendor of the marine realm was also closely tied with their creation stories, religious, magical and cultural practices[2] – as one might expect from people living on atolls in a very large sea, the ocean was an integral part of their daily existence.

Sharks feature prominently in Gilbertese culture. Sharks form constellations, and are in creation myths. Shark fishing is the measure of a man and that knowledge was passed down using very specific rituals.[3] In addition to fulfilling spiritual needs, sharks met several key physical needs for those living in an environment with relatively limited resources. Besides

1 Arthur Grimble, "From Birth to Death in the Gilbert Islands," *The Journal of the Royal Anthropological Institute of Great Britain and Ireland* 51 (1921): 25–54; Katherine Loumala, "Sharks and Shark Fishing in the Culture of Gilbert Islands, Micronesia," In *The Fishing Culture of The World*. Budapest: Akademiai Kaido. 2 (1984): 1203–1252; and Katherine Loumala, "Some Fishing Customs and Beliefs in Tabiteauea (Gilbert Islands, Micronesia)," *Anthropos* 75 (1980): 523–558.
2 Loumala, "Sharks and Shark Fishing," 1203–1252; J. E. Newell, "The Legend of the Coming of Nareau from Samoa to Tarawa, and his Return to Samoa," *The Journal of the Polynesian Society* 4 (1895): 231–235.
3 Grimble "Birth to Death," 25–54; Loumala, "Sharks and Shark Fishing," 1203–1252.

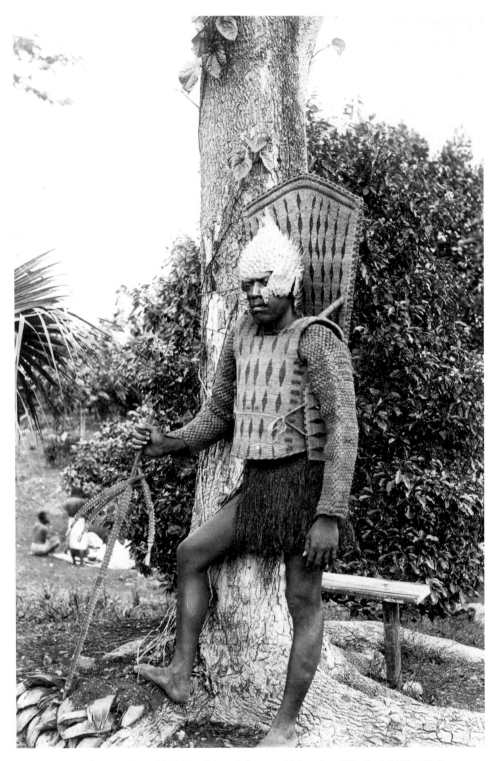

Figure 10.1 Kiribati warrior, *c.*1890. Pitt Rivers Museum, University of Oxford, 1998. 359.2.

the obvious caloric and nutritional value of shark meat and liver,[4] sharks teeth were key components for numerous weapons and tools,[5] including the item shown here – a shark toothed sword made from the teeth of *Carcharhinus obscurus* AMNH ST1277.[6]

My research, along with Mark Westneat and Chris Phillip of the Field Museum of Natural History (Chicago) has shown that a wide variety of sharks were used for the making of tools and weapons. We have also demonstrated that two of the species present during the mid-nineteenth century were extirpated even before the first ichthyological surveys of the reefs were taken.[7] Had we not looked at these collections we would have never known that these species once existed in the Gilbert Islands.

Placing these artifacts in a historical context requires interpreting the data through multiple lenses. There are some questions that simply cannot be answered simply using biology, and require a more robust analysis. For example, one plausible hypothesis for the presence of teeth from sharks not currently found within the Gilberts in these weapons could be that the Gilbertese traded for them with people who lived in areas where those sharks were present. Biologically we have no way to support or refute that hypothesis. However when we view the evidence from an archaeological,[8] linguistic[9] or ethnographic[10] perspective we see that there is little evidence to support large-scale inter-ocean trade in shark teeth. That lack of evidence for external trade, combined with the cultural significance of catching sharks[11] and the technological developments in shark fishing present in Gilbertese culture[12] mean that we have confidence in interpreting these biological data as evidence for localized extinction of apex predators in the Gilbert Islands – an extinction that took place even before we had the forethought to look.

This loss of shark diversity foreshadowed a broader trend of marine degradation in the region,[13] despite a traditional marine conservation ethic.[14] Because so much of the indigenous Gilbertese culture drew from marine resources, healthy marine environments are not only essential for biological but for cultural diversity.

4 Rene L. A. Catala, "Report on the Gilbert Islands: Some Aspects of Human Ecology," *Atoll Research Bulletin* 59 (1957): 1–256.
5 H. C. Maude and H. E. Maude (1981). "Tioba and the Tabiteuean Religious Wars," *The Journal of the Polynesian Society* 90 (1923): 307–336; G. M. Murdoch, "Gilbert Islands Weapons and Armour," *The Journal of the Polynesian Society* 32 (1923): 174–175. doi:10.2307/20701930
6 *Squalus obscurus* (LeSueur 1818).
7 Joshua Drew, Chris Philipp and Mark W. Westneat, "Shark Tooth Weapons from the 19th Century Reflect Shifting Baselines in Central Pacific Predator Assemblies," *PloS One* 8 (2013): e59855.
8 R. J. Lampert, "An Archaeological Investigation On Ocean Island, Central Pacific," *Archaeology & Physical Anthropology in Oceania* 3 (1968): 1–18.
9 Richard Walter, "Lapita Fishing Strategies: A Review of the Archaeological and Linguistic Evidence," *Pacific Studies* 13 (1989): 127–149.
10 Loumala, "Sharks and Shark Fishing," 1203–1252.
11 Loumala, "Sharks and Shark Fishing," 1203–1252.
12 Eugene Gudger, "Wooden Hooks Used for Catching Sharks and Ruvettes in the South Seas: A Study of their Variation and Distribution," *Anthropological papers of the American Museum of Natural History* 28 (1923): 199–384.
13 Jim Beets, "Declines in Finfish Resources in Tarawa Lagoon, Kiribati, Emphasize the Need for Increased Conservation Effort," *Atoll Research Bulletin* 490 (2001): 1–14.; Stuart A. Sandin et al., "Baselines and Degradation of Coral Reefs in the Northern Line Islands," *PloS One* 3(2010): e1548.; Sandin, 2008)
14 R.E. Johannes and Being Yeeting, "I-Kiribati Knowledge and Management of Tarawa's Lagoon Resources," *Atoll Research Bulletin* 489 (2001): 1–24.

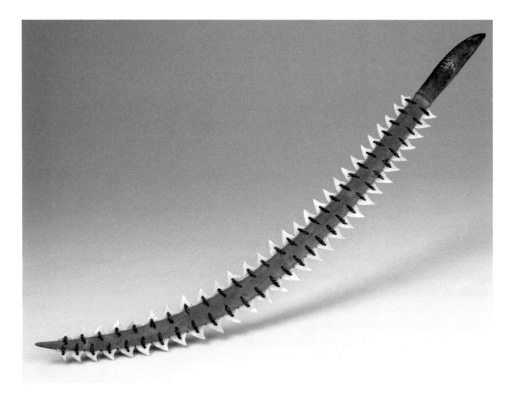

Figure 10.2 Kiribati shark-tooth weapon. American Museum of Natural History, New York, Anthropology Division, St/1277. See Plate 8.

Collections held in natural history museums represent biodiversity time capsules, recording a species' presence at a specific latitude, longitude and time. Because of this spatial and temporal specificity, collections can be used to examine changes in biodiversity across both time and space, and they provide researchers the opportunity to address ecological questions about processes occurring beyond the timescale of an individual researcher.[15] Their value is especially poignant when the items in the collections can no longer be found outside museums, as is sadly evidenced by the Tasmanian Thylacine.[16]

Yet these collections have something to tell us about the future as well. We can be proactive in building our collections by targeting areas that we know are facing immediate pressure. The Gilbert Islands are just such an area. These low lying atolls are facing the dual threat of sea level rise and ocean acidification, which could infiltrate the freshwater table on

15 Joshua Drew, "The Role of Natural History Institutions and Bioinformatics in Conservation Biology," *Conservation Biology* 25 (2011): 1250–1252.
16 Kathryn Medlock, "The Thylacine Trade" (paper presented at the Collecting the Future: Museums, Communities and Climate Change Conference, American Museum of Natural History, New York, New York, October 4, 2013).
17 Natasha Kuruppu and Diana Liverman, "Mental Preparation For Climate Adaptation: The Role of Cognition and Culture in Enhancing Adaptive Capacity of Water Management in Kiribati," *Global Environmental Change* 21 (2011): 657–669.

the islands[17] and dissolve away life on the reefs.[18] Given the threats facing this region we should prioritize large-scale coupled biological and cultural diversity to preemptively record what is almost certain to be lost or changed, as well as understanding the cultural conditions which may lead towards adaptation.[19]

The strength of these preemptive collections would be to record the linkages between culture and the reef, which would serve as a snapshot of how the Gilbertese culture existed as it stood on the precipice of a potentially environmentally mediated diaspora. Given the large-scale cultural and biological repercussions that climate change will bring to these environments making these collections, and curating them in an accessible fashion, will provide a unique link to a way of life. We do not want to lock culture in a static representation, but preemptive collections could serve as reflexive historical examples to show future Gilbertese Islanders of how the current generation dealt with environmental perturbation never previously experienced in their culture's history.

18 Ruben Van Hooidonk *et al.*, "Opposite Latitudinal Gradients In Projected Ocean Acification and Bleaching Impacts on Coral Reefs," *Global Change Biology* 20 (2014).
19 Kuruppu and Liverman, "Mental Preparation for Climate Adaptation," 657–669.

PART II
Reinventing nature and culture

Figure II.1 Abandoned vehicles in a winter forest: A Swiss *Autofriedhof* slowly subsides in the leaf litter, 2007. Photo: Alison Pouliot. See Plate 9.

11

TOWARDS AN ECOLOGICAL MUSEOLOGY

Responding to the animal-objects of the Australian Institute of Anatomy collection

Kirsten Wehner

> Somehow, one needs to vivify, to leap across imaginative realms, to connect, to empathise, to be addressed and brought into gratitude.
>
> *Deborah Bird-Rose*[1]

In Australia, where I live, the summer of 2012–13 was hot. Despite a weak to neutral La Niñã system, which usually produces cooler conditions, temperatures soared, an intense heat wave affected 70 percent of the country, and the hottest day ever for the entire continent was recorded. As we all became inured to the evening television news leading with images of violent bushfires consuming tinder dry bush and coating the landscape with smoke, the Climate Commission, then a government-funded independent expert body, dubbed the season the "Angry Summer."[2]

As certain politicians like to remind us, one year's unusual weather pattern, or even several particularly intense fire events, do not demonstrate climate change. But viewed against the evidence of many long years of data collection and analysis, it now seems incontrovertible that the Angry Summer was merely an instalment in an on-going process of climate change that will render my home hotter and drier; threatening water supplies, reducing the range and productivity of agricultural land, and shifting forever the conditions, and the possibility, of life for the continent's people, plants and animals.

1 Deborah Bird-Rose, "Val Plumwood's Philosophical Animism: attentive interactions in the sentient world," *Environmental Humanities* 3 (2013): 106.
2 For a discussion of the extreme temperatures of the 2012–13 Australian summer as evidence of anthropogenic climate change, see Sophie Lewis and David Karoly, "Anthropogenic contributions to Australia's record summer temperatures of 2013," *Geophysical Research Letters*, vol. 40, issue 14, pages 3705–3709, 28 July 2013. The Climate Commission was a Commonwealth government funded body established in 2011 to provide expert information to the Australian public about climate change. The in-coming government abolished the commission in 2013 and the Climate Council, a non-profit organization with similar aims to the commission but funded through public donation, was launched shortly afterwards. The council's report on the 2013–14 summer, authored by Will Steffen, was also titled "Angry Summer," available at: www.climatecouncil.org.au/angry-summer (accessed 16 March 2015). Subsequent reports document that summer temperatures since 2012-13 have continued to rise.

Monday to Friday during that summer I went in as usual to work at the National Museum of Australia, startled for a moment each morning by the disjunction between the promise of another baking day outside and the air-conditioned comfort of the building. At the time, my curatorial colleagues Martha Sear and Elizabeth Knox and I had recently finished working on the refurbishment of an exhibit featuring the Australian Institute of Anatomy collection. This collection is one of the National Museum's oldest holdings, comprising thousands of faunal specimens such as bodies and body parts preserved in fluid, taxidermy, skeletal material and illustrations. As is often the way at the end of a project, I was delighted that the new exhibit was open and over those summer months I often wandered down to the gallery to stand in front of it. I was drawn again and again to look, in particular, at the series of "wet specimens" we'd positioned as the central element of the display.

Each time, as I stood in the quiet, cool dimness gazing at these small creatures floating in their liquid-filled jars, I found myself reflecting on the immanence of their deaths, the fact and moment of their killing expressed forever in their preserved bodies. They became for me peculiarly resonant with the oppressive, smoky heat outside the Museum. I began to wonder whether, or how, the deaths of these animals might be connected to the broader decimation of animal and plant life, and particularly diversity of animal and plant life, that will inevitably result from climate transformation and trajectories of environmental crises, such as habitat loss, that are part and parcel of the life choices producing it.

Yet, despite my meditations tending to questions of death, I found my responses to the animal-objects on display strangely encouraging.[3] For as much as they moved me to feelings of loss and sadness, I was also often struck by their power to lead me to consideration and care. They prompted me to come into relationship with them and their individual lives and further with the species of which they were a part and even further with the whole suite of the non-human world, as well as with the people who had shared their lives and who had brought them with violence but also respect to their present. They asked me to consider how might understand my relationships with them, as objects, individuals, species, animals, and more-than-human beings, and consequently to consider how I was the same as, as well as different from, them. How I might consequently understand my relationships with them. These are questions that recognize the animals' deaths, but that are also expressions of hope, of wondering about my, their and our lives and futures and how we might make them in a climate-changed world.

This chapter springs from my experiences that summer and the series of long conversations about them that I have shared, before and since, with my colleagues at the National

[3] Following a range of writers on taxidermy, in this chapter I refer to the preserved animals and animal parts held in the Australian Institute of Anatomy collection as "animal-objects." My intent is to hint at the way in which they are not wholly either animal or object, but simultaneously encompass some of the qualities of each. I'm particularly interested in rejecting the terms "specimen" and the more historically accurate variation of "anatomical preparation" as, a priori, privileging scientific discourses that occlude object and animal agency, and their relationships with affective responses. My approach is resonant with Rachel Poliquin's use of "animal-thing" to refer to taxidermied animals. See Rachel Poliquin, *The Breathless Zoo: Taxidermy and the cultures of longing* (University Park: Pennsylvania State University Press, 2012) 5.

Museum of Australia.[4] To my mind, the animal-objects of the Australian Institute of Anatomy collection hold considerable potential for generating new stories and sensibilities that may help develop our capacities to respond to climate change, and my aim in this chapter is to tease out some of these possibilities. I am particularly interested in exploring here how these preserved creatures might help us re-shape some of the foundational cultural tenets that have led us to climate change, specifically the Western worldviews that have historically constructed human beings as distinct, separated from and superior to "Nature" and, as such, entitled to dominate and exploit the non-human creatures and forces that comprise it.[5]

Following the lead of environmental philosopher Val Plumwood, among others, I want to ask how the Institute of Anatomy animal-objects might help with what I conceptualize as, in concert with museum theorist Fiona Cameron, the process of "ecologizing" the museum, and, in the current context, the National Museum of Australia in particular. As Cameron suggests, this process entails the development of "different museum ontologies and practices" that "engender new forms of social interaction" between peoples and between humans and non-humans and that "engender respect for various forms of life and inanimate things."[6] Or, as Plumwood might put it, new museum practices that produce ways of being, thinking and acting in the world that position people as integrally part of ecological communities and that conceptualize those communities as comprised of and inhabited by diverse, creative and communicative non-human beings (living and not) whose flourishing is inherently interwoven with our own.[7]

From within a museum, where I work and from where I write, this process of developing "different museum ontologies and practices" is engaged by building curatorial practices through which collections and exhibitions can be re-examined and re-shaped, angled and stretched to open up chinks in existing institutional discourses that divide "Nature" and "Culture." Over time, in any museum, objects and collections become, through successive practices of organization, documentation and exhibition, imbued with certain expectations about the kinds of meanings they can produce. Artifacts collected and exhibited by a technology museum, for example, come to be seen as machines. Ecologizing the museum may consequently depend on disrupting institutional assumptions about the kinds of histories embodied by particular objects.

As anthropologist Nicholas Thomas writes, "the activity and method of museum work was and is profoundly different from that of the academic discipline." Where "the academic project begins with theories and questions that are brought, through research methods, to the analysis of a particular case," the museum worker's "practical project," although shaped by

4 My understanding of the Australian Institute of Anatomy collection, and many of the ideas expressed in this chapter, have emerged through my collaboration over many years with my colleague Martha Sear. I owe her many thanks for her generous contribution of knowledge, experience and creativity. I am also very grateful to George Main, Daniel Oakman and Libby Robin, and my other colleagues in the National Museum of Australia's People and the Environment program, for their conversations about "how we might do ecological museology."
5 Lesley Head and Mark Gibson, "Becoming differently modern: Geographic contributions to a generative climate politics," *Progress in Human Geography* 36 (2012): 699–714.
6 Fiona Cameron, "Ecologizing experimentations: A method and manifesto for composing a post-humanist museum," in *Climate Change and Museum Futures,* ed. Fiona Cameron and Brett Neilson (New York: Routledge, 2015), 28.
7 Val Plumwood, "Nature in the active voice," *Ecological Humanities* 46 (2009): 1–10. Accessed online at www.australianhumanitiesreview.org/archive/Issue-May-2009/plumwood.html, 17 March 2015.

conceptual baggage, "tends to start from, and stop with, the object." Curators certainly "choose" or "select" objects for collection and display, but "these terms imply operations more rational than might be apt." Thomas argues that we should consequently see curatorial engagement with objects as a process of "discovery"—a process involving encounter and distraction, and as a method that is "powerful because it is unpredictable." He writes,

> There are two reasons why "happening upon" things might have methodological potency. The first is that a preparedness to encounter things and consider them amounts to a responsiveness to forms of material evidence beneath or at odds with canonical ethnographies, national histories, reifications of local heritage – and subaltern narratives … Second, [discovery licenses a kind of] eclectic antiquarianism … that throws wide open the questions of history – what, out of all that has happened in the past, are we to remember and consider significant? What presence and what bearing do histories and their residues have in our various lives?[8]

Few scholars have articulated this distinctive character of curatorial work, perhaps because many museums, reflecting their Enlightenment origins and values, and bureaucratic structures, tend to reward performances of rationality and suppress validation of curiosity, instinct and emotion as integral elements of practices of collection and exhibition. Yet, in searching for curatorial practices that can ecologize museums, it may be precisely these kinds of responses that museums need to energize and find means of building into engagements with audiences.

Curatorial engagements with objects that are attentive to experiences of surprise, sadness and serendipity, as well as developing detailed, rigorous analysis of collections, may help unearth the kind of subterranean meanings, resonances and agencies that can fracture the entrenched conceptual frameworks that separate "Nature" from "Culture" and impede the development of more inter-relational understandings. Moreover, if addressing climate change relies, in part, on us establishing new modes of respect for and empathy with non-human beings, a new ethics of care, then I would argue it is productive to both understand how emotional, affective responses shape curatorial engagement with objects and to explore modes for enabling those responses to inform exhibition practice.

In this chapter, I explore these ideas through engaging with a series of curatorial processes that have over time constructed the Australian Institute of Anatomy animal-objects, focusing particularly on how successive interpretive experiments with this collection have proposed—materialized—particular constructions of human relationships with non-humans. I describe some of the ways in which these animal-objects have been understood and used within particular collection and exhibition practices, aiming to draw out how these "moments" have both expressed dominant conceptual frameworks and contested them in ways that might be instructive for an ecological museology. And I speculate on how curatorial practice that embraces emotional responses to these animal-objects might help develop spaces for, even point towards ways to amplify, empathetic and reflexive engagements between museum visitors and these collections.

8 Nicholas Thomas, "The museum as method," *Museum Anthropology* 33 (2010): 6–10.

Mackenzie's menagerie

The Australian Institute of Anatomy collection has its origins in the work of Melbourne orthopedic surgeon William Colin Mackenzie, later Sir Colin Mackenzie, who in the early twentieth century began acquiring and preparing a range of faunal specimens as part of his research in comparative anatomy.[9] Like many scientists of the period, Mackenzie believed deeply in the value of evolutionary hierarchies and was convinced that the description and analysis of the anatomical structures of "lower," less evolved and therefore less complex, animals would help explain the character and development of the bodies of more "advanced" species such as humans. From a medical point-of-view, comparative anatomy revealed the array of nature's solutions to the functional challenges of life, bringing the specific qualities of the human body into scientific focus while also potentially suggesting ideas about how to address therapeutically the body's shortcomings, such as might be generated through disease.

Mackenzie was particularly interested in Australian native species, reflecting his belief that the continent's monotremes and marsupials were more primitive than placental mammals of the Northern Hemisphere. He saw the Australian biosphere as an evolutionary backwater, its inhabitants "mediaeval types" who had only survived into the twentieth century by virtue of the continent's isolation. As such, Mackenzie was convinced that Australia's indigenous fauna was both a unique and invaluable scientific and national resource, and one that was doomed to extinction since native animals were inherently ill equipped to compete with the "modern" species introduced by European settlers. Mackenzie saw preserving native animals' bodies, or prepared parts of their bodies, as ensuring that the information they contained would remain available to science when living examples could no longer be found.

By the 1920s, Mackenzie had amassed thousands of anatomical preparations, including whole and dissected wet specimens, skeletal remains, taxidermy and associated objects such as nests, and had converted part of his house into a laboratory and museum which he called the Australian Institute of Anatomical Research (later the National Museum of Australian Zoology). The collection focused on Australian species, but also included non-native animals, such as horses, sheep, mice, chickens, cows, cats, orangutans and monkeys, and human (including Aboriginal and non-Indigenous) body parts, skulls and bones. Mackenzie also collected individuals with unusual or anomalous features, such as a nine-legged spider and a two-bottomed piglet, reflecting his interest in defining and explaining what was "normal."

Mackenzie donated his collection to the Australian federal government in 1923, together with a substantial financial gift designed to support the construction of a purpose-built storage, research and display facility. Seven years later, the Australian Institute of Anatomy duly opened in Canberra, Australia's national capital, with Mackenzie as foundation director. In the following decades, despite Mackenzie retiring in 1937 and his death the following year, the Institute continued to expand, acquiring several highly significant zoological collections, such as Henry (Harry) Burrell's platypus specimens and research materials, as well as a range of anthropological material, including Aboriginal remains and stone tools excavated by farmer and collector George Murray Black from burial mounds along the Murray River. By

[9] My summary here of the history of the Australian Institute of Anatomy draws strongly on Libby Robin, "A Report of the historical, cultural and biological significance of the National Historical Collection's MacKenzie Wet Specimens," Consultancy for the National Museum of Australia, May–June 2005, 1–21, and Martha Sear, "Stilled lives," *The Museum* 4 (2013–2014): 14–19.

the 1950s, the Institute had also come to care for a number of large Commonwealth government collections, principally ethnographic material and artworks acquired by anthropologists and administrators working in northern Australia and Papua New Guinea.

The Australian Institute of Anatomy, with its collections deteriorating significantly, closed in 1984 and its holdings were transferred to the National Museum of Australia, becoming one of that institution's founding acquisitions. The National Museum is mandated to acquire, preserve, research and interpret material relating to the history and culture of Australia. In the institution's establishing legislation this "history of Australia" is defined as including the continent's "natural history," that is, non-human history, as well as its Indigenous and non-Indigenous human history. Indeed "the history of the interaction of man with the Australian natural environment" was described during this period as one of, if not the, institution's core themes.

Since concerted planning began for the National Museum in the early 1980s, however, powerful stakeholders have tended to frame the institution as a "social history" museum that, reflecting broader shifts in Australian historiography and museology of that time, should aim to create cultural narratives characterized by the inclusion of the diverse social fractions of the nation-state. This overall thrust has meant that, although some Museum staff and stakeholders have consistently championed the importance of addressing and exploring human-environment interactions, non-human Australia has occupied a relatively minor note in the institution's overall interpretive program. Where the non-human world has figured, the Museum has tended to frame it in terms of how people have perceived and used its constituents, or been acted upon by environmental forces, rather than, for example, exploring non-humans' lives, experiences and agencies in and of themselves, or in the sense of tracing human embeddedness in webs of ecological inter-relationships.[10]

Given the National Museum's museological trajectory, it is perhaps not surprising that the Australian Institute of Anatomy collections have settled rather unevenly into its milieu. The Institute's ethnographic holdings, for example, have meshed well with the Museum's deep interest in documenting the diversity of Aboriginal and Torres Strait Islander cultures and perhaps almost as well with the institution's commitment to moving these peoples to the center of national narratives. The Institute's holdings of Aboriginal remains have become the subject of an extensive repatriation program. In contrast, the Institute of Anatomy's non-human collections, Mackenzie's and his successors' faunal specimens, have remained relatively marginal to the Museum's identity. To date, for example, the Museum has never developed a significant temporary exhibition focused on this foundational collection, and only a small number of animal-objects have ever been displayed at all.

As Libby Robin has written, it is probable that Mackenzie's menagerie made it to the National Museum only because, by the time the Institute of Anatomy closed in 1984, these animal-objects were no longer seen as valuable zoological or medical resources.[11] Mackenzie's passion for comparative anatomy had fallen well out of fashion, and the specimens he and those who followed him had created had become historical oddities. Since then,

10 For a discussion of the museological history of the National Museum of Australia and the development of its opening exhibitions see Kirsten Wehner, "Exhibiting Australia: Negotiating national identities at the National Museum of Australia" (Unpublished PhD thesis, New York University, 2007).

11 Libby Robin, "Weird and wonderful: The first objects of the National Historical Collection," *Recollections: Journal of the National Museum of Australia* 1 (2006): 115–129.

discursive frameworks that might have helped make new sense of the collection, such as histories of medicine and science, have failed to find significant spaces in a museum focused on social history, and it is perhaps fair to say that the Museum's curators have often been left essentially perplexed about what to do with the Institute's animal-objects.

Towards the cultural center

As I described in the introduction to this chapter, it is now widely understood that climate change is, at its foundations, the outcome of Western worldviews that position humans, or "Culture," as distinct and separate from and superior to non-humans, or "Nature." Addressing this disjunction requires new ecological museum practices that "engender respect for other things, plants and animals through attributing personhood to nonhumans, and by inducting them into civic life as part of an interrelated social system."[12] At first glance, it has to be said, the Australian Institute of Anatomy animal-objects do not seem very promising material through which to respond to this call to action. In many ways, the collection embodies and finds its rationale in human assumptions about our right to exploit the non-human world for our own ends, and the preparation and display of the animals' bodies as specimens can be seen as reproducing the unequal power relations that legitimated the killing of these creatures in the first place.

Colin Mackenzie's interest in developing the Australian Institute of Anatomy collection was deeply instrumental, arising as part of his conviction that the preparation and study of comparative zoology specimens provided information that could be used to improve human health. In the early 1900s, for example, Mackenzie was interested in developing new treatments for the effects of poliomyelitis, also known as infantile paralysis, which was then sweeping through many Australian communities. Many patients were left with weak, withered limbs, and Mackenzie conducted careful dissections of a koala's arm and shoulder in order to understand how the animal could grasp and climb so well, using what he learned to design splints that facilitated the rehabilitation of people's upper-body muscles.

When the Australian Institute of Anatomy opened in Canberra in 1930, Mackenzie voiced his hope that its research program and public displays would demonstrate "the importance of zoology to medical science." His collection was displayed in two large exhibition galleries, where visitors could encounter several thousand skeletons, skins and wet specimens. In many cases, these objects were arranged in evolutionary sequences, demonstrating, for example, the development of certain anatomical features from "lower" life forms such as fish and amphibians, through reptiles and various mammals, to humans, positioned as the apex of evolutionary achievement. Within these trajectories, human remains were conventionally ordered to reveal the supposed hierarchy in the evolution of the "races," with Aboriginal Australians generally positioned as closest to other non-human mammals.

Today, zoologists have rejected the understanding that different animals can be simply arranged in evolutionary hierarchies, focusing instead on how each species has developed to exploit a particular ecological niche and are all, in a sense, equally well or "highly" evolved. The idea that different human "races" either exist in any meaningful biological sense or can be seen to represent an evolutionary progression has also, of course, long been widely

12 Cameron, "Ecologizing experimentations," 27.

discredited. Yet I would argue that the Australian Institute of Anatomy collections and its early configurations have still some interesting things to say to a contemporary museological practice trying to work towards ecological understandings.

First, I think it is worth noting how the Australian Institute of Anatomy resolutely drew non-humans to the center of national narratives. As Mackenzie's choices for the name of his institution—the National Museum of Australian Zoology and the Australian Institute of Anatomy—made clear, he perceived the continent's native fauna as a significant national resource, one of the distinctive capacities through which a young state could contribute to the world's body of scientific knowledge.

Moreover, the Australian Institute of Anatomy promulgated an approach to non-humans that differed significantly from the dominant practices in natural history museums of the time, and since, through Mackenzie's insistence on meaningful inter-connections between the human and non-human worlds. Mackenzie hardly advocated for an understanding of different species as equally, if differently, sentient beings sharing an ecological community, but he did insist on considering how species related to each other (at least within the domain of anatomy). He attended to some of the continuities and differences between humans and non-humans rather than arguing for their radical separation.

To my mind, newspaper accounts and the extant photographs of the Institute of Anatomy exhibition halls suggest that visiting them would have produced an experience of being enclosed by a crowd of different animals, with kangaroos and gorillas adjacent to humans, the mix creating an assertion of equality in tension with the carefully organized evolutionary hierarchies.[13] Perhaps this mix of species reflects, at least in some dimensions, Mackenzie's own complex attitudes to different species, for while he certainly saw humans as, in general, superior to other species, he was also interested in how other species were, in certain particulars, superior to humans. His interest in the koala's shoulder, for example, stemmed precisely from his perception that its upper body was stronger and more able—better built—than that of a human.

These dimensions of the Australian Institute of Anatomy suggest to me that while we might reject Mackenzie's fascination with evolutionary hierarchies and his highly instrumental sense of the value of non-humans, this doesn't necessarily mean that we should completely discount all aspects of the frameworks of knowledge that shaped the animal-objects he created, or indeed turn away from the animal-objects themselves. Indeed, if we attend to how the Australian Institute of Anatomy collection has historically brought non-humans into public view, and how it brings into view their inter-relationships with humans, then we might see the collection as encouraging us to move past the historical tendencies of social history museums to privilege the human world as distinct and exceptional, and the tendencies of natural history museums to focus on the non-human world as a realm apart from human life. These are shifts, I would argue, that are essential to any project of ecologizing museums.

New national narratives

In early 2001, the National Museum of Australia opened its major exhibitions and public programs facility in Canberra, and in the new *Tangled Destinies* gallery the Australian Institute

13 Photographs of the Institute of Anatomy are held at the National Archives of Australia.

Towards an ecological museology 93

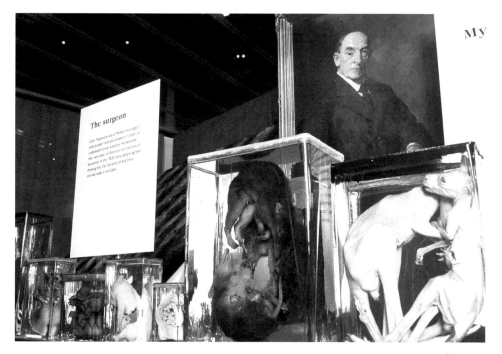

Figure 11.1 The Australian Institute of Anatomy exhibit in the *Tangled Destinies* gallery, National Museum of Australia, 2001. Photo: Kirsten Wehner.

of Anatomy collection, or at least some elements of it, was brought back onto public display after a hiatus of several decades.[14] Just inside the entry to the gallery, a large "island" exhibit featured Harry Burrell's platypus studies and a substantial structure enshrined one of the Australian Institute of Anatomy's Thylacine preparations, marking the marsupial's status as an icon of extinction. Nearby, in a section titled "Biological Cringe," a modest display focused directly on Colin Mackenzie and his work creating the Australian Institute of Anatomy. Mackenzie's portrait gazed out at the visitor, overlooking seven wet specimens of native fauna, with interpretive panels explaining how "The Surgeon," like many British-Australians of his day, had seen local mammals as inferior species who would inevitably be replaced by more advanced introduced varieties as civilization transformed the Australian continent (see Figure 11.2).

The *Tangled Destinies* curators, led by archaeologist Mike Smith, developed the gallery as a broad environmental history of the continent, with the gallery narrative focusing particularly on processes and experiences through which settler European-Australians had responded to the continent's distinctive biota. Reflecting the National Museum's self-definition as a place of social history, this narrative attended especially to people's ideas about Australian environments, with the overall trajectory tracing how settler encounters with, and alteration and accommodation of, the continent's biota had led to a distinctive Australian

14 For a discussion of the *Tangled Destinies* display in the context of national history, see Robin, "Weird and wonderful," 115–129.

society and identity. The opening exhibits, for example, traced European colonists' sense of shock and confusion at animals like the kangaroo and platypus that seemed, to them, incomprehensible. Displays explored these early settlers' attempts to fit local biotas into existing, imported ways of seeing and systems of classification and to remake them in more familiar forms, and then traced the gradual processes through which European-Australians began to recognize and embrace Australia's environmental particularities.

Just as Mackenzie's formation of the Australian Institute of Anatomy collection constructed Australia's fauna as a significant and distinctive national resource, the *Tangled Destinies* exhibits built around the collection asserted that these animals were key to any national cultural narrative. Indeed, the gallery insisted that any understanding of Australian society and identity relied upon an investigation of how the continent's human inhabitants had perceived and responded to its plants and animals, opening at least some room for the idea that human lives were, and implicitly are, interwoven with those of non-humans. After all, it is surely no small gesture for the National Museum of Australia's overall visitor experience in its permanent exhibition galleries to begin with stories about people's engagements with plants and animals.

Moreover, *Tangled Destinies* drew the Australian Institute of Anatomy animal-objects into public view in a particular way. Through telling the story of Mackenzie's and his successors' creation of these animal-objects, the "Biological Cringe" display asked visitors to focus on how this process expressed a certain historically located and culturally produced way of understanding human relationships with animals. This invitation was further developed through the gallery bringing the Institute of Anatomy story into juxtaposition with other exhibits that, for example, explored very different Indigenous understandings of native species, or shifting settler responses.

Through constructing this comparative discourse, *Tangled Destinies* began to show how specific constructions of human-non-human relationships emerge as part of specific historical-cultural formations, revealing them as not in any way natural and inevitable, but as rather malleable and open to reinvention within a more "ecological" mode. *Tangled Destinies,* to my mind, consequently suggested ways of developing our conceptual capacities to re-imagine received understandings of human-non-human relationships, a move surely foundational to the development of any ecological understanding.

Historical particularity and animal agency

In 2011, my colleague Martha Sear and I began discussing a refurbishment of sections of *Tangled Destinies*, by then renamed *Old New Land*, including the "Biological Cringe" display presenting the Australian Institute of Anatomy objects. Our conversations were driven partially by the need to refresh a gallery showing the wear and tear of a decade, but it also reflected our increasing disquiet about some of the ways in which *Tangled Destinies* framed its objects, and particularly the Australian Institute of Anatomy animal-objects.

Martha's and my discomfort with the *Old New Land* Australian Institute of Anatomy display arose, in part, from the way that it interpreted the particular history of Colin Mackenzie's vision for and creation of the institution in terms of the gallery's overall interest in the evolution of a national identity emerging in response to the Australian environment. We struggled, for example, with the fact that the exhibit included only native fauna. This approach resonated with established traditions of using Australian indigenous

animals to symbolize a distinctive national identity, but it sat uncomfortably with Mackenzie's historical practice of bringing native and non-native species (and indeed humans and non-humans) into comparative relationships. Moreover, the interpretation touched only lightly on the genesis of the Australian Institute of Anatomy collection as a comparative anatomy collection designed for medical research, consequently tending to elide the specific cultural context that had provided its *raison d'être*.

To our minds, these characteristics limited the exhibit's ability to engage audiences with Mackenzie's distinctive conceptualization of the relationship between humans and non-humans (and indeed between different kinds of non-human beings), and consequently to relativize our understandings of this relationship. And indeed, interestingly, visitors to *Old New Land* also seemed to be signaling a desire for more information about the Institute's history, often asking for more details about the specific animals on display, including how and why they had been collected, dissected and preserved.

Martha and I also felt that the *Tangled Destinies/Old New Land* exhibit suggested, but did not fully realize, the potential of the Australian Institute of Anatomy objects to engage people thoughtfully and empathetically with the animals they incorporated. As we planned the refurbishment of the exhibit, we spent considerable time with the full Institute collection, exploring the literally thousands of bottled animal bodies arrayed in great tiers in the Museum's stores. These encounters generated in us powerful, often confronting, experiences of wonderment, beauty, loss, revulsion, care, laughter and affection. They created in us both a desire to know more about the animals (individually and as a species) included in the collection and an overwhelming sense of the capacity of these animal-objects to bring us into a greater awareness of ourselves in relation to these "others." In contrast, although the *Old New Land* exhibit drew visitors' attention, despite gallery circulation paths and sightlines that did not necessarily encourage stopping and contemplative looking, people's responses to the animal-objects often seemed relatively fleeting and muted.

As Martha and I began working, together with assistant curator Elizabeth Knox, on re-shaping the Australian Institute of Anatomy exhibit, we consequently became focused on changes that enabled the display to more faithfully and fully communicate the Institute's particular history, providing a stronger context for the items on display and working against the idea that this institution and collection could easily be encompassed by the frame of nation-making. In addition, we searched for ways to allow or, even better, amplify the animal-objects' capacity to generate and shape audiences' affective and empathetic responses to the animals they incorporated. We wanted, in a way, to enable the animal-objects to overwhelm, or at least destabilize, their own historical context through their immanence in the present.

Working within the existing casework, and constrained by a very modest budget, we drew on our own experiences in the Museum's collection stores and began by simply increasing the physical presence of the Institute animal-objects in the gallery. In the original *Tangled Destinies* exhibit, Mackenzie's large color portrait had been the most striking object in the visual field, dominating the modest group of animal-objects. In re-developing the display, we re-located Mackenzie's image, in much smaller scale, onto a modest graphic panel and instead centered the exhibit on thirty-five animal-objects, arranged side-by-side on three long tiered shelves. There was nothing particularly scientific in our choosing this particular number of animal-objects; it just seemed about right in the available space. Thirty-five was not so few that they felt like a token gesture, not so many that they lost their individual identities, and

enough that together they created a physical mass that held its own in the context of the surrounding walls and spaces.

Reflecting Mackenzie's original shaping of the Australian Institute of Anatomy collection, and particularly his interest in cross-species comparison, we developed the new display to include native and non-native species, partially and fully dissected specimens, segmented and complete creatures and "oddities" as well as "types." In accordance with contemporary ethical standards, as well as the National Museum of Australia policies that codify them, however, we did not include any human remains. Martha re-wrote the interpretive text and included images that more fully detailed the history of the Australian Institute of Anatomy, and its practices of collection and exhibition. On the back wall of the display, she also located large-scale reproductions of drawings by the artist Victor Cobb, who worked with Mackenzie to produce illustrations of the Institute specimens. Many of these were eventually published in Mackenzie's *The Comparative Anatomy of Australian Fauna*, which appeared in four volumes in 1918–19.

Martha's, Elizabeth's and my emotional responses to the Institute animal-objects strongly shaped which, of the thousands available, we chose to include in the exhibit. When a particular animal-object captured our attention, when it moved us in some way, we added it to the list for the new display (or at least the long list since, inevitably, we couldn't fit everything we would have liked). The new exhibit consequently included a number of preserved whole animals—a baby wombat, a bat, a lizard—that evoked powerful feelings of loss, care and protectiveness. Some dissected body parts, in contrast, proved persuasively intriguing because of the ways in which they seemed to drift away from their anatomical moorings, with brains and spinal columns becoming eerily evocative of insect bodies and marine creatures. And sometimes, an animal-object evoked a kind of black humor. The spleen of a Tasmanian Devil, a species often characterized in popular culture as irretrievably irascible, for example, proved irresistible as it invited us to both reflect on the idea of the spleen as the anatomical source of irritability and reminded us, as a dissection, of the final ending of this particular Devil's capacity for aggressive behavior.

As we refined the new Australian Institute of Anatomy display, and especially its design, we focused particularly on valorizing the arrayed animal-objects, aiming to signal their significance and interest and, consequently, encourage visitors to pause, contemplate, perhaps admire, and, hopefully, reflect on their understanding of and connection with them. In the original display, for example, the animal-objects had often seemed somewhat orphaned, dwarfed by the surrounding walls, and with lighting that had tended to bleach from them colors and details. In re-developing the display, we instead focused on the animal-objects a soft, warm light, giving the preserving fluid in each jar a characteristic, inviting warm golden "glow" while also enabling visitors to better see the tiny details of each individual animal's form.

We positioned the Institute animal-objects in the center of the exhibit's display field, and sought to minimize visually distracting elements such as object labels by pulling them to the front of the case and positioning them below visitors' sightlines. We aimed to create a direct and uninterrupted articulation of visitors' bodies to those of the animals on display, in order to encourage visitors' embodied responses and to signal that the animal-objects were the primary carriers of meaning in the display. Moreover, on the rear wall of the exhibit, we displayed those of Victor Cobb's finely detailed illustrations that depicted the specific animal-objects on display, aiming to help visitors learn how to look closely at each animal's body

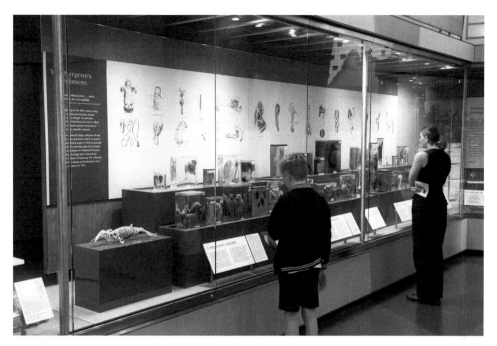

Figure 11.2 Visitors to the *Old New Land* gallery, Natural Museum of Australia, examine the refurbished Australian Institute of Anatomy exhibit, 2013. Photo: George Serras. © National Museum of Australia.

and begin to see and appreciate its complexity, particularity and perhaps its beauty. We aimed, overall, to create an exhibitionary experience that would engage visitors interactively with the material on display, encouraging them to connect together different elements in a way that also drew attention to their own bodies in relation to the animal-objects on show.

Beyond specimen-ness

Over the summer of 2012–13 and on many occasions since, I have loitered in the *Old New Land* gallery near the refreshed Australian Institute of Anatomy exhibit, observing how visitors responded to the display. My observations have been far from systematic and empirically conclusive, but it has been instructive to watch people lingering, looking, uttering apparently involuntary exclamations, "Oooh... Eeew... Yuck... Wow... Beautiful... Sad." Individuals in a group frequently follow each other to gaze at successive objects, with vocalizations often accompanied by people sharing with each other what I interpret as looks of surprise, sorrow and concern. On one day, I watched a mother instinctively edge closer to her son as they stood in front of the case, and then lay her hand on his shoulder. On another day, a man placed a finger gently on the glass of the showcase adjacent to a young wombat's nose, and later flexed his fingers as he looked at the Thylacine paw. His friend twisted his head sideways to align his eyes with the crocodile's gaze.

It's dangerous to assume that relatively brief periods of observation and conversation constitute robust knowledge about visitor responses to the Institute of Anatomy exhibit. My modest research does suggest, however, that visitors are having affective experiences

indicative of reflexive and empathetic engagements with the animal-objects on display.[15] Visitors certainly express, often in a disjointed manner, shock and sadness at seeing the animal-objects, particularly when they have been dismembered and "laid out." However, visitors also hint that they are responding to the animal-objects as signaling life, reminding us of the living animals from which the animals have been made and in which they are, in some sense, still present in the bodies on display. This is perhaps particularly true of the whole specimens, about whom visitors often comment that they look as if they are simply asleep, and towards whom visitors often seem to behave as if they were living animals such as they might encounter, for example, in a zoo.

In re-developing the *Old New Land* gallery's Australian Institute of Anatomy exhibit, Martha and I aimed to encourage a practice of detailed, interrogative looking; a kind of contemplation that enables people to become aware of their own bodies and emotions—their own affective responses—as they engage with the bodies and lives of the animal-objects on display. The Institute animal-objects permit this kind of prolonged, intense looking. Indeed, they permit it in a way that is impossible with living animals, who move restlessly on with their own lives, often frustrating our gaze. It is apparent, however, through my own experience, and perhaps through my observations of visitors, that this looking is not easy. I would suggest that the animal-objects disturb the gaze as much as submit to it. They refuse any simple, unreflexive engagement, producing an emotionally complex, unsettling experience, and inviting me to become aware that "strangeness and ignorance" and "familiarity and knowledge" are inherently simultaneous characteristics of my relations with non-human beings.

To my mind, the Institute animal-objects have proven humbling, provoking awareness of how I am not the inhabitant of some separate realm, but are rather inter-connected, emotionally, anatomically and otherwise, with them. They draw my attention, and perhaps that of other people, to the similarities and differences between my body and theirs, and insist that I ask myself what that means to me and for them. Moreover, I believe that the Institute animal-objects encourage me to think of these inter-connections as extending beyond the boundaries of my life, to the fact, meaning and experiences of my death. As such, they encourage me to find modes of ecological understanding; modes grounded in a deep awareness of the ways in which all our lives, human and non-human, interweave with the deaths of those with whom we share communities.

Towards a climate-changed future

Every process of collection and exhibition making is essentially an interpretive experiment; the "trying-out" of a series of ideas about how to create meaning through arranging a set of material elements in ways that draw people into particular kinds of conversations. Through this chapter, I've attempted to delineate how a series of interpretive efforts focused on the animal-objects—the "wet specimens," as they're often known—of the Australian Institute of Anatomy collection can be understood as suggesting more ecologized museological

15 Extensive research on visitor responses to the Institute of Anatomy exhibit has not been undertaken. Conventional "summative evaluation" techniques that rely on visitors describing the character of their experience may not capture visitors' embodied and emotional, primarily non-linguistic, responses.

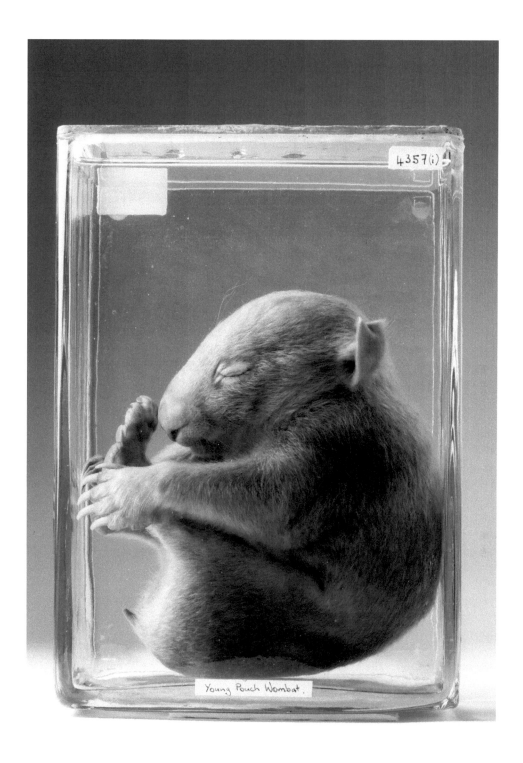

Figure 11.3 Preserved young pouch wombat, about 1920, Australian Institute of Anatomy collection, National Museum of Australia. Photo: George Serras. © National Museum of Australia. See Plate 10.

practices. I've focused in particular on how different modes of exhibiting these animal-objects have engaged projects of, on the one hand, historicizing particular constructions of human–non-human relationships, consequently articulating them in a way that makes them available for cultural re-imagining and, on the other hand, enabling the capacities of these animal-objects to evoke in people empathetic responses that in some significant way problematize and even explode these objects' historical constructions.

Since the summer of 2012–3, with which I began this chapter, my thinking about the Australian Institute of Anatomy objects has turned increasingly to new interpretive processes that might link them more strongly with contemporary and future contexts of climate change and associated events such as species extinction and increasing social injustice. What would it mean, for example, to create a massed display of many hundreds of these animal-objects, an array of different species, huddled cheek by jowl, or appendix by brain? Would this exhibit disrupt received ideas about the natural order of things, producing a kind of anti-taxonomy that insists that, in a climate-changed world, there is no settled order? How would visitors' responses be shaped if this overwhelming display were designed to echo the experience of a shrine, or a laboratory, or a forest?

Or should I attempt to overcome Colin Mackenzie's historical lack of interest, reflecting his focus on functional anatomy, in documenting his specimens' species, location, date or habitat of collection? Such lack of information makes it difficult to explore the Institute of Anatomy animal-objects in terms of scientific ecology, that is, in terms of each animal's role in an ecological system. It makes it almost impossible to trace anything about the lives of these animals as individuals. Yet, as I think about climate change, it seems to me imperative to reconnect the Institute animal-objects back to their living brothers and sisters, where they still exist, or at least to their longer species histories, where they no longer tread the Earth. And so I find myself delving into records to try to learn the histories of specific animal-objects, talking with zoologists who can help identify their species and sub-species and thinking about what would happen if the next exhibitionary iteration of the Institute of Anatomy collection brought together its sequence of platypus embryos, with for example, video footage of platypuses foraging in a river in southern New South Wales and a story about how the local community are trying to protect their habitat.[16]

Collections constitute an inheritance, one that embodies older structures of knowledge but that also holds great potential to disrupt disciplinary boundaries and established modes of thinking and acting in ways that open up space for new ecological and empathetic understandings. If we are to build communities' capacities to respond to climate change, if we are to re-think what it means to be human in terms of ecological community, then we may need to not only explore collections such as the Australian Institute of Anatomy animal-objects in all their registers—historical, cultural, scientific, affective—but also begin to imagine new registers that map across these conceptual and experiential boundaries.

16 See Libby Robin, "Dead museum animals: Natural order or cultural chaos," *reCollections: A Journal of Museums and Collections* 4 (2006), for a discussion of some contemporary museum responses to "dead animal" collections.

12
OBJECT IN VIEW

Harry Clarke's high-wheeler bicycle

Daniel Oakman

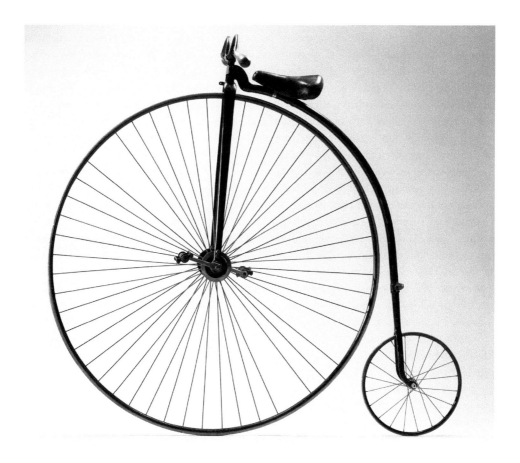

Figure 12.1 English-made "Cogent" penny-farthing bicycle belonging to Harry Clarke, 1884. National Museum of Australia. Photo: George Serras. © National Museum of Australia. See Plate 11.

In 1983, Harry Clarke, an engineer and former professional cyclist, attended an antiques auction in Melbourne, Australia. There, he purchased a bicycle that would shape the rest of his life, an 1884 English-made "Cogent" high-wheeler, also known as a penny-farthing. He named it "*Black Bess*." Once Clarke had learned to ride his new bike – a process that involved numerous spills – he competed in the National Penny-Farthing Championships in Evandale, Tasmania, winning the relay event in his first race. For the next two decades, Clarke attended the annual Evandale vintage bicycle festival, winning the veterans' category over several years.

Not content to master the high-wheeler over a short distance, Clarke set out to reenact one the great overland journeys undertaken by penny-farthing. In 1988, as President of the Vintage Cycle Club of Victoria, he joined with 23 other cycling enthusiasts to mark the centenary of the round the world journey made by Melbourne penny-farthing riders George Burston and Harry Stokes. Celebrations included a partial re-enactment of their adventures, with the group spending two weeks riding from Melbourne to Sydney on their penny-farthings (a distance of some 1,000 kilometers/621 miles), following the original route where it still existed.

Invented in England, high-wheelers spread across the world in the 1870s. They represented a significant technological advance in bicycle design, with rubber tires and a large front wheel making them more comfortable and faster than the primitive, if popular, iron and wooden wheeled "boneshaker" velocipedes. High-wheelers, however, like the velocipede, lacked the chain and cogs now widely used in bicycles to amplify the rider's effort. A single turn of the pedals produced only one revolution of the front driving wheel, so the only way to go faster was to make the driving wheel larger. However, this also made the bicycle heavier, and as bicycle makers responded to a demand for speed by increasing the size of the front wheel, they also decreased the size of the rear wheel to save weight. The resulting stark difference in wheel size reminded people of the British penny and the much smaller farthing (quarter-penny), giving rise to the name "penny-farthing."

Penny-farthings were difficult and dangerous to ride, but they grew quickly in popularity, especially among athletic young men, introducing people to the speed, excitement and potential of the bicycle. For the first time in history, a person moving under their own power could sustain speeds of between 15 and 25 kilometers an hour, about the same speed as a trotting horse. And while travelling while seated at nearly 2 meters off the ground is astonishing to the modern perspective, it would have been less confronting to a generation accustomed to riding horses.

Movement is an essential component of being human, but how we move and the objects we use to achieve locomotion are not somehow "natural." Rather, the ways in which humans, in concert with their objects, interact with and move in their surrounds emerge through a complex interplay of cultural, historical, technological and environmental factors. Each relationship between human and machine is distinctive, enabling and requiring certain things of people's bodies and opening them up to particular kinds of interactions with their environment. As Luis Vivanco has argued, riding a bike is a "relationship, even a temporal fusion or assemblage, between human and machine that is distinctive from other vehicles."[1] Every kind of bicycle has the potential for fostering a particular sensory knowledge of the world. From this perspective, we might see riders mounted on a high-wheeler less as a

1 Luis A. Vivanco, *Reconsidering the Bicycle: An Anthropological Perspective on a New (Old) Thing* (New York: Routledge, 2013): 11–12.

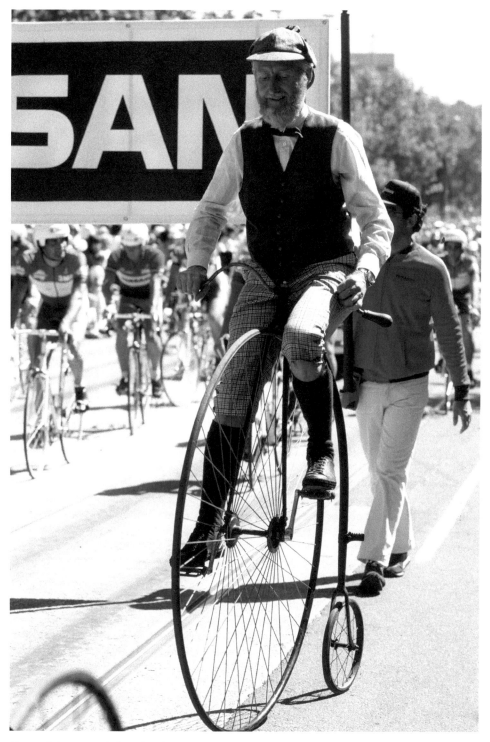

Figure 12.2 Harry Clarke riding his penny-farthing, "Black Bess," in the Melbourne Moomba Parade, 1984. Photo: Rennie Ellis, State Library of Victoria.

curiosity of Victorian-era ingenuity, and more as a symbol of what made riding this distinctive machine so different, exciting and alarming in the 1870s and 1880s. The high-wheeler rider's extreme position seems unusual, even comical, to the modern eye, but this also means that it can highlight the cultural and historical construction of mobility and help us understand the role of human-powered mobility in our own cultures.

As it became established as a widely used form of transport, the bicycle – in its myriad forms – altered understandings of the human body as a source of power and locomotion. Nineteenth-century social reformers, religious leaders, suffragists and eugenicists all embraced the bicycle as a conduit to a more vital, healthy and disciplined lifestyle. In a literal sense, the bike quickened the pace of modern life and human physiology. Exercise, toned muscles, raised heart rates and expanded chests all created a palpable sense that the bike was a vital dimension of modern life that could also serve as an antidote to the ills, such as physical inactivity, urban congestion and pollution, that modernity might bring. Today, this vision for the bicycle remains pertinent as societies around the globe wrestle with complex inter-related issues of climate change, sustainability, urban design and public health concerns such as obesity and diabetes.

The penny-farthing records the particular role of the body in transport modes in the nineteenth century. Riders reveled in their physicality and some wrote passionately about their experiences. For Harry Clarke and other vintage bicycle enthusiasts, rediscovering the penny-farthings offered a chance to recapture that sense of wonder at these impressive machines and relive, in performative and embodied ways, the speed and excitement that animated Victorian-era riders and spectators.

Museums can play a role here in presenting the penny-farthing, as well as other bicycles, in ways that foster a deeper understanding of the complex cultural and historical contours that shape how we choose to move and how those choices sustain car dependency and its consequences, such as climate change. It took the invention of the low-slung, chain driven safety bicycle to extend the experiential, sensual and social repercussions of the bike to the majority of the population, but the penny-farthing remains a useful prism through which to think about a range of contemporary health and mobility issues. Indeed, the "extreme" shape of this object might help jolt us into (re)discovering ways of living that activate our bodies and connect us to the corporeal, social and visceral experience of human-powered movement; enlarging our capacity to re-imagine our surrounds and how we move through them in more sustainable ways.

13

FOOD AND WATER EXHIBITIONS AS LENSES ON CLIMATE CHANGE

Eleanor Sterling and Erin Betley

Through participatory dialogue processes, museums can inform communities and visitors about key issues and also equip them with the knowledge to participate in public debates and actions around climate change. Museums and science and technology centers, especially in their communication and education roles, often enjoy high levels of trust by audiences and visitors.[1] The sector therefore has a role to play in supporting the creation and transformation of political and public consensus, enabling visitors to feel increased agency in developing responses from local to global scales to the uncertainties aroused by climate change.[2]

The most powerful museum exhibitions tell stories: text, images, media, and objects combine to weave a narrative that excites the visitors while also imparting sound information. A complex topic such as climate change presents unique challenges for museums: the science can be difficult to grasp, the public debate can be emotional and polarizing, and the implications point to a need for significant changes in individual and societal behavior in the short term while consequences are often displaced across time, and communities. How can exhibitions navigate such a multilayered landscape?

In recent years, there have been several examples of exhibitions centered on climate change. An ongoing exhibition at the Harvard Museum of Natural History, *Climate Change: Our Global Experiment,* presents the scientific study of climate change at a global scale and includes a computer model that allows visitors to simulate courses of action and explore the consequences of their choices.[3] Other museums have taken regional perspectives on the issue: the Yale Peabody Museum of Science has an interactive traveling exhibition that illustrates how climate change is affecting New England,[4] while the University of Alaska

1 Juan F. Salazar, "The Mediations of Climate Change: Museums as Citizens' Media," *Museum and Society* 9 (2011): 123–35.
2 Fiona Cameron and Ann Deslandes, "Museums and Science Centres as Sites for Deliberative Democracy on Climate Change," *Museums and Society* 9 (2011): 136–53.
3 Harvard Museum of Natural History. *Climate Change: Our Global Experiment.* Accessed April 14, 2015. http://hmnh.harvard.edu/climate-change-our-global-experiment
4 Yale Peabody Museum of Natural History. *Seasons of Change.* Accessed April 14, 2015. http://peabody.yale.edu/exhibits/seasons-change

Museum of the North featured a photography-based exhibition, supplemented by media exhibits and animations, on climate change effects in the Arctic.[5] An exhibition of curated artist interpretations of climate change developed by the Cape Farewell art project at the Science Museum's Dana Centre in London has traveled through the UK, US, and China, and had an active presence at the COP21 Climate talks in Paris in December 2015.[6] The MIT Museum at the Massachusetts Institute of Technology used a photographic exhibition to illustrate graphically the effect of glacial melt in the Himalayas.[7]

Some museums have conducted ethnographic research on climate change in their local communities – for example, the Field Museum's *Engaging Chicago Communities in Climate Action (ECCo)* project leverages ethnographic studies and participatory action research and storytelling to identify community engagement platforms and creative models for dialogue with local residents about climate change-related concerns.[8] The Liberty Science Center in New Jersey has tackled the issue of climate change in several ways, exhibiting climate change as a topic in itself, and also addressing it within other exhibitions, like *Energy Quest*, that connect climate change to topics relevant to a visitor's daily life.[9] Basic pedagogical techniques, like focusing on the services provided by energy, such as lighting and cooking, and not "energy" itself, turns attention to the everyday activities of people, locating climate change as not merely a matter of individual choice but also shaped by collective sociotechnical change. Each of these exhibitions and initiatives, among many others, triggers a public dialogue about climate change and its impacts.

As part of the mission of the American Museum of Natural History (AMNH) in New York City, "to discover, interpret, and disseminate—through scientific research and education—knowledge about human cultures, the natural world, and the universe," exhibitions and public programs are designed to foster visitors' informed engagement in topics of critical importance to contemporary society. Over the past several decades we have taken on a series of exhibition topics of concern for society ranging from endangered species and genomics to water stewardship, energy use, and the food system. As part of this series, we tackled the particularly tricky issue of climate change through various exhibitions, public programs, and resources. In 2008, the AMNH dealt directly with this issue by opening a temporary special exhibition, *Climate Change: The Threat to Life and a New Energy Future,* curated by Edmond Mathez of the Department of Earth and Planetary Sciences (see his Object in View, p. 240). Issues of climate change have also indirectly informed the museum's exhibitions featuring stories about food and water, the most basic human needs. In this chapter, we explore how water and food exhibitions have included questions of climate change, through narrative techniques that integrate science and art.

Water: H₂O=Life, a breakthrough exhibition on one of the most pressing environmental issues that society faces today, opened in 2007 at the AMNH and then traveled to many other

5 University of Alaska Museum of the North. *Then and Now: The Changing Arctic Landscape.* Accessed April 14, 2015.
6 "Unfold," Cape Farewell, accessed April 14, 2015. www.capefarewell.com/art/past-projects/unfold.html
7 MIT Museum. *Rivers of Ice: Vanishing Glaciers of the Greater Himalaya.* Accessed April 14, 2015. http://web.mit.edu/museum/exhibitions/rivers-of-ice.html
8 "Engaging Chicago Communities in Climate Action," The Field Museum, accessed April 14, 2015. www.fieldmuseum.org/science/research/area/science-action/communities/engaging-chicago-communities-climate-action
9 "Exhibitions and Experiences," Liberty Science Center, accessed April 14, 2015. http://lsc.org/see-whats-happening/current-exhibitions-and-experiences/

places.[10] From its first showing and ongoing touring, *Water: H₂O=Life* illuminated some of the many challenges related to humanity's sustainable management and use of the life-giving, but finite, resource: water. The exhibition has traveled the world, exploring the many ways that water shapes life on Earth and makes our planet livable. It also suggests actions people can take to help conserve our planet's water. This exhibition was informed by a 2006 AMNH survey that revealed a strong public concern about water, as well as a substantial lack of knowledge, with only 4 percent of respondents, for instance, knowing that of all the world's water, less than 1 percent is readily available for human use.

Our organizing principle for this exhibition centered around the idea that water is essential to the existence and evolution of life on Earth, as well as playing a key role in shaping the face of the planet and in governing climate. Flowing through a vast, continuous cycle, water connects our oceans and atmosphere, deserts and glaciers, rain gutters and rivers. Yet, we also were guided by how water influences human culture, as a powerful force underlying the most basic aspects of our lives. Water resonates at so many levels: its beauty inspires joy and the pleasures of art, poetry and music, while at the same time, abundance or scarcity of water can determine the fate of nations. More than 90 artifacts and models from the AMNH's and other collections highlight diverse cultural and spiritual aspects of water. This includes the role water has played in the rise of civilizations around the world. Throughout the exhibition, visitors are challenged to reconsider the way they view water—to see it not as a limitless resource to be taken for granted, but as the finite and precious resource it truly is. This point is illustrated by a centerpiece sculpture at the entrance of the exhibition. Within a large, dark open space, visitors see and hear individual water drops falling into a lighted pool, emphasizing the beauty and universality, as well as the scarcity and vulnerability, of water.

Water is also an effective lens for exploring the biophysics of climate change. In a section on "The Blue Planet," we address the mysterious properties of water: like few other substances on Earth, water exists as liquid, solid, and gas under everyday temperatures and pressures. A touchable sculpture follows the transformation of water from a frozen ice block to a liquid pool to a mist of water vapor. Given its remarkable ability to absorb and hold heat, liquid water in the form of ocean currents plays a large role in regulating the Earth's climate as warm tropical waters run towards the poles and cold polar waters return to the tropics. We visualize this dynamic process with a narrated, three-dimensional video exhibit called "Science on a Sphere" (Figure 13.1, Plate 12), a 68-inch (1727 mm) globe displaying maps and satellite images of Earth. The exhibit illustrates how water is distributed and used around the world. It describes graphically the ceaseless, flowing cycle of water that goes on all around us every day on the planet's surface, in its depths and in the atmosphere above. Lakes, rivers, and oceans lose water to the air through evaporation. Plants draw water from the soil and return it to the air. Volcanoes release water once locked in rocks deep within the Earth. All that water rises and falls back to Earth as rain or snow. Eventually, it all finds its way back underground and to lakes, rivers, and the sea and the whole cycle then repeats itself. This approach is an example of the use of "eco-visualization," or artwork that dynamically interprets environmental data with custom software to make it meaningful to a museum visitor.[11]

10 American Museum of Natural History. *Water H20-Life*. Accessed April 14, 2015. www.amnh.org/exhibitions/past-exhibitions/water-h20-life
11 Tiffany Holmes, "Eco-visualization: Promoting Environmental Stewardship in the Museum," *The Journal of Museum Education* 32 (2007): 275–85.

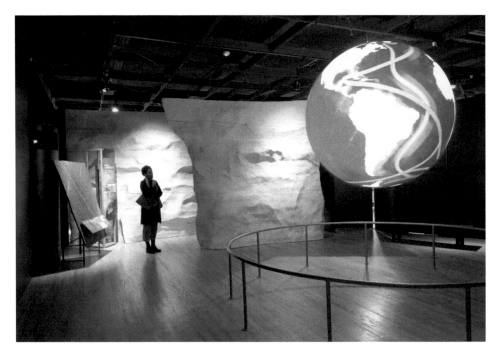

Figure 13.1 "Science on a Sphere" display in the *Water H₂O=Life* exhibition, American Museum of Natural History, 2007. Photo: Denis Finnin. See Plate 12.

As a compelling visual narrative, "Science on a Sphere" engages visitors with the story of water and climate.

A recurrent theme in *Water: H₂O=Life* is how water is crucial to all life on Earth. We explore how humans have put water to work for countless purposes—drinking and cleaning, raising animals and crops, generating power, making paper, and irrigating lawns. Over 70 percent of the world's fresh water is used for agriculture, while 20 percent is used for industrial purposes and household and municipal water use accounts for only about 10 percent. The networks that support such water use, include massive dams, wells, canals, and irrigation ditches. A 1,500-year-old section of clay water pipe from Xoxocotlan, Oaxaca, Mexico (Figure 13.2), illustrates the long history of irrigation, damming, and irrigated agriculture as humans learned to survive in marginal lands. Such changes in water systems both affect, and are affected by, climate change. In a fast-forward to the present, the exhibition examines, through text and photos, the Three Gorges Dam, the world's largest concrete dam, which spans the Yangtze River in south central China. The dam's massive reservoir caused the relocation of more than 1.2 million people and, through the submerging of vegetation under water, the emission of large amounts of methane and carbon dioxide—greenhouse gases that contribute to climate change. Here, we use the contemporary photography of Ed Burtynsky, an artist known for his study of industrial landscapes, to evoke the overwhelming scale of the transformation. Rich, oversized landscape-scale photographs also complement a column filled with medium-grain white rice anchoring an exhibit on the use of water in agriculture, while highlighting how the way we produce our food can in turn be impacted by climate

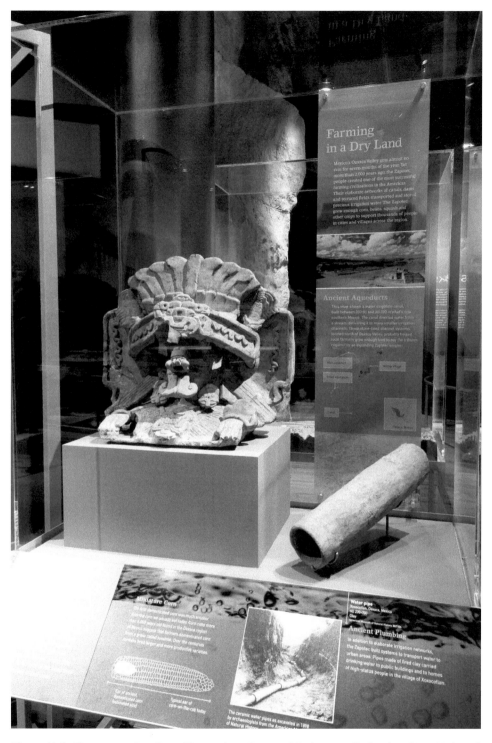

Figure 13.2 Clay water pipe from Xoxocotlan, Oaxaca, Mexico, on display in *Water: H₂O=Life* exhibition, American Museum of Natural History, 2007. Photo: Denis Finnin.

change. In the agricultural powerhouse of California's Central Valley, farmers depend on a vast network of federally funded dams, pumps, and canals and if climate change causes reductions in California's annual rain and snowfall as predicted, growers may be forced to alter the crops they grow to less water-intensive options.

The exhibition explores competing demands for water among all of the Earth's ecosystems and species through the evocative frame of the Arctic polar regions, where climatic shifts are magnified. Water in its solid form is a key element of the emerging climate change story: salt lowers the freezing temperature of water, which means that seawater freezes at about −2.2°C (28°F). At the North and South Poles, temperatures in the winter drop low enough to turn parts of the ocean into solid ice. This "sea ice" freezes and thaws with the seasons and plays a key role in regulating Earth's climate. We explore, using images and text, the dynamics of Arctic Ocean sea ice and global warming. A section titled "Water Everywhere," a diorama of a taxidermied polar bear (*Ursus maritimus*), anchors lessons about the amazing adaptations of bears, seals, birds, and other Arctic creatures for life surrounded by frozen water. The display explains how these animals are adapting anew to an environment with the ice melting earlier in the warmer season, meaning less time to hunt and, for polar bears, less time to build up fat reserves and more tiring swimming required to find prey.

A panel on "A Warming Planet" explains that average temperatures are rising worldwide and humans contribute to greenhouse gas emissions. Ice actually helps fight global warming by reflecting some of the Sun's energy back into space. So the more ice melts, the faster the land and ocean in the Arctic warm up (see also Chapter 17). These complex concepts are reinforced in an interactive audiovisual media display called "Story Blocks," where visitors assemble four-sided blocks with various images into four cohesive stories, including two on polar bears and their dependence on shrinking sea ice. Another story captures the human element of climate change in the Arctic, through an audio presentation of an Inuit man's observations of change:

> There has been a few salmon. It tells us that the weather is getting warmer. It's quite noticeable over the last few years more so than it has been in the 60s ... 50s, 60s ... and even as far as 70s it wasn't this warm. In the last five years or so the land has been eroding quite a bit. The freeze–ups are later. Like last year it must have been a month and a half to two months later, freeze-up. The winds are a lot stronger in the fall – like gale force winds.

With this narrative approach, the exhibition starts to communicate some of the human dimensions of climate change, including indigenous and traditional knowledges. Through this the exhibition opens up spaces for a diversity of understandings of climate change and its impacts.

The exhibition deploys not just words but cultural objects to give material substance to aspects of peoples' relationship with water. In a section titled "Not a Drop," the exhibition explores how people have shown great ingenuity in procuring water in places where it is scarce, including parts of India. Ritual objects on display allow us to discuss the deep connection between the people of India and the great Ganges River. A point about the maintenance of spiritual connections to the gods and goddesses associated with the river is made through two objects. One is a *uddharane* (ritual spoon) of the 1900s, used to illustrate votive images. The other is a brass figure of Annapurna, goddess of food, and consort of Shiva,

who allowed the Ganges to fall to Earth through his hair. The goddess figure would have been used in ceremonies to request blessings or assistance from Annapurna. The narrative of this section explores the deep, ongoing importance of the Ganges as a source of spiritual sustenance, placing it alongside the ongoing diverting and polluting of the river through the industrial, agricultural, and everyday human activities that depend upon it. This is compounded by the fact that today, in dry seasons, the Ganges no longer reaches the sea. Climate change is shrinking the glaciers that feed the river high in the Himalayan mountain chain, contributing to reductions in its flow and exacerbating other threats. In concluding sections called "Healthy Water" and "Restoring Ecosystems," several panels explore the challenges and possible solutions for conserving water, with the Mississippi River Delta wetlands as a case study.

Water: H_2O=Life explores our own role in adapting to and mitigating climate change. The "Water Everywhere" section highlights how Inuit and other Arctic peoples are learning ways to adapt to the warming climate. We felt it was important to provide some answers to what is likely to be a common question for visitors confronting the material on climate change: "what can I do?" The point is made that we all need to use less electricity and fossil fuels, and urge government officials—from the local to the federal level—to help fight climate change by legislating to reduce emissions of greenhouse gases.

Since *Water: H_2O=Life* closed at the AMNH in 2008, it has traveled to nine other locations in the United States and Canada, and seven locations around the world, ranging from Singapore to Australia to the United Arab Emirates to Colombia. Over 1.5 million people have visited the exhibition and many others have viewed its accompanying website. Building on the Museum's long-standing tradition of educating the public about pressing and topical issues, *Water: H_2O=Life* was complemented by a more recent exhibition *Our Global Kitchen: Food, Nature, Culture*, that explores the complex and intricate food systems that bring what we eat from farm to fork.[12]

Our Global Kitchen was exhibited at the AMNH from 2012 to 2013 and has since traveled in the United States, providing another rich lens through which to consider the effects of climate change on our daily lives. This wide-ranging exhibition explores a suite of issues related to our food system, from the role of human ingenuity in shaping food past, present, and future and how food reflects and influences culture and identity, to the environmental impact of the food we eat and the importance of resilient food systems. These topics are introduced using video and images in a large narrated theater experience, designed to embed visitors in the steps of the food system from growing, trading and transporting, and cooking to tasting, eating, and celebrating. Visitors are introduced to the primary role of climate and climate change in each step of the food system, particularly in agriculture and food distribution, as they consider the challenge of feeding a projected nine billion people by 2050.

In a section on growing food, visitors confront climate change in several different contexts. For millennia, farmers have been keen observers of nature and natural cycles, constantly innovating to improve their crops and overcome challenges, creating a rich traditional ecological knowledge base. A model of a seed-saving vessel used by farmers in India, made of clay with a dung stopper, highlights the age-old struggle to select and conserve the best seed from the harvest for the next season. Through seed-saving practices, farmers

12 American Museum of Natural History, *Our Global Kitchen: Food, Nature, Culture*, Accessed April 14, 2015. www.amnh.org/exhibitions/past-exhibitions/our-global-kitchen-food-nature-culture

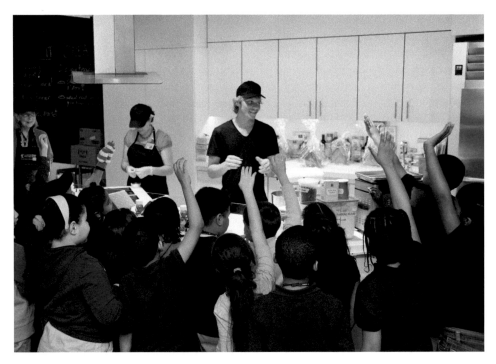

Figure 13.3 The demonstration kitchen in *Our Global Kitchen* exhibition, American Museum of Natural History, 2012–2013. Photo: Denis Finnin.

improve the resilience of their harvest, as plant varieties are selected to adapt to changing climate variability, pests and diseases, and shifting availability of water and nutrients. Questions of biodiversity in livestock are explored in part through Ankole cattle in East Africa. Able to thrive in hot, dry conditions, such cattle require relatively little water and forage. As the global climate warms, conserving resilient livestock and their genetic traits will be crucial to an unpredictable future. This kind of adaptability and need for genetic diversity is a key focus of seed banks, both large and small, around the world. Through text and graphics, the exhibition includes the story of the Global Seed Vault, nestled in underground chambers built into permafrost on the Norwegian island of Svalbard. This facility can store up to 4.5 million seed samples from food crops and their related wild species. Such seeds are already serving as a backup in cases where politics, war, climate change, and other factors cut off access to other seedbanks.

There are many different ways of producing foods, often dependent on the climate, geography, and soils of a particular place, and these ways of growing are constantly changing as humans innovate. In "Ways of Growing," the exhibition explores five different systems of producing food, from subsistence rice farming in Vietnam to urban agriculture in Brazil to large-scale commercial farming in the Midwest of the United States, through innovative "mini-dioramas" that allow visitors to explore a three-dimensional case study along with wall mounted text and images. All of these systems both impact and are impacted by climate change—visitors learn that agriculture is responsible for a third of global greenhouse gas emissions, with the majority of those emissions from the livestock industry.

The advantages of crops that can thrive in areas of climate vulnerability are also explored in a section on "Reshaping our Foods," exploring the little-known story of how humans bred the familiar plants and animals of today from their wild ancestors. In recent decades, farmers and scientists in Africa and elsewhere have been working together to improve the yields of crops like cassava through better pest management and developing cultivars resilient to diseases and pests. These crops are key to the food security of millions. The tuberous roots of the cassava plant yield more food per acre, grow on poorer soils, and need less water than grains like wheat and rice so in places where irrigation is impossible, it is literally a lifesaver. This section also highlights the ways that scientists and farmers are developing more resilient and productive perennial crops that—unlike annuals—develop substantial root systems and stabilize soils. A life-size photo of wheatgrass, with roots several feet long, demonstrates this point.

All around the world, food is exchanged in many ways—among family, friends and neighbors, in stores and markets, in restaurants, between governments and corporations. Humans have been as creative in coming up with ways to trade and transport food as they have in growing, cooking, and eating it. In a section on trading food, visitors consider this next step in the food system, and some of the unexpected ways that our global food economy intersects with climate change. A critical and often-overlooked externality is the pervasive issue of food loss and waste—worldwide, more than 30 percent of the food that is produced is never eaten, wasting all the labor, resources, and greenhouse gas emissions involved in growing the food in the first place. Food loss and waste is explored in depth in a display that includes a text and graphics panel examining various causes for waste and loss in high and lower income countries, along with an accompanying sculpture that convincingly illustrates the over 0.75 ton (750 kg) of food wasted by a typical family of four in the United States every year. This amount represents just consumer waste—even more food is lost on farms and in processing and transportation. Visitors learn that discarded food is the number one source of waste reaching landfills and incinerators in the United States, and methane from decaying food is a significant cause of global warming. For each cause of food loss and waste, the panel explores promising alternatives, from improving food storage, processing, and distribution systems in lower income countries to creating secondary markets and food recovery programs in higher income countries.

In a supporting video "Thoughts on the Future of Food," experts on the food system explore concerns about biotechnology, food security, and climate change. The video explores how we can reduce our vulnerability to climate change through more diversity in our systems, and also to evaluate our need:

> to improve our ability to adapt to climate change. We're going to be facing periods of high heat, we're going to be facing greater floods, more possibilities for droughts and we're going to need crops that can withstand some of these conditions.[13]

Evaluations of both special exhibitions came from interviews with visitors at the exhibition entrances and exits. The results from the *Water H₂O=Life* exhibition were encouraging. A vast majority, 99 percent of respondents, was able to articulate some aspect of the exhibition's

13 "Thoughts on the Future of Food" video, American Museum of Natural History, 2012.

main messages and relate it to their own lives, and over 70 percent realized there was more they could do personally to conserve water as a result of their experience. The exhibition also expanded visitor's views of global water issues, including the connection between water and climate change. When asked what they found most interesting, many people identified specific exhibits or media such as "Science on a Sphere" and the interactive exhibits, while others referred to information that may have been surprising to them, for example, how little fresh water is available for use and how much water is used for agriculture. Overall, visitors indicated that their interest in global water issues increased significantly as a result of their experience. AMNH also surveyed over 200 primary school educators who included the exhibition in their curricula, and they reported that the most useful exhibition elements for teaching were the hands-on interactives.

The AMNH also surveyed museum members and primary educators after a visit to *Our Global Kitchen: Food, Nature, Culture*. Members most enjoyed tasting foods and seeing cooking demonstrations in the interactive working kitchen, and participating in interactive elements of the exhibition such as the touch screens. Of the six main messages in the exhibition, members recalled the following as memorable: "current issues surrounding food such as environmental impacts, sustainability, waste, and science/technology." A little more than half of the respondents thought that the exhibition influenced their thoughts on food, with one member noting that they were struck by "the transportation burden of food. I under appreciated that beforehand: having year round fresh produce expends a lot of energy, to get it here." Educators who incorporated an exhibition visit and/or educational content from the exhibition into their lessons noted that the content in the exhibition linked with topics in their curricula, such as food and agriculture. One educator said that the exhibition "opened the eyes of a lot of students who beforehand had no idea about global food issues." While the results do not allow for a dissection about how well the exhibition captured the salient connections with climate change, the surveys indicate that the AMNH was successful in its mission of fostering an informed and engaged public, aware of the broader societal implications of food systems.

The fundamental, yet accessible and engaging topics anchoring *Water $H_2O=Life$* and *Our Global Kitchen: Food, Nature, Culture* provided an opportunity to link everyday concerns of visitors to emerging critical issues—including the challenge of climate transformation. Museums face numerous contemporary challenges in communicating with diverse visitors on complex and multifaceted issues. In the public domain, empirical studies of fear-inducing climate change representations have shown that while these approaches attract attention to climate change, fear is generally an ineffective tool for motivating engagement.[14] Nonthreatening imagery and content that link to people's everyday emotions and concerns in the context of this issue tend to be the most engaging. In keeping with this understanding about the power of effective communication, the approach of the AMNH was to embed critical content about climate change in a topical matrix, using positive, interactive, and engaging messages, and to spread its message in exhibitions not directly focused on climate change. By fostering informed engagement, the AMNH connects with a new movement within museums focused on facilitating learning, debate, and change in the household and public domains on key societal issues.

14 Saffron O'Neill and Sophie Nicholson-Cole, "Fear Won't Do It: Promoting Positive Engagement with Climate Change through Visual and Iconic Representations," *Science Communication* 30 (2009): 355–79.

14
OBJECT IN VIEW

A stump-jump plough: reframing a national icon

George Main

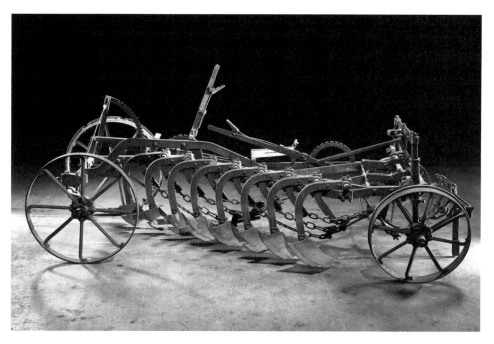

Figure 14.1 Eight-furrow stump-jump mouldboard plough, in use 1940s–50s, National Museum of Australia. Photo: Jason McCarthy. © National Museum of Australia. See Plate 13.

This eight-furrow plough was used throughout the 1940s and 1950s on an experimental station in Canberra, Australia's capital, where the Commonwealth Scientific and Industrial Research Organisation (CSIRO) undertook a range of pasture and crop trials. The plough entered the National Museum of Australia's collection in 1987.

It is a "stump-jump" plough, an Australian invention developed in the 1870s by brothers Richard and Clarence Smith, South Australian farmers. In the Australian colonies, the 1870s was a period of land reform, closer rural settlement, railway expansion and commercial development. Farmers sought new technologies and methods to swiftly transform diverse biological communities, often dominated by eucalyptus trees, into simplified monocultures of imported crop species.

They hastily cleared scrubland, burned what timber they could, then used horses to drag stump-jump ploughs through their new, ashen paddocks, strewn with stumps, roots, and the many stones that characterize the old, shallow soils of Australia. The new plough's great innovation was a linkage mechanism that allowed each individual ploughshare to lift over roots, stumps, and rocks, thereby avoiding damage to horses and equipment.

The stump-jump plough became a national icon, celebrated for its powerful capacity to transcend, to jump over, stumps and stones, the particular characteristics of Australian places, for its powerful ability to overcome natural limitations to export oriented agricultural production. A rough sketch by inventor Clarence Smith of his first stump-jump plough featured in the 2005 exhibition *National Treasures from Australia's Great Libraries*, at the National Library of Australia in Canberra.

Modern, industrial desires to overcome natural, ecological constraints drove the imposition of European agricultural systems onto Australian terrain. Since the emergence of agricultural science late in the nineteenth century, a belief that humans could defy natural limits and boost primary production through the simplification and strident transformation of local ecologies defined the discipline. "No one argued that we should accept this poor, old continent for what it was," remembered agricultural scientist David Smith. "It was ours to improve, to manage. We were to take what was and use our knowledge to make gain for our nation and humanity."[1]

Agricultural scientists and technologists rejected the idea of adapting to local conditions. They cast the natural characteristics of rural Australia as problematic barriers to production. "The history of Australian agriculture," agricultural economist Bruce Davidson wrote in 1985, "is largely a story of developing new technologies to overcome problems as they arise." According to Davidson, limits to development included those "caused by the physical environment," by the natural realities of the land. The application of industrial power across rural terrains defined modern strategies of primary production. Agricultural science had become "a world force," declared the chief of the Division of Plant Industry at CSIRO in 1962, helping "to conquer the earth for man's use."

Industrial agriculture, observes Vandana Shiva, is "based on the assumption that technology is a superior substitute for nature, and hence a means of producing limitless growth, unconstrained by nature's limits." Perceptions of nature "as a source of scarcity," she continues, "and technology as a source of abundance, leads to the creation of technologies which create new scarcities in nature through ecological destruction."[2]

The erasure of indigenous biological communities held devastating consequences for land and climate. Such efforts induced unprecedented erosion events, and transferred immense

[1] David F. Smith, *Natural Gain in the Grazing Lands of Southern Australia* (Sydney: UNSW Press, 2000): 201–205.

[2] Vandana Shiva, *The Violence of the Green Revolution: Third World Agriculture, Ecology and Politics* (London: Zen Books, 1991): 24.

volumes of carbon from Australian soils into the global atmosphere. Since 1850, the conversion of grasslands and forests into farmland has delivered 44 billion tons of carbon into the air, representing one-tenth of anthropogenic carbon emissions.

The biologically diverse, complex ecologies of temperate Australia, transformed into regular patchworks of rectangular paddocks, groomed and uniform, are now subject to ever hotter and drier droughts, ever more destructive storms and floods. "[T]he Enlightenment project," wrote Nigel Clark, "the quest to impose order and intelligibility on the world—has ultimately exacerbated the very uncertainty it sought to abolish."[3]

Informed by scientific understandings of climate change and its historical foundations, possibilities exist to reinterpret the stump-jump plough and its history, to reveal and help undermine cultural processes that generate climatic and ecological disorder. The stump-jump plough held by the National Museum of Australia was originally owned and operated by the CSIRO's Division of Plant Industry, part of a national institution that served the needs of Australian agriculture, an industrial sector that generated food and fiber for people across the continent and around the globe.

What opportunities for understanding might arise if the plough is re-framed in local rather than national terms? In a project called *Food Stories*, the National Museum of Australia is enabling understandings of this object within a local history of food systems.[4] After the Canberra experimental station run by the Division of Plant Industry closed in 1965, brick homes and bitumen streets were constructed across the paddocks once turned by this plough.

The *Food Stories* project draws links between the scientific trials undertaken on the experimental farm, the long established food systems of the Indigenous Ngunnawal people, and the kitchen gardening activities practiced today at a local primary school. As children hear stories about the plough in their schoolrooms, as they see plants growing in their home gardens and fall asleep above earth once turned by its ploughshares, will their imaginations be stimulated to "inhabit the breathing Earth once again," in the words of ecophenomenologist David Abram? Will they find themselves back inside the same world that kangaroos and magpies inhabit, with new powers to notice and respond to the great changes unfolding around them?[5]

3 Nigel Clark, "Wild Life: Ferality and the Frontier with Chaos," in *Quicksands: Foundational Histories in Australia and Aotearoa New Zealand*, ed. Klaus Neumann, Nicholas Thomas, and Hilary Ericksen (Sydney: UNSW Press, 1999): 145.
4 *Food Stories*, National Museum of Australia, www.nma.gov.au/food_stories. See also Chapter 8.
5 David Abram, "Storytelling and Wonder," *Encyclopedia of Religion and Nature* 1 (London: Thoemmes, 2005): 1603.

15

TELLING TORRES STRAIT HISTORY THROUGH TURTLE

Leah Lui-Chivizhe

Marine turtles are cold-blooded reptiles slow moving on land, but in the water they glide effortlessly. Using their forelimbs for thrust and rear limbs as a rudder, they navigate seasonal winds and crisscrossed currents to take themselves thousands of kilometers across oceans. Like their distant cousin the crocodile, they move between the land and the water. But unlike their cousin, their time on land is generally restricted to the sandy beaches where mature female turtles go to lay their eggs. Invariably, it is on the beaches where they first entered the ocean as hatchlings that female green turtles return to lumber up the beach and excavate a nesting pit to lay their clutch of eggs. In their only vaguely parental gesture they brush sand over the newly laid eggs before trudging back to the sea.

For the next two to three months the females stay in nearby shallow waters feeding, mating and returning every two or so weeks to lay further clutches. Under the right conditions, the eggs hatch. At peril from predators from sky and sea, dozens of tiny hatchlings scuttle into the water and head into the open ocean. There they will spend the "lost years," ten to twenty years foraging and growing in the open ocean before returning to coastal zones to feed, mate and nest, continuing the cycle that has taken place for millennia.

In the Torres Strait, due to seasonal winds and the ocean currents that surge through this narrow passage, marine turtles and Islanders have been a part of each other's existence for a very long time. Of the seven identified species of sea turtle in the world, six are known to either breed or migrate through the Torres Strait, and Islanders chart their seasonal movements. As the winds of Sager (the Southeasterly trade winds), transition to Naigai (the doldrums), mature turtles return to the region to mate. The period of mating is known to Islanders as *surlal* or *surwal*. By Kuki (the early NW monsoons) hundreds of hatchlings are taking to the ocean.

The relationship Islanders have with marine turtles can also be measured through archaeological evidence, which has provided chronologies of human occupation of the region along with insights into environmental changes and subsistence practices.[1] Archaeological

1 Joe Crouch *et al.*, "Berberass: Marine Resource Specialisation and Environmental Change in Torres Strait During the Last 4000 Years," *Archaeology of Oceania* 42 (2007): 49–64; Duncan Wright, "Mid Holocene Maritime Economy in the Western Torres Strait," *Archaeology of Oceania* 46 (2011): 23–47.

investigations on the western island of Mabuiag and on the Mer islands in the east have shown the longevity of Islanders' reliance on marine resources. At an excavation site at Dabangai, a settlement on the north east coast of Mabuaig associated with the Goemulgaw clan, occupation involving marine based subsistence was dated to the mid-Holocene period ranging 7180–4960 cal BP.[2] While in the eastern Torres Strait the archaeological examination of marine and terrestrial faunal use by Islanders at two sites on Dauar, found the use of turtle coincided with the occupation of the islands 2600 cal BP.[3]

Islanders' own histories of deep time resonate with these findings and evidence how the social and cultural lives of Islanders were enriched by physical and spiritual relationships between Islanders and turtles. Islanders are maritime people, and the sea, with all its temperaments and treasures, is interwoven into the subsistence and cultural fabric of Islanders' lives. Turtles are a significant item in the region and Islanders have hunted two marine turtle species extensively: the green turtle (*Chelonia mydas*) and the hawksbill (*Eretmochlys imbricata*).

The longevity of Islander use of turtle facilitated the development of a rich bank of knowledge on turtle and turtle ecology, and particular taxonomies exist in the two languages of the region. In Meriam Mir, the language of eastern Islanders, the green turtle is *nam*. In the western islands' language of Kalaw Lagaw Ya, the green turtle is *waru*. In the eastern islands the hawksbill turtle was generally called "shell turtle," and was distinguished by its size and quality of its shell: the large hawksbill was called *olai* and the small, *baug*. The strongest shell was called *karar* and the inferior, *kasoor*. Meriam le also named three varieties of green turtle based on their size and age: along with *nam*, green turtle without shell was *on*, and *mergie* the young green turtle.[4]

In the 1970s it was recorded that of all marine fauna, it was turtle and dugong that Islanders described with the utmost precision. Western Islanders distinguished between 13 varieties of green turtle "based on size, sex, age, color, habitat, agility and appearance and taste of the animal's fat."[5] Islanders selected *kapu waru* (good turtle) over *gatau waru* (dry turtle); *gatau waru* are sedentary, staying close to reefs they eat a type of algae that makes their fat black and unpalatable. Good turtle is often female and fat, and they are usually in this condition during the mating season, known throughout the Torres Strait as *surlal* or *surwal*.[6] The *surlal* season generally occurs from September through to October. During this time turtles are plentiful and locating a suitable turtle is made simpler as, along with their need to surface to take in oxygen, their mating habits involve many hours of coupling, and can render them utterly oblivious to the threat of hunters.

There are numerous Islander ceremonies associated with preparations for tracking and hunting, butchering and sharing the meat of the green turtle. Most of these ceremonies fall within the domain of men. While as a general rule women do not hunt, various historical accounts indicate that women played a range of roles prior to hunting expeditions and once

2 Wright, "Mid Holocene Maritime Economy."
3 Melissa Carter, "North of the Cape and South of the Fly: The Archaeology of Settlement and Subsistence on the Murray Islands, Eastern Torres Strait" (PhD diss., James Cook University, 2004): 319.
4 William MacFarlane, Papers, diaries and journals. Anthropological notes, Book 14, 1925, AIATSIS, Canberra. MS 2616/1
5 Bernard Neistchmann, "Traditional Sea Territories, Resources and Rights in Torres Strait," in *A Sea of Small Boats*, ed. John Cordell (Cambridge: Cultural Survival, 1989).
6 Haddon defines *surlal* as "copulating turtle," 1 (1935): 383.

the turtles were landed. Ceremonies included those to influence the outcome of hunting trips and to give thanks when the first turtle was caught at the beginning of the *surlal* season.[7]

Aside from being meat, turtle was also material for Islanders' sculptural works, tools and status ornaments, and they used the shell of the hawksbill turtle to produce some of the most sophisticated sculptural work in turtle-shell of any culture. The large three-dimensional masks can be categorized into two main groups. The *op le* masks represented elongated human faces, and are associated with eastern Torres Strait. The composite masks of animal forms surmounted by a human face or *krar* are associated with western and central islands. The masks were constructed from panels or scutes of turtle-shell, the semi-transparent keratin based material attached to the bony dome-shaped carapace of the turtle. The scutes are removed from the carapace by either placing the carapace in hot water or by burying the carapace in the sand for up to a week.[8] Scutes also peel away from the carapace of dead turtles and are found in areas where turtles were butchered or where their remains were stored or buried.[9]

Pliable on heating, the pieces of shell can be shaped by pressing and molding over a hot stone. Holes were made along the edges of panels, possibly with bone or turtle-shell needles and the panels sutured together with natural fiber string. To give large masks their overall form, pre-cast turtle-shell pieces were attached to bamboo or wooden frames, and holes were made along the edges of these panels and stitched together. As new materials such as wooden boxes, tin, cloth and wool also became available through trade, over time, these materials were taken up and mask makers and incorporated into turtle-shell masks. Smaller masks, such as the *op le* masks associated with the eastern islands, are made entirely of turtle-shell pieces, fashioned through heat, molded into the required form and stitched together with vegetable fiber string.

While we might look to archaeology to date the general use of turtle in the region, we can turn only to Islander accounts for the origin of the turtle-shell masks. In the late 1890s Kuduma of Nagir in the central Torres Strait recounted the following:

> Naga of Nagir knew how to make the *urui krar*, or masks in the form of animals, he instructed the men in singing and dancing and in everything relating to the *kwod* [ceremonial ground]. Naga taught men how to "make *taiai*" [funeral ceremony].
>
> He was unmarried, and did not live in the *Taiai kwod*, but in his own *kwod*.
>
> Waiat of Mabuiag came to Nagir to learn how to beat the drum and Naga taught him. Then Waiat stole a famous mask. After this Naga gave a mask to the men of Tutu, another to those of Waraber, a third to those of Moa, and he kept one mask in Nagir. Naga gave akul-shells to all the islands, Muralug, Waraber, Tutu, Yaru, Moa, Badu, Mabuiag, Masig, Paremar, Aurid, so that the men in these islands might in future make their own masks.

7 Neitschmann, "Traditional Sea Territories."
8 Wayne Witzell. *Synopsis of Biological Data on the Hawksbill Turtle, Eretmochelys Imbricata* (Linnaeus, 1766) (Rome: Food and Agriculture Organisation of the United Nations, 1983).
9 Yessie Mosby, personal communication, May 2013.

Naga was very angry because Waiat stole his mask.[10]

From Kuduma's account we learn not only that the potential origin point of the masks is Nagir, in the central Torres Strait, but also about the diffusion of mask making practices across the region. When Naga lived and began this tradition is impossible to determine. However, the removal of a "famous mask" by Waiat, presumably to Mabuiag, enables a glimpse of the historical richness of the Mabuiag mask tradition, a tradition rooted in a time known through mythical stories and histories.

In terms of outsider knowledge of mask making, the first recorded European sighting of turtle-shell masks predates James Cook's 1770 claim of the eastern part of the Australian continent by almost 170 years. In September 1606, Luis Vaes de Torres became the first known European to navigate a passage through the region. A member of his party, Spanish captain, Don Diego de Prado y Tovar, wrote,

> In the morning we went ashore and to the village, which was abandoned, and we found a quantity of turtle of the sort greatly valued by the East Indians ... and a quantity of masks made of the said turtle, very well finished, and a fish called *albacore* [tuna] imitated so naturally that it seemed to be the very thing and a half man-half-fish of a yard and a half high, also made as a good sculptor might have finished it.[11]

The island identified by de Prado in this passage is part of the central islands group and is known to Islanders as Zegai. Of these central islands, Tudu, Iama and Aureed in particular are recognized as being critical in the historical movement of materials between the eastern and western islands of the Torres Strait and between the eastern islands and the Australian mainland.[12]

From the mid- to late nineteenth century, as commerce and then Christianity took hold in the region, many of the masks were traded or taken, and they are now held in museums around the world. Yet, for Islanders today, the turtle-shell masks are important historical and cultural objects. They hold the histories of Islander ceremonies and cultural practices and are imbued with a multifaceted regime of meaning tied to their making and their use.

Importantly, practices related to their use recognized the spiritual power of the living turtle and of the objects made of turtle-shell. Anthropologist Alfred Haddon, long-time student of Torres Strait cultures, acknowledged the power of the masks. He wrote in 1935:

> Masks certainly had a religious significance and therefore had to be treated with respect. It was probably always the case that when a man wore any particular mask he for the time being became identified with the personage or power which that mask

10 Alfred C. Haddon, *Reports of the Cambridge Anthropological Expedition to Torres Straits, vol. 5: Sociology, Magic and Religion of the Western Islanders* (Cambridge: Cambridge University Press, 1904): 49.
11 Don Diego de Prado and Luis Vaes de Torres. *The Discovery of Australia: Discovery Made by Pedro Fernandez De Quiros in the Southern Land, and Afterwards Completed for Him by Don Deigo De Prado Who Was Afterwards a Monk of the Order of S. Basil.* Translated by George F Barwick (1922): 1607.
12 Wolfgang Laade, "Notes on the clans, economy, trade and traditional law of the Murray Islanders, Torres Strait." *Journal de la Société des Océanistes* 29 (1973): 159; John Sweatman, Jim Allen and Peter Coris, *The Journal of John Sweatman: A Nineteenth Century Surveying Voyage in North Australia and Torres Strait* (St. Lucia: University of Queensland Press, 1977).

symbolized. We may take it for granted that, at all events in most cases, a mask could be worn only by a man who had inherited the right to perform that particular ceremony or who had been specially initiated into that cult.[13]

Here Haddon identifies the elements of respect, gender and inheritance as playing a significant mediating role in the way masks were viewed and treated. These same aspects continue to play a role in Islander understandings of and interactions with masks today. They have shaped my own approaches to accessing historical and cultural knowledge about the masks and also informed my interactions with Islander cultural knowledge-holders and Torres Strait Island people more generally.

Sadly for Islanders, none of the old turtle shells masks has remained in the Torres Strait. Of the 80 or so masks in existence, most of them are housed in overseas collections. Yet, despite the fact that the masks I have viewed and photographed for my research are far away from the Torres Strait, this does not make them any less potent in the eyes of many Islanders. While Islanders today do not use turtle-shell masks, in the way of their ancestors, they are increasingly aware of the ancient turtle-shell objects, as collections are made more accessible through exhibitions and the digitization of museum collections. The endeavors of museum staff to find out more about the objects and their source communities and the work of Islander artists, community leaders, and others who have traveled to the United Kingdom, Europe, and North America to view the material has also opened them up to new interpretations by Islanders. While many of these objects were collected as evidence of a "dying" culture and exhibited in museums around the world as still and silent, or interpreted through the discourses of western aesthetics and the primitive "other"[14] (see also Rudiak Gould, Chapter 9) the power of the objects remains known and potentially accessible to appropriate Islanders. Contemporary Islanders' belief about the latent power of the turtle-shell materials compresses the time and space divide and compels us to consider the masks as evidence of cultural endurance rather than objects of long-dead cultural practices. This makes the telling or writing of this history both compelling and incredibly challenging.

My research pursues a reading of Torres Strait turtle-shell masks as enduring historical texts and in doing so, attempts to bring to light a human-animal history of the Torres Strait that continues to be enacted in the Islander-turtle relationship.

A turtle-shell mask and human-animal histories

The turtle-shell mask (1) brings into sculptural form animals of the sky and sea; the *kaigas* (shovelnose ray), the snout of a *kodal* (crocodile), two smaller fish and the head of the *womer* (frigate bird). Measuring about 122cm in length, the mask was taken from Mabuiag in the mid-1880s by the Reverend Samuel McFarlane of the London Missionary Society (LMS). Fostering the Christian faith was McFarlane's primary activity in the region and his reports to the LMS headquarters in the UK reveal nothing about his proclivity for collecting. However, his letters and transaction records with museums show that over a period of about

13 Alfred C. Haddon, *Reports of the Cambridge Anthropological Expedition to Torres Straits, vol. 1: General Ethnography* (Cambridge: Cambridge University Press, 1935): 370.
14 See Nicolas Thomas, *Entangled Objects: Exchange, Material Culture, and Colonialism in the Pacific* (Cambridge: Harvard University Press; 1991); Tom Griffiths, *Hunters and Collectors: The Antiquarian Imagination in Australia* (Cambridge: Cambridge University Press, 1996).

12 years he collected and sought recompense for a number of animal specimens and at least a dozen large turtle-shell masks from Mabuiag. It is unclear how he came to acquire the objects; perhaps he took them from their usual resting place in a quiet dark cave near the *kwod* (ceremonial grounds), or maybe in his role as missionary and savior he was asked to take them, or he confiscated them from the people of Mabuiag. Whatever the reality, his own papers and journals are silent.[15] The mask was acquired by the British Museum in 1886; its purpose was not recorded in their documentation.[16]

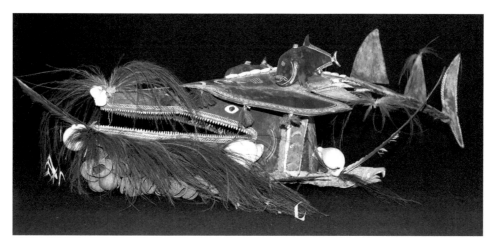

Figure 15.1 Kaigas mask from Mabuaig Island, Torres Strait, Length: 119cm. Oc.+,3278. © The Trustees of the British Museum. See Plate 14.

Made primarily of wood and turtle-shell, the mask is embellished with feathers, sea shells, goa nuts and tufts of red and blue wool. The animal forms of the *kaigas* (shovelnose ray), and sculptural representations of two fish are fixed to the top of what is perhaps a combination of a *kodal* (crocodile) and *baidam* (shark) head. All are made of turtle-shell. The heads of the *womer* (frigate bird) are made from wood. Coloration of the natural ochres differentiates the animals and draws attention to particular features of the animals – such as the yellow of the fins and the red inner mouths of the *womer*. In its assemblage, the animal figures also face in different directions; the *kaigas* sees above, the crocodile-shark and two top fish gaze ahead, while the birds look behind.

Stunning in its construction and finish, in gazing on it, we can only marvel at the vision and skill of its maker. Undoubtedly, it was made to be worn and performed in. Imagine it being placed on the head of wearer, like a biker's helmet. His identity is not revealed to us, as he looks out on us through the mouth of the fish. Biting down on a cross bar he guides the direction and angle of the mask by moving his head. He has complete control over which

15 Samuel MacFarlane, Papua New Guinea Journals 1871–1883, London Missionary Society Collection, School of Oriental and African Studies Archives, University of London, CWM/LMS.
16 Jude Philp's "Krar: 19th century turtle-shell masks from Mabuyag collected by Samuel McFarlane" provides a detailed account of McFarlane's dealings with the British Museum and the Natural Historical Museum, in Ian J. McNiven and G. Hitchock, eds. *Goemulgal: Natural and Cultural Histories of the Mabuyag Islands, Zenadth Kes (Torres Strait), Memoirs of the Queensland Museum – Cultural Heritage Series* 8, 1, (forthcoming).

view of the mask we see. When he tilts his head forward, we see the *kaigas*, as he turns to the side the two fish and crocodile-shark head are most obvious. When he turns his back to us, the birds are prominent and we glimpse the three human figures etched in lime on the rear panel. As he moves, the rattle of the shells and dried goa seeds create percussive accompaniment. In his wearing of the mask, he brings the human and the animal together. Fleetingly and figuratively, human and animal become one.

The animal forms are rendered with neat accuracy. The *kaigas* is anatomically precise and presented in outline form, in the manner it might be observed when looking at it from above; as when standing in a boat or on the beach and looking down into the clear water. Along the edge of the snout and pectoral fins is an engraved band of wave-like patterning, with white infill. Along the dorsal or top surface, in a line between the eyes and dorsal fins, 12 small cowrie shells represent the thorny teeth-like structures, known as denticles (Figure 15.2). Their bases removed, the shells sit neatly along the dorsal surface. The turtle-shell dorsal fins of the kaigas are fixed to the tail in an upright position. Along with the tail fin and dorsal fins, the pelvic fins are colored by yellow ochre, and engraved geometric designs cover the edges of the pelvic fins and the tail fin, which the artist has filled in with lime.

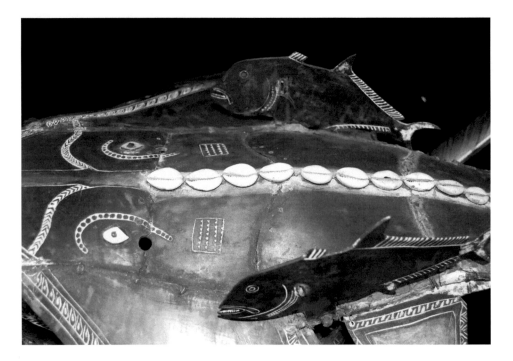

Figure 15.2 Overhead view of the mask showing details of the fish and the *kaigas*. Oc.+,3278. © The Trustees of the British Museum. See Plate 15.

Looking down on the mask, the *kaigas* obstructs a clear view of the figure below. The long snout of a crocodile is readily identifiable and the inclusion of gills suggests that this figure is also a shark. On either side of the *kaigas* are the profiles of two whole fish, approximately 220mm long and each cut from a single piece of turtle-shell. The fish, possibly golden trevally (*Caranx ignobilis*), are engraved to show eyes, nose, gills and fin markings. Finally, the heads of

the birds are carved from wood, etched to show the markings of the eyes and painted red, yellow and white. They are tied to the base of the mask and look backward. On the back panel of the mask, three human forms are outlined in lime (Figure 15.3). With their arms raised they gaze wide-eyed at the world. The meaning of their posture and positioning on the mask is puzzling. One reading is that their presence brings together the human and animal even when, or perhaps especially when, the mask is stored away between ceremonies. Furthermore, Islander histories include transformation as a common aspect of mythic times, when animal became human, and this mask is perhaps one way this transformation is symbolized.

Figure 15.3 Detail of the rear of the *kaigas* masks showing human figures, the colors on the head of the *womer* and the teeth of the *kodal*. Oc.+.3278. © The Trustees of the British Museum.

When worn, the identity of the wearer is concealed from the audience. This is especially important when the mask is used in funeral ceremonies. The mask wearer, customarily an in-law of the deceased, is required to take on the guise of the deceased person. Wearing a mask that references the totemic animals of the clan of the deceased, the in-law imitates the mannerisms and attitude of the deceased through movement and attitude; indeed, they perform the human and animal identity of the deceased. In a liminal space, the performance enacts the unification of the spirits of the human with that of the totemic animals.

The human-animal association contained by the mask reflects the totemic affiliation of clan or extended family groups. The table below summarizes information from a sketch map of Mabuiag made by Ned Waria and published in 1904.[17] Waria recorded 11 animals as

17 Alfred C. Haddon, *Reports of the Cambridge Anthropological Expedition to Torres Straits: Sociology, Magic and Religion of the Western Islanders, Vol. 5.* (Cambridge: Cambridge, University Press, 1904): 163.

having totemic significance to six clan groups on the island. The information presented here is contemporaneous with the collection of the mask and through it one can reconstruct the layers of relationships between people and animals.

Table 15.1 Totemic animals of Mabuiag Island clans

Totem/CLAN	WAGEDUGAM	PULU	GOEMU	MAIDI	DANAI	AUBAIT
Kaigas (shovelnose)			kaigas			
Surlal (turtle)	surlal	surlal	surlal★	surlal		
Kodal (crocodile)	kodal★				kodal	kodal
Gapu (suckerfish)	gapu	gapu		gapu		
Sam (cassowary)		sam				
Womer (frigate)	womer					
Sapor (bat)	sapor					
Umai (dog)		umai	umai			
Dangal (dugong)	dangal	dangal★			dangal	
Tabu (snake)	tabu	tabu		tabu		

★ Denotes the primary totem of the clan group.

Based on the information from Waria, the most apparent of the mask's layers is the association of the animals with particular clan groups as totemic animals. Five totem animals named by Waria are represented on the mask: *surlal* (turtle during mating season), *kaigas* (shovelnose), *kodal* (crocodile), *womer* (frigate) and *sam* (cassowary). As *surlal* and *kaigas* are both totems of the Goemu clan, this suggests that the mask is strongly associated with Goemu. This is also supported by the *kaigas* being the dominant feature of the mask, and that it is recorded by Waria as being a totem only to the Goemulgal. Providing a contemporary Islander perspective on one aspect of the relationship between the Goemulgal and the *kaigas*, cultural knowledge holder and elder Dimple Bani has highlighted how the behaviors of clan members can also reflect the behavior of particular animals. *Kaigas* are known for concealing themselves on the ocean floor, under a shallow layer of sand, and Bani likens this to the expression of humility in his Goemulgal clan members.[18] For Goemulgal today, such links between the human and the animal are recognized by clan members and are revealed and interpreted in specific ways.

Regarding the other clan totem, *surlal,* clan members are responsible for turtle hunting and for the performance of ceremonies to ensure success in turtle hunting outings. The use of *surlal* to reference the green turtle coincides with an important hatchery site, just north of the Mabuiag sea territory boundary. Known as Deliverance Island, it has long been a hatchery for marine turtles and this might explain the use of *surlal* in place of *waru*. To Islanders, Deliverance is known as *Warul Kawa*, or "island of turtles," and is shared by five island societies, including Mabuiag.[19] It is also believed to be the final resting place of the ancestral spirits of western Islanders.[20] A physical place where ancestral spirits and turtle are together

18 Dimple Bani, personal communication, August 2013.
19 *Akiba on Behalf of the Torres Strait Islanders of the Regional Seas Claim Group v State of Queensland* (No 2) July 2011 Federal Court of Australia 643, accessed November 2013.
20 Dimple Bani and Stan Lui, personal communication, December 2013.

adds a further layer of substance to the historical use of turtle-shell masks in Islander funeral ceremonies, and exemplifies the closeness between animal and human in Torres Strait Islander culture.

Connecting with the past and looking to the future

As museums have opened their doors to the descendants of source communities, Islanders' interest and engagement with their ancestral materials have steadily increased. Given the long time the turtle-shell masks have been separated from cultural practice, we might ask whether they mean anything more to Islanders now than they do to exhibition goers who have no cultural association with them. As I talk to Islanders around Australia and document the meaning of the turtle-shell material to Islanders today, I am constantly referred to the expansive creative work of Islander artists such as Alick Tipoti, Dennis Nona and Ken Thaiday Snr, along with dancer/choreographer Elma Kris, who are inspired by the old masks to create symbolically rich works of art or choreograph hauntingly evocative productions. The masks were made to be performed in and performance continues to be the principal way Islanders pass on cultural knowledge, affirm Islander identity and indeed, tell history. The old masks remain important to all Islanders because of what they can tell us about the people they were, before everything changed.

Islanders' current and growing interest and engagements with museum collections of Torres Strait material speak also to our lives today and our broader concerns. In contemplating the future of Islander-turtle relationships, there is perhaps no greater fear than the projected impacts of climate change on the habitats of turtle and Islander populations. Through their burgeoning collaborations with Islanders, museums are well placed to extend their engagements with Islander communities to explore how the revivification of interest in Torres Strait cultural material might also contribute to or support adaptive strategies and engender greater resilience among Islanders.[21]

21 I wish to acknowledge and thank the following people who took the time to discuss my ideas about turtle and turtle-shell masks and for their assistance with reading and commenting on various versions of this Chapter: Dimple Bani of Mabuaig Island, Stan Lui, Yessie Mosby, Frank David, Iain McCalman, Jude Philp and Kirsten Wehner.

16

FOUR SEASONS IN ONE DAY

Weather, culture and the museum

Kirstie Ross

Introduction

For over seven hundred years of human occupation, the weather has been an ongoing daily concern for the people living in Aotearoa New Zealand. Today, it influences health, smooths polite conversation, structures daily routines, affects work and leisure, and shapes thoughts of the recent past, the present and the near future. The nation's changeable weather features in art, music and popular culture; it illustrates calendars, while television weather presenters are national treasures, referred to fondly by their first names. Popular song lyrics invoke its unpredictability, feeling like four seasons in one day.

Some places are known by their climate: the subtropical region at the top of the country is the "winterless north." Wellington, the capital of New Zealand, has a reputation for bad weather and the strong winds that funnel into the city. "Windy Wellington" is the butt of a national joke, though locals counterclaim that "nothing beats Wellington on a good day" while conceding such days are few and far between. Even first-time visitors flying into the city (weather permitting) are alerted to the city's winds: a "Wellington" sign, modeled on the famous Hollywood one, located a stone's throw from the airport, is made to look as if it is being blown away by a strong gust.

New Zealanders' tendency to dwell on the weather has a corollary with the population of another island nation, Great Britain, where the weather is said to be "crucial" to Britons' "apprehension of [their] country and [their] place in it."[1] To this observation, British commentator Richard Mabey adds: the "[w]eather is what happens here and now, to our settlements and landscapes, to *us*. In that sense, it's part of our popular culture."[2] He also points out how "the weather, in our culture and our psychology, is intricately linked with *time* and especially with time's familiars, memory and expectation."[3] The weather literally and imaginatively shapes our past, present and, with less certainty, our future.

1 Tom Fort, *Under the Weather* (London: Arrow Books, 2006), 9.
2 Richard Mabey, *Turned Out Nice Again: Living with the Weather* (London: Profile Books, 2013), 3–4.
3 Mabey, *Turned Out Nice Again*, 15.

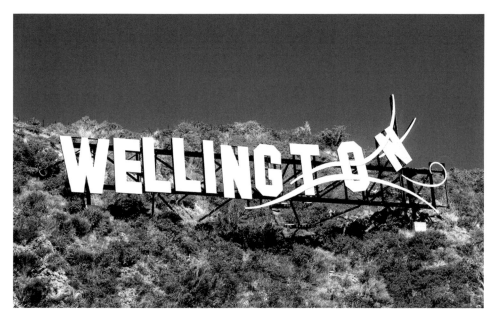

Figure 16.1 Windy Wellington. This sign greets visitors as they fly into New Zealand's capital city, 2015. Photograph by Norm Heke.

The relative physical and temporal immediacy of yesterday's or last summer's weather makes them tangible and memorable. Daily weather forecasts presented by charismatic forecasters enjoy a high degree of visibility in popular culture, and shore up the weather's ability to elicit personal and affective responses. However, climate – meteorological data and statistical trends aggregated and averaged over long periods of time – seems detached from community and culture, and divorced from personal experience. This has negative implications for promoting action on global climate change. Geographer Mike Hulme describes this as "de-culturating" climate. By doing this, he claims we "contribute to conditions that yield psychological dissonance in individuals: the contradictions between what people say about climate change and what people do."[4]

American climate scientist Heidi Cullen insists that weather and climate must not be separated. She stresses how crucial it is for people to "understand that their weather is their climate. … If climate is impersonal statistics, weather is the personal experience. We need to connect them."[5] One way to unite the weather with climate is to consider both as culture. This is an approach proposed by Hulme, who suggests that if climate is treated "unambiguously as a manifestation of both Nature and Culture" people will engage more deeply with the issue of climate change. In order to bring about this deeper engagement, he advocates a re-imagining of the discourses of climate change "as the relationships between weather and local physical objects and cultural practices."[6]

4 Mike Hulme, "Geographical Work at the Boundaries of Climate Change," *Transactions of the Institute of British Geographers* 33 (2007): 8.
5 Heidi Cullen, *The Weather of the Future: Heat Waves, Extreme Storms, and Other Scenes from a Climate-Changed Planet* (New York: Harper, 2011), 8.
6 Hulme, "Geographical Works," 6.

This focus on local objects and practices points to museums and their collections and a role they could play in connecting weather and climate, and re-orienting the universalizing, globalized discourses of climate change. The following discussion uses Hulme's suggestions for museological practice, one that encourages, juxtaposes and blends "small talk" about the weather with difficult debates about climate change. It focuses in particular on the culture of New Zealand's weather and potential directions that the Museum of New Zealand Te Papa Tongarewa could take to give Hulme's ideas substance.

New Zealand's weather and climate

Before discussing weather and climate as cultural terms, I will briefly outline the basic conditions and meteorological phenomena that New Zealanders experience. The prevailing wind, ocean and terrain are the three main physical factors that determine the country's weather patterns and climate. New Zealand is a small mountainous land mass surrounded by the Pacific Ocean, so when air arrives in the country it is moist, having crossed thousands of kilometers of water. This moderates temperatures but invariably means wet weather. The country is situated in the mid-latitudes of the southern hemisphere – from 34° to 47° – which means it lies in the "roaring forties" weather system and is a windy place. Its elongated shape also creates regional variation: the far north experiences a subtropical climate while the far south experiences a cool temperate one. Severe alpine conditions prevail in the mountains. Because the currents moderate the ocean, the variation between summer and winter temperatures is relatively minimal (less than 10°C).

The West Coast of the South Island is the wettest part of the country. Westerly winds are the most common; northerlies also bring warm air down from the tropics – sometimes in the form of tropical cyclones – while southerlies blast cold air up from Antarctica. The mountain ranges running from north to south in the two main islands act as barriers to the prevailing westerly winds, and make eastern regions drier.

The coldest month is July, and the warmest is either January or February. Overall the climate is fairly mild. The mean annual temperature ranges from 10°C in the south to 16°C in north. The weather is unpredictable but without extended periods of extreme heat or cold that characterize continental climates. Most places experience a lot of sunshine – at least 1,800 hours a year – but also a good deal of rain. In fact, scientists predict that one of the local effects of global climate change will be an increase in rain in the south and west, a decrease in the north and east, and a greater westerly wind-flow across the country.

Landfall

The islands known today as Aotearoa New Zealand were not inhabited by humans until 700–800 years ago. It was the arrival of people from Polynesia that created a culture of the weather. Aotearoa is the name for New Zealand in the indigenous Māori language and means "land of the long white cloud."

According to one oral tradition, it was the name was given to the land mass by Kuramarotini, the wife of Kupe, leader of the first voyage from the Eastern Pacific to New Zealand. These experienced oceanic navigators understood from the clouds they saw on the horizon that they were close to land. These were characteristic of the new land's weather: Aotearoa New Zealand is therefore named after its weather.

Figure 16.2 Cloud by John Reynolds, 2006, installed at Te Papa, 2009. Te Papa (2007-0007-1-7081). See Plate 16.

These voyagers arrived with a range of tropical plants in their *waka* (canoes). The temperate maritime climate of their new home, with its clearly defined growing seasons, meant only some could be successfully raised and then only in certain parts of the country. The *kumara* (sweet potato), for example, grew best in the far north while the particular strain of *aute* (mulberry), which was brought to use for clothing, was not successfully transplanted.

Basil Keane has outlined the cultural responses that structured Māori understandings of the weather. This cultural knowledge was inter-connected with Māori cosmology. The deity controlling the weather is Tawhirimatea (god of wind and storms). According Māori creation story, out of all the children of the sky father (Ranginui) and the earth mother (Papatuanuku), Tawhirimatea was the only one who did not want his parents to separate. After Ranginui and Papatuanuku were separated by Tawhirimatea's brothers – in order to let light into the world – Tawhirimatea joined his father in the sky where the two plotted against Tawhirimatea's brothers. This revenge took the form of extreme weather, including the release of many types of intense rain and various cloud forms. Tawhirimatea's offspring, the four winds, were also implicated in this meteorological reprisal.

The distinguishing elements of the weather were reflected linguistically. A variety of words in the Māori language were given to clouds – including those that preceded hurricanes, those that reflected red light, and those that brought thunderstorms. Clouds were used to predict the weather: *he whare hau* denotes is a bank of clouds indicating coming wind. Rain, too, amassed numerous finely grained terms. Place names also reflect weather conditions, such as Hautere (swift wind), given to Solander Island, which is close to one of the windiest places in the country.

Global climate change profoundly affected the lives of these Polynesian settlers. While experienced oceanic navigators, scholars have found evidence that suggests that the Little Ice Age, which began around 1300, ended regular reciprocal visits made between the tropics and New Zealand. A climatic event and subsequent cooling meant that the weather in the Pacific Basin became less predictable and windier, and storms more frequent and violent.

Alexander Wilson argues that "it was changes in storminess which ended the migrations of the Polynesians."[7]

A second wave of settlers

By the time that New Zealand became a British colony in 1840, Māori had been refining their cultural framework around the daily weather, seasons and climate for at least 500 years. Māori had dispersed in tribes throughout the country and were sensitive to regional climatic variations; economic activity was based around the lunar calendar, and environmental indicators underpinned understandings of the seasons.

The formal political annexation of the country initiated a growing stream of British settlers, who possessed little or no knowledge of New Zealand's climate. Some had misconceptions about the weather, having been wooed by immigration agents who talked up the country's benign and healthy climate and its potential for economic prosperity.

A few were conscious of Māori meteorological knowledge. John Barnicoat, a surveyor who settled and worked in the north-west of the South Island in the 1840s, commented on a mid-winter weather forecast made by local Māori:

> Another and third day of rain. Nelson is it seems in a great measure under water. It appears that the natives tell us that we are to have no fine weather till Tuesday next, after which we are to expect three or four such days as this each fortnight at the change of the moon.[8]

British settler responses to the elements were shaped by their culture of the weather, including comparisons with "home." Mary Anne, Lady Barker, who lived with her husband on a South Island sheep run in the 1860s, wrote appreciatively in March 1866 that the "climate now is delicious, answering in time of year to your September; but we have far more enjoyable weather than your autumns can boast of."[9] However, Lady Barker soon became attuned to the atmospheric conditions of her new country and her letters are peppered with descriptions that reveal an understanding of the local weather. On one summer's evening, for example, she and her husband "noticed immense banks and masses of clouds, but they were not in the quarter from whence our usual heavy rain comes; and besides in New Zealand clouds are more frequently a sign of high winds than of rain."[10]

In the nineteenth century, most of New Zealand's growing European population was keen to discern patterns in the local weather and to establish some predictability about them. Mid-summer's and mid-winter's day were common reference points for first and second generation migrants trying to reconcile existing knowledge about the weather with the

7 Alexander T. Wilson, "Isotope Evidence from Past Climatic and Environmental Change," in Robert I. Rotberg and Theodore Rabb, eds, *Climate and History: Studies in Interdisciplinary History* (Princeton, NJ: Princeton University Press, 1981), 225. See also Patrick D. Nunn, *Climate, Environment and Society in the Pacific During the Last Millennium* (Amsterdam/London: Elsevier, 2007).
8 Cited in Peter Holland, *Home in the Howling Wind: Settlers and Environment in Southern New Zealand* (Auckland: Auckland University Press, 2013), 25.
9 Mary Anne, Lady Barker, *Station Life in New Zealand,* London: MacMillan & Co. (1883) (facsimile edition, Auckland: Wilson & Horton, n.d.), 48.
10 Barker, "Station Life," 209.

antipodean cycle of seasons. Other newcomers sought indigenous environmental signs of seasonal change, such as the song of the migratory shining cuckoo (known to Māori as the *pipiwharauroa*) whose return was considered a harbinger of spring.[11]

A number of settlers also contacted experts for meteorological information. The tenor of some of these requests suggests that the weather and the seasons were topics of intense conversation that sometimes turned into debate. In September 1915, for example, Mr. C. Ward wrote to the Meteorological Service from the North Island town of Palmerston North. He informed the director that "the question of the actual commencement of the Seasons in New Zealand is in dispute with a number of persons"; Ward was nominated to seek accurate information from experts to settle their argument.[12]

New Zealand had, by the 1860s, a centralized colonial meteorological service for weather-forecasting and data collection (established in the 1860s). However, some European New Zealanders also became knowledgeable in their own local weather through close observation and diary-keeping.[13] These activities were undertaken for practical economic reasons, with many settlers taking up farming without any knowledge of local conditions. As geographer Peter Holland writes: a farm or station might survive poor market prices but the "impact of a spell of bad weather was immediate and long lasting."[14] By chronicling their own weather histories, farmers had data upon which they could tentatively base future farmwork. For example, Leslie Adkin, who farmed on the west side of the lower North Island, mentioned the weather 142 times in the 12 months from March 1913. "Rain" appeared in 91 entries and "wind" in 29. But some diarists, such as Adkin, interwove the weather with descriptions of everyday activities: the weather was not separated from life.[15]

While they were gaining knowledge about ordinary weather patterns, settlers also had to accommodate exceptional weather, such as floods, snowstorms and droughts. Lady Barker experienced the effects of a terrible snowstorm that hit Canterbury in August 1867. This was an extraordinary event: "there is no tradition among the Māoris of such a severe one ever having occurred" she wrote.[16] Settlers also had to contend with flooding.[17] Rising rivers and flood waters damaged property, swept away stock, washed out roads and bridges, and cut communities off from one another. In Southland, after heavy rain fell in November 1891, Joseph Davidson recorded in his diary that:

> the Dome Creek was bank-to-bank, washing the fence down and changing its channel in many places. The lower parts of the paddocks and my potatoes are under water.[18]

Some settlers blamed flooding on the clearance of indigenous forests for pasture. Millions of acres of forest were cleared by Māori, then by European settlers. As historian James Beattie has shown, some settlers grew anxious about the climatic effects of deforestation. The

11 Holland, "Home in the Howling Wind," 26.
12 C. Ward to the Meteorological Office, 22 September 1915, ABLO W4117 5/2/49 Archives New Zealand Te Rua Mahara o te Kawanatanga.
13 Holland, "Home in the Howling Wind," 35–66.
14 Holland, "Home in the Howling Wind," 37.
15 Leslie Adkin diaries, CA000245, Museum of New Zealand Collected Archives.
16 Barker, "Station Life," 157.
17 Holland, "Home in the Howling Wind," 71–7.
18 Cited in Holland, "Home in the Howling Wind," 75.

conventional wisdom of the late nineteenth century was that forests held water and prevented flooding. Even the director of the Colonial Museum agreed that deforestation would eventually dry up New Zealand's climate.[19] Legislation for tree planting and to set aside climatic reserves was passed in 1870s and 1880s. However, there was no science to support fears about the climate and these initiatives had no effect on the climate. A century later, the tide had turned.

Exhibiting the weather

Currently, there are no exhibitions in New Zealand museums investigating the weather, nor the potential impacts that climate change will make on everyday life. However, in 2015 Palmerston North's Te Manawa: Museum of Art, Science and History opened its touring exhibition Sunlight-Ihi Kōmaru. The museum's senior curator indicated that climate change and global cooling and warming were considered for one of the exhibition's segments.[20] Sunlight-Ihi Kōmaru is "a fun and interactive science-based exhibition for all ages … [that considers] how light has shaped the world around us."[21]

One current exception to this dearth of museum coverage is a permanent exhibition at the Wellington Museum of City and Sea. The *Wahine Disaster*, about an extraordinary and tragic weather event that occurred in April 1968. The exhibition is noteworthy because of what it reveals about visitor behavior and public engagement with the weather. This exhibition is about the "*Wahine* disaster" which was the result of tropical cyclone Giselle. Bringing winds of up to 130 knots, the cyclone disabled and sank the *Wahine,* an inter-island passenger and car ferry, in Wellington Harbor. Fifty-one lives were lost. This loss still resonates today: when I visited the gallery, two unofficial personal memorials had been placed in a corner – small objects that conveyed the ongoing grief felt by those affected by the event.

The museum has a large collection of objects salvaged from the wreck, some of which are displayed around the perimeter of the gallery. The exhibition's centerpiece is a short film comprised of contemporary black and white television footage, and photographic stills. Made by a local documentary film maker, the film eschews voice over or analysis (although fragments of television interviews from the time are used). Instead, Albinoni's "Adagio in G minor for strings and organ" forms the sound track to the tragedy. This grave and measured piece is like a guy-rope or anchor in the midst of a storm.

Explanations of the extreme weather that caused the shipwreck receive minimal attention in the gallery: this is an experience that is about *feeling* the elements. In fact, near the gallery exit, there is evidence that visitors, literally, need to touch the weather. Near the exit, an artwork *Wahine Weather Maps* by David Ellis is mounted on the wall. This triptych of plaster models shows the course of cyclone Giselle on 8, 9, and 10 April. According to the artist, he has reinterpreted the weather map as a "moving series of frozen landscapes." By turning isobars into contours, "troughs become valleys, anticyclones become mountains, and cyclones become whirlpools." The artwork's final component shows Giselle's location at the time the *Wahine* sank; visitors have worn away the text here by repeatedly rubbing the center of the storm.

19 James Beattie, "Environmental Anxiety in New Zealand, 1840–1941," *Environment and History* 9 (2003): 383.
20 Jeff Fox, personal email to author, January 2014.
21 www.temanawa.co.nz/sunlight/

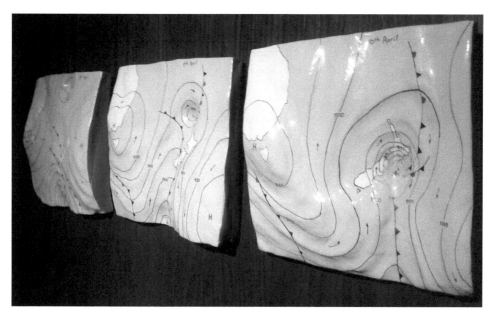

Figure 16.3 Wahine Weather Maps by David Ellis displayed at Wellington Museum of City and Sea, 2015. Photo courtesy of David Ellis.

The weather at Te Papa

What is New Zealand's national museum, Te Papa, doing to tap into museum visitors' desire to touch and be touched by the weather? What can Te Papa do to ensure visitors become personally invested in and not overwhelmed or disempowered by global change? How can the national museum bring weather and climate under a single umbrella of culture?

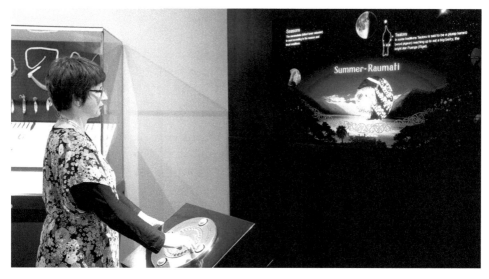

Figure 16.4 The *maramataka* (Māori calendar) interactive, developed at Te Papa in 2005–2006, shows seasonal and lunar cycles in food planting and gathering, 2016. Te Papa Tongarewa. Photo: Michael Hall.

Currently, Te Papa's galleries do not convey the distinctive culture or nature of New Zealand's weather and climate to its visitors. It is absent from the one gallery in which it might be expected: the environmental history exhibition *Blood Earth Fire: Whangai Whenua Ahi Ka. The Transformation of Aotearoa New Zealand*. Elsewhere, however, there is coverage of how water has shaped New Zealand's landscape. This is in *Awesome Forces* which is an exhibition that shows how "plate tectonics, earthquakes, volcanic eruptions, and erosion have shaped one of the most dynamic landscapes in the world." Although *Awesome Forces* is dominated by geological content, and the ever-popular interactive "Earthquake House" (the Earthquake Commission helped develop the display), the exhibition also includes an area that reveals "the effects of rainfall and extreme weather events – by-products of New Zealand's unique location."[22]

The "Wild Water" segment of *Awesome Forces* covers a raft of information using geological samples, text, diagrams, graphs, images and computer interactives. It explains the factors affecting New Zealand's weather, including the large-scale weather patterns El Niño and La Niña, flooding and droughts, and the geophysics of erosion. The *Wahine* appears briefly amongst film footage showing ordinary and extreme weather. This area also discusses global warming. It shows, using a computer interactive, how melting ice caps will affect the sea levels around the country's three main cities. As in other exhibitions at Te Papa, strict word limits on text panels have been applied here. This means that the commentary on anthropogenic climate change is notable for its brevity: two paragraphs with a total of 71 words.

The geological emphasis of *Awesome Forces* betrays Te Papa's origins as a museum attached to the Colonial Geological Survey and the museum's ongoing partnership with the survey's successor, GNS Science, rather than a deliberate strategy to sideline global climate change. However, Te Papa's past, when the museum's director oversaw weather-forecasting and the collection of meteorological data from 1867 to 1891, also provides the museum with an uncontroversial precedent for connecting weather and climate.[23] There is no reason why weather and climate cannot be part of the museum again.

Throwing caution to the wind

The wind, as I have noted above, is a defining features of New Zealand's weather and climate. Some regions are identified with their prevailing winds. Areas east of the main divide of mountains are prone to north-westerly winds. Lady Barker understood this after she moved to the Canterbury Plains, situated to the east of Southern Alps. In a letter dated April 1866 she wrote about "an arch-like appearance in the clouds" which was "the sure forerunner of a violent gale from the north-west. … a few hours afterwards the mountains were quite hidden by mist, and a furious gale of hot wind was shaking the house as it must carry it off into the sky."[24] These winds and the weather they brought were the subject of mid-century regional painters, many of whom studied or lived in Canterbury.

22 *Awesome Forces* web page, www.tepapa.govt.nz/WhatsOn/exhibitions/Pages/AwesomeForces.aspx accessed 1 May 2015.
23 Jock Phillips, "Forecasting the Weather and Telling the Time," in Simon Nathan and Mary Varnham, eds, *The Amazing World of James Hector* (Wellington: Awa Press, 2008), 85–7.
24 Barker, "Station Life," 54–5.

The wind can be "smelt, heard and felt, if not touched, and its effects are visible," write Chris Low and Elizabeth Hsu.[25] But how can the wind be materialized in a museum? Can museum collections and future collecting render climate change as a relationship between weather, local physical objects and cultural practices? The literal use of collections associated with measuring and quantifying the weather is one such starting point. For example, the Canadian Museum of Civilization holds a collection of over 100 weather vanes. In Canada, a "flexible and accurate gauge of wind direction … became an indispensable tool to the pioneer."[26] These are now also valued as folk art, incorporating distinctive motifs, such as beavers, horses, cows, fish and roosters. Such objects might prompt discussions about how increasing amounts of greenhouse gases in the atmosphere are affecting established or vernacular understandings of the wind.

The real challenge is to think beyond the material culture explicitly associated with knowing the weather, to that which is associated with experiencing it. In this respect, Te Papa's collections, covering natural environment, New Zealand and international history, Pacific cultures, Māori *taonga* (treasures), art, and photography, are ideal. This breadth of holdings encourages cross-disciplinarity (also a fundamental philosophy of the museum), and has the potential to materialize the weather in ways that engender a range of responses.

To illustrate this potential, I'd like to briefly consider one object in Te Papa's history collection as the centerpiece for an exhibition about the wind. The object given to the museum in 2003 is one of national and arguably international significance. It is NZL 32, the

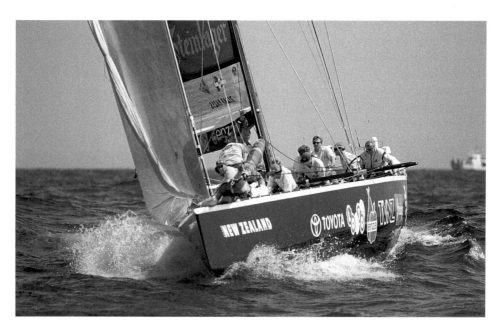

Figure 16.5 NZL 32, New Zealand's entry in and the eventual winner of the 1995 America's Cup, *c.*1995. Photo: Ivor Wilkins.

25 Chris Low and Elizabeth Hsu, "Introduction," *Journal of the Royal Anthropological Institute* 13 (supplement 2007): S10.
26 Pierre Crépeau, *Pointing at the Wind: The Weather-vane Collection of the Canadian Museum of Civilization*, Canadian Museum of Civilization, Hull, 1990, 6.

yacht skippered by Sir Peter Blake when Team New Zealand won the America's Cup in 1995.

Currently NZL 32 is on loan to Voyager Maritime Museum in Auckland, displayed in *Blue Water Black Magic,* which is a tribute to the late Sir Peter Blake. The exhibition is a celebration of his life and achievements, within a broader context of New Zealand maritime and yachting history. The yacht is also displayed as an exemplar of national technical innovation, while covertly suggesting a particular tenacious national character.

These provide enticing hooks for visitors, especially for sports enthusiasts and visitors interested in New Zealand's national identity. However, NZL 32 also launches multiple narratives about the wind and by extension the culture of the weather. A provisional set of exhibition themes could encompass recreation and the wind; depicting the wind; predicting the wind and the weather; dressing for the wind; feeling the wind; measuring the wind; wind power and technology; and the future of the wind. A decent exhibition budget might cover the cost of a wind tunnel so that visitors really get to feel the force of the wind. None of these themes are directly about emissions of greenhouse gases, complicated or contentious climate models, or an imminent apocalypse. Many of these things are intangible or abstract. But the material culture of the weather, such as NZL 32, will ground people facing the challenge of an elusive, unpredictable climatic future.

Conclusion

We are faced today with unknown weather patterns and erratic seasons. Sometimes it does feel as if there are four of them in one day. People talk a lot about the weather but rarely discuss the issue of climate change or how they will mitigate or cope with its impact. It is an emotional topic, which often evokes negative responses and feelings, and a sense of helplessness. Where can we get authoritative information about climate change that helps us live in the present and do something about the future? Museums can play a role here by creating an emotional and social space for communities to come together to personally explore and respond to climate change.

Mike Hulme contends that by presenting climate change "as a global problem, one that is distanced and un-situated relative to an individual's world, we make it easier for citizens to verbalise superficial concern with the problem, but a concern belied by little enthusiasm for behavioural change."[27] By exhibiting the weather as culture in a national and even regional context, and giving visitors the opportunity to feel the weather themselves, Te Papa and other museums may be able to break down this distance.

27 Hulme, "Geographical Works," 8.

17

OBJECT IN VIEW

Nelson the Newfoundland's dog collar

Martha Sear

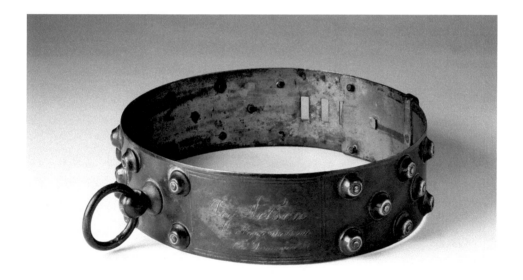

Figure 17.1 Nelson the Newfoundland's dog collar, *c.*1880. National Museum of Australia. Photo: Katie Shanahan. © National Museum of Australia. See Plate 17.

At 8pm on 15 November 1881, a thunderstorm broke over central Melbourne, in the Australasian colony of Victoria. Heavy rain fell for nearly an hour, and the city was soon flooded. The south ends of Elizabeth Street and Swanston Street were worst affected. The *Argus* reported, "in both these streets the water was flowing in one broad stream extending from shop door on one side to shop door on the other."[1]

1 "Flood in the Melbourne Streets. Miraculous Escape of a Cab Driver." *The Argus* (Melbourne, Vic.), 16 November 1881, 8.

At the intersection of Swanston and Lonsdale streets, cab driver Thomas Brown was trying to calm his frightened horse, when it tossed its head and knocked him, dazed, into the torrent.

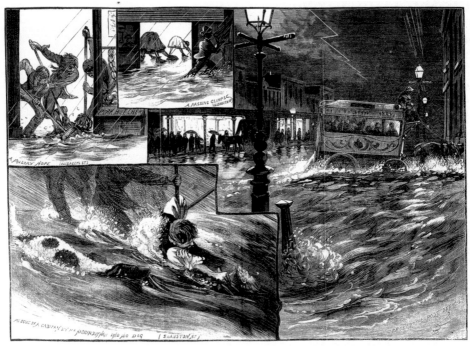

Figure 17.2 An engraving of the rescue and other scenes from the flood, from the *Illustrated Australian News*, 30 November 1881. State Library of Victoria.

The cabman's cries were heard by Swanston Street tobacconist, wig-maker and hairdresser Bill Higginbotham and his dog, Nelson. Luckily for Brown, Nelson was a Newfoundland. Bred by fishermen in Canada, Newfoundland dogs have a strong instinct for water rescue and retrieval. With their large, powerful bodies, water-resistant coat and webbed feet, they were often employed to save people and cargo from shipwrecks.

Nelson made repeated attempts to catch hold of Brown, persisting even when the cab driver was sucked into a culvert and given up for dead. In a final effort, Higginbotham, another man Mr. Mates, and Nelson plunged into the racing stream and managed to haul Brown out of the water. Bleeding and with his clothes torn to shreds (probably by Nelson's teeth), Brown was taken to hospital but was not badly injured. Higginbotham and Nelson, on the other hand, took weeks to get over the incident and never fully recovered their health.

Months later, Nelson led a fire bridge parade and was presented with this engraved dog collar in recognition of his role in the rescue. Although it is now worn back to the underlying copper, conservation tests show it was once nickel-plated so that it shone like silver.

The National Museum of Australia acquired the collar following an auction in 2011. It is currently on display in an exhibit exploring the colonial foundations of Melbourne in the

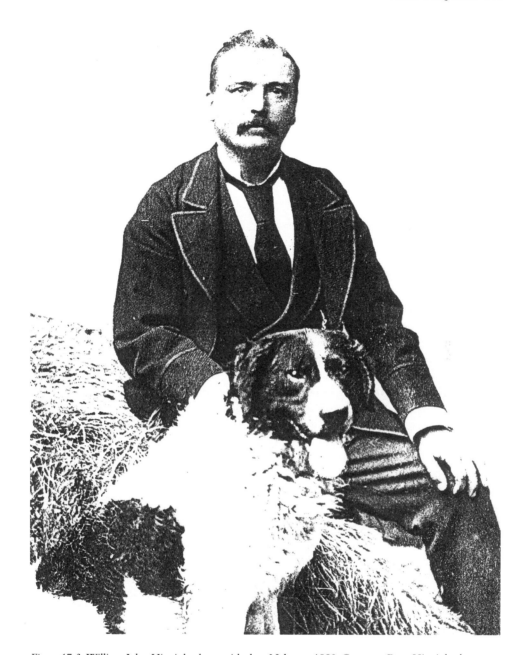

Figure 17.3 William John Higginbotham with dog, Nelson, c.1880. Courtesy Russ Higginbotham.

Museum's *Landmarks* gallery. Above the collar sits an 1837 plan showing the grid of streets overlayed by surveyor Robert Hoddle onto a gently sloping valley lying north of the final freshwater stretch of the Yarra River.

At the bottom of the valley was a creek gully, whose undulating path to the river was replaced by the straight lines of Elizabeth Street. A block further east, Swanston Street

followed a parallel course along low ground. From their creation in the late 1830s, both streets were subject to severe flash flooding. When it rained, reported the *Illustrated Australian News* in 1881, city streets became "miniature rivers, down which the water rushes at an extraordinary rate, and pedestrians find it exceedingly difficult to cross".[2]

Crowded House sing of Melbourne's *Four Seasons in One Day*. The area's Indigenous people likely recognized many more than four seasons in their yearly cycle, and its two rainfall peaks, the steepest of which aligns with September, October and November. It is fitting that the city's Rugby League team is named "The Storm". In those months sudden, drenching storm fronts soak the city, many of them the result of warm, humid air from northern Australia meeting cold low pressure systems in northern Victoria, hundreds of kilometres away.

In the nineteenth century, these downpours posed a significant risk to human life in Melbourne. Besides the threat of the rising river, flash flooding in city streets caused major damage and frequent loss of life. Major stormwater mitigation measures removed this danger from the Central Business District by the early twentieth century. The large, open street drains of 1881 – into which city dwellers poured their waste and sewage, earning the city a new nickname "Smellbourne" – were replaced by huge network of underground drains now maintained by the City of Melbourne. Hidden beneath skyscrapers and footpaths, stormwater from Melbourne's streets still travels on its ancient course to the river and the sea.

So what meanings could Nelson's collar, and the story of a stormy November night in 1880s Melbourne, have for contemporary audiences?

First, it makes me wonder about our consciousness of weather in the city, and of the interplay between land, sea and sky that produces it. Weather, like the seasons and the movement of the sun, alters the experience of being in a city in each moment. As a storm approaches, we watch the clouds fill up the spaces between buildings, or if we work or live high above the ground, we see them coming from afar. Perhaps if we live in a tall skyscraper, they could even envelop us completely. Rain falls, people get wet, cars plough through temporary puddles, yet the centers of most cities today are fairly insulated from the dangerous impact of stormwater, as it is swiftly swallowed by a huge network of drains below the streets that capture the dumping rain and channel it elsewhere, out of sight.

Storms still drench the streets of Melbourne, and the contours of old creekways still shape the city plan. A key map in the Melbourne Planning Scheme is the "Special Building Overlay", which shows in blue the corridor of an ancient creek/floodway running down Elizabeth Street (one street West of the scene of Nelson's heroics) marking "land in urban areas liable to inundation by overland flows from the urban drainage system". The purpose of the document is to direct building and construction work that "maintain[s] the free passage and temporary storage of floodwaters" and "minimises flood damage".[3]

The collar asks us to imagine living in a city where a storm, especially a violent and sudden one not presaged by a weather warning or radar image, brought a potential risk to life and limb. And it asks us to consider the powerful presence in the inner city of large volumes of water dropping from the clouds and forcefully making its way to the river and the sea, changing the street suddenly from dry land into a river.

2 *Illustrated Australian News* (Melbourne, Vic.), 30 November 1881, 217, 218.
3 Melbourne Planning Scheme, accessed at http://planningschemes.dpcd.vic.gov.au/schemes/melbourne

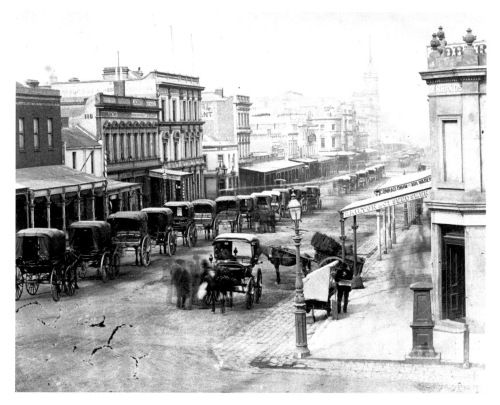

Figure 17.4 "Swanston Street looking S [South] from Lonsdale Street", c.1870–1880. Albumen silver photograph: 14.5 × 19.0cm. State Library of Victoria, Accn No: H31510.

The collar also invites us to connect our reflections on how we understand weather in the city to growing knowledge around the probable impact of climate change on urban environments, especially around flash flooding events. It seems likely that climate change will reintroduce some of the experiences bound up in the Nelson's collar story back into Melbourne's city life. The City of Melbourne's *Adapting to Climate Change* document explains that "climate change is predicted to increase the frequency and intensity of flood and extreme storm events in Melbourne."[4]

Flash flooding is known to cause the most deaths or injuries of all natural disaster weather events and is the main threat in an intense rainfall event. New rainfall patterns and models predict rainfall intensity will increase 0.9 per cent by 2030 and 5.9 per cent by 2070, and extreme event scenarios are likely to increase the extent of flooding in those areas but unlikely to create new flooding hotspots altogether.

So the environmental forces that shaped the Melbourne of 1835 and 1881, some of which still lie deep below the city streets, will assert their presence again in the midst of new dynamics in the land, sea and sky. The city's own micro-climate, the product of new buildings, hot concrete, air-conditioning vents, parks and windways, will interact with these

[4] City of Melbourne, Climate Change Adaptation Strategy, 2009, accessed at www.melbourne.vic.gov.au/AboutCouncil/PlansandPublications/strategies/Documents/climate_change_adaptation_strategy.PDF

changing systems in new and unexpected ways. City planners will seek to channel and redirect the results in an effort to protect lives and property.

Some of the suggested changes to urban infrastructure include improved capture and reuse of stormwater ("stormwater harvesting" – recognition of the likely increase in drought as well as flood); the introduction of "permeable pavements" to the city's streets (allowing water to be stored in the soil rather than running off); the application of part of the Urban Forest Strategy that sees the introduction of "tree pits" to absorb water from the street; and encouraging residents to install "rain gardens" and water tanks to contribute to water capture – all plans that reintroduce historical environmental elements back into the cityscape to address future climate change.

How else could we respond to these new storms and floods? We will need to become more aware of allowing (and not fighting) the "free passage" of water from storms through our places and our days, as well as the growing risks that come with of those waters. Perhaps we should also encourage the training of dogs who, like Nelson, are fitted for swimming and rescue and could help as rising water levels and flash flooding become more common in our cities and towns.

18
THE LAST SNAIL
Loss, hope and care for the future[1]

Thom van Dooren

In a single room, tucked away on the main Honolulu campus of the University of Hawai'i, a group of dedicated people have set up an "ark" – a place of last refuge – for some of the islands' many highly endangered tree snails. The ark is not a particularly fancy affair. It is comprised of about six "environmental chambers" that look quite a lot like old refrigerators. These units allow staff to control daily temperature, light and "rain" cycles to provide ideal conditions for their slimy inhabitants. Inside each unit are a whole lot of small terrariums – like the kind you might keep a pet rat or fish in – these ones, however, are home to a variety of local snails, and have been filled with the 'ōhi'a and other local vegetation that they would ordinarily live amongst.

On a warm January afternoon in 2013 I was lucky enough to get a tour of this facility from its founder, Professor Mike Hadfield. Amongst the many things that I learned chatting with Mike that afternoon was the fact that these snails don't actually eat the leaves that they live amongst. Rather, they eat an invisible layer of molds and algae that they scrape off the top of leaves. Consequently, in order to ensure that their charges have a good, balanced, diet, Mike and his team have developed a method of culturing one of these molds on agar in petri dishes to produce little "cakes" that can be used to supplement the fresh vegetation.

In addition to the daily maintenance of the facility, every two weeks each of the terrariums is taken out, its inhabitants carefully counted, and the whole unit disinfected. All in all, keeping snails alive and thriving in a captive ark like this one is hard work, requiring dedicated daily care and an ongoing curiosity about how to make their conditions, and indeed their lives, better. Donna Haraway, the mutual friend who put me in contact with Mike, has written elsewhere about the careful practices that underlie work in this snail program.[1] For Haraway, this work is an exemplar of the kind of attentiveness practiced by good biologists – in the field or the lab – that enables them to simultaneously care for the wellbeing of their "critters" and generate reliable data about the world. Here, we see that care,

1 This short chapter is adapted from a larger discussion of conservation in Hawai'i, to be published as Thom van Dooren, "Banking the Forest: Loss, Hope and Care in Hawaiian Conservation," in *Defrost: New Perspectives on Temperature, Time, and Survival*, edited by Joanna Radin and Emma Kowal (MIT Press, forthcoming).
2 Donna Haraway, *When Species Meet* (Minneapolis, MN: University of Minnesota Press, 2008).

Figure 18.1 An environmental chamber. University of Hawai'i, 2013. Photo: Thom van Dooren.

far from being antithetical to research, might enable new forms of responsiveness – perhaps even "politeness"[3]– that broaden our sense of what matters to others and consequently enrich our understandings. This is a possibility for people involved in the maintenance of "collections" of all kinds, from galleries and museums to snail arks.

My specific interest in this short chapter lies in the way these caring practices might enable hopes for the future. What kinds of possibilities for the future does the snail ark hold open?

But before turning to these more complex questions, it is perhaps necessary to start with a basic one: why go to all this trouble to keep snails in captivity? The answer is an all too familiar one. As with most captive breeding programs, the snail ark is an effort to hold species that are at the edge of extinction in the world a little longer. In little over a thousand years these snails have gone from having no significant predators at all, into an environment with numerous overlapping threats. First of all came the rats – introduced by Polynesian peoples, but then supplemented with additional species by later European explorers and settlers. Rats can eat a huge number of snails when they put their minds to it, and they have done so in Hawai'i. In addition to these key predators, over the years Hawai'i's endemic tree snails have also had to cope with massive losses of native forest habitat and the introduction of other significant predators, like Jackson's chameleons (*Trioceros jacksonii*) from East Africa and a species of larger, carnivorous snail (*Euglandina rosea*) from North America.

While some of Hawai'i's snails now hang on in this small ark, they are a tiny fraction of the islands' original diversity. An estimated 75 percent of the more than 700 named species have already been lost.[4] Of the 43 species in the particular genus of snails on O'ahu that Mike's work focuses on (*Achatinella*), only ten remain – all are federally listed as endangered.

Figure 18.2 Hawaiian tree snail shell collection, University of Hawai'i, 2013. Photo: Thom van Dooren.

3 Vinciane Despret, "Sheep Do Have Opinions." In *Making Things Public. Atmospheres of Democracy*, edited by Bruno Latour and Peter Weibel (Cambridge, MA: MIT Press, 2006).
4 Robert. H. Cowie, Neal L. Evenhuis, and Carl C. Christensen. *Catalog of the Native Land and Freshwater Molluscs of the Hawaiian Islands*. Netherlands: Backhuys Publishers, 1995.

Many other groups of plants and animals in Hawai'i are in a similar state. Of the 113 bird species known to have lived exclusively on the Hawaiian islands just prior to human arrival, almost two-thirds are now extinct. Of the 42 species that remain, 31 are federally listed under the *Endangered Species Act*.[5] Roughly a third of Hawai'i's 900–1,000 endemic plant species are similarly listed and as many as 100 are already thought to be extinct.[6] With these statistics in mind, it is not hard to see why Hawai'i is now considered to be one of the "extinction capitals" of the world.

While conservation in general is often poorly funded, Hawai'i really is in a league of its own in the United States. Despite having a huge proportion of the country's federally listed endangered species, the state receives a tiny percentage of the relevant funding. Without the political or economic clout to change this situation, Hawai'i's vanishing species remain largely invisible.[7] And so, slowly, silently, a whole range of endemic species – including many that are yet to be documented – are slipping away in Hawai'i.

In this dire context, Mike explained this particular project as "a last-ditch effort to "save snails" that would certainly have been devoured by alien predators … in the immediate future."[8] Although underwritten by intense processes of loss, this snail ark represents an important site for the production and maintenance of hope: it contains within it the possibility that at some time in the future, after the wreckage has cleared, at least some future might be possible for these species.

More specifically, I view this project as an example of what Eben Kirksey has called "modest forms of biocultural hope."[9] Kirksey is here writing with and against Jacques Derrida, and in particular the emptiness, or indeterminacy, of Derrida's notion of the "to come," of a messianicity without messianism.[10] Here, Derrida emphasizes a relationship of radical openness towards the future that is not locked down to any particular vision or project. Grounded in the notion of the event, the unexpected, that ruptures temporal continuities in the name of something wholly new, Derrida sees a primary responsibility in remaining open to the unpredictable, the incalculable.[11]

5 David L. Leonard, "Recovery Expenditures For Birds Listed Under The US Endangered Species Act: The Disparity Between Mainland And Hawaiian Taxa," *Biological Conservation* 141 (2008): 2054–2061.
6 J. Delay, Mark Merlin, Juvik, J., Perry, L., and Castillo, M. (n.d.). *Rare and Unusual Plants: Island of Hawaii*. Lyon Arboretum Special Report (2005).
7 Leonard, "Recovery Expenditures," 2054–2061; Marco Restani and John M. Marzluff, "Funding Extinction? Biological Needs and Political Realities in The Allocation Of Resources To Endangered Species Recovery," *BioScience* 52 (2002): 169–177.
8 All references to Mike Hadfield refer to our conversation during my visit in January 2012 or a personal email correspondence with him in February 2014.
9 S. Eben Kirksey, Nicholas Shapiro, and Maria Brodine, "Hope in Blasted Landscapes," *Social Science Information* 52 (2013).
10 Jacques Derrida and Maurizio Ferraris. *A Taste for the Secret* (Cambridge: Polity Press, 2001).
11 I am not sure that Derrida's approach is as empty of content as it first appears. His approach is centrally occupied with bringing about a better future. In this context, the "to come" takes the form of what Paul Patton has called "a promise": "it is a means by which an imagined future can intervene in or act upon the present. Just as a promise in relation to some future state of affairs has consequences for one's actions in the present, so the appeal to justice or to a democracy to come will have consequences in the present" (Paul Patton, "Politics." In *Understanding Derrida*, edited by Jonathan Roffe and Jack Reynolds (Continuum: New York, 2004), 26–34. Here, Derrida's broader body of work gives many indications of the kinds of "projects" – democracy, justice, hospitality – that might animate and guide our actions in the present. The fact that justice, for example, will never "arrive" in the present – that perfect justice is *impossible* – is precisely what gives it, and will continue to give it, the capacity to motivate *better* futures (Derrida and Ferraris, *A Taste for the Secret*; Cantall Mouffe and Ernesto Laclau, "Hope, Passion, Politics." In *Hope: New Philosophies for Change*, edited by M. Zournazi, 122–149 (Annandale, NSW: Pluto Press, 2002), 128).

In contrast, Kirksey emphasizes the need for more *grounded* hopeful projects, engaged in practical and concrete acts of care for the ongoing biological and cultural richness of our world. These are not utopian visions that hope to set everything to rights in one fell swoop, but modest efforts to make a difference in often creative and inclusive ways that draw others into an opening – rather than recruiting them into a fixed vision of how things might be. Although the future remains fundamentally unknown and unknowable, Kirksey calls for modest projects that respond where they can to the challenges we can already see around us in an effort to build a better future (however partial and uncertain our vision of it may be).[12]

At the snail ark this hope takes the form of the daily acts of care that sustain living beings, and through them the future of their species: the maintenance of environmental chambers, the cleaning of terrariums and the careful counting of individuals that helps to ensure the good mortality records that enable early detection of any potential problems.[13] Beyond this life support, staff and students are also engaged in larger efforts to better understand the causes of snail decline in the islands' forests and ultimately to get them back out into the world. This is an intensely grounded and practical form of hope; working to imagine and craft better futures.

But if we slow down with these snails for a moment, enough to think into their complex situation, we might be able to understand more fully the forms of hope produced and sustained here. In what sense have these snail extinctions really been delayed in this ark? What kinds of futures, what kinds of hopes, should we really entertain on behalf of these species?

Amongst the many endangered snails that I saw in the lab, one in particular stood out: *Achatinella apexfulva,* a single snail in a terrarium all on its own. It is on its own because this tiny being is now thought to be all that is left of its species. After a decade of searching in the wild, scientists have been unable to locate any more. Hope mingles with loss in palpable ways in an interaction like this. We are compelled to hope and care and yet we must also acknowledge the hopelessness of the situation.

This snail offers a tragic example of the "non possibility" of at least some of the lives "banked" in facilities like this one. When this snail dies, a whole evolutionary lineage will pass from the world, and yet at the same time nothing much will really change. This species is already one of what some biologists call the "living dead": it is a species whose population has become so small that extinction in the near future is now inevitable.[14] Alongside this obvious example, many of the other snail populations in the ark are also in dire trouble. In Hadfield's words, "after functioning very well for more than fifteen years, something changed a few years ago, and most of the lab-snail populations have gone into severe decline."[15] Inbreeding within small isolated populations seems to be at least partly to blame. Wherever possible, staff are now working to introduce new snails into these populations to increase "genetic vigor." But for some of the species in the ark there are now no – or very few – other survivors to draw on. For at least some of these species, there will be no release. The "ark" is in reality something more like a living tomb.

12 On a related theme, see David Wood, "On being Haunted by the Future," *Research in Phenomenology* 36 (2006): 274–298.
13 Haraway, *When Species Meet*, 91–22.
14 Genese Marie Sodikoff, "The Time of Living Dead Species: Extinction Debt and Futurity in Madagascar," in *Debt: Ethics, The Environment, and the Economy*, ed. Peter Y. Paik and Merry Wiesner-Hanks (Bloomington, IN: Indiana University Press, 2003).
15 Pers. comm. 2014.

Figure 18.3 The last snail: *Achatinella apexfulva*. University of Hawai'i, 2013. Photo: Thom van Dooren. See Plate 18.

In fact, all of Hawai'i's endangered tree snails find themselves in a dire situation. Restoring habitat for these species will be an incredibly difficult task, if it is possible at all. Their diverse introduced predators – rats, other snails, chameleons – are very difficult to control in a forest environment. Even introduced ants have been known to kill snails. In relatively small spaces, conservationists have worked to establish habitat for release. With assistance and funding from the US Army, they have set up high-tech barriers incorporating electric fences, video surveillance and a range of other devices to both exclude predators and monitor the barrier. It is then a matter of eradicating all predators inside the fenced area along with ongoing vigilance to ensure that they don't reestablish themselves.[16] This is an approach that can obviously only be applied in small areas. It is also an approach with a questionable chance of *long term* success. For now, however, it may carry these snails through a little longer.

These gastropods help us to see that in at least some cases, living "collections" like this ark are not quite what they seem. Rather than preventing extinction, what has actually been delayed – with respect to at least some of these species – is simply the *recognition* of extinction, the recognition that something significant *has been* lost. Single individuals or declining populations stand in for this thing called a species, keeping it off the official listings of the departed. This way, when that moment of recognition does finally arrive, extinction has been so long coming that no one can really be surprised. After so long in a refrigerator, even the

16 Hadfield 2014, pers. com.

long drawn out ripples of loss and change that constitute an extinction,[17] will have largely settled into new patterns of life (and death). This, I think, is a key part of the danger of hope, of working to imagine a better future: if it is a future that cannot come – if it is a future that has already been lost – then hoping for it is no longer helpful.

Hope is often associated with the affirmation of life, the refusal to give up, and consequently the absence of hope is associated with despair. As Mary Zournazi puts it: "Without hope what is left is death – the death of spirit, the death of life – where there is no longer any sense of regeneration and renewal."[18] But sometimes affirming life is not what is needed. Instead, hope for ongoing life becomes a form of denial that allows us to go on without having to come to terms with our reality or with the vital need for change. In this way, these hopeful conservation projects enable the laundering of what some biologists call our "extinction debt"[19] – rendering invisible all those extinctions that are now inevitable as a result of our past actions, extinctions that are already unraveling the world in various ways. In so doing, these kinds of biodiversity banking projects, whatever their intentions, can play an important role in undermining our imaginative and moral capacity to *perceive* the pressing crisis of the current mass extinction event.

Beyond delaying the recognition of extinction, however, these banks also have the potential to delay much-needed conservation action, providing an excuse for inaction, resting in the comfort that we have a secure "backup." In some cases they might have a positive effect, providing strong incentives to deal with larger conservation issues to create the habitat necessary for a population's release. Banked lives can be mobilized in either rhetorical direction. There is a worrying analogy to be drawn here with debates about ecological restoration and the way in which the spin and quasi-possibility of "putting things back later" has been captured by mining companies and others interested in the continuation of business as usual. If species can be collected, held in captivity and put back later – or rather if the perception can be created that they can be – then new possibilities open up for exploitative practices in fragile places. As Chantal Mouffe reminds us "hope can be something that is played in many dangerous ways."[20]

This surely is not the intention of the many committed individuals who dedicate so much of their lives to the snail ark and other biodiversity banking initiatives, but in dark times the lure of hope as a form of denial or distraction can be very strong. In this context, the ongoing call in the environmental movement to focus on hope and hopeful narratives becomes somewhat worrying. Increasingly we are told that "good news stories" instead of "doom and gloom" are what is needed to compel people to appropriate action.[21] There is a strange similarity, although far from an equivalence, between Derrida's appeal for a radical openness towards the future, a hopeful invocation of the "to come," and the vague way in which environmentalists now often urge one another to focus on the positive. In this context, what is hoped *for*, often seems less important than the act of being hopeful, of encouraging others

17 Thom Van Dooren, *Flight Ways: Life and Loss at the Edge of Extinction* (New York: Columbia University Press, 2014).
18 Mary Zournazi, *Hope: New Philosophies for Change* (Annandale, NSW: Pluto Press, 2002), 16.
19 Sodikoff, "Time of Living Dead Species."
20 Mouffe & Laclau, "Hope, Passion, Politics," 126.
21 Brand 2013, *Futerra Sustainability Communications: Branding Biodiversity: The New Nature Message*. Retrieved from www.futerra.co.uk/downloads/Branding_Biodiversity.pdf ; Elin Kelsey and Clayron Hanmer. *Not Your Typical Book about the Environment*. Toronto: Owlkids Books, 2010.

into a particular state of being towards the future. But vague and general "hope" is not always helpful. Instead, what is needed is more attention and a critical lens on what it is we are *specifically* hoping and working towards. As Ghassan Hage has argued, "we need to look at what kind of hope a society encourages rather than simply whether it gives people hope or not."[22] What should we be hoping *for* in these times of incredible loss? Are we able to hope responsibly? Which is to say, can our hopes be translated into meaningful action and taken up in a way that recognizes the myriad losses and exposes the dangers that lie within the things we hope may come to pass?

I see this kind of hope as a practice of "care for the future." Care must be understood here as something far more than abstract well-wishing. As Maria Puig has noted, a "thick" notion of care requires that it be understood as simultaneously, "a vital affective state, an ethical obligation and a practical labour."[23] To care for another, to care for a possible world, is to become emotionally and ethically entangled and consequently to get involved in whatever practical ways that we can. But, as Haraway notes, caring deeply also "means becoming subject to the unsettling obligation of curiosity, which requires knowing more at the end of the day than at the beginning."[24] Knowing more, in this sense, is about being drawn into a deep contextual and critical knowledge about the object of our care: *what* am I really caring for, *why*, and at *what cost* to whom?

The grounded and responsible hope that we need today, hope for a world still rich in biocultural diversities of all kinds, requires this kind of care for the future. It requires a grounded and practical care, but also one that is committed to a critical engagement with the means and consequences of its own production. I am not sure how this understanding might alter the snail ark; how an ark constructed along these lines might function to make visible its own concerns for all of those things that it cannot quite hold onto, and all those that it cannot hope to restore.

Ultimately, I don't think that this discussion means that we should abandon the snails in the Hawaiian ark, or the countless other species "banked" in similar conservation facilities around the world. Importantly, some of these projects have and will "work" – in the sense of getting species back out in the world in meaningful ways. Even where this will not be possible, however, I understand the desire to hold onto individuals like the last *Achatinella apexfulva* for as long as we can – provided that they are living flourishing lives – as an effort to cultivate some semblance of responsibility for another whose world we (collectively) have destroyed. Instead, my intention has simply been to unsettle the notion that banking biodiversity and embracing hopeful futures are both unproblematically "good." While in times like these we certainly need all of the conservation efforts that we can muster, it remains vital that we pay careful attention to the means by which particular approaches generate and sustain their visions for the future. For at least some species, the time for hopefulness about a return to the wider world has passed. It is time for us to acknowledge, to take responsibility and care for, other kinds of futures.

22 Ghassan Hage, "'On the Side of Life' – Joy and the Capacity of Being." In *Hope: New Philosophies for Change*, ed. by M. Zourna (Annandale, NSW: Pluto Press, 2002), 152.
23 Maria Puig de la Bellacasa, "Nothing Comes Without Its World: Thinking With Care." *The Sociological Review* 60, no. 2 (2012): 197.
24 Haraway, *When Species Meet*, 36.

19
OBJECT IN VIEW

Hiding in plain sight: lessons from the Olinguito

Nancy B. Simmons

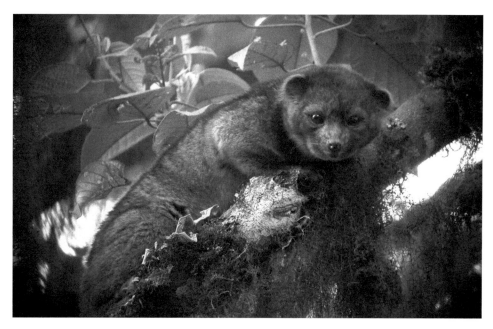

Figure 19.1 The Olinguito, *Bassaricyon neblina,* alive in the wild, Tandayapa Valley, Ecuador, 2013. Photo: Mark Gurney. See Plate 19.

The Olinguito (*Bassaricyon neblina*; Figure 19.1) is a new species of mammal described in 2013 by Helgen *et al.*[1] This species – and the story of its discovery – is remarkable for many reasons. An elegant, long-tailed creature weighing a little less than a kilo, the Olinguito is

1 Kristofer Helgen *et al.*, "Taxonomic Revision of the Olingos (*Bassaricyon*), with Description of a New Species, the Olinguito," *ZooKeys* 68, no. 324 (2013).

the first new living species of Carnivora (the group containing cats, dogs, bears, weasels, raccoons, and their relatives) to be named from the Americas in over 35 years. Although now known to be extant in the wild, the authors first discovered the Olinguito in museum collections.

The holotype of *Bassaricyon neblina* is AMNH 66753, old adult female collected by curator George Tate in 1923 in Las Máquinas, Ecuador. But the Olinguito is not known from only a single specimen: once the authors knew what they were looking for, they found specimens in six museums including the American Museum of Natural History (New York), Field Museum of Natural History (Chicago), National Museum of Natural History, Smithsonian Institution (Washington DC), Museo de Zoología, Pontificia Universidad Católica del Ecuador (Quito, Ecuador), Museo Ecuatoriano de Ciencias Naturales (Quito, Ecuador), and the Naturhistoriska Riksmuseet (Stockholm, Sweden). These specimens had been in museum drawers for decades, preserved and maintained but not recognized as a new, undescribed species.

Smithsonian Curator Kristofer Helgen was the initial discoverer of the Olinguito. He was working on a revision of the Olingo group (genus *Bassaricyon*), which are small members of the raccoon family. Opening a museum drawer one day, he found preserved skins that were a different color – more reddish – than any he had seen before (2). Careful examination and comparison of skulls and teeth confirmed that this was a new animal that was different from any previously described. Using a combination of anatomy, morphometrics, DNA analyses, and geographic range modeling, Helgen and his colleagues documented not only the

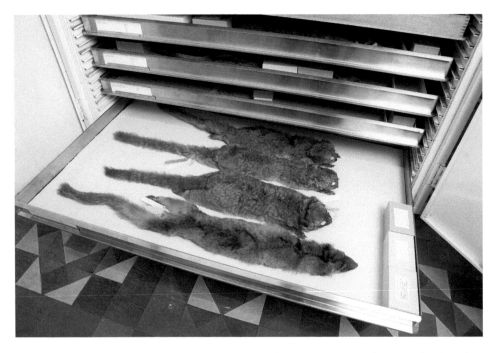

Figure 19.2 Specimens of the Olinguito, *Bassaricyon neblina*, in a museum drawer at the American Museum of Natural History. All of these specimens were collected in the early 1900s. Photo: Denis Finin, AMNH. See Plate 20.

existence of this species, but also four subspecies within it, all endemic to threatened cloud forests of the Andes of Colombia and Ecuador.[2]

Once Helgen and his colleagues had documented the existence of the Olinguito as a new species based on museum specimens, this raised another question: were these animals still alive in the wild? The authors staged an expedition to the Andes of Ecuador to try to find out. Sure enough, their first night in the field they found a living Olinguito, and they were able to obtain photographs (Figure 19.1) and samples for genetic analyses. Armed with photos of the animal and data regarding the phenotype, geneotype, and geographic range of each unique subspecies, Helgen and his colleagues published their account in the open-access journal *ZooKeys*. Their publication included comparative plates of skulls of museum specimens, historic photos, maps, and color illustrations of both the Olinguito and its close relatives in the genus *Bassaricyon*. Bioclimate and vegetation models allowed them to hypothesize the possible geographic range of each species and to evaluate their conservation status of species following IUCN guidelines. They recommended that the Olinguito be categorized as "Near Threatened" based on its reliance on cloud forest habitats threatened by deforestation.[3] They noted that the long-term survival of the Olinguito will depend on the preservation of the upland forest fragments that remain within their range, and restoration of degraded habitat to maintain connectivity between populations.

Simultaneous with the *ZooKeys* publication, the authors staged press conferences in Washington DC, Raleigh, North Carolina, and Quito, Ecuador to announce the discovery of the Olinguito. These events were picked up by major news organizations around the world including CNN, ABC, The Wall Street Journal, Time Magazine, The Huffington Post, National Geographic, The Daily Mail, and the Spanish language outlets El Comercio and El Universo in Ecuador. Videos about the Olinguito were produced by groups ranging from news organizations to science bloggers, and many of these were posted on YouTube. By the end of 2013, a simple Google search on "Olinguito" resulted in over 650,000 hits, with a similar search on YouTube returning records of over 6,600 videos. School children learned about the Olinguito in "Time For Kids" magazine and in "Scholastic News." In short, the Olinguito had become a well-known animal in a remarkably short period of time.

Helgen et al.[4] suggested that "[the Olinguito's] discovery introduces a novel flagship species around which to rally conservation initiatives in the [Andes of Colombia and Ecuador]. Preserving cloud forests in this region would benefit the long-term conservation of the Olinguito, and many other Northern Andean cloud forest endemics." Given the attention that the Olinguito has garnered, this seems like an achievable goal. And it all started with a scientist sorting through decades-old specimens in a museum drawer.

2 Ibid.
3 Ibid.
4 Ibid., 53.

PART III
Focusing on the future

Figure III.1 PHARMAZIE exhibition, Deutsches Museum, 2000. Photo: Deutsches Museum. See Plate 23.

20
THE REEF IN TIME

The prophecy of Charlie Veron's living collections

Iain McCalman

In the year 1972 young Charlie Veron felt bewildered as he swam underwater among the dazzling corals of the Great Barrier Reef. Perhaps this was a moment of nemesis, he mused; he'd fluked a job as the first full-time professional scientist on the Great Barrier Reef without any qualifications in marine biology, and now the identity of the corals he saw among the fringing reefs off Townsville eluded him.

Little John Veron had been known as "Charlie" ever since his first grade teacher had given him the nickname in honor of his Darwin-like passion for nature. She was not to know that he would also go on to emulate Charles Darwin's dismal senior school and university achievements. Even so, Charlie had fluked a university scholarship by passing an experimental IQ exam, which funded his science degree at a small rural university in New South Wales. Falling in love and marrying a fellow student kept him rather reluctantly in academic harness, though his dream was to emulate Darwin's friend Alfred Wallace by making a field trip to the Amazon. By 1970, though, Charlie was still at university, struggling to complete a self-discovered, self-supervised PhD thesis on dragonflies that seemed to be flitting in too many directions. Believing that it would never come together, he had one day answered an advertisement from another university, James Cook, newly established in northern Queensland. They wanted a marine biologist with diving experience to undertake postdoctoral work studying Great Barrier Reef corals. Apart from his BA Hons. in entomology, Charlie's sole qualification was having once collected corals on a beach holiday with some scuba diver friends. They'd blundered on a small, undiscovered embayment of tropical corals lurking in the temperate zone off the coast of New South Wales. Excited by their find, the students had intended to push for the area to be listed as a marine reserve, but they'd never quite got around to it.

Still, Charlie forgot all about his dubious James Cook application because the dragonfly thesis eventually clicked and he found himself in 1971 receiving a PhD, a prize, and an offer to undertake postdoctoral work in entomology at a major North American university. Though tempted by the thought of an income, Charlie was nagged by doubts. He'd always been a passionate nature lover and seaside specimen collector. For much of his childhood he had even kept a baby blue ring octopus as a pet, in happy ignorance of its fatal venom. He'd

certainly never wanted to become an academic; and the thought of submitting to a disciplined and competitive North American university environment made him bilious. Just then he'd received a terse reply from James Cook: as the sole applicant, he had the job. Lured by the thought of the underwater beauty, freedom and mystery of the Great Barrier Reef, Charlie accepted. By this one impulsive action, Charlie had triggered a series of bizarre outcomes. He was berated by his supervisor for chucking up entomology in favor of "a diving holiday"; he became a marine biologist without ever having attended a lecture in the subject; he learned that he was the Great Barrier Reef's first full-time scientific researcher; and he found himself utterly unable to identify the corals around the reefs, cays and islands of Townsville.

In this chapter I will attempt, to show, first, how the bafflement of a maverick Australian diver-collector culminated in the discovery of three key properties of Barrier Reef and other world corals: their distinctive mode of evolution; their capacity to archive past planetary catastrophes; and, most importantly, their ability to predict the future plight of our climate-affected oceans. Second, I will show how these discoveries have precipitated an urgent museum-type mission to collect and preserve what we know of our planet's living corals before they disappear for perhaps 2 million years.

Lacking expert supervision because the new Professor of Zoology at James Cook University knew even less than he did about corals, young Charlie Veron knew he would have to teach himself. But how? True, thanks to the new "sport" of scuba diving, he was able to enter a living world that had been closed to earlier scientists, but viewed in underwater situ, corals seemed to be a taxonomic nightmare.

"[T]he essential problem," Charlie later recorded, "was that on the reef slopes, corals varied their growth forms and skeletal structures according to the environment in which they grew." A well-known type might appear stumpy and compact on the wave-pounded reef front, but as he swam down the protected slope it would mutate into delicate, long-branched fans. And "to make matters worse, big colonies regularly had one growth form on their top, different growth forms on their sides, and another form at their base." Yet the taxonomic guides invariably described each of these variations as a different species. Charlie had to assume that the experts were correct, but he couldn't make sense of this mélange of forms. The fact that particular coral species usually clustered together on the same reef patches "suggested there was some sort of order or natural reality, behind the apparent chaos."[1] but what was it?

All Charlie could do was improvise. Abandoning the formal taxonomic lexicon, he devised nicknames of his own to identify familiar species. He then used a way of describing them that he borrowed from the work of some local rainforest ecologists. Confronted with similarly chaotic environmental variations, they'd mapped the dynamic relationships between different rainforest species and communities, looking for patterns of connection, struggle and dominance – a process they called "population or community ecology."[2] Instinctively, Charlie was groping to apply similar ecological methods.

But as his two-year postdoctoral scholarship drew to an end, Charlie, now married with a child, needed a paid job. A longtime mentor urged him to apply for the position of foundation coral scientist at the newly formed Australian Institute of Marine Science (AIMS)

1 "1996 AMSA Silver Jubilee Awardee, Dr Charlie Veron," reprinted from *Golden Anniversary Issue of the Atoll Research Bulletin*, (2001): 494 www.amsa.asn.au/awards/winners_silverjubilee/1996_veron_charlie.php.
2 "Charlie Veron's Story," unpublished autobiography, December 2011, 80–82.

in Townsville. Charlie hedged. "I'm ineligible," he said. "I am a naturalist. Not a scientist. I'm a nature-lover naturalist, that's what I am."[3] Nobody was paying naturalists to observe and reflect about what they saw around them. The freewheeling days of Charles Darwin were long gone. AIMS would naturally want a scientist with formal marine biology credentials.[4]

In the end Charlie was again lucky. His equivalent of Darwin's Captain FitzRoy, proved to be an earthy, energetic American called Red Gilmartin, who'd been attracted to take up the inaugural Directorship of AIMs by the challenge of starting a first-class marine research center in Reef frontier port of Townsville. Meeting Charlie at a dinner party, he was drawn to this outspoken and unorthodox young scientist. Next morning, through the blur of a hangover, Charlie learned that he'd been offered the job as AIMS's first coral reef scientist. He was to start the following day, working out of a tin shed at Cape Pallarenda, northeast of Townsville, with a brief to produce a series of monographs on the corals of the Great Barrier Reef.

Charlie had no choice now but to make himself a proper taxonomist. Red told him that a comprehensive coral taxonomy had to precede any "meaningful ecological work."[5] His first task must be to visit the great natural history museums of London, Paris, Berlin and New York in order to examine the "type specimens" collected there, which underpinned the coral taxonomies of the world. On doing so, Charlie's characteristic response was to conclude that most of these foundational type specimens were "dodgy." Desk-confined taxonomists had named new coral species with promiscuous abandon. Charlie later estimated that 5,000 different names had been given to around 200 coral species.[6] The legendary British marine zoologist, Henry Bernard, whose type specimens were in the United Kingdom's Natural History Museum, was the worst offender. Had the great man spent just one day diving in the Great Barrier Reef, Charlie reflected, "his world would have been turned upside down."[7]

For the next eight years Charlie and his colleagues at AIMS threw themselves into a grinding routine of identifying, observing, mapping, collecting, illustrating, photographing and describing the myriad reef-growing corals (*Scleractinia*) in the Barrier region, from its southern temperate to its far northern tropical zones. In doing so, Charlie clocked up a record 7,000 hours of underwater diving. *Scleractinia of Eastern Australia*, the first in what would become a multi-volume monograph series, appeared in 1976 to a rough reception from Northern Hemisphere paleontologists. He found himself the target of sniffy reviews or scathing letters, all taking exception to his unorthodox views on environmental variations within coral species. His only consolation came via a letter from John W. Wells, Professor of Geology at Cornell University, one of the world's most distinguished taxonomists, who thought the book "refreshingly original."

Even so, Wells, a specialist on Marshall Islands corals, suggested that Charlie had exaggerated the problem of environmental variations in that particular location. There remained only one way for Charlie to prove his point to the famous non-diving professor. Visiting a Marshall Islands reef with Wells, he swam down around 50 meters and, at decreasing depths,

3 Veron and Borschmann, *Interview*, NLA, Tape 3.
4 "Charlie Veron's Story," 86.
5 Veron Interview, 1996 AMSA Silver Jubilee Awardee, 4.
6 J. E. N. Veron, interviewed by Gregg Borschmann, "The Songlines Conversations: John (Charlie) Veron." *Big Ideas*, ABC Radio, 6 Aug. 2006: www.abc.net.au/rn/bigideas/stories/1702863.htm
7 "Charlie Veron's Story," 106.

Figure 20.1 Charlie Veron dressed for work. Image courtesy of Charlie Veron.

collected samples of a single well-known coral species that Wells himself had described. Laying these out on a bench, Charlie left the great man to examine the samples. Wells was rocked. Shaking his head in disbelief, he conceded that they were indeed from a single species, yet most paleontologists "would have called … these specimens a different species and … would probably have made several genera of them." So converted was Wells to Charlie's viewpoint that he now began to doubt whether a single taxonomic framework of the world's corals would ever be possible.[8]

For several decades Charlie pursued the nagging puzzle of the tiny divergences between common species at different locations. His quest took him to hundreds of reefs in both hemispheres and across the Indian and Pacific oceans. He dived, observed, photographed and collected in Japan, the Philippines, Indonesia, the Cocos (Keeling) Islands, and then further afield, in Zanzibar, off the east coast of Africa, to remote Clipperton Atoll in the eastern Pacific,[9] and, after that, to almost all the earth's major reef regions. Always he traveled by boat, always he worked with locals, and always he spent hours underwater, observing, recording and comparing.

These underwater observations produced a fresh discovery. When he mapped, gathered and tracked all his records of species distribution, via what was later to become his computer database *Coral Geographic*, the data confirmed that the Great Barrier Reef's coral diversity, rich though it was, was eclipsed by the reefs of Indonesia and the Philippines. The greatest

8 Veron interview, *AMSA 1996 Silver Jubilee Awardee*, 4; Charlie Veron's Story, 116–117.
9 Clipperton Atoll is 1,200 kilometers southwest of Mexico.

coral diversity in the world comprised a roughly triangular area within the Central Indo-Pacific, known ever since as "The Coral Triangle."[10]

Yet the more Charlie ventured into these new regions, the less certain he became about his previous Barrier Reef observations. "My confidence faltered, not because the corals were different, but because most were neither different nor the same."[11] A trip to the reefs of Vanuatu, which were linked to those in Australia by ocean currents sweeping through the Coral Sea, only intensified his anguish. When Vanuatu reefs featured species in common with the Barrier Reef, they proved "virtually identical." yet not actually so. Despairing, Charlie teetered on the edge of giving up his 20-year struggle to produce a unified taxonomy of coral species: "I can't publish work on something that's only half right," he tortured himself.[12]

> a well-defined species on the central Great Barrier Reef might be a bit different at Vanuatu or the West Australian coast and be a bit different in other ways in Indonesia. In Fiji it might be a different species altogether but if it turned up in Papua New Guinea it might be seen to be a hybrid. These sorts of patterns recurred in one country after another and did so for most species. The more I worked in different countries, the deeper the problem became. It was an unhappy state of affairs because there was no way through; more work made the problem worse not better. There was no solution.[13]

One morning Charlie rose around 5 a.m. to begin work, and as usual made himself a cup of coffee. As the jug boiled he had a flash of insight that offered up an answer. There was nothing mystical about this moment: he'd always believed that humans were "good at subconsciously synthesizing information"[14] though not so good at grasping aspects of nature that didn't easily fit into rational hierarchies, even though nature's products were "seldom organized into species at all." Considered over large-scale geographical space and long swathes of geological time, coral "species," he speculated, were malleable and temporary units, fluidly interlinked by their genes to other units, and forming ever-changing patterns. To understand their living patterns, corals needed to be treated as continua, not as fixed, isolated units.

Of course if corals did become isolated and unable to interbreed for long periods, then the fittest among them would, as Darwin argued, be selected to survive, and so eventually form a genetically cohesive new species. Corals certainly struggle with each other to survive and dominate within a particular area, but their spectacular mass spawnings hurl out gene-carrying larvae into the ocean, to be carried by the chance actions of currents. Where they land and how they interbreed with existing species becomes a lottery. Eventually the larvae might settle to grow and breed within a distant coral empire. Here they would, over geological spans of time, intermix to produce new variations, reconnections, or even "fuzzy" hybrids. Such a skein of chance interconnections meant that coral health could not be controlled and guaranteed even in a well-regulated marine park like the Great Barrier Reef.

10 "Charlie Veron's Story," 207–211, 214–215.
11 Veron interview, 1996 AMSA Silver Jubilee Awardee, 6.
12 Veron, ABC Interview, *Big Ideas*, p. 13; "Charlie Veron's Story," 175–176.
13 "Charlie Veron's Story," 211.
14 Veron interview, 1996 AMSA Silver Jubilee Awardee, 5.

The life and death of reefs in Indonesia and the Philippines could therefore affect reefs all over the Pacific and Indian Oceans.

Realizing, therefore, that corals behave in evolutionary terms a lot like plants, which is what they were once considered to be, Charlie consulted a colleague at AIMS, who explained how his new insight aligned with the concept of "reticulate evolution," a process that many plant geneticists consider a convincing alternative explanation of how species change over space and time. The theory of reticulate evolution argues for the formation of a net-like skein of evolutionary threads, determined by environment, rather than the famous branching tree of natural selection sketched by Darwin in the *Origin*. Had Darwin known what modern geneticists do, he might have agreed, for he was, in Charlie's words, "a fabulous thinker, just a wonderful, wonderful thinker."[15] And while Darwin in his day acquired a reputation as a heretic for denying the divine fixity of species, now Charlie was doing the same by denying the exclusive power of natural selection to shape coral species.

Like his namesake, too, Charlie needed a hellish amount of research to support his controversial case. Beginning in 1992, he navigated a maze of disciplines, from paleontology, taxonomy, biological oceanography and ecology through to systematics and molecular science. Darwin had been forced to do something similar, but disciplinary boundaries were

Figure 20.2 Charlie Veron exploring Madagascar corals. Image courtesy of Charlie Veron. See Plate 21.

15 Veron, ABC interview, *Big Ideas*, 12.

neither so numerous nor so heavily patrolled in his day. Specialized terminologies had become impenetrable to outsiders, an exasperating problem for Charlie because, like Darwin, he aimed to reach a general readership.

His resulting book, *Corals in Space and Time* (1995), containing the dual discoveries of the "Coral Triangle" and "Reticulate Evolution in the *Scleractinia*," was revolutionary by any standard.[16] The magisterial journal *Science* devoted a full article to its contents, and in 1996 the International Coral Reef Society awarded Charlie the famous Darwin Medal. Yet even while still working on his revolutionary book, Charlie had begun to sense the shadow of a new and graver problem. His vast range of underwater explorations was revealing both the network of interconnections and the growing degradations of the world's reefs. For the first time optimistic, ebullient Charlie Veron began to worry. In 1980 a terrible personal disaster confronted him with the issue of nature and mortality in the most unbearable way. Just as Charles Darwin, struggling to finalize his theory of evolution, had been nearly broken by the emotional loss of his daughter, Annie, so it was with Charlie Veron.

Working in Hong Kong one April evening, Charlie received a phone call from his wife Kirsty to say that their darling ten-year old daughter Noni had drowned while playing in a creek with a friend. A light went out in Charlie's life. Somehow he got himself back to Townsville the next morning to see Noni lying in her coffin. "I kissed her face; it was frozen. This is the worst memory of my life." She was cremated on her birthday.[17] One hundred and twenty nine years earlier almost to the day, Charles and Emma Darwin's ten-year-old daughter, Annie, had also been laid to rest.

Weighed down by "such unrelentingly bad times," domestic life for Charlie and his wife disintegrated. Though they remained close and supportive of each other, they eventually agreed to divorce. "I think the death of a child is the biggest thing someone can live through, it takes away, almost everything," Charlie later wrote to a friend. And it is surely true, too, that when you have faced the death of someone inconsolably dear, nothing else can defeat you. Charlie survived this dark night of the soul thanks to his beloved bush house, Rivendell, the solace of diving on the Reef, and his loving dogs. Often he simply took the phone off the hook and lived the life of a shattered recluse. Looking back, he sees himself as "a cot case."[18]

Charlie's intense personal reminder of the contingencies and fragilities of human life inevitably found echoes in his research. Exploring the underwater environments of the Pacific, Indian, Caribbean and Atlantic Oceans for *Corals in Space and Time* had confronted him with inescapable evidence of the degenerating state of the world's corals. He began to notice and log the effects on the Great Barrier Reef of changing sea levels, temperature stresses, crown-of-thorns starfish predations, and human-influenced changes in nutrient levels.

An instinctive conservationist, Charlie had been troubled way back in the 1970s by the rampant depredation of the coral-eating crown-of-thorns starfish. He believed that overfishing and growing levels of chemical pollution were enhancing the survival of the millions of larvae expelled annually by female starfish into the ocean currents. What provoked him to fury, though, was the way that the vested interests of tourist developers and politicians,

16 J. E. N. Veron, *Corals in Space and Time: The Biogeography and Evolution of the Scleractinia* (Sydney: University of New South Wales Press, 1995) see especially Part D, Evolution, Chapters 12–13.
17 "Charlie Veron's Story," 144.
18 Veron, ABC Interview, *Big Ideas*, 16.

combined with the craven behavior of government bureaucracies, forcibly discouraged scientists from studying the problem. This was the onset of a process, ubiquitous today, whereby government funded researchers were no longer free to pick their own questions or seek their own answers. Politicians of various kinds set self-interested agendas based on money and voter appeal, instructing bureaucrats to herd the scientists into yards like cattle. Concerned scientists were purposely deflected from working on the crown-of-thorns starfish problem, even though it had in no way receded.[19]

Looking back, Charlie realized that, like most of his generation, he'd taken for granted that "the oceans [were] limitless and the marine world indestructible." including the vast, relatively well-managed region of the Great Barrier Reef Marine Park. His discovery that the Central Indo-Pacific functioned as the prime disperser of coral biodiversity exacerbated his worry because of the region's lack of legal protections. Diver friends had urged him to visit the spectacular reefs of eastern Indonesia, but by the time he got there during the early 1990s it was already too late. Dazzling reefs that had run for thousands of kilometers were now masses of slimy algae-overgrown rubble.

Charlie had seen his first patch of coral bleaching off Palm Island in the early 1980s, a tiny clump of white skeletons that he photographed as a curio.

> And then I saw a whammy, a mass bleaching event … where everything turns white and dies. Sometimes it's only the fast-growing branching corals, but … corals that are four, five, six hundred years old, they die too. It's a very recent thing.[20]

The first recorded global mass bleaching occurred in 1981–1982. The site on which Charlie was then working, a beautiful embayment off Orpheus Island, 110 kilometers (68 miles) north of Townsville, experienced 60–80 percent bleaching. Within the Reef region overall, around 66 percent of inshore and 14 percent of offshore reefs registered moderate to high levels of damage.

The next major spate of mass bleaching, in 1997–1998, hammered reefs in over 50 countries, through the Indo-Pacific, the Red Sea, the Caribbean, and even among the hot-water corals of the Persian/Arabian Sea. On the Great Barrier Reef this bleaching coincided with the warmest sea temperatures ever recorded. In an even worse bleaching event of 2001–2002, the global damage also confirmed a close connection with El Niño weather cycles.[21] Global warming had arrived. Charlie began frantic work on his grim Harvard book of 2008, *A Reef in Time. The Great Barrier Reef, from Beginning to End*.

Up until the 1980s, theories that the earth's climate was changing because of human-engendered greenhouse gases, carbon dioxide and methane, had seemed remote from Charlie's concerns as a reef scientist. He was at first wary of some of the startling claims of coral scientists – like those of his biologist friend Ove Hoegh-Guldberg of Sydney University. But the more Charlie immersed himself in the floods of papers and data on the subject coming from all over the world, the more convinced he became that corals were showing

19 Veron ABC interview, *Big Ideas*, 17–18. Given that the exhaustive recent AIMS survey of the Barrier Reef contends that 42 percent of the present coral loss still comes from this voracious starfish, Charlie's fury was not misplaced. "The Great Barrier Reef has lost half of its coral in the last twenty-seven years." *AIMS News*, 2 October 2012, www.aims.gov.au, 3/10/12 11.21 am.
20 Veron ABC interview, *Big Ideas*, 6.
21 Veron, *A Reef in Time*, 57–59.

Figure 20.3 Charlie Veron observing bleached corals. Image courtesy of Charlie Veron. See Plate 22.

themselves to be "the canaries of climate change." Just as the deaths of those tiny yellow birds had alerted nineteenth-century coal miners to the otherwise undetectable presence of poisonous gases, so reef-growing corals were alerting scientists to climatic changes through their peculiar susceptibility to increases in water temperature and light.

Charlie's research told him that during El Niño weather cycles the surface seawaters in the Reef lagoon, already heated to unusually high levels by greenhouse-gas-induced warming, are being pulsed from the Western Pacific Warm Pool onto the Barrier Reef's delicate living corals. Temperatures two or three degrees hotter than the corals' evolved maximum of 31 degrees Celsius, in combination with raised levels of sunlight, become lethal. The powerhouse algae living in the corals' tissues, and providing their color, food and energy through photosynthesis with sunlight, then begin to pump out oxygen at levels that are toxic to their polyp hosts. The corals have to either expel their symbiotic algae solar panels or die. Row upon row of stark white skeletons result.

These damaged corals are capable of regeneration if water temperatures return to normal and water quality remains good, but the frequency and intensity of bleaching outbreaks is now such that the percentage of reef loss from coral deaths is increasing remorselessly.[22] Charlie predicts that the widening and deepening of the Western Pacific Warm Pool through atmospheric warming will mean that "every year will effectively become an El Niño year as far as the corals are concerned."

Of course, he hopes that some as yet unknown strains of symbiotic algae, better able to cope with a heat-stressed world, might eventually form new partnerships with the corals. Or perhaps the adaptive energies of fast-growing corals like *Acropora* might somehow outpace the rate of bleaching. Or that pockets of coral lying in shadowed refuges on cool, deep reef slopes or in recently discovered deep waters might survive to become agents of future renewal.[23]

But heat is not the only problem reef corals face. Other more stealthy greenhouse gas-induced destructions are in train, and may already be impossible to stop. Reefs, Charlie, points out, are nature's archives. Like historians we need to interpret what they tell us about past extinctions, for they record evidence of environmental changes from millions of years ago up to the present. Imprinted in their fossil typographies are the stories of the mass-extinction events of the geological past, including their causes. They tell us that four out of the five previous mass extinctions of coral reefs on our planet were linked to the carbon cycle and were likely caused by changes to the oceans' chemistry through their absorption of carbon dioxide and methane. This process is known as ocean "acidification."[24]

Today's culprits are the same gases – carbon dioxide and methane –though their increased presence is not due to the massive meteor strikes or underwater volcanic eruptions that caused earlier catastrophes. We humans are doing that work by knowingly pumping these gases into the atmosphere at unprecedented rates. Already the oceans, the planet's usual absorber of these gases, have reached a third of their capacity to soak them up and balance them chemically. Stealthily, the oceans of the world have already begun the process that scientists call "commitment": an "unstoppable" change that presages destruction long before

22 The just released AIMS survey calculates that 10 percent of Barrier Reef coral loss can be attributed to climate change, but, like Charlie, it anticipates sharply increasing incidences of excess warming. *AIMS News*, 2 October 2012.
23 Veron, *A Reef in Time*, 56–65, 200–211.
24 Veron, *A Reef in Time*, 89–112.

Plate 1 Global Warming: Understanding the Forecast exhibition, American Museum of Natural History, 1992. Photo: American Museum of Natural History.

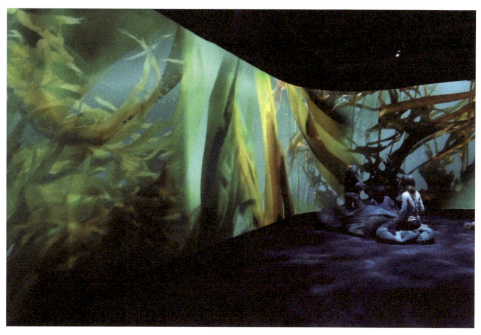

Plate 2 Cordell Bank Underwater Reef Installation, Oakland Museum of California, 2015. Visuals collage and design by Olivia Ting. Photo: Kirsten Wehner.

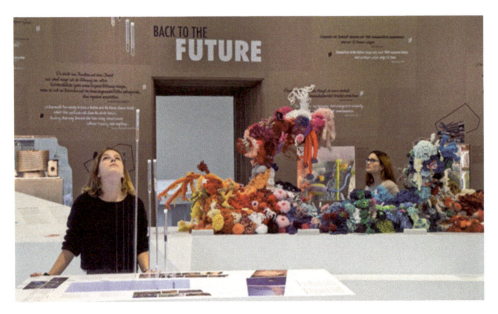

Plate 3 Crocheted coral reef, *Welcome to the Anthropocene* exhibition, Deutsches Museum, Munich, 2014. Photo: Axel Griesch.

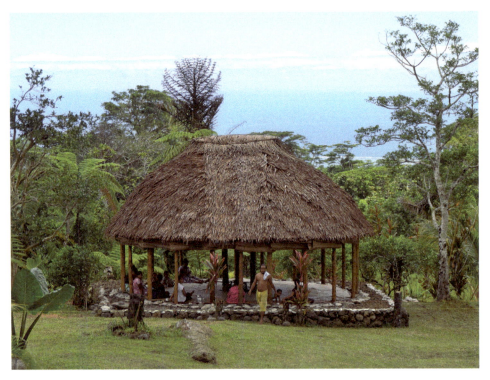

Plate 4 *Faletalimālō* (house for receiving guests) built by Master Builder Laufale Fa'anū and a team of traditional house builders from Sa'anapu, for the Tiapapata Art Centre, Apia, 2014. Photo: Galumalemana Steven Percival.

Plate 5 Jaki-ed, Marshall Islands. Donated by Mrs William J. Peters, 1926. American Museum of Natural History, New York, Anthropology Division, 80.0/4652.

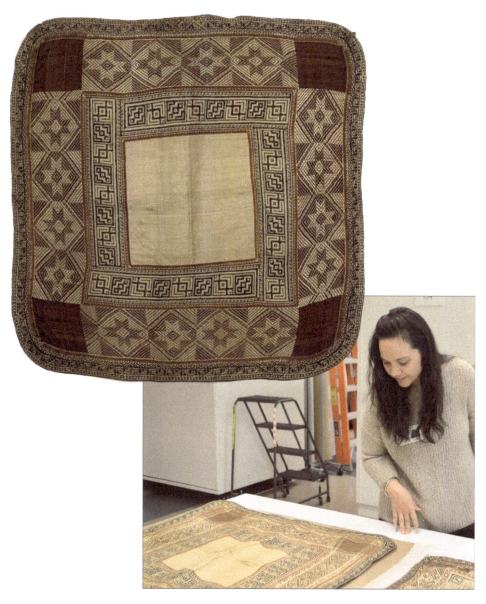

Kristina Stege in the storeroom of the American Museum of Natural History, with *jaki-ed*. 2015 Photo: J. Newell.

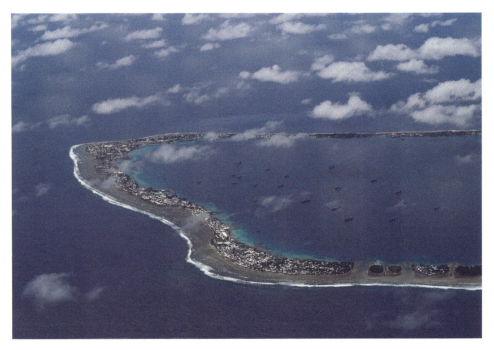

Plate 6 Majuro, capital of the Marshall Islands, Majuro Atoll, 2015. Photo: Alex de Voogt.

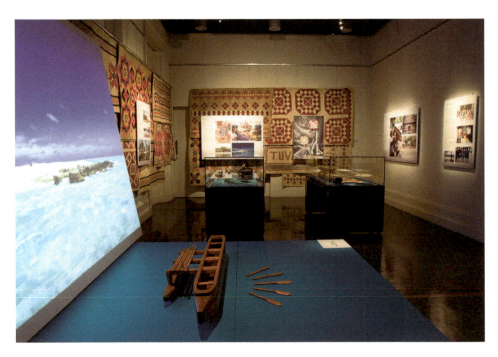

Plate 7 Objects on display in the Tuvalu community exhibition *Waters of Tuvalu: A Nation at Risk*, Immigration Museum – Museum Victoria, 2008. Photo: Rodney Start. © Museum Victoria.

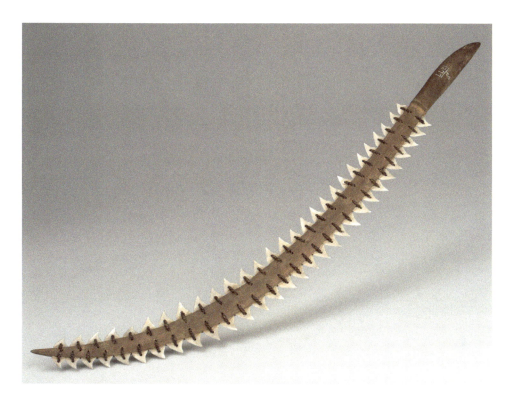

Plate 8 Kiribati shark-tooth weapon. American Museum of Natural History, New York, Anthropology Division, St/1277.

Plate 9 Abandoned vehicles in a winter forest: a Swiss *Autofriedhof* slowly subsides in the leaf litter, 2007. Photo: Alison Pouliot.

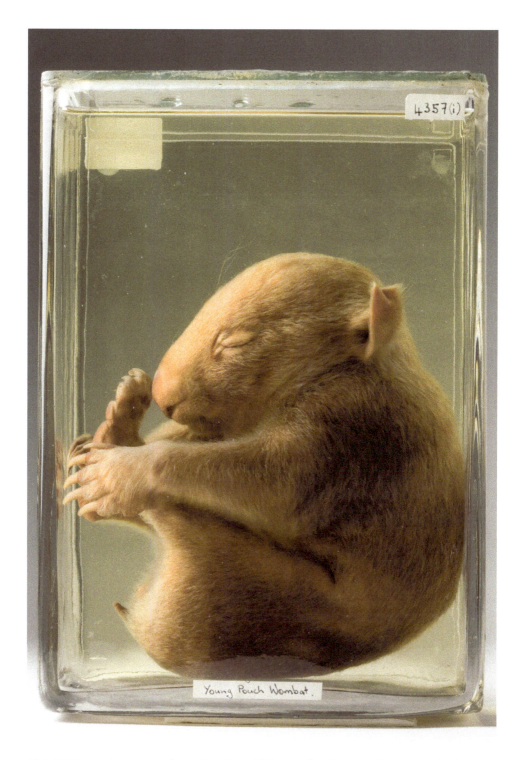

Plate 10 Preserved young pouch wombat, about 1920, Australian Institute of Anatomy collection, National Museum of Australia. Photo: George Serras. © National Museum of Australia.

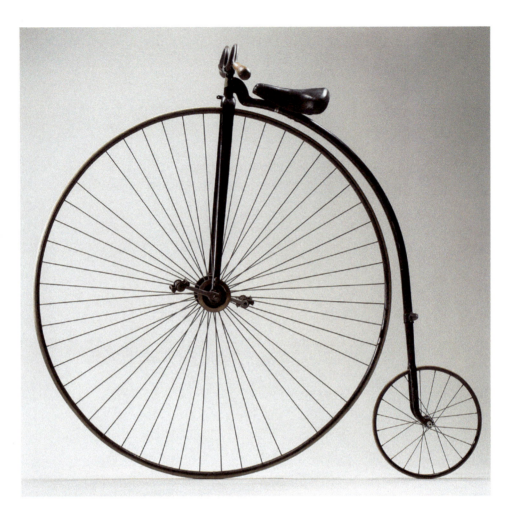

Plate 11 English-made "Cogent" penny-farthing bicycle belonging to Harry Clarke, 1884. National Musem of Australia. Photo: George Serras. © National Museum of Australia.

Plate 12 "Science on a Sphere" display in the *Water: H₂0=Life* exhibition. American Museum of Natural History. Photo: Denis Finnin.

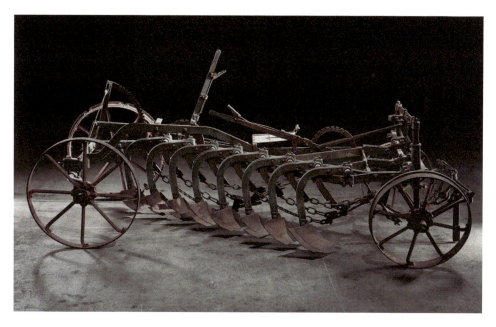

Plate 13 Eight-furrow stump-jump mouldboard plough, in use 1940s–50s, National Museum of Australia. Photo: Jason McCarthy. © National Museum of Australia.

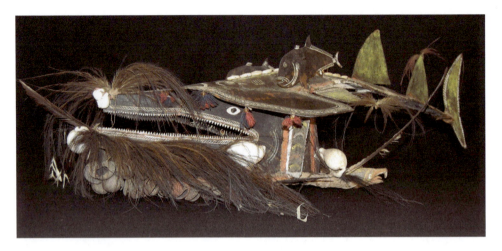

Plate 14 *Kaigas* mask from Mabuaig Island, Torres Strait, Oc.+,3278. © The Trustees of the British Museum.

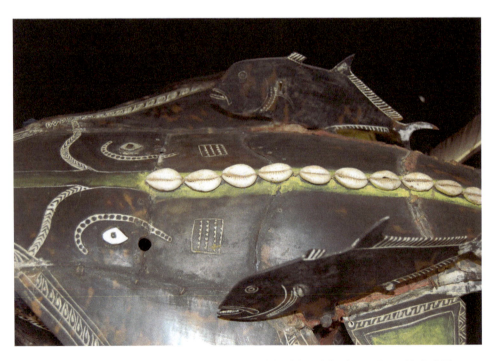

Plate 15 Overhead view of the mask showing details of the fish and the *kaigas*. Oc.+,3278. © The Trustees of the British Museum.

Plate 16 *Cloud* by John Reynolds, 2006, installed at Te Papa Tongarewa. 2009. Te Papa (2007-0007-1-7081).

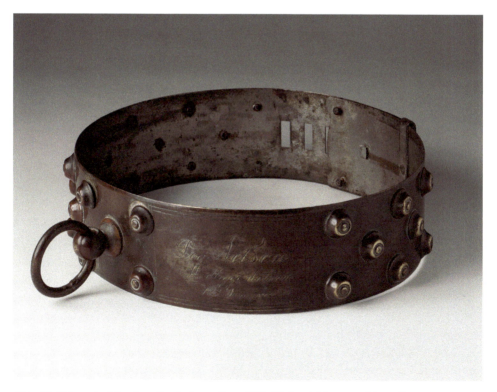

Plate 17 Nelson the Newfoundland's dog collar, *c.*1880. National Museum of Australia. Photo: Katie Shanahan. © National Museum of Australia.

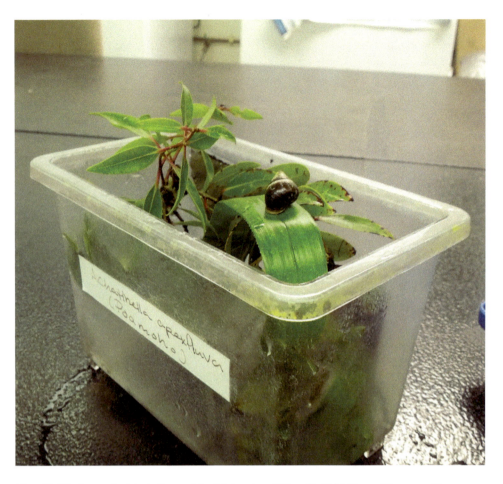

Plate 18 The last snail: *Achatinella apexfulva*. University of Hawai'i, 2013. Photo: Thom van Dooren.

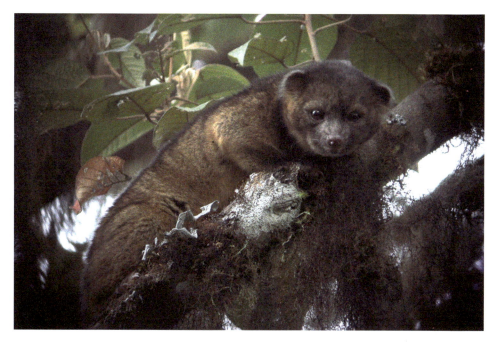

Plate 19 The Olinguito, *Bassaricyon neblina*, alive in the wild. Tandayapa Valley, Ecuador, 2013. Photo: Mark Gurney.

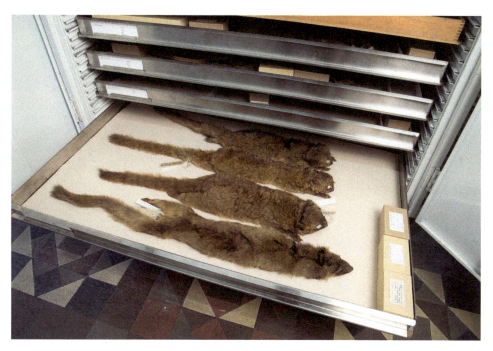

Plate 20 Specimens of the Olinguito, *Bassaricyon neblina*, in a museum drawer at the American Museum of Natural History. All of these specimens were collected in the early 1900s. Photo: Denis Finin, AMNH.

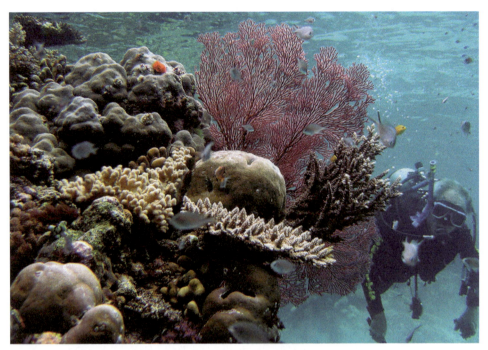

Plate 21 Charlie Veron exploring Madagascar corals. Image courtesy of Charlie Veron.

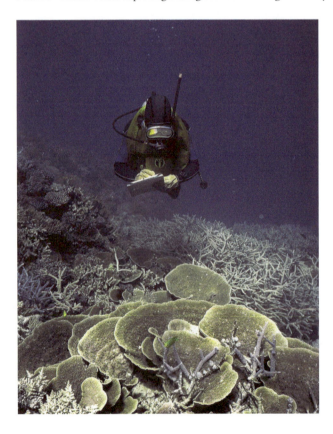

Plate 22 Charlie Veron observing bleached corals. Image courtesy of Charlie Veron.

Plate 23 PHARMAZIE exhibition, Deutsches Museum, 2000. Photo: Deutsches Museum.

Plate 24 The Australian Garden, show garden, Royal Horticultural Society, Chelsea, UK, 2011. Photo: Jay Watson; courtesy of the Royal Botanic Gardens, Victoria.

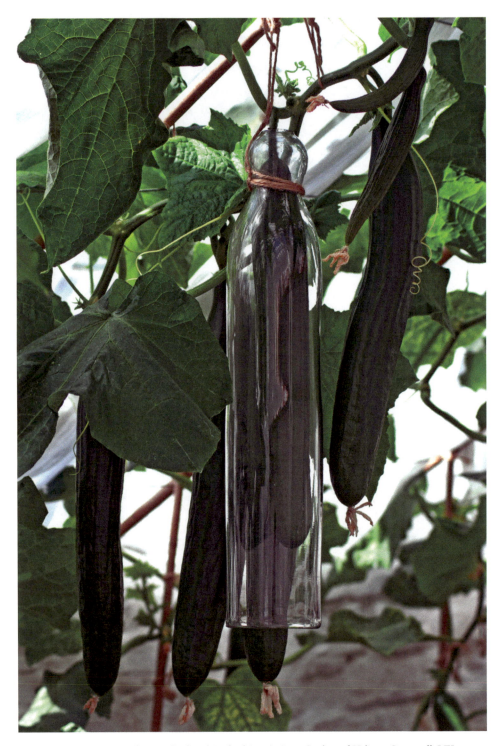

Plate 25 Cucumber straightener displayed in the historic *Lost Gardens of Heligan*, Cornwall, UK. Photo: Michelle Garrett.

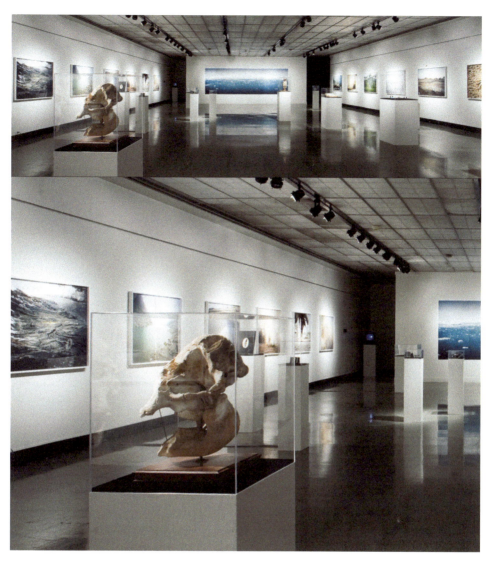

Plate 26 Installation view from *The Canary Project Works on Climate Change: 2006–2009*, Grunwald Gallery, Indiana University, 2009, Sayler/Morris.

Plate 27 Fossil Study 1, 2, 3, from *A History of the Future*, Sayler/Morris, 2014.

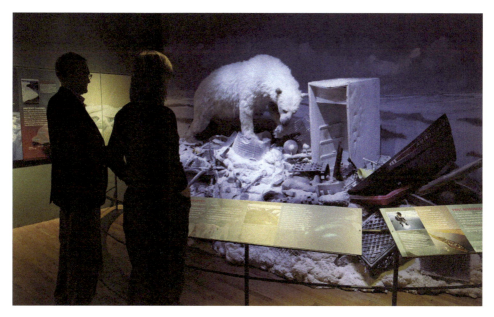

Plate 28 Polar bear exhibit in the *Climate Change: The Threat to Life and a New Energy Future* exhibition, American Museum of Natural History, 2008. Photo: Denis Finnin.

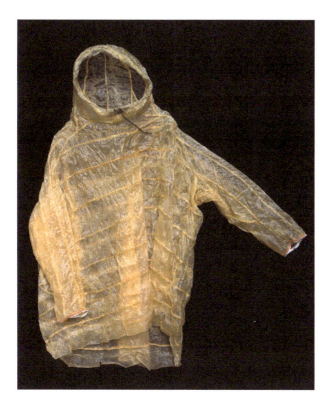

Plate 29 Anorak of seal intestines, Inuit, Central Yup'ik, Tooksik Bay, Alaska. Hood Museum of Art, Dartmouth College, Hanover, New Hampshire; gift of Dr. Philip O. Nice and Cheryl Roussain-Nice.

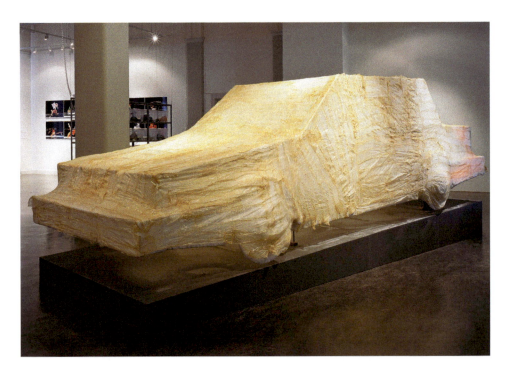

Plate 30 Volvo installation made of cow intestines and aluminum, Swedish Museum of Natural History, 2008. Artist: Gunilla Bandolin in collaboration with Sverker Sörlin. Photo: Michael Perlmutter.

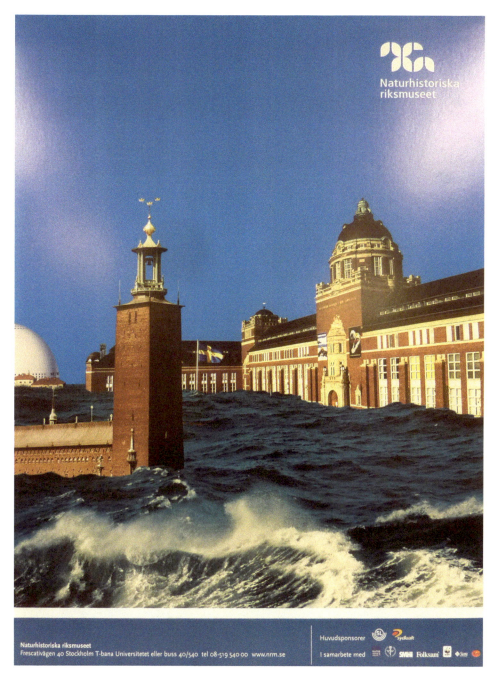

Plate 31 A poster presenting the *Mission: Climate Earth* exhibition, showing well-known Stockholm locations flooded by high waters. Swedish Museum of Natural History, 2014. Photo: Ewa Bergdahl.

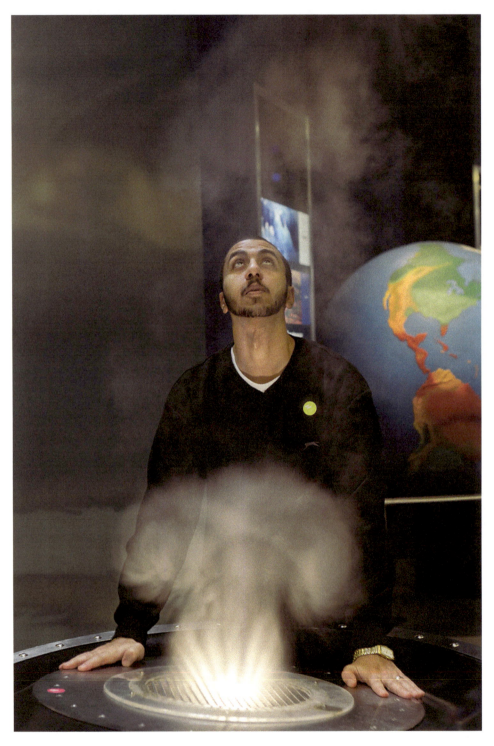

Plate 32 Create your own cloud interactive in the *Mission: Climate Earth* exhibition, Swedish Museum of Natural History, 2004. Photo: Mikael Axelsson, SMNH.

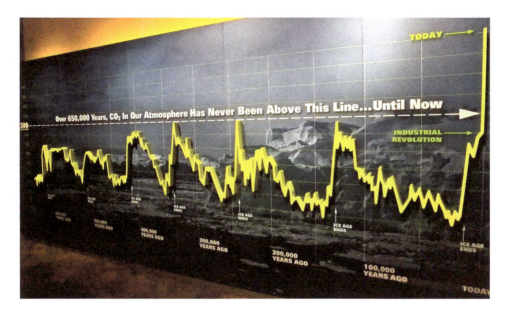

Plate 33 *Feeling the Heat: The Climate Challenge* exhibition, Birch Aquarium, 2007. Photo: Susanna Lidström and Anna Åberg.

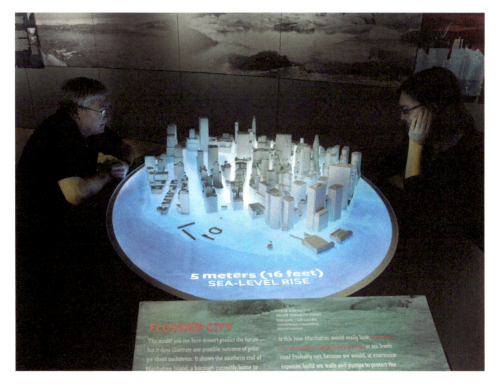

Plate 34 Model of Manhattan, flooded, in the *Climate Change: The Threat to Life and a New Energy Future* exhibition, American Museum of Natural History, 2008. Photo: Denis Finnin.

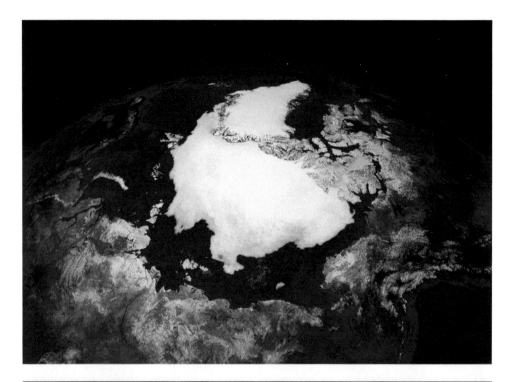

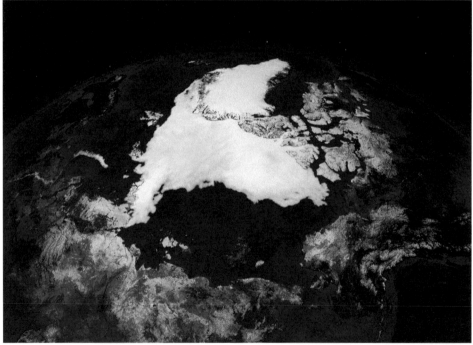

Plate 35 "Arctic sea ice melts to all-time low" (2005 and 2007). NASA/Goddard Space Flight Center Scientific Visualization Studio. Next Generation Blue Marble data courtesy of Reto Stockli (NASA/GSFC).

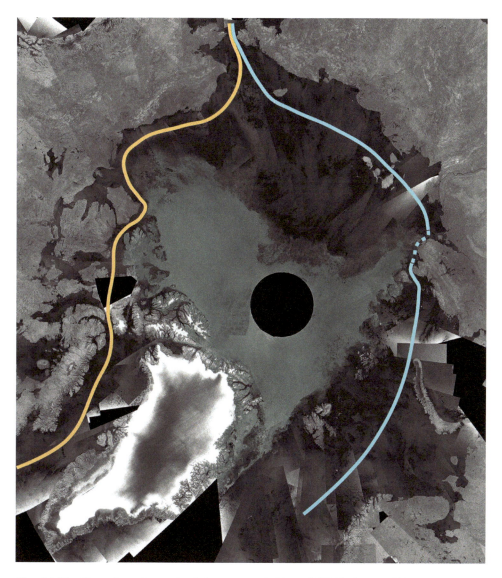

Plate 36 "Satellites witness lowest Arctic ice coverage in history" (2007). Source: ESA.

Plate 37 Installing the *Welcome to the Anthropocene* exhibition, Deutsches Museum. Photos: Axel Griesch.

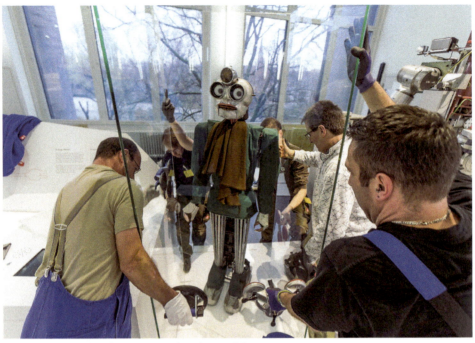

Placing the "robot" in the *Humans and Machines* exhibit.

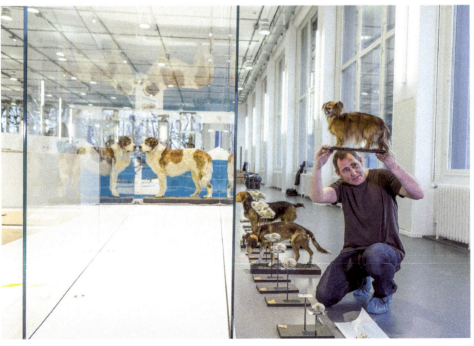

Lining up the dogs, *Evolution*.

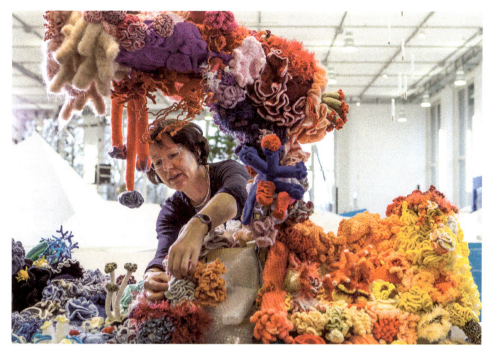

Curating the crochet coral reef, *Evolution*.

Calligrapher creating the wall.

Plate 38 Three dimensions of the *Welcome to the Anthropocene* exhibition, Deutsches Museum. Photos: Axel Griesch.

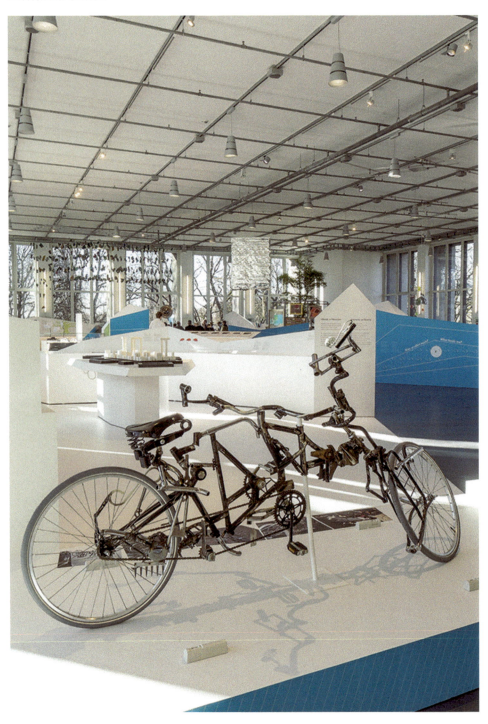

Artistic interpretation: Victor Sonna's recycled art bike "Guernica", *Cities exhibit*.

Publications: Catalogue and graphic novel, with curators Nina Möllers and Helmuth Trischler.

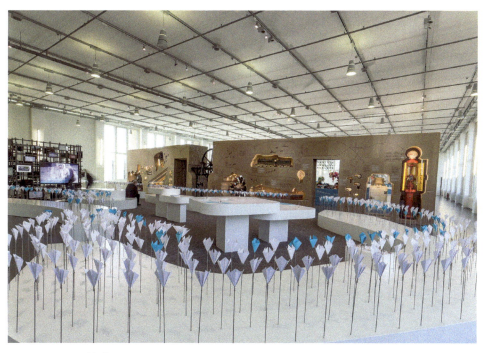

Participation: *Field of Daisies.*

Plate 39 Various elements of the *Welcome to the Anthropocene* exhibition, Deutsches Museum. Photos: Axel Griesch.

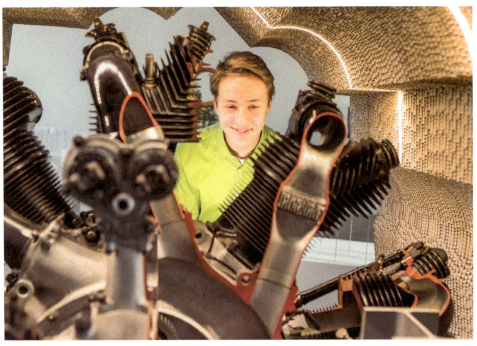

Engine block inside object shelf.

The digital media cube.

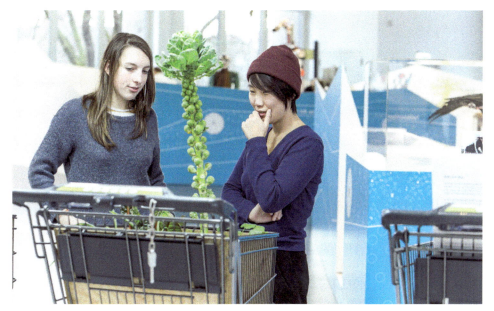

Brussels sprout growing in shopping trolley.

Planting a tree.

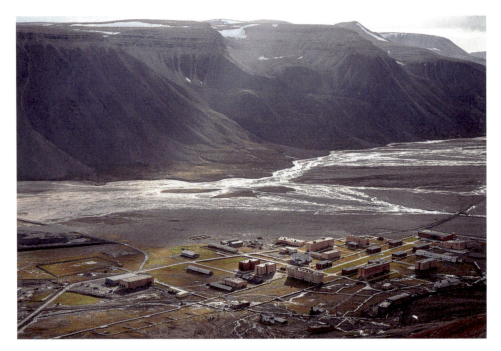

Plate 40 Pyramiden: a coal-mining town above the Arctic Circle, 2012. Photo: Dag Avango.

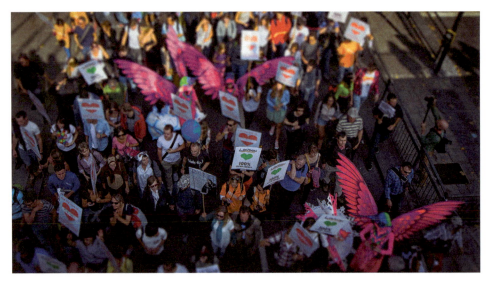

Plate 41 People's Climate March, London, with hummingbirds, September 21, 2014. Photo: Antonio Acuña.

it is clearly visible. Eventually – possibly as early as 2050 – we will have reached the point where coral skeletons become soluble in seawater. Carbonate forms, including reefs, will start dissolving: like "a giant antacid tablet" in order to balance the ocean's pH.[25]

If, as AIMS recently tells us, the Great Barrier has already lost half its coral cover during the last 27 years through bleaching, cyclones, pollution and crown-of-thorns starfish, what will happen to this figure as the effects of acidification take hold? Reef corals are among the first organisms in the oceans to be stricken, in effect, with a fatal form of "coralline osteoporosis." Over time their calcium skeletons will either stop growing altogether or become too brittle to resist the eroding effects of waves. They will also crumble before the lashing cyclones that are already on the increase.[26] Rising sea levels caused by the melting of land ice will probably also compound the inability of corals to grow, by diminishing their exposure to light.

Phytoplankton, the food of tiny krill, a key element in the food web of the southern oceans, will be equally affected by acidification. And who knows what terrible chain of ecological consequences will follow? We could face something like the great K-T extinction at the end of the Cretaceous Period, around 65 million years ago, a disaster that put an end to much life on our planet for millions of years.[27] Eventually a remorseless domino effect, beginning with coral reefs and their marine communities, will presage a succession of ecosystem disasters. The earth's sixth mass extinction will have arrived.

So, Charlie Veron, who has celebrated the dazzling multiplicity of Barrier Reef corals for over 40 years, now finds himself having to prophesy their extinction. He feels, he says, "very very sad. It's real, day in, day out, and I work on this, day in, day out. It's like seeing a house on fire in slow motion … there's a fire to end all fires, and you're watching it in slow motion."[28]

Charlie's anguish is understandable. No individual has explored the Reef more widely; no mind has engaged more with its deep history; no heart has felt its present and future plight so intensely. The video of his special address to the Royal Society is the most moving thing I have ever seen about climate change.

Still, Charlie, his new partner, and many of his scientific friends have decided there is at least one positive thing they can do in the face of these implacable forces. They've committed themselves to an exhaustive type of coral collecting. They are building a complete digital database of all the corals of the world for an AIMS website (coral.aims.gov.au) because they believe that most will soon be gone from our oceans. Not even natural history museums will be able to preserve them for posterity as they have done with other endangered creatures of the past. Only by capturing and storing how corals actually live in their environments can we preserve our knowledge of these complex creatures in meaningful ways. Future generations need to learn about corals and coral reefs as they live and grow within countless underwater environments and ecosystems across the globe. And of course a digital website enables an infinite and instant dissemination of this material across the web.

Theirs is an act of resurrection for future generations who may not share our good fortune of swimming among the exquisite corals of the Great Barrier Reef. It also a Re-Enlightenment quest, a transmission of knowledge that cannot simply be conveyed in books

25 Veron, *A Reef in Time*, 214–216.
26 *AIMS News*, 2 October 2012.
27 Veron, *A Reef in Time*, 212–220.
28 Veron ABC interview, *Big Ideas*, 3.

and might otherwise be lost. To achieve it, they've been forced to embrace the methods of the historian, the artist, the filmmaker, and the ecologist, as well as the scientist. Theirs is a holistic collaboration between the humanities, the natural sciences and the technological sciences, and an example that I hope will be shared by the great natural history museums of the world on whom we must rely to collect for our uncertain futures.

Reef corals themselves offer us an inspiring collaborative metaphor of heart and mind working in unison: the magical reef-creating symbiosis between microscopic algae and a tiny polyp. We might see the algae as the heart that generates the energy on which its partner depends, and the polyp as the mind with a purposive drive to build their joint production of coral and to protect it in the face of torrential forces of destruction – breakers, coral-feeders, cyclones, sediment, pollution, mining, overfishing, and water that is too hot and too acidic to bear. It is a symbiosis which has survived for some 240 million years, but which will soon split if we allow it. Surely if anything can inspire us to act, it's this ancient and powerful partnership between two of the tiniest and most fragile creatures in the sea.

21
FOOD STORIES FOR THE FUTURE[1]

George Main

Agriculture connects everyone "in the most vital, constant, and concrete way to the natural world" wrote environmental historian Donald Worster.[2] As the global climate warms and shifts, ever more extreme weather events are beginning to undermine the viability of agricultural systems that emerged during the relatively stable climatic regime of the Holocene. Perhaps the great cultural challenge of climate change to the modern, industrial mind is an assertion in storm and flood and drought and fire that the realm of people and culture, including agri-culture, is now and always has been inextricably intertwined with the material and ecological realm of nature. The destruction of crops and livestock by drought and extreme cold challenges us to acknowledge and attend to our intimate, bodily ties to the rest of nature, those material bonds that modern, industrial modes of agriculture and thought have for so long denied and obscured. Such threatening events invite a deeper application of

1 *A note on sources*: Ben Gleeson's paper "Terra Nullius in Australian environmentalism and agriculture: implications for ecologically-based intra-action within a living landscape" *PAN: Philosophy, Action, Nature* 11 (2015), 63–73. http://arrow.monash.edu.au/hdl/1959.1/1232137 and Donald Worster, *The Wealth of Nature: Environmental History and the Ecological Imagination* (New York: Oxford University Press, 1993) offer useful insights into the cultural frameworks of modern, industrial farming. Jane Bennett, in *Vibrant Matter: A Political Ecology of Things* (Durham, NC: Duke University Press, 2010), and David Abram, in his *Becoming Animal: An Earthly Cosmology* (New York: Pantheon, 2010), articulate the active nature of materiality.

The significance of permaculture is explained by Patrick Jones in his article "Gifting economies." published in *Arena Magazine,* no. 119, Aug/Sept 2012: 23–27.

The necessity of careful storytelling to secure the resilience of productive terrain is explored by Gary Paul Nabhan in "Restoring and Re-storying the Landscape." *Restoration and Management Notes*, vol. 9, no. 1, 1991, by William Cronon in his chapter "Caretaking Tales: Beyond Crisis and Salvation." published in *The Story Handbook: Language and Storytelling for Land Conservationists* (San Francisco, CA: Centre for Land and People of the Trust for Public Land, 2002), and by David Abram in "Earth Stories." *Resurgence*, issue 222, January/February 2004. Val Plumwood's insights are accessible in her papers "Shadow Places and the Politics of Dwelling." *Australian Humanities Review*, Issue 44, March 2008, and "Nature in the Active Voice." Australian Humanities Review, Issue 46, May 2009, and are usefully interpreted by Deborah Bird Rose in "Val Plumwood's Philosophical Animism: attentive interactions in the sentient world." *Environmental Humanities*, vol. 3, 2012.

2 Donald Worster, *The Wealth of Nature: Environmental History and the Ecological Imagination*, Oxford University Press, New York, 1993, p. 50.

ecological thinking to the material realities of gardening and farming, to honor and strengthen ties that instill resilience and productivity within dynamic terrain. And they reveal a need to abandon industrial frameworks of the imagination that drive the application of technologies and poisons to master farmland and suppress the agency and expression of natural forces and other species.

What calls do the increasing number of ever more destructive climatic events—a frightening trend driven by the relentless operation of industrial culture—make on cultural institutions? Can museums redirect their core functions in ways that help people grapple with the monumental emotional, cultural and physical challenges posed by climate change and faltering food systems? Might the practical and theoretical skills of museum practitioners that allow the emergence of meaning and understanding through bodily engagement with material things offer ways to navigate our era of escalating ecological and social crisis? In this chapter, I explore two projects underway at the National Museum of Australia that attempt to apply museological skills and capacities in ways that allow constructive responses to climate change and its varied challenges.

The Paddock Report

"North Taylors" is the name of an Australian paddock on the relatively fertile southwest slopes of New South Wales, south of the Murrumbidgee River, between the farming towns of Narrandera and Boree Creek. The sixty-hectare paddock is part of "Oakvale," one of

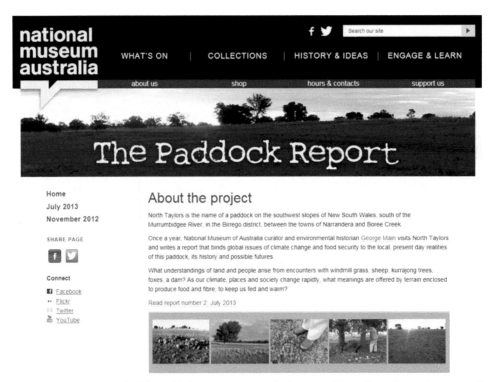

Figure 21.1 Homepage for *The Paddock Report*, a National Museum of Australia online project, created 2012. © National Museum of Australia.

several farms owned by the Strong family. Since the early 1990s, the Strong family has bolstered the resilience and productivity of their land by developing innovative methods of ecological farming. Hundreds of thousands of trees and shrubs, including swathes of various acacia species sown with machinery developed to establish annual monocultures of wheat and canola, now support an array of beneficial insect and bird species. Rows of perennial saltbush stretch across paddocks once reserved for wheat, and careful grazing strategies continue to regenerate the ecological fabric of their country.

As a major cultural institution with a continental reach, the National Museum of Australia is increasingly using its website to connect with individuals, communities and institutions. *The Paddock Report* utilizes the outreach capacities of the Museum's website to explore how an intense focus on material and ecological particularities present within a locale can reveal relationships between globalized forces of industrial modernity and the dynamic character of a particular place, framed by a contemporary context of rapid climatic, ecological and social change. At a time when life is determined like never before by vast physical and social phenomena, an approach that casts humanity as embedded within material and ecological patterns, and sees agency as arising from within an assemblage of both human and non-human components, can allow alternative, useful understandings about how people might respond to change.

Once a year I visit North Taylors, and afterwards write a short report on the People and the Environment section of the National Museum of Australia website. As a museum curator and environmental historian, I write each report with an intense focus on material and ecological particularities encountered within the fenced enclosure. Reports contain photographs taken inside the paddock, and my writings seek to bind global issues of climate change, its social and ecological disruptions, to the local, present-day realities of this one paddock, its history and possible futures, to draw meaning from encounters with the material particularities of terrain enclosed to produce food and fiber, to keep us fed and warm.

By returning annually to the same paddock, I respond to changes in its material patterns, in vegetation, animals, soils and moisture, and reflect on these physical changes in relation to the productive capacity of the paddock to keep human bodies clothed and fed. Sheep, weeds, wire fences, stone tools, broken machinery parts and other material things encountered inside the paddock are considered in historical and ecological terms, to reveal the cultural and physical processes that have generated the paddock's material realities at a particular moment in time, and which define the terrain upon which contemporary, globalized forces of nature and culture are acting.

Structurally, the process of a regular return, of an annual encounter that enables reflection on short-term changes, interplays with reflection on broader processes of change that encompass deeper time frames into the past and into the future. Interviews and archival research complements the understandings gained from paddock visits. On each visit, I walk across the paddock with members of Strong family, or others who know it well. Through conversation, movement and encounters, we generate a sharing of comprehension, an honoring of place.

"Shadow places" was the term given by environmental philosopher Val Plumwood to the many unseen terrains "that provide our material and ecological support" and "which, in a global market, are likely to elude our knowledge and responsibility." North Taylors can be understood as one such shadow place, a rectangle of country responsible for nourishing many thousands of people who have never seen it or known its name.

In response to scholarly interest in place studies and notions of "belonging," Plumwood cautioned against swimming with "the current of the self-sufficiency tide," of honoring too intensely our individual home places. Instead, she argued that a need existed for "strong institutional and community networking arrangements" that enabled people to take responsibility for the many remote, "shadow" places to which we are all materially, ecologically bound. "Exchange" of material goods and money between people living in different places, Plumwood proposed, "could also have at its core celebration and exchange of place and place knowledge, and [occur] under conditions of connection, knowledge, care and responsibility." *The Paddock Report* is an attempt to apply the capacities of the National Museum of Australia to help foster the sort of institutional and community networks that Plumwood called for.

Ecophenomenologist and writer David Abram argues that in modern societies like Australia, a great need exists to recover human capacity for attunement to the particularities of the material and ecological world, in ways that maintain intellectual rigor. Terrain our bodies may directly experience, "rippling with cricket rhythms and scoured by the tides, is the very realm now most ravaged by the spreading consequences of our disregard," argues Abram, and is in need of careful attention. Since the colonization of Australia began in the late eighteenth century, cultural processes operating in settler society often cast a distant place, Britain, the colonial center, as the primary source of value and significance. Such processes devalued local particularities and favored powerful demands and interests arising elsewhere.

By enabling encounters with the material particularities of places and objects, museums engender a way of knowing that counters destructive colonial dynamics and allows useful responses to the crisis of climate change. Honoring and foregrounding place and materiality challenges modern ways of knowing, those universalist methods of understandings abstracted from the expressive characteristics of objects, water, land and other species.

"We are by now so accustomed to the cult of expertise," argues Abram, "that the very notion of honoring and paying heed to our directly felt experience of things—of insects and wooden floors, of broken-down cars and bird-pecked apples and the scents rising from the soil—seems odd and somewhat misguided as a way to find out what's worth knowing. According to assumptions long held by [Western] civilization," he continues, "the deepest truth of things is concealed behind the appearances, in dimensions inaccessible to our senses." Stories, representations and other cultural processes that devalue the local and the particular serve industrial development at great cost. Philosopher Freya Mathews argues that the adoption of a universal perspective, a framework that retreats from the particularity of things, denies the subjectivity of others and refuses dialogue. "This is because the subjectivity of others is communicated to us via particulars," she writes. "Communicative cues reside deep within the particularity of things: communicative intent is recognisable only at the level of the particular instance, at those junctures at which behaviour departs from an anticipated norm."

'To initiate communication [with the world at large]," Mathews continues, "we must address it at the level of particulars. This requires awareness of intricate patterns of unfolding, attunement to the minutest details in the order and sequence of things; we must be prepared to pay attention to things in their infinite variability."

Museums are uniquely positioned to foster the sort of attunement to particularity advocated by both David Abram and Freya Mathews. By enabling encounters with

particular, material things, and with the people, places and other species to which those things are connected, museums enable dialogue and the witnessing of suffering. Dialogue and witnessing give people opportunities to respond, to build the social and ecological links that lend resilience in the face of crisis.

Food Stories

The *Food Stories* project represents another attempt to apply the core storytelling functions and capacities of the National Museum of Australia to help people respond constructively to the crisis of climate change. *Food Stories* engages audiences with selected objects held by the Museum—and the place-oriented narratives that they embody and inspire—to foster social and ecological resilience. The project aims to embed primary schools, their kitchen gardens and their communities within local narratives of food production and consumption. For one primary school in each of the eight Australian states and territories, this project highlights significant objects held by the Museum that reveal powerful stories about the history and culture of food systems within each particular locale. *Food Stories* will generate primary school curriculum resources and an online exhibition.

To develop the *Food Stories* project, Museum curators are working with the Stephanie Alexander Kitchen Garden Foundation. The purpose of the Foundation is to support the establishment and ongoing management of kitchen garden projects in primary schools across Australia. The program offered by the Foundation is designed to be fully integrated into the primary school curriculum, and distributes resources for teaching in literacy, numeracy, science, cultural studies, history, geography and all aspects of environmental sustainability. Furthermore, the objective of the Foundation to enhance learning by folding kitchen and garden activities into the teaching of all curriculum areas, by integrating embodied and experiential modes of understanding with more traditional, intellectual and abstracted ways of knowing, aligns well with museum practice.

The Stephanie Alexander Kitchen Garden Foundation requires that participating schools design their kitchen gardens "according to organic and permaculture principles." On its website, the Foundation explains that each school garden "should maximise the opportunities that the site provides in terms of slope, light and adjoining vegetation." Garden designers are encouraged to value the particularities of their places and communities:

> Using recycled materials, hand-made stepping stones, curving paths and fences, and scattering artwork amongst the plants will add a special touch of magic that makes each garden individual. Encouraging children to contribute to the design process ensures the garden reflects the school community, and adds to their sense of pride and accomplishment.[3]

Organic and permaculture principles are ecological in orientation, and provide the foundation for gardens that rely on a healthy biological community, tended by people attentive to the particularities of garden places and the expressive capacities of various

3 Stephanie Alexander Kitchen Garden Foundation website, www.kitchengardenfoundation.org.au, accessed 3 March 2014.

organisms, for their capacities to produce food. The webs of ecological relationships that enable productivity also lend resilience to extreme weather events and other environmental shocks. "Permaculture" is a term defined by Australian teachers and writers Bill Mollison and David Holmgren to define a food gardening system that works with the natural dynamism of biological communities. Holmgren, in his book *Permaculture: Principles and Pathways Beyond Sustainability*, states that "Observe and interact" is the first principle of permaculture.[4] Here is a model of production antithetical to the scientific abstractions and monocultures of industrial agriculture. Land is considered active, and the individual gardener is drawn into a personal, ecological relationship with a particular place and its forces. As a concept that has "influenced ecological and social sustainability practices across every continent," permaculture is, according to celebrated poet and talented permaculturalist Patrick Jones, "one of Australia's most significant intellectual 'exports' of the past forty years," while remaining undervalued in modern Australia, where a domineering industrial culture dismisses ecological knowledge.

Methods of permaculture and their capacities to draw people into active relationships with an expressive material and ecological world mirror the experiences of museum visitors. Curators collect and display objects for their vibrancy, for their powers to tell stories, to reveal their marks of use, to convey their relevance to historical and contemporary life. Stories, carefully constructed and told, can evoke ties and foster networks that instill resilience within land and people. In May 2013, after the American climate activist Tim DeChristopher was released from prison for thwarting coal mine developments, the renowned ecological writer Terry Tempest Williams sent a tweet: "When asked what the Climate Movement needs now, Tim DeChristopher said, 'More stories + more storytellers.'"[5] Agricultural ecologist Gary Nabhan emphasizes the role of storytelling and related cultural activities to restore and revitalize terrains degraded by industrial practices: "To truly restore these landscapes, we must also begin to re-story them, to make them the lessons of our legends, festivals, and seasonal rites."[6]

"Stories are the indispensable tools that we human beings use for making sense of the world and our own lives," writes William Cronon, "They articulate our deepest values and provide the fables on which we rely as we confront moral dilemmas and make choices about our every action. Here is a new situation: What should we do?"[7] In his book *Man's Search for Meaning*, Holocaust survivor Viktor Frankl described how the unimaginably horrific setting of a concentration camp itself offered a guiding framework through which to locate meaning and purpose:

> We who lived in concentration camps can remember the men who walked through the huts comforting others, giving away their last piece of bread. They may have been

4 David Holmgren, *Permaculture: Principles and Pathways Beyond Sustainability*, Holmgren Design Services, Hepburn, 2002.
5 Terry Tempest Williams, https://twitter.com/TempestWilliams, 18 May 2013.
6 Gary Paul Nabhan, 'Restoring and Re-storying the Landscape', *Restoration and Management Notes*, vol. 9, no. 1, 1991.
7 William Cronon, "Caretaking Tales: Beyond Crisis and Salvation," in *The Story Handbook: Language and Storytelling for Land Conservationists*, Center for Land and People of the Trust for Public Land, San Francisco, 2002, p. 88.

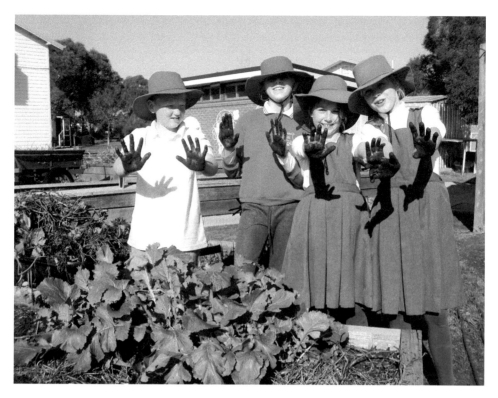

Figure 21.2 Children in the kitchen garden at Collingullie Public School, southern New South Wales, 2013. Photograph courtesy of Collingullie Public School.

few in number, but they offer sufficient proof that everything can be taken from a man but one thing: the last of the human freedoms – to choose one's attitude in any given set of circumstances, to choose one's own way.[8]

The global climatic and ecological crisis shares with the Holocaust outcomes of mass death and immense suffering. Working with communities to help navigate cultural and imaginative pathways through the unfolding chaos of climate change is a role available to museums. "What I hear Frankl saying," writes Carolyn Baker, in her book *Sacred Demise: Walking the Spiritual Path of Industrial Civilization's Collapse*, "is that our power to find meaning in a horrific experience may be the only power we have in a particular situation, but that [meaning] may be more powerful than the horror of the experience itself."[9] Perhaps the challenge now facing museums, as the traumatic consequences of rapid, erratic changes in climate patterns begin to unfold, is to enable storytelling that constructs meanings that are themselves more powerful than the most ferocious storms, devastating fires, churning floods, and bitter droughts.

8 Viktor E. Frankl, *Man's Search for Meaning*, Pocket Books, New York, 1985 [1959], p. 86.
9 Carolyn Baker, in her book *Sacred Demise: Walking the Spiritual Path of Industrial Civilization's Collapse*, iUniverse, New York, p. 149.

What styles of storytelling, what modes of imagination, might construct meanings that build social and ecological strength and resilience? David Abram describes how our senses "wither and grow dim" when "we speak of the things around us as quantifiable objects or passive 'natural resources'."[10] When we imagine other species and the material world as devoid of agency and vibrancy,

> we find ourselves living more and more in our heads, adrift in a net of abstractions, unable to feel at home in an objectified landscape that seems alien to our own dreams and emotions. But when we begin to tell stories, our imagination begins to flow out through our eyes and our ears to inhabit the breathing Earth once again. Suddenly, the trees along the street are looking at us, and the clouds crouch low over the city as though they are trying to hatch something wondrous. We find ourselves back inside the same world that the squirrels and the spiders inhabit, along with the deer stealthily munching the last plants in our garden, and the wild geese honking overhead as they flap south for the winter.[11]

In contrast with the destructive imaginative frameworks of industrial culture, *Food Stories* seeks to foster the sort of narratives Abram describes, place stories that acknowledge and draw meaning from the ever more forceful and unpredictable dynamics of land and climate in which we are all ecologically embedded, and which allow us to identify and choose constructive ways to respond. The operation of permaculture gardens by schools participating in the *Food Stories* project provides scope to hear and share stories of other species and the ecological communities to which school gardens are bound. The first principle of permaculture, to observe and interact, calls on teachers and students to pay attention to local patterns of life. Such attentiveness enables interaction, a process defined by anthropologist Deborah Bird Rose as denoting "action undertaken in a participatory field of actors all or many of whom are actively paying attention."[12] Rose is referring to both human and non-human actors, and she calls for modes of listening attentive to expressions other than the spoken word. Listening to the various expressions of plant and animal species, entering into dialogue with local ecological communities, allows the stories of other species to enter our imaginations and to guide our interactions with productive terrains. Stories for resilience then, to paraphrase Rose, are stories interwoven with the stories we acknowledge others to be telling.

One such story might be that of successful adaptions made by the Aṉangu people of central Australia, to the forceful intrusions of industrial society—improved roadways, faster cars, petrol stations and motels—that rapidly changed their homelands over the past 50 years. Yulara Primary School, located in the tourist village beside Uluṟu-Kata Tjuṯa National Park, is participating in the *Food Stories* project. While in the midst of a vast desert, many food species grow across the National Park and the surrounding region. Perhaps because of the

10 David Abram, *Becoming Animal: An Earthly Cosmology* (Pantheon, New York, 2010).
11 David Abram, "Storytelling and Wonder." In *Encyclopedia of Religion and Nature*. Volume 1. London: Thoemmes, 2005.
12 Deborah Bird Rose, "Val Plumwood's Philosophical Animism: Attentive Interactions in the Sentient World," *Environmental Humanities*, 3 (2013), 93–109: 102–103.

relatively extreme environment, these useful species are consistently honored and celebrated in local traditions of storytelling and art production, and in representations of the place and its institutions. Beside the walking track that circles Uluṟu, the great stone monolith also called Ayers Rock, walkers encounter a water tank painted with honey ants, a local delicacy, by children from nearby Mutitjulu Primary School. The National Museum of Australia holds several red gum carvings of the perentie lizard, or *ngintaka*, made in the early 1980s by Billy Wara, a senior Aṉangu man. Wara helped establish the thriving arts enterprise Maruku Arts, based on the use of traditional skills to make artefacts for the local tourist market. He was responsible for telling the traditional Aṉangu story of the *ngintaka*, a creation figure who brought some edible grass seed species, staple plant foods for Aṉangu, to the Uluṟu region. The lizard's fatty flesh is highly prized by Aṉangu, who hunt perentie lizards and roast them on open fires.

Throughout the 1960s and into the 1980s, as the tourist industry made major inroads into the Uluṟu area, the sale of carvings and other artworks and artefacts gave Aṉangu people an independent source of income that helped them live and travel through their home country. Custodianship of country is core to Aṉangu life and law. Income from the production of carvings and other artworks helped Aṉangu people engage in a long political struggle for land rights that culminated in the return of Uluṟu and surrounding lands in 1985. By enabling encounters with Billy Wara's striking carvings of perentie lizards, the *Food Stories* project reveals a local, hopeful story about the capacity of humans to adapt with creativity to dramatic changes, a process vitalized by long established cultural and material ties to local ecologies.

Mobilizing materiality

In his book *Museums in a Troubled World*, Robert Janes argues that in response to the ecological and economic crises of our time, museums need to transform their "public service persona, defined by education and entertainment, to one of a locally-embedded problem solver, in tune with the challenges and aspirations of the community." The alternative, he asserts, is a decline into irrelevance.[13] *The Paddock Report* and *Food Stories* projects apply museum expertise in the drawing of meaning from materiality to engage Australians in efforts to understand and respond constructively to the great cultural, emotional and physical challenges of climate change.

Australian food production systems are especially vulnerable to the ecological disruptions of climate change because they are productions of modern, industrial culture. Devaluation of the local and the particular, and a scientific stance that casts Australian agricultural terrain as devoid of agency and story, as blank surfaces upon which to apply abstracted scientific and industrial imaginings, are characteristics of modern farming that expose Australians to more erratic and extreme climatic patterns. Like never before, attentiveness to the expressions of natural forces and other species are necessary to secure the ongoing productivity of gardens and farms. Engagement with dynamic terrain demands the valuing and reimagining of materiality. "Philosophical alternatives that discern wisdom and intelligence in the material world can help move us from the monological to the dialogical, from domination to negotiation with our very material ecological context," wrote Val Plumwood.

13 Robert R. Janes, *Museums in a Troubled World* (London: Routledge, 2009), 173.

Museums hold capacities and skills to mobilize materiality itself to uncover deep histories of human embeddedness within material and ecological networks. The repositioning of expressive museum objects within rich contexts of particular places and their histories enables and vitalizes understandings of human ties to productive terrains. At this time of unfolding climatic chaos and its cultural challenges, embodied and imaginative encounters with the active material particularities of gardens, farms and museum objects allows storytelling that brings resilience to land and people.

22
SHAPING GARDEN COLLECTIONS FOR FUTURE CLIMATES

Sharon Willoughby

All great cities of Australia, by an instinct as artistic as it is wise, have made excellent provision for botanic gardens.

Picturesque Atlas of Australasia, 1888[1]

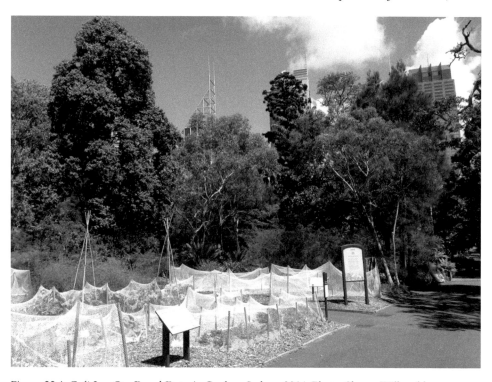

Figure 22.1 *Cadi Jam Ora*, Royal Botanic Gardens Sydney, 2014. Photo: Sharon Willoughby.

1 Cited in Murray Fagg, "A Brief History of the Botanic Gardens in Australia," online (2000). www.anbg.gov.au/botanic-gardens/history-botanic-gardens-in-aust.htnl

Collecting: the quest to name and know

For almost 200 years museums and botanic gardens in Australia have been collecting and preserving physical evidence of the natural world. Sydney was host to the first botanic garden in the Australian colonies, which opened to the public in 1816. It also established the first museum, which opened in 1827. These were the local institutions that began the project to collect, name and know the biota of the Australian continent. They were supported by imperial gardens and museums in Europe and elsewhere. In 1787, Rules for Collecting and Preserving Seeds from Botany Bay were laid out by the enterprising London nurseryman James Lee,[2] promoting his Hammersmith nursery, the Vineyard, to wealthy private collectors in England. The Australian flora was first known to western science by Europeans as exotica traded and transplanted to the northern hemisphere for ex situ collections, both botanic and private.[3]

The task of growing plants in situ in the Australian climate became the particular task of local private and public gardens.[4] Following the opening of Sydney, the number of botanic gardens in Australia grew rapidly to more than 40 by the end of the nineteenth century.[5] The next boom in building gardens, with a new focus on growing Australian native plants, came between 1950—2000, with a total of 140, with each State and Territory capital city having at least one major garden.[6] Gardens were also built in many regional centers, especially in the more temperate and populous south-eastern Australia. The location of Australian gardens reflects the different Australian biomes with the Royal Tasmanian Botanic Gardens in cool temperate Hobart, the Olive Pink Botanic Garden in arid Alice Springs, Northern Territory, and Cooktown Botanic Garden in the wet and steamy tropics of Cape York Peninsula, Queensland.

The living collections displayed in nineteenth-century gardens were driven by aesthetic considerations, the aspirations of acclimatization societies, the scientific quest for discovery and the moral challenge of acquiring exotic, new plants.[7] These early collections were encyclopaedic in nature amassing as many species, native to Australia or from exotic locations, as could be acquired and grown within the climatic and soil conditions of each garden. Climate

2 Philip A. Clarke, *Aboriginal Plant Collectors: Botanists and Australian Aboriginal People in the Nineteenth Century* (Kenthurst, Australia: Rosenberg Publishing, 2008), 59.
3 Richard Aitken, Julie Collett, Thomas Darragh, A., Jennifer Jones-O'Neill, and Gordon Morrison. *Capturing Flora: 300 Years of Australian Botanical Art* (Ballarat, Australia: Art Gallery of Ballarat, 2012), 84.
4 "More About Us," Australian Seedbank Partnership, www.seedpartnership.org.au/about/moreaboutus. The Australian collecting project is enormous. It is now estimated that this mega-diverse region is home to some 560,000 species of organisms with a staggeringly high level of endemism as some 94 percent of frogs, 93 percent of reptiles, 87 percent of mammals, 45 percent of birds and 92 percent of flowering plants occur nowhere else on the planet.
5 Some were public and some privately funded – numbers of botanic gardens in nineteenth-century Australia vary from 30 in Leslie Lockwood et al., *Botanic Gardens of Australia: A Guide to 80 Gardens* (Sydney, London, Auckland, Cape Town: New Holland Publishers, 2001): 9 to 42 in Gwen Pascoe, *"Long Views and Short Vistas": Victoria's Nineteenth-Century Public Botanic Gardens* (North Melbourne: Australian Scholarly Publishing, 2012), in Victoria alone.
6 It is estimated by BGCI that by 2010 there were 2,500 botanic gardens worldwide. This number changes depending on the definition of a "botanic garden." The same is true of figures quoted for Australia.
7 Sandra Beckwith, *Royal Botanic Gardens Melbourne: Master Plan* (South Yarra, Victoria: Royal Botanic Gardens Melbourne, 1997), 22. See also, Pascoe, *"Long Views and Short Vistas": Victoria's Nineteenth-Century Public Botanic Gardens*, 172–173.

is, in a very real sense, an important curator of these collections.[8] Sarah Hayden Reichard and Peter White discuss the extensive role of nineteenth-century gardens in moving flora around the globe through live plant and seed exchange.[9] In Australia "reshuffling" has created legacies of extraordinarily exotic plant collections, beautiful historic gardens and environmental weeds that irreversibly affect native ecosystems.[10]

Sitting alongside living collections there are 28 major herbaria in Australia holding more than 6 million specimens of plants, algae and fungi. While the Australian flora is largely captured in these herbaria, the classification of these specimens, a dynamic project as new technologies such as DNA sequencing continue to redefine plant relationships, is ongoing.[11]

The Millennium Seedbank Project launched by the Royal Botanic Gardens, Kew in 1996 aimed to bank the seeds of 25 percent of the world's flora by 2020.[12] A number of large gardens in Australia have specialized in growing Australian plants exclusively: the Australian National Botanic Gardens in Canberra holds 6,200 species which represents around a third of Australian plants; the Australian Botanic Garden, Mount Annan outside Sydney holds 4,000; Kings Park in Western Australia has specialized in the flora of Western Australia, which makes up around 50 percent of the Australian flora; and the Australian Garden at the Royal Botanic Gardens Cranbourne holds 1,200 taxa in the living collection.[13] How these collections relate to plants that are rare and threatened in the wild or the amount of duplication between them has not been evaluated systematically. The collections that have been amassed contain the whispers of past species and ecosystems. In the light of climate change, the key question becomes – do they also hold the seeds of the future?

8 John Prest. *The Garden of Eden: The Botanic Garden and the Re-Creation of Paradise* (New Haven and London: Yale University Press, 1981), 6. To read the extensive list of nineteenth century Botanic Gardens Director describing the role of Botanic Garden collections, see, Baron Ferdinand von Mueller, *The Objects of a Botanic Garden in Relation to Industries: A Lecture Delivered at the Industrial and Technological Museum Melbourne* (Melbourne, 1871).

9 This "reshuffling" must also have been driven to some degree by private collections and commercial nurseries, the influence of which little is currently written about in Australian terms. Sarah Hayden Reichard and Peter White, "Horticultural Introductions of Invasive Plant Species: A North American Perspective," in *The Great Reshuffling: Human Dimensions of Invasive Alien Species*, ed. Jeffrey A. McNeely (Gland, Switzerland and Cambridge, UK: IUCN Biodiversity Policy Coordination Division, 2001).

10 Philip E. Hume, "Addressing the Threat to Biodiversity from Botanic Gardens," *Trends in Ecology and Evolution* 26 (2011): 168–74.

11 With thanks to Professor David Cantrill, Chief Botanist Victoria and Director of Plant Sciences and Biodiversity, Royal Botanic Gardens Melbourne, for a conversation on this topic on 30 December 2013. See, *The Darwin Declaration*, 1998 on www.environment.gov.au/node/13848, which discusses the taxonomic impediment to conservation efforts. It is also worth noting that not all gardens have a herbarium and not all herbaria are located in gardens – these organizations are however closely associated.

12 For more information on the Royal Botanic Garden Kew's Millennium Seedbank Project and the role of Australian herbaria see the website of the Australian Seedbank Partnership, www.seedpartnership.org.au and www.kew.org/science-conservation/save-seed-prosper/millennium-seed-bank/index.htm By 2013 the Australian Seedbank Partnership had banked a third of the Australian flora including 25 percent of the plants considered threatened in Australia.

13 While all major gardens record and database the plants that are in their living collections the synthesis of these collections, a project that the Botanic Gardens Conservation International (BGCI) has underway, is not a straightforward process. Different organizations have historically used different platforms in which to record these data, which is problematic. To read more about this project see www.bgci.org/usa/makeyourcollectionscount/. For the statistics on living collections see: www.anbg.gov.au/gardens/living/index.html, www.rbgsyd.nsw.gov.au/annan, www.bgpa.wa.gov.au/about-us/horticulture/wa-botanic-garden and Bev Roberts, *The Australian Garden*, ed. Helen Vaughan (South Yarra, Victoria: Royal Botanic Gardens Board Victoria, 2007).

Re-imagining the future for botanic gardens

> Putting collections to work for conservation, and understanding global change are both natural progressions from areas of traditional strength in botanic gardens.
> Crane et al., *Plant Science Research in Botanic Gardens, 2009*[14]

As well as seeing a boom in building new gardens in Australia the 1970s saw an important shift in the work of gardens. The rise of ecological science and the conservation movement saw gardens increasingly adding conservation of plants to their mix of objectives and organizational missions.[15]

The establishment of Botanic Gardens Conservation International (BGCI), based at Kew Gardens in 1987 was the next big step in re-imagining the way that gardens would function in the future. BGCI was formed as a small secretariat under the auspices of the International Union for Conservation of Nature (IUCN).[16] The role of BGCI was to establish a network of international botanic gardens providing a focus for collaborative work on plant conservation. While gardens have a long history of international collaboration, the formation of BGCI provided a more formal and coordinated focus to international and national partnerships in the modern era. It also set the scene for a collaborative approach to issues of global change and collections.

One of the first and most important projects that BGCI worked on was as the lead organization in developing the Global Strategy for Plant Conservation (GSPC), adopted by 187 countries under the United Nations Convention on Biological Diversity in 2002. The key objective of the GSPC was to "halt the current and continuing loss of plant biodiversity by 2010."[17] In their 2011 paper Schulman and Lehvävirta credit BGCI with the important role of bringing the GSPC into the mainstream and for adding the conservation of plants to the traditional repertoire of botanic gardens, expanding their role beyond garden displays, research and teaching.[18]

It can also be argued that the key achievements of BGCI are that it has provided a focus and frameworks for formalizing plant conservation in botanic gardens and, more importantly, publicizing the conservation work of botanic gardens. The *International Agenda for Botanic Gardens in Conservation* was first published in 2000 with 472 botanic gardens across 83 countries as signatories to the convention.[19] Sitting alongside this work is the establishment of a database that documents over 150,000 plants in cultivation in botanic gardens worldwide. Included in this database are over 12,000 species that are considered under threat in the

14 Peter R. Crane, Stephen D. Hopper, Peter H. Raven, and Dennis W. Stevenson, "Plant Science Research in Botanic Gardens," *Trends in Plant Science* 14 (2009): 576.
15 Michael Maunder, "Botanic Gardens: Future Challenges and Responsibilities," *Biodiversity and Conservation* 3 (1994): 97.
16 "The History of BGCI," Botanic Gardens Conservation International, www.bgci.org/global/history/. The IUCN was formed in 1948 by UNESCO.
17 Leif Schulman and Susanna Lehvävirta, "Botanic Gardens in the Age of Climate Change," *Biodiversity Conservation* 20 (2011): 217–220. An updated version of the strategy was produced in 2010 by the Convention of Biological Diversity. This takes the goals of the strategy up to 2020.
18 Leif Schulman and Susanna Lehvävirta, "Botanic Gardens in the Age of Climate Change," *Biodiversity Conservation* 20 (2011): 217–220.
19 BGCI, "The History of BGCI." Botanic Gardens Conservation International, www.bgci.org/global/history.

wild.[20] As well as providing a focus for the conservation role of botanic gardens, BGCI has maintained a sharp focus on the educational and public engagement roles of gardens as a key strategy in supporting plant conservation science. This work has had a particular emphasis, since 2006, on education about climate change.[21]

Gardening the Antipodes – botanic gardens in Australia and New Zealand

> The onset of the second transition – from an Aboriginal culture to an industrialized European culture – occurred just as global changes were moving Earth into the Anthropocene.
>
> *Libby Robin,* How a Continent Created a Nation, *2007*[22]

Over the past 200 years the Australian continent, by world standards, has seen swift changes in its extraordinary biodiversity with some 1,289 species of flora and 444 species of fauna now considered extinct, endangered or vulnerable in the wild.[23] This is part of a worldwide trend where up to 50 percent of the world's vascular plants will be threatened with extinction within the next 100 years.[24] Climate change has rapidly been recognized as the primary threat to many plants.[25] *The Botanic Gardens Australia and New Zealand Inc.* (BGANZ) was formed in 2004[26] and in 2008, a National Strategy and Action Plan for the Role of Australia's Botanic Gardens in Adapting to Climate Change was published (www.anbg.gov.au/chabg/climate-change/).[27] The use of the word "adapting" is significant here its strategy demands a "climate change preparedness and adaptation," rather than mitigation. The strategy highlights three key ranges of activity: providing a "safety net" for plants through *ex situ* conservation, providing specialist knowledge and providing community awareness about climate change. It also points to the need for funding for botanic gardens to reach their full potential in conserving plants.

20 Ibid.
21 Botanic Gardens Conservation International, "Towards a New Social Purpose: Redefining the Role of Botanic Gardens." Richmond, UK: Botanic Gardens Conservation International, 2010. This publication provides a good summary of the current state and focus of education in Botanic Gardens.
22 Libby Robin, *How a Continent Created a Nation*. (University of New South Wales, Sydney, Australia: University of New South Wales Press Ltd, 2007): 208.
23 "EPBC Act List of Threatened Flora," www.environment.gov.au/cgi-bin/sprat/public/publicthreatenedlist.pl?wanted=flora.
24 B. Hawkins, S. Sharrock, and K. Havens. "Plants and Climate Change: Which Future?." Richmond, UK.: Botanic Gardens Conservation International, 2008: 4.
25 Leif Schulman, Leif and Susanna Lehvävirta, "Botanic Gardens in the Age of Climate Change," *Biodiversity Conservation* 20 (2011): 217–220.
26 BGANZ. "About BGANZ." Botanic Gardens Australia and New Zealand, www.bganz.org.au.
27 CHABG, "National Strategy and Action Plan for the Role of Australia's Botanic Gardens in Adapting to Climate Change." Canberra: Council of Heads of Australian Botanic Gardens, 2008.

The new acclimatizers

> While the debate on assisted migration continues, it is clear that, across the planet, we have already given many species an unintentional head start on climate change.
>
> *Veken* et al., Garden Plants Get a Head Start on Climate Change, 2008[28]

A number of botanic gardens in Australia have developed their own site-specific responses to climate change, acknowledging that living collections are unlikely to escape the impacts of climate change. Both the Royal Botanic Gardens Melbourne (Melbourne Gardens) and the Australian National Botanic Garden (ANBG) strategies also stress the need to ensure that the "carbon footprint" of the organization doesn't increase in seeking to maintain the living collection under these changes.[29] This may rule out an era of high energy "Cooling Houses" (beyond the freezers of Seedbanks) for plants as the climate warms.

The *RBG Melbourne Landscape Succession Plan Framework* highlights conservation of the historic garden landscape rather than individual species. The framework advocates changing the "planting palette" of the garden, replacing more vulnerable species with hardier species from hotter and drier climatic regions.[30] It also aims for a secure water supply (using reclaimed water as an alternative supply to potable water) and to ensure an age-balanced population of trees in the garden.[31] This work is about acclimatization of the whole landscape to climate change, shaping the garden to deal with predicted changes whilst maintaining the design character and public amenity of the space. The longevity of the botanic gardens as an experience for the community is a key concern.[32]

There are obvious tensions here between the role of a garden as a landscape, the conservation aims of the organization and the reality that without massive inputs of energy and water plants will only grow in certain climatic conditions. Will gardens need to work in collaboration in the future to ensure that those plants that will no longer grow, for example, in Melbourne are still grown somewhere else where the climate is still temperate? How will this reshuffling occur? Which plants are a priority to save?

Another direction that gardens in Australia may take towards climate change mitigation is the move towards a scientific and practical focus on restoration ecology. Restoration ecology seeks to rebuild or replant habitat that has been lost where *in situ* conservation has failed. Hardwick and colleagues argue that adding restoration ecology to the scientific disciplines

28 Sebastiaan Van der Veken, Martin Hermy, Mark Vellend, Anne Knapen, and Kris Verheyen, "Garden Plants Get a Head Start on Climate Change," *Frontiers in Ecology and the Environment* 6 (2008): 212–216.
29 Chris Cole, "Landscape Succession Plan – Framework," At *BGANZ Plants Forum: Putting the Botanic Back into Botanic Gardens*. Royal Botanic Gardens Melbourne Australia, 2013. And: Director of National Parks "Australian National Botanic Gardens Climate Change Strategy." Canberra, Australia: Commonwealth of Australia, 2010–2015.
30 The Köpper-Geiger climate classification map is one of the tools used to assess which plants to grow in the future.
31 Peter Symes, "Rethinking Botanic Gardens in the Face of Climate Change – Perspectives on Planning, Landscape Design, and Implementation," In *BGANZ Congress* (2009): 29.
32 Royal Botanic Gardens Melbourne, "Living Plant Collections Plan, Rbg, Melbourne." South Yarra, Melbourne, Australia: Royal Botanic Gardens Melbourne, 2011.

of a botanic garden would "maintain the relevance of botanic gardens and arboreta by addressing the challenges posed by global change."[33]

Beyond *ex situ* conservation of plants in gardens and seed banks, beyond *in situ* conservation of plants in the wild, and the recreation of habitats that have been lost by withdrawing species that have been banked in collections, sits the "difficult discussion" of translocating species that went global in the IUCN publication *Saving species by translocation*.[34] Rather than arguing that moving plants around the globe causes problems, including the introduction of environmental weeds, the new guidelines make a case for "deliberately moving plants and animals for conservation purposes around the world."[35] The IUCN publication acknowledges that humans have moved species around the globe "for their own purposes for millennia, and this has yielded benefits for human kind, but in some cases has led to disastrous impacts." In many ways the legitimization of the translocation of species turns the role of gardens full circle where the acclimatization of species has accidently saved some species from extinction. Hard core conservationists still concerned about the lack of purity or authenticity in "novel ecosystems" may be surprised by the 2013 guidelines; for most, creating deliberately novel ecosystems beyond agriculture or gardening may be a step too far.

Australian Gardens are yet to respond to or incorporate these latest guidelines into current discussion on the role of gardens in plant conservation. How will gardens navigate the specter of their role in the blunders of nineteenth-century acclimatization societies as they undertake this work? In many ways gardens have never abandoned the acclimatization project and this may be to global benefit in the long run.

Michael Maunder in a prescient paper "Botanic Gardens: Future Challenges and Responsibilities," observed that unlike zoos, botanic gardens were not forced to review their *ex situ* conservation activities, Maunder also posed a question:

> Do we expend large efforts on maintaining increasingly artificial fragments of historical community (using the techniques of ex situ conservation to sustain anachronistic biological community); or will we accept new assemblages possibly dominated by exotic species and perhaps even accept that exotic species might play a valuable ecological role in the new "greenhouse" ecology?[36]

More importantly it will be interesting to see how the debate about which plants we will elect to save unfolds. Will we only save what we love, what we find beautiful, useful, edible? How will we decide which plants to translocate? Will non-native plant species be introduced into Australia in order to save them as habitat is lost to changing climate elsewhere? Will Australian plants be sent off shore in order to save them?

33 Kate A. Hardwick, Peggy Fiedler, Lyndon C. Lee, Bruce Pavlik, Richard J. Hobbs, James Aronson, Martin Bidartondo, et al., "The Role of Botanic Gardens in the Science and Practice of Ecological Restoration," *Conservation Biology* 25 (2011): 274.
34 IUCN. "Saving Species by Translocation – New IUCN Guidelines." www.iucn.org/?13519/Saving-species-by-translocation--new-iucn.
35 Ibid.
36 Maunder, Michael, "Botanic Gardens: Future Challenges and Responsibilities," *Biodiversity and Conservation* 3 (1994): 97–103: 98.

Growing the future

> "Some organizations in the vanguard of species protection are, although steeped in scientific understanding of these issues, still too introspective to engage effectively with their local communities. Botanic Gardens may be numbered among such organisations."
>
> BGCI, Towards a New Social Purpose, 2010[37]

The 2010, BGCI paper, "Towards a New Social Purpose: Redefining the Role of Botanic Gardens," highlighted the tension that exists within modern gardens between their role as a source of authoritative scientific information about global change and their potential for advocacy within the public education space. Zoos in Australia and international social enterprise gardens such as the Eden Project in the United Kingdom have been successful in creating displays, exhibitions and programs that advocate for action to mitigate climate change. Gardens in Australia have just begun to make steps towards this work.[38]

Gardens in Australia are the second most visited places after cinemas. Thirteen million Australian adults visit botanic gardens every year.[39] When you consider the virtual visitors that a modern garden can also reach through social media, gardens have an enormous audience.[40] Projects that gardens have developed since the 2010 report include the development of citizen scientist programs such as "ClimateWatch" created in partnership with EarthWatch.[41] This activity uses mobile technology to encourage visitors to gardens to record the date and location of key indicator species in flowers. This tool also links visitors to information about climate change mitigation and impacts.

Gardens are also working more closely with their community through partnerships. An example of this is the Carbon Futures program, an initiative of the Royal Botanic Gardens Cranbourne and the social enterprise project WithOneSeed.[42] This program allows students to explore the role of plants in the carbon cycle and investigates issues such as deforestation and social justice. Students work towards offsetting the carbon footprint they generate through their own personal technology usage by trading carbon credits with students in Timor Leste who are regrowing Mahogany forests. Gardens are increasingly working across their traditional boundaries, their "garden fence." in order to engage their communities.

Maunder pointed to change in the design of new gardens as evidence of a shift in the way that gardens are using good design to attract and educate the public, citing the Australian

37 Botanic Gardens Conservation International. "Towards a New Social Purpose: Redefining the Role of Botanic Gardens." BGCI, 2010:1.
38 Botanic Gardens Conservation International, "Towards a New Social Purpose: Redefining the Role of Botanic Gardens," BGCI (2010):12. See also, www.edenproject.com This may in part be due to how close gardens sit administratively to government and consequently their ability to lobby.
39 CHABG, "National Strategy and Action Plan for the Role of Australia's Botanic Gardens in Adapting to Climate Change," Canberra: Council of Heads of Australian Botanic Gardens, 2008: 8.
40 Bridie Smith, "Tweets All Part of Growth and Change," *The Age*, 26 February 2013. An interview with the CEO and Director of the Royal Botanic Gardens Melbourne, Tim Entwisle on his appointment in 2013.
41 www.climatewatch.org.a See also, www.climatewatch.org.au/trails/australian-national-botanic-gardens for more detailed information about how this works in a garden.
42 For more detail about this project see, http://withoneseed.org.au See also the video http://withoneseed.org.au/video-gallery/#slide-3

Garden at the Cranbourne Gardens and the Eden Project, Cornwall, England, as examples of this shift.[43] This may suggest a start, but left open is the question of how to mobilize living collections to create engaging exhibits that provoke curiosity in the exploration of global change. There is still a tension within the modern garden between reduced investment in collections, the need to generate commercial revenue and the expectation of working in community education, communication and development.

The Anthropocene ark

Figure 22.2 The Australian Garden show garden, Royal Horticultural Society Chelsea UK, 2011. Photo: Jay Watson; courtesy Royal Botanic Gardens Victoria.[44] See Plate 24.

> The movement to conserve nature in private gardens and yards has been enthusiastically championed by scientists, especially those at botanical gardens."
> *Emma Marris.* Rambunctious Garden: Saving Nature in a Post-Wild World, *2011*[45]

Primack and Miller-Rushing have argued that gardens are uniquely placed to research and respond to climate change because of the quality, specificity, geographic and taxonomic range

43 Maunder, Michael, "Beyond the Greenhouse," *Nature* 455 (2008): 596.
44 The Australian Garden Show Garden was created by landscape architect Jim Fogarty for display at the 2011 RHS Chelsea Flower and Garden Show, London, UK.
45 Emma Marris, *Rambunctious Garden: Saving Nature in a Post-Wild World* (New York: Bloomsbury USA, 2011): 146. Photograph showing the Australian Garden display being enjoyed by the public at the RHS Chelsea Flower and Garden Show, London, 2011. Photograph by the author.

of their collections.[46] They argue that gardens contain key data about the impact of anthropogenic change in the records that show the effect of temperature change on flowering time and leaf-out. Herbarium collections are especially significant because they contain records of past and present plant distribution, biodiversity, phenology and bioclimatic data. These data sets are important tools for assessing extinction risk for species as climates change.

The original sin of gardens, the reshuffling of the nineteenth century meant that the living collections of gardens provide examples of plants growing beyond their usual range in the wild. These *ex situ* collections of plants have great conservation value as they provide critical data about where plants might grow under climate change.[47]

Seedbanks, an increasing focus on restoration ecology and the potential of botanic science to include the translocation of exotic species, are ideas on the frontier of botanic science.

Figure 22.3 The Australia Landscape created in partnership between the Royal Botanic Gardens Kew and the British Museum, British Museum forecourt, 2011. Photo: Sharon Willoughby.

46 Richard B. Primack and Abraham J. Miller-Rushing, "The Role of Botanical Gardens in Climate Change Research," *New Phytologist* 182 (2009): 303–313.
47 This point relates to the untapped potential of botanic gardens living collections. It is reliant on knowing the inputs required to establish and maintain these species outside their natural range. This is a question that ecologists grapple with: what is the potential versus realized niche of any species, the autecology. Without this information we may not have the full picture on the future ranges of species. Personal communication, Professor David Cantrill, January 2014.

Global change is likely yet to take gardens into uncharted territory in terms of our relationships with plants and test the relationship between gardens and their communities. Given the number of gardens in Australia and the world, the breadth of their collections, the wealth of expertise they contain and their popularity with the visiting public, the re-imagined garden could be a uniquely important tool in human adaptation to climate change.

The most distinctive thing about gardens is their living collections, a collection that visitors can touch and engage with using all their senses. Gardens provide important encounters with plants and nature in the urban world. Until 2000 this was the key difference between gardens and museums. Since 2000 this boundary has blurred in Australia with the development of the Forest Gallery at the Melbourne Museum (a garden like museum display) and the Australian Garden at the Royal Botanic Gardens Victoria, Cranbourne Gardens (a museum-like garden).[48] Gardens, museums, zoos and galleries are increasingly working together across their boundaries in recognition of the complexity of the stories they are trying to use their collections to tell and the difficulty of the conversations they need to facilitate with their communities about global change.

Ideas about the role of a botanic garden and its collections have changed through time. From the private collections of the European elite at the dawn of the nineteenth century, institutional collections to support the work of botanic science and industry, to modern collections mobilized to support the needs of the public. Through all this time the public have continued to access the living collections, play under the trees when they were young and bring their grandchildren back when they were older. These gardens have become an important part of the life of our communities and they will be an essential part of re-imagining the future.

48 Libby Robin, "The Red Heart Beating in the South-Eastern Suburbs," *reCollections* 2 (2007).

23

OBJECT IN VIEW

A past future for the cucumber

Sharon Willoughby

This long hollow tube is a mysterious object to find in a garden. Its glass is slightly green, uneven and wavy, yet it feels light, delicate, fragile and easily broken. At the top the glass is pinched and shaped into a button, opening into an open hollow tube, a stretched version of the more familiar horticultural "cloche" or bell jar.[1] This cylinder of delicate glass is a rare survivor from the mid-nineteenth century: a relic of another time and a past dream of straightening cucumbers for better sandwiches.

The Gardener's Chronicle of April 1848 reports the Stockport Cucumber Show's obsession with the "cucumber in its perfect proportions." The winner was "22 ½ inches, perfectly straight and level as the barrel of a gun."[2] A straightener assisted in persuading nature to full perfection. But this was not without risks, as the famous Mrs Beeton noted: "When the tubes are used, it is sometimes necessary to watch them, in order that, during the swelling of the fruit, they are not wedged into the tubes so tightly that they are difficult to withdraw."[3] A crooked cucumber met a different fate: if they were "small, crooked or discoloured" they were given to the pigs.[4] In a stove or glasshouse, cucumbers were often trained into

[1] Glass has been used in a number of ways in the garden from the larger sheets of glass used to make glasshouses to cloches (also called "bell," "melon" "cucumber" or "hand glasses") used (like a mini-glass house) to protect newly established plants, wasp traps, hyacinth vases, grape bottles and fairy lights for garden parties. See John Viska, "Handle with Care: Collectable Glass for the Garden," *Australian Garden History* 23 (2012): 5–10.

[2] *The Gardener's Chronicle and Agricultural Gazette* (1848): 319.

[3] Isabella Beeton, *Mrs Beeton's Garden Management: The Art of Gardening* (Ware: Wordsworth Editions Ltd, 2008), 705.

[4] *The Gardener's Chronicle and Agricultural Gazette* (1859): 707.

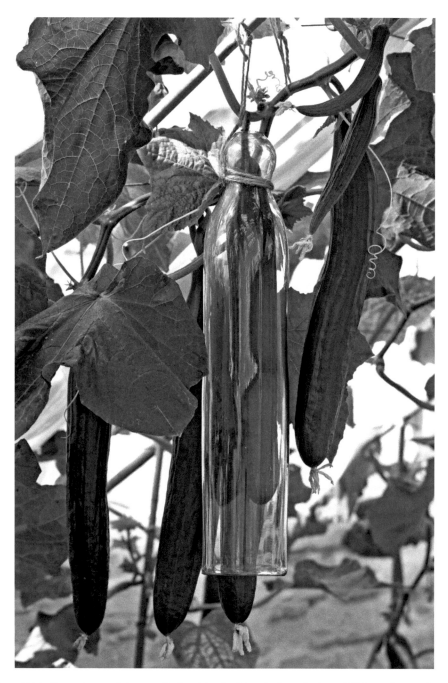

Figure 23.1 Cucumber straightener displayed in the historic *Lost Gardens of Heligan*, Cornwall, UK.[5] Photo: Michelle Garrett. See Plate 25.

5 The Lost Gardens of Heligan is a living museum demonstrating Victorian horticulture on a large estate. Image reproduced with permission of Michelle Garrett, www.michellegarrettphotographer.co.uk.

straighteners on a trellis angled just below the glass roof. Mrs Beeton described the power of gravity thus:

> Cucumbers are sometimes allowed to trail over a trellis. By this means the fruit are suspended, and no glass tubes are required to keep them straight, some, even when grown on a bed, are tied up with sticks for the same purpose.[6]

"Pharo" of *The Gardener's Chronicle* remarked, "I remember the time when the production of a cucumber in winter was considered a mighty horticultural feat; and when such a thing was accomplished by some lucky gardener his neighbors were placed in no enviable position."[7] By 1850, the future was cucumbers all year around, unencumbered by seasons.

The inventor of the cucumber straightener

George Stephenson (1781–1884), "father of the British railways," best known for the "Rocket" (an early steam locomotive of 0-2-2 wheel arrangement), was also a gardener.[8] Frustrated with crooked cucumbers, Stephenson designed glass straighteners and had them made at his Newcastle steam engine factory in 1845. Stephenson must have enjoyed his sandwiches: he also improved the Cucumber Slicer.[9]

It is likely that glass and other transparent materials, such as oiled paper, cloth and sheets of mica, have been important to serious gardeners for thousands of years: the first users of horticultural glassware are lost in the mists of time.[10] Surviving examples are rare objects in collections. Cucumber plants grown in the open were commonly started under cloches and it isn't difficult to imagine how the straightener may have evolved from this practice.[11]

The modern cucumber

It is tempting to think of perfection in fruit and vegetable production as a rather Victorian concern until you consider the modern supermarket cucumber vacuum-sealed and straitjacketed in its plastic film, perfect and unblemished.[12]

6 Beeton, *Mrs Beeton's Garden Management: The Art of Gardening*, 704. This book was originally published as *Beeton's Book of Garden Management* in 1861.
7 *Gardener's Chronicle* (1850): 597.
8 William Edgar, "Engineering: From the Depths to the Heights," *The Institute of Mechanical Engineers*, May 26, 2004.
9 Both a cucumber straightener and slicer are on display at the Chesterfield Museum, Derbyshire. Emma L. Oram, "Historical Heroes and Heroines: Part Two, George and Robert Stephenson," Vintage Script-Editors (blog), February 22, 2012, vintagescript.blogsport.com.au/2012/02/historical-heros-heroines-part-two.html
10 Peter Thoday, *Two Blades of Grass: The Story of Cultivation* (Wiltshire, UK: Thoday Associates, 2007), 371–389.; Audrey Noel Hume. *Archaeology and the Colonial Gardener* (Virginia: Colonial Williamsburg Foundation, 1974), 62.; Viska, "Handle with Care," 5.
11 Thomas Watkins, *The Art of Promoting the Growth of the Cucumber and Melon; in a Series of Directions for the Best Means to Be Adopted in Bringing Them to a Complete State of Perfection* (London: Harding, St James Street, 1824), 51; Thomas McMillan, *Plain and Practical Hints on the Cultivation and Management of the Melon, Cucumber, Gourd and Vegetable Marrow* (Melbourne: Slater, Williams, and Hodgson, 1856); James Cuthill, *A Treatise on the Cucumber and Melon* (London: Groombridge and sons, Paternoster Row, 1870).
12 Steven Aldridge and Laurel Miller, *Why Shrinkwrap a Cucumber?: The Complete Guide to Environmental Packaging* (London: Laurence King Publishing Ltd., 2012).

While the straight lines of industrial modernity may have begun in the Victorian era, they continue to shape the vegetables of the twenty-first century. In June 2011 Japanese astronaut Satoshi Furukawa grew cucumbers at the International Space Station as part of a series of experiments to see how future space explorers might produce their own food.[13] It is not reported whether the cucumbers were curly or straight in zero gravity. Will the International Space Station be the next to press the cucumber straightener into service? The cucumber straightener is a reminder of past visions for the future of vegetables. Our future visions continue to bend – or perhaps straighten! – plants into our service.

13 "Cucumbers in Space: Astronaut's Horticultural Mission," *The Guardian*, June 6, 2011, www.theguardian.com/science/2011/jun/06/cucumbers-in-space-japanese-astronaut-mission.

24
THE ART OF THE ANTHROPOCENE

William L. Fox

Introduction

What I propose in this short chapter is that as our understanding of earth systems science has grown, so has our artistic response co-evolved from the same set of observations about and measurements of the world; the two modes of inquiry, the artistic and the scientific, are inextricably linked in a common set of stimuli.[1] This is clearly evident in much Euro-American art produced during the Anthropocene. As anthropic effects on the planet increased, became more visible, and finally started to have negative impacts on human society, both art and science were paying attention and reinforcing one another's actions. Art museums, as it turns out, are excellent laboratories in which to test this proposition, which describes an ongoing synergistic process as well as a conjoined history.

The ideas expressed here stem from the writing about art and the Anthropocene that I began in 2003, and the mission that the Nevada Museum of Art subsequently set out in 2008 for its Center for Art+Environment. The adoption of the rubric was logical, given the history of the Museum, which was established in Reno eighty-one years ago by two close friends, James Church and Charles Cutts. Church, a classics professor at the University of Nevada, was an aspiring polar explorer who took to climbing several times every winter nearby Mt. Rose, at 10,775-feet the highest Sierra Nevada peak outside Reno. His excuse to the University for his frequent ascents was that he was measuring the annual water content of snow, which allowed him to predict to farmers in arid Nevada how much water they would have for irrigation in the spring. Although Church never reached the North Pole, he did gain international recognition for establishing the world's first snow survey and spreading his techniques around the world. His methodology is still used today, and his work generated an early and valuable climate data set.

1 Jack Burnham, "Systems Esthetics," *Artforum* 7, no. 1 (1968): 30–35. This is the first of what would become a number of articles and books exploring the relationships among systems and communications theory, cybernetics, and art. Barbara Novak, *Nature and Culture: American Landscape and Painting, 1825–1875* (New York: Oxford University Press, 2007). An enduring classic of transdisciplinary art history first published in 1980.

Charles Cutts was a local mercantilist who was also an avid book and art collector. Together with his friend Church, he started what would become the Nevada Art Gallery, then the Nevada Museum of Art, a place they hoped would be a center for conversation among humanists, artists, and scientists. Among the books that Cutts collected was a 1911 volume titled *Art and Environment*, an early attempt to relate culture to geography. In its early years the Museum was administered largely by local *plein air* painters, a group that by its very nature maintained an allegiance to the environmental orientation of the founders.

In the late 1980s the Museum established what has since become its largest permanent collection, the Altered Landscape, which holds photographs that deal with the ways humans have changed the face of the planet. In turn, this led to the establishment in 2009 of the Center for Art + Environment, the only such research institute in the world. The overarching rubric for what we collect, study, and promote at the "CA+E" is the Art of the Anthropocene, which we frame as "creative human interactions with natural, built, and virtual environments." The CA+E Archive Collections already hold materials from more than 1000 artists working on all seven continents, the source materials for the half dozen or so exhibitions that the Center presents annually, as well as associated public programs and publications.

This brief history of the Museum expresses a parallel to the way our understanding of the environment has become larger and deeper over time. Artists used to just paint a picture of a forest, the ocean, the mountains. Then, as the human footprint became larger on the planet, they began to make paintings and photographs of the anthropic influence on the Earth. And now, as the effect of that footprint has been to change the way the Earth functions, artists create interventions that both represent and seek to change those functions. This is part of why Paul Crutzen had to formally recognize the Anthropocene. It wasn't just that the physical evidence of our effect had accumulated to the point where it was verifiable, but that human society had begun to address anthropic global change through its culture.

The definition of the Anthropocene that we use at the Museum is the one originally proposed by Crutzen in 2000, which pegs the beginning of the epoch in the late 1700s with the widespread use of coal as the fuel of choice for the Industrial Age.[2] Crutzen, Will Steffen (ANU) and John McNeill (Georgetown) later proposed that three stages could be identified within the development of the Anthropocene. The first started when the commercial success of James Watt's steam engine made possible the industrial-scale consumption of coal; the second commenced after World War II with the greatly accelerated use of fossil fuels worldwide. The third stage they defined as the period when humanity becomes "a self-conscious and active agent in the operation of its own life support system economies."[3] There is a correspondence, or perhaps more accurately a consonance among these three stages of the Anthropocene and the movement of artists from picturing nature into imaging the human footprint upon it, and then to intervening in the systems of the world.

2 Paul J. Crutzen, "Geology of Mankind," *Nature* 415, no. 6867 (2002): 23.
3 Will Steffen, Paul J. Crutzen and John R. McNeill, "The Anthropocene: Are Humans Now Overwhelming the Great Forces of Nature," *Ambio* 36, no. 8 (2007): 619. This is the paper that outlines the first, second and third stage of the Anthropocene.

The first stage

Just as Paul Crutzen has become the one of most cited geoscientists of the early twenty-first century, so Alexander von Humboldt (1769–1859) was 200 years ago. Humboldt was a polymath who spoke Spanish, English, Latin, French, and German; he was a physicist, chemist, biologist, botanist, physiologist, geologist, artist, writer, and linguist who invented the field of physical geography. Humboldt has nine minerals, 107 animals and fossils, 267 plants, and more geographical features on the Earth and Moon named after him than anyone else in history. From 1799 through 1804 Humboldt traveled around South and Central America with his companion Aime Bonpland, a botanist and scientific illustrator. Along the way they climbed above 19,000 feet on what was then thought to be the highest mountain the world, Chimborazo in Ecuador (20,565 feet / 6268 meters). While doing so they mapped the vegetation changing from the tropics to alpine zones, which Humboldt later graphically charted.[4]

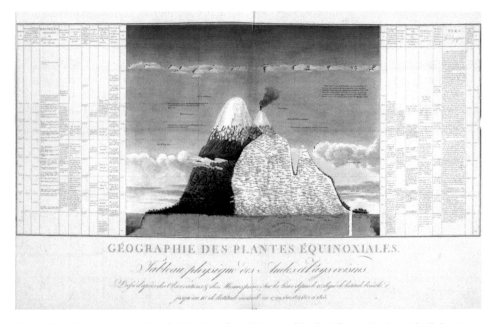

Figure 24.1 Alexander von Humboldt, plate from "Geographie des Plantes Equinoxiales," showing a cross-section of Mount Chimborazo volcano, Eucador: flora, topography and altitude mapping, published in *Essai sur la Geographie des Plantes*, A.v. Humboldt & A. Bonpland, Paris, 1805.

Humboldt sketched out the physical attributes of the mountain on the left half of his picture, then listed the ensembles of plants on the right side, illustrating the correlations among ensembles of plant life found within each climate zone in the Andes—tropical,

4 Alexander von Humboldt, *Personal Narrative of Travels to the Equinoctial Regions of the New Continent During the Years 1799–1824*, trans. by Helen Maria Williams (London: Longman, Rees, Orme, Brown, and Green, Paternoster Row, 1826): Vols. 1–6; Hein Wolfgang-Hagen, *Alexander von Humboldt: Life and Work* (Ingelheim am Rhein: C.H. Boehringer Sohn, 1987); Aaron Sachs, *The Humboldt Current* (New York: Viking, 1966), offers an excellent overview of Alexander von Humboldt's life and work, and his enduring influence on science and the humanities.

subtropical temperate, subalpine and alpine. He realized that he had earlier seen an equivalent series of zones and groupings of plants while climbing in the Alps, meaning that this was a global phenomenon. In turn, this led him to establish that the changes in temperature, climate zone, and associated flora observed while climbing in altitude were equivalent to those that would be seen while traveling away from the equator toward higher latitudes. Extrapolating from this correspondence of altitude with latitude, he proposed that isotherms, or lines of equal temperature, must extend around the globe, lines determined not just by latitudinal position, but also by the elevation of land masses, and the play of ocean currents with prevailing winds. Humboldt gained the cooperation of expeditions worldwide to verify his theories with measurements of every type from barometric to thermal. Thus was born the first systemized notion of a global environment based on accurate observations.

Upon his return to Europe, Humboldt spent the entirety of his not inconsiderable fortune on publishing a set of lavishly illustrated volumes about his journey and findings. These books became an inspiration for generations of artists, who took Humboldt at his word when he declared that understanding the world required both art and science. In the second volume of his life's summary work, *Kosmos*, he wrote a chapter about landscape painting and urged artists to portray with accuracy the face of nature.

The artists heeding Humboldt's exhortation did, indeed, seek to portray the world accurately both at the scale of visual minutiae, as well as at the system level. A primary and influential painter of the nineteenth century who best exemplifies this was Frederic Church (1826–1900), a Hudson River School painter based in New York City. Church was so enamored of Humboldt's life and travels that he retraced the scientist's footsteps through South America and assembled enormous panoramic views that were both accurate depictions of the local landforms and flora, but also grand encyclopedias of entire ecologies. Church's early masterpiece, *Heart of the Andes*, was painted in 1859 and displayed in a rented auditorium with imported plants placed on either side. He kept viewers behind a velvet rope at some distance from the painting and rented them opera glasses through which to examine the canvas, in essence creating a kind of natural history diorama that made people feel as if they were actually standing in Ecuador. The painting is an important object in the history of landscape art, a document of colonial imperialism, and much else—but it is also a presentation of the hydrological regime of the country, which starts in the glacial fields of the peaks and descends through temperate zones and into the jungle. Close to the center of the painting is a plume of smoke indicating the highest point in this environment where it would be practical to have a sustainable farm, a device Humboldt and his followers often used when creating maps of global plant distribution. Humboldt had planned to ship the painting to Europe in order for Humboldt to see it, a gesture of tribute, but sadly the elderly scientist passed away just as its exhibition in New York was ending.

Albert Bierstadt, who had a studio in the same building as Church and wished to emulate the other artist's commercial success, followed with large canvases of his own about the American West. Although more fanciful than Church's works, they nonetheless followed the same encyclopedic impulse, depicting the world as descending from the eternal snows downward into the more temperate regions inhabited by humans. A more objective painter from the next generation was Thomas Moran, who accompanied Dr. Ferdinand Hayden's geologic expedition to the Yellowstone region in 1871. His sketches and paintings of the geomorphology and geothermal geysers, along with photographs by William Henry Jackson, helped convince the United States Congress to make the region the first national park in the United

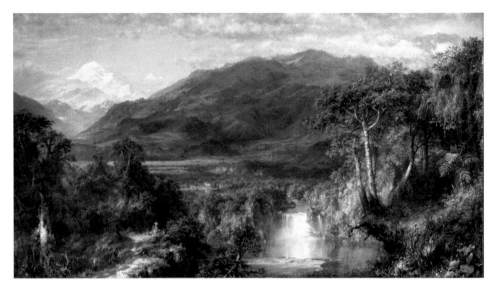

Figure 24.2 Frederic Edwin Church, "Heart of the Andes," oil on canvas, 167.9 × 302.9cm, 1859. Image courtesy of the Metropolitan Museum of Art.

States. These artists, and many others of the time, were picturing the world not simply to sell paintings to a public eager to learn more of the world, but were also helping to catalogue typologies in the earth sciences as a way of making comprehensible the mechanisms of nature.

Photographers greatly accelerated this process in two ways: They photographed nature at the direction of expedition leaders with whom they served, but also the visible human footprint from ancient monuments to examples of steam-powered industry. Timothy O'Sullivan, a Civil War photographer who was hired by Clarence King to accompany the Geological Exploration of the Fortieth Parallel, was an early practitioner who did both and has had an enduring influence. King, a government geologist, was looking for evidence to support the uniformitarian argument for the shaping of the Earth's surface—slow forces exerted over time, such as erosion. But the evidence of geological upheavals that he encountered along his traverse of the American West led him to accept portions of the argument from the other side of the aisle, which postulated that it was more recent incidents of Biblical catastrophism that had created such dramatic features as the Grand Canyon. He had O'Sullivan photograph it all, and by the end of his life was using the images to suggest that long periods of slow process were interrupted by violent events, such as volcanic eruptions and earthquakes. His understanding of geomorphological processes was formed, in part, around the photographs of O'Sullivan, enabling him to propose a theory we still accept today.

King was also fascinated by mining, and while in Nevada had O'Sullivan document the silver mining operations on the Comstock Lode in the mountains southeast of Reno. The photographs included general views of Virginia City and the local mining operations, one of the largest in the world, and most notably a series that was made underground in the tunnels with artificial light. The photographs O'Sullivan made of natural landscape features helped uncover the geologic past, while those of the mining made apparent as never before the new power and expansion of human anthropic effects. While the CA+E Research Library

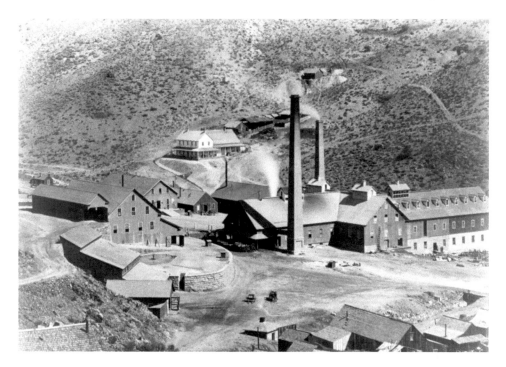

Figure 24.3 Timothy H. O'Sullivan, "Gould and Curry Mill, Virginia City," albumen print, 19.7 × 26.9cm, 1867. Library of Congress.

holdings begin with the literature of exploration from Humboldt's time, the Altered Landscape collection begins with O'Sullivan's photographs.

Once the broad outlines of the world were known—the continental shorelines and grand contours of the interiors mapped, the major phyla and classes of plants and animals catalogued, the monuments of the past fixed in emulsion—art turned to other more aesthetic concerns. Both the grand encyclopedic style of Church and Moran and the straight-ahead and relatively affectless images by Timothy O'Sullivan lapsed in popularity as Impressionism, Expressionism, and Abstraction became fashionable in painting, and soft-focus pictorialism followed by photojournalism became the predominant styles in photography. But artists never stopped painting the landscape, nor did photographers succumb completely to the urge to romanticize the land. And once the human footprint became inescapably obvious in the mid-twentieth century, artists would start to look again at earlier models for assembling typologies.

The second stage

One of the most famous photographs made by Ansel Adams is of the eastern Sierra Nevada from the town of Lone Pine as seen in 1944. A shadowed meadow in the foreground features a horse grazing in a patch of sunlight. Behind the animal is a line of trees and the Alabama Hills, the features of which are almost completely obscured in darkness. Rising behind them are the shining snow clad escarpments of the 14,000-foot high Sierra Nevada. It's a picture that proceeds deliberately from the pastoral to the sublime, and was featured in the Sierra

Club's first coffee-table book *This is the American Earth*, which Adams edited with photo historian Nancy Newhall. The image, which includes the highest point in the lower United States, Mt. Whitney, was meant to portray a pristine wilderness to be protected at all costs.

What the photograph does not show are the letters in whitewashed stones spelling out LP on the side of the hills, which stood for Lone Pine, stones which to this day are refurbished each year by local high school students. Adams considered the letters an abomination to nature and had them dodged out on his prints in the darkroom. He later commanded his assistant to obliterate them on the negative itself. But that's not all that's hidden. Behind the line of trees is the Los Angeles Aqueduct, which was built in 1913 to capture water from the Eastern Sierra and Owens Valley and carry it 233 miles (375 km) south to Los Angeles. It was one of the largest feats of human engineering ever made. By choosing his vantage point carefully, Adams made sure that it, too, was invisible to viewers of the photograph. "Winter Sunrise" is a work made just as the first stage of the Anthropocene was ending and the postwar expansion of consumption marking the Great Acceleration of the second stage was beginning.

When you contrast the Adams image with those he choose to counterpoise in *This is the American Earth*, you have a stark example of how art participated in the second stage of the epoch. While Edenic black-and-white images by Adams dominate the first and third portions of the book, the middle section descends into hell on Earth, portrayed as aerial views of the Los Angeles region photographed by William Garnett in 1950. Hired by a developer to showcase his ability to turn the landscape into an assembly line, Garnett flew over the planned community of Lakewood, one of the many new communities being built adjacent to Los Angeles. He took successive views that showed the development scraped clean of orange groves by bulldozers, then platted, overlaid with a street grid, filled in with hundreds of identical housing foundations and, finally, houses. Capping the series was an oblique view from the air of downtown Los Angeles almost completely obscured by smog. The message of the book was inescapable: humans were obliterating the natural world. This was artwork that both documented the spread of the human footprint and propelled a political message meant to limit it.

Many of the landscape photographs and paintings created during the second stage of the Anthropocene display the rapid spread of the anthropic effects of the Great Acceleration. And many of the photographers—from Robert Adams and Lewis Baltz working in the subdivisions and industrial parks of the American West to Bernd and Hilla Becher among the blast furnaces of Germany's Ruhr Valley—adopted the flat and documentary style pioneered by Timothy O'Sullivan in order to play down the easily politicized visual drama of the change. O'Sullivan and Garnett were both precursors to what would be labeled the New Topographics by curator William Jenkins, who assembled an exhibition of the same name in 1975. He was acknowledging the influence of Humboldt upon the formation of the original U.S. Army Corps of Topographical Engineers and the profound connection between mapping and imaging the world. The majority of the work in the Nevada Museum of Art's Altered Landscape collection starts with the New Topographers, whose very lack of affect ironically only increased the emotional impact of their images. There was no escaping the brutal assault of human expansionism across the natural world in such a factual aesthetic.

The second stage of the Anthropocene was also signaled by the burgeoning popularity of environmental writing. Rachel Carson's *Silent Spring* was so effective because it not only

traced a threat to human health through the environment, but it provided a layperson's introduction to ecology, hence to the systems science that underlies environmental dynamics. Carson's books provided readers a new vision of how the world operates, and was thus as compelling as Humboldt's observations had been more than a century earlier. Systems science—defined by MIT mathematician Norbert Weiner, anthropologist Margaret Mead, and many others in the mid-twentieth century—is a theoretical practice that uses predictive models to uncover recursion, causal loops, and feedback mechanisms. The field also became a powerful generator of metaphors tying together art and science, as those attributes are characteristic of various contemporary creative practices as well as scientific ones. Minimalism, which uses the fewest number of elements possible, often in various iterative combinations, is the most famous example. The crossover was especially visible in Earthworks, which began in the late 1960s.

Much confusion exists over Earthworks, and the larger movement of Land Art to which it belongs. It's not that these were environmental art movements, but that they arose as modes of inquiry informed by the same stimuli as science. Systems thinking led to minimalism, which led to the desire to write large a few elements on the land, which in itself was a manifestation of the increasing presence of anthropic effect and the human footprint. Artists such as Michael Heizer (1944–), Robert Smithson (1938–1973), and Walter De Maria (1935–2013) were minimalists working with bulldozers to create enormous sculptures. It is not that they were unaware or uncaring about the environmental movement, but it wasn't the impetus behind their work. Nonetheless, their ideas and methods developed a vocabulary which would later be adopted by artists whose concerns were environmental, during the third stage of the Anthropocene.

The third stage

Remember that Steffen and others defined the third stage as the period in the 1990s when humanity became "a self-conscious and active agent in the operation of its own life support system economies." How this manifested in art can be illustrated by examining two related land art works. The first is Walter De Maria's classic earthwork, *The Lightning Field*; the second is Richard Box's *Field*. De Maria, who accompanied Heizer out to the Mojave Desert in 1967, had started his career as a musician and avant-garde composer, and was interested in rule-governed actions using a minimal number of recursive geometric elements. *Bed of Spikes*, which De Maria created in 1968–69, comprised sharpened metal spikes mounted vertically on five 2 × 2 meter steel plates and arrayed in formal ranks of increasing density according to a mathematical progression. This was a precursor to the design he drew on a cocktail napkin in a Las Vegas coffeeshop for pilot Guido Deiro, whom he instructed to locate a piece of desert real estate where lightning was frequent. The site eventually used was near Quemado in south central New Mexico. It holds 400 stainless steel rods that stand twenty feet and seven inches above the ground to form a conceptually even plane a mile wide by a kilometer deep. The work literally does attract lightning, especially in the late summer, and a photograph of the field during a storm taken by John Cliett has become an iconic image for twentieth-century American art.

De Maria's work is both a masterpiece of rule-driven minimalism but also a clearly realized ambition to connect Heaven to Earth. By creating a conceptual ceiling above the desert floor, he built a transparent temple of slender metal columns that people are invited to visit

six at a time. They are escorted onto the property, which is fenced, and spend the night with a handy guidebook in the guest cabin, a text explaining how to view the work. It is a highly directed experience, and Cliett's photographs are the only ones sanctioned by the artist to have been taken. De Maria, as is the case with Heizer, insisted that the artwork could not be experienced in a photograph, but had to be encountered directly in the world. *The Lightning Field* is a classic example of an artwork committed on the cusp of the second and third stages of the Anthropocene.

Richard Box (1969–) was an artist-in-residence at the University of Bristol's Physics Department in 2003 when he discovered that the nearby high-tension power lines leaked enough electricity to light up household fluorescent tubes held in the hand on the ground below. Box collected 1,300 tubes from local hospitals, rented a field from a farmer near the M4 motorway over which 400,000-volt lines passed, and set out the reclaimed 58-watt tubes in an equidistant grid over 3,600 square meters. The resulting *Field* artwork not only lit up, but when people stood next to the tubes, being taller, they disrupted the field and the light went out until they moved. It was an interactive installation that demonstrated the effect of power on people and of people upon a system of power, thus was both a literal illustration and metaphorical artwork, a self-referential trope.

The Lightning Field plays off the notion of the human footprint on the natural world in a system-based work that acknowledges the relationship, and connects the mythological to the sublime. *Field* more prosaically connects sky to ground, and instead of alluding to the divine through lightning makes apparent anthropic light and the imperfect transmission of power in all senses of the word. Unlike De Maria's project, which is fenced, tightly controlled, and meant to be permanent, *Field* was accessible to anyone driving by with no interpretation provided, and an ephemeral project up only for a few weeks. While on the surface a more modest gesture than De Maria's *The Lightning Field*, Box's work was both mindful of the environment—a work that once removed left no trace behind—and revelatory on an entirely different scale.

Much land-based art made during the third stage of the Anthropocene has moved increasingly from being hands-off to hands-on. It is not just that an artist would be out working in the field, but working on a particular field and changing the way it functions, and the CA+E Archive Collections and programs are designed to collect and present this evolution. The Nature Conservancy (TNC) have recently been re-meandering the Truckee and Carson rivers in western Nevada, which the U.S. Corps of Army Engineeers had attempted to channelize during the twentieth century. This remedial work has created a situation where TNC has stream bank erosion to mitigate at the same time they are trying to attract the public to the sites. An archive held in the CA+E is that of the work by Daniel McCormick and Mary O'Brien, artists from Marin County who specialize in wetlands and habitat restoration. One of their most frequent practices is to measure an eroded stream bank, design a sculpture that will fit into it, then have that form woven out of native plant materials by local community groups and schools. The sculpture is then carried to the site and "live staked" into the bank (using, for example, willow cuttings). This creates a beautiful and robust object that prevents erosion and acts as a sediment trap to rebuild the bank. On returning to the site two years later, one finds the sculpture has virtually disappeared, having taken root and become live habitat. The CA+E has worked during the last two years to bring TNS together with these two artists to initiate in 2014 a pilot program of collaboration between the organization and artists working on environmental issues.

Another and more ambitious project with which we are involved is one by Helen and Newton Harrison, who while teaching at the University of California San Diego in the 1970s helped invent the field of eco-art. Art that collaborates with nature to complete itself is part of what we call "art that walks in the world." The creators of such works are not content to picture nature, or even the human footprint upon it, but are compelled to intervene directly in the ecological system. A recent project of the Harrisons that the CA+E has commissioned is their *Sierra Nevada: An Adaptation*. The Harrisons have long been concerned with the rapid rise of temperatures in the 400-mile-long mountains range, the consequent disappearance of important species for erosion control, such as the Lodgepole Pine, and the succession by invasive weedy species that degrade downstream water quality. They have mapped, photographed, and written about these changes on their trademark large wall works, which present proposals to test ensembles of plants at various altitudes, an attempt at a human-guided succession that will be resilient in the face of global change. Humboldt would have grasped the concept immediately.

In 2013, working at the University of California Berkeley Sagehen Research Station and in collaboration with the UC Santa Cruz Arboretum, the Harrisons planted more than 10,000 plants from 200 species in test plots to begin the experiment.[5] The Museum has committed to presenting the results of these trials for as long as fifty years. It is not just that the Anthropocene is global in geographic reach, but that in order to grasp its scope, long arcs of study are needed over time. And museums are institutions devoted to transmitting knowledge from generation to generation.

The CA+E was recently called an "activist archive" in that we are not content to collect archives from past endeavors, but actively encourage and commission projects in order to create future archives. We do so as part of our work to generate new knowledge and transmit it to others. This is, perhaps, a somewhat unique collecting strategy for an art museum, but during a time of rapid global change, it seems prudent for a museum and research center focused on art and the environment to collect proactively, versus reactively. We are aware of the fact that our doing so helps create a feedback loop as human society looks at itself and its effects upon the world, and then changes its behavior. But that is, of course, the nature of ecologies.

5 More information about the Sierra Nevada project of Helen and Newton Harrison can be found on their website: http://theharrisonstudio.net. This page in particular addresses the project: http://theharrisonstudio.net/?page_id=85.

25
OBJECT IN VIEW

The Canary Project: Photographs and fossils

Edward Morris and Susannah Sayler

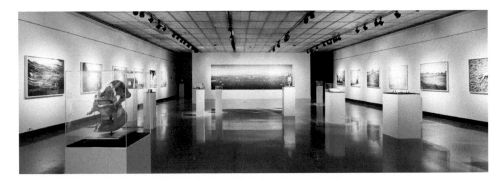

Figure 25.1 Installation view from *The Canary Project Works on Climate Change 2006–2009*, Grunwald Gallery, Indiana University, 2009. See Plate 26.

A photograph and a fossil have something in common: Both are defined by a body of knowledge and yet both emit the trace of an existence that cannot be fully absorbed.

Diverse writers such as Roland Barthes, André Bazin, Jacques Rancière and Tom Gunning have carefully analyzed the way in which a photograph, any photograph, emanates an indeterminate reality. In looking at a photograph we are looking at something that absolutely was but will absolutely never be again. We are looking at both presence – the literal shining forth of a person or object in the world (the quality of space) – and absence – the disappearance of that thing (the quality of time). A photograph at its core does more than point to a reality in the manner of a sign; It re-presents that reality. Whatever else is added by way of contemporary context, a photograph most essentially says: HERE NOW is/THIS/that was THERE THEN.

The same could be said of any fossil, and by extension any archival object held by a museum, whether that museum be dedicated to natural history or cultural history. The object is an extraction – something taken out of time. Whatever we know about it, we can never know it completely. It emanates an existence, a presence.

Generally, in a museum we try to pull that presence closer to us with information, by knowing more about it, becoming familiar with it. However, paradoxically, the more the object is made subordinate to knowledge, the more its aura recedes. The more general the object becomes within a taxonomy, the less its specificity is allowed to flourish. Its aura wholly resides in this very specificity, which is most often buried beneath information when positioned within an archive. In other words, the authentic relation to us of any archival object or image is its remoteness. When we draw something close with interpretation and a determination of its exact significance, we lose that essential distance, call it an exoticism, in which we can feel our own selves made strange through the interaction.

In photography we can broadly distinguish between pensive and illustrative images. The illustrative image is speedy and delivers information. It depends for its efficacy on the unique truth claim of the photograph (THIS was THERE THEN), but makes quick work of it – employing it to gain our trust but then steering that trust towards a statement (journalistic, scientific or rhetorical). As with the archival object, the image, in this instance, is subordinate to text, and therefore, the crushing specificity of the captured image is not allowed a full unfolding (lest it distract us). Nearly all images are illustrative.

With the more rare pensive image, on the other hand, the truth claim (THIS was THERE THEN) is not choked off and made subordinate, but instead allowed a full unfolding. This opening is essential to a depth (rather than an accuracy) of feeling and is made possible by the independence of the truth claim from context. That is to say, all photographs are tied to propositions (i.e. have a context), but the reality re-presented in the photograph is aside from that context and cannot be reduced to it. All context is contingent and the product of interpretation, unlike existence which is at the bottom of all interpretation and cannot be touched by it, like a stone you can kick but cannot move. Therefore, an image that manages to subvert, radically minimize or pierce through context, whether by accident or artistic intent, has the potential to manifest a presence.

Such "presencing" in an image is profoundly unsettling because of the breakage it creates in our spatio-temporal orientation. This has to do with the physicality of the photograph – the fact that we are not merely signifying, we are actually seeing what was once seen by somebody else and is now being seen by us at a different time. Untethered from the useful orientation of an image's context, we hover uncertainly between presence and absence, familiarity and unfamiliarity, death and life, present and past, the self and other.

If the pensive image is rare (because its use is less apparent), then the pensive object is even more rare, particularly in those institutions born of the Enlightenment that are dedicated to educating, namely orienting, their visitors. So we pose the question, what would it mean for an object to be pensive? And further, what could such an object or set of objects accomplish in a cultural institution?

The first question is easier to answer than the second. For an object to be pensive in the manner described here, it needs to be liberated to some greater or lesser degree from its context. In the domain of cultural institutions, that context is determined by specific historical or scientific narrative. In a word: Context is constituted by the archive. So, liberating the object from context means liberating it from the archive. There is no total liberation possible, just as it is never entirely possible for the photographic image to be entirely innocent. The point is to create enough of an opening for the presence of the object or image to be keenly felt by the viewer. One obvious strategy for this is withholding information, partially or wholly, temporarily or entirely. A fuller catalog of possible strategies for the rendering

objects in collections pensive is beyond the scope of this chapter, but would make an interesting project.

Yet why would any institution do this? There are many reasons, but there is one that primarily concerns us: articulating the Anthropocene and its most traumatic consequences, climate change and mass extinction.

The Anthropocene is difficult to grasp because it requires us to apprehend at once both the enormous power and the bewildering fragility of human beings. We must see ourselves as both master and slave. Furthermore, we must see ourselves in the perspective of geologic time where we are just a speck. Last, we must see ourselves in relation to other species, both those here now and those that have already vanished. In other words, we must travel out of ourselves to see ourselves.

Climate change is difficult to grasp because whatever we know about it, we cannot fully believe it. Slavoj Žižek diagnoses this as follows: "Our attitude here is that of a fetishist split. I know very well (that global warming is a threat to the entire humanity), but nonetheless I cannot really believe it. It is enough to see the natural world to which my mind is connected: green grass and trees, the sighing of the breeze, the rising of the sun … can one really imagine that all this will be disturbed?"[1]

The skeptics are right on one point: climate change *is* a matter of belief and not of knowledge – belief first in the science, which in its totality cannot not be known by any one individual, not even a specialist; and belief second in the potential for trauma. In the Global North especially, without the more common personal experience of erosion, disaster and loss that is already being experienced in the Global South, we can arrive fairly quickly to a belief in the science (even the entire system of science and knowledge) but this does not get us very far towards any action or any substantial sense of what is at stake because it is countered by a stronger lack of belief in the potential for trauma.

The potential disorientation, even discomfort, caused by a non-illustrative, pensive display of objects from an archival collection can be an opening onto a more substantial sense of what it might mean, in Žižek's words, to disturb the sighing of the breeze, the green grass and trees of our normal quotidian world. Furthermore, the enormity of these concepts such as geologic time or extinctions cannot be grasped by the rational mind without analogy, abstractions or something else we might term negative capability.

Negative capability is defined by the poet John Keats as: "when man is capable of being in uncertainties, Mysteries, doubts, without any irritable reaching after fact & reason."[2] We will need recourse to negative capability if we are to overcome the fetishistic split articulated by Žižek and to truly believe (as opposed to simply know) that we have been on this planet only for a fraction of a geological second, that we have the capacity to change the climatic conditions on this planet, and that we can be erased from history just as surely as we can we write down words.

The following is a sequence of diptychs pairing photographs from our series *A History of the Future* with objects curated from various university collections (labeled Fossil Study 1–3). The photographs are all of places where scientists are studying the impacts of climate change. Photographs are the thinnest, lightest slice of time. Archival objects are relatively heavy. We

1 Slavoj Žižek, "Censorship Today: Violence, or Ecology as a New Opium for the Masses, part 2," Lacan, last modified 2007, www.lacan.com/zizecology2.htm
2 John Keats to George and Tom Keats, December 26, 1818, in *John Keats Selected Letters,* ed. Robert Gittings (Oxford: Oxford University Press, 2002), 40–43.

are interested in that juxtaposition and with the experiment of viewing the objects representing history as equivalent in some significant way to photographs and vice versa.

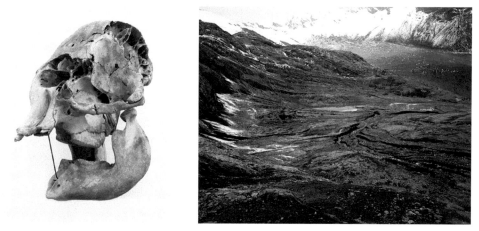

Figure 25.2 Fossil Study 1, from *A History of the Future*, Sayler/Morris, 2014. See Plate 27.

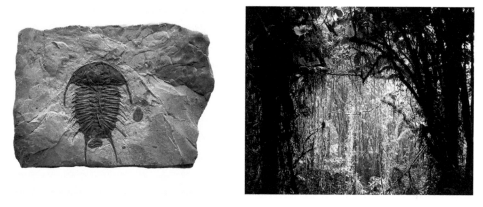

Figure 25.3 Fossil Study 2, from *A History of the Future*, Sayler/Morris, 2014. See Plate 27.

Figure 25.4 Fossil Study 3, from *A History of the Future*, Sayler/Morris, 2014. See Plate 27.

PART IV
Representing change and uncertainty

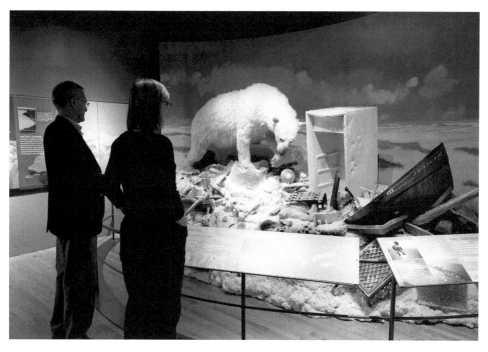

Figure IV.1 Polar bear exhibit in the *Climate Change: The Threat to Life and a New Energy Future* exhibition, American Museum of Natural History, 2008. Photo: Denis Finnin. See Plate 28.

26
CAMEO
The vulnerable Volvo

Sverker Sörlin

It was March 2007, days of snow, mixed with days of thaw. I was at Dartmouth College, Hanover, New Hampshire for an Arctic Science Summit Week. The International Polar Year 2007/2008 was just about to start in July the same year. I went to sessions with scientists and professionals and politicians, listened to papers, engaged in project planning and science diplomacy. It was fulfilling, urgent; the best knowledge available was present.

Still, what made the deepest impression on me were objects in the college's Hood Museum, curated into an exhibition by a visiting Dutch anthropologist, Nicole Stuckenberger. It was especially the anorak, the extremely light piece made from seal intestines that impressed me. From a distance it looked like a new creation of Japanese haute couture artist Issey Miyake, transparent, almost lucent as from an inner light that just refracted the light from around it.

This garment, thinner than a space age material and almost weightless, would mean the boundary between life and death for the hunter in his kayak at sea. The Inuit women scrape and wash the intestines, blow them up with air they breathe, hang these intestinal balloons to dry in the Arctic sun and wind, cut them into strips, then wet them again and glue the strips together into this ancient "survival kit" parka.

Through this parka I came closer to climate change than in any session.

The Hood Museum is one of these fine university museums that light up, and enlighten, even the most culturally impoverished town in the United States. *Thin Ice* was the name of the exhibition and the book (University Press of New England).

When the ice grows thinner, so narrow the conditions of life for hunters and fishermen of the Arctic. Stuckenberger makes the voice of climate speak through the exquisitely crafted artefacts. A seal paw with its claws carefully tied to a wooden rod allows the hunter, hidden in seal skin, to draw himself forward on the ice and silently approach his prey. Most wonderful are the miniature models of kayaks with crew. Icons for a life form that risks being washed into the sea with the deluge that we are all responsible for – although with unequal shares. I have rarely seen the tragedy of the climate dilemma exposed so movingly and convincingly.

My sentiment further deepens when I hear a lecture by Igor Krupnik at the Smithsonian Institution. He talks about Inuit elders who for decades have seen signs of a warmer climate.

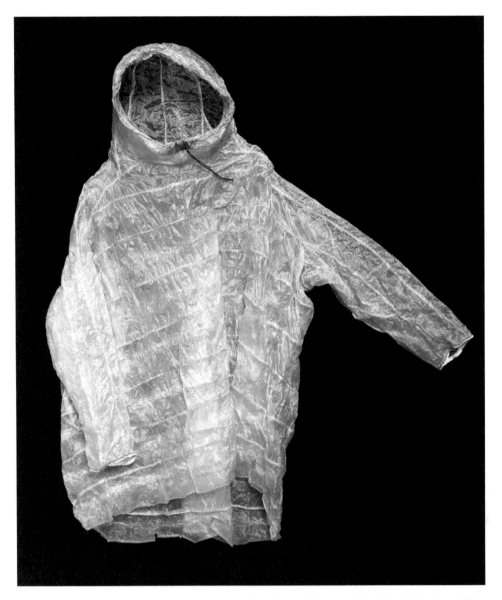

Figure 26.1 Anorak of seal intestines, Inuit, Central Yup'ik, Tooksik Bay, Alaska. Hood Museum of Art, Dartmouth College, Hanover, New Hampshire; gift of Dr. Philip O. Nice and Cheryl Roussain-Nice. See Plate 29.

Ice formation occurs later in the fall. Ice is wetter, cracks more easily. The sled team whirlwind of furry barking dogs must be replaced by the lonesome dragging of boats and sleds across crevasses and Kolymnas; an entire culture's desert march into an uncertain future.

When the observations by the Inuit are laid next to the data from satellites and instruments, they are completely congruent. The difference is that the Inuit saw the pattern earlier. The conclusion is that scientists and local residents should collaborate and that science should turn to the ground to learn, just as they did during the Polar Year.

This was a profound experience: recognizing symbols of survival under climatic conditions to which it has taken generations upon generations to adapt. These will soon be gone, with little time to adapt. What could be a response from temperate Europe? Were we – who contribute infinitely more to the melting ice than any of the Inuit – equally vulnerable? In what ways? What could be a fitting comment to our predicament, at the same time signaling our responsibility for the distant effects in the Arctic?

Sooner than expected, I was given an opportunity to answer these questions. In connection with the World Resilience Conference in 2008, which was hosted by the Stockholm Resilience Centre, a competitive art exhibition was announced the year before. I discussed the idea of a possible contribution with the artist Gunilla Bandolin. We agreed to make an object of art that spoke to the cultural contradictions of climate change, to echo both Daniel Bell's *Cultural Contradictions of Capitalism* (1976) and Max Horkheimer and Theodor Adorno's *Dialektik der Aufklärung* (1944). Our conversations were much inspired by what I had encountered at the Hood Museum; without that experience I don't think our proposal had been thinkable. It was selected for the exhibition and shown in the Museum of Natural History in Stockholm in the spring and summer of 2008 as one of a dozen or so other art works (among 300+ submitted).

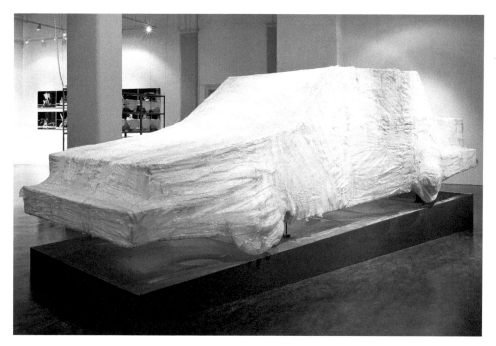

Figure 26.2 Volvo installation made of cow intestines and aluminum, Swedish Museum of Natural History, 2008. Artist: Gunilla Bandolin in collaboration with Sverker Sörlin. Photo: © Michael Perlmutter. See Plate 30.

Our object was a sculpture, or installation, in the form of a Volvo car, the infinitely boring 1989 version, reflecting the height of industrial modernity with its individualism, CO_2 emissions, and unsustainability. This car, despite all its connotations of quality and reliability, is at the same time the quintessential antithesis to the kinds of technologies used by the Inuit.

Everything it is and stands for demands extraction of fossil fuels and minerals. It contributes to the heavy toll being taken on marginal modes of existence lived on the Greenland coasts. These coasts are part of Nordic countries, but a universe away from the bulky car society.

We positioned the car diagonally on a podium, just as in the automobile fairs organized in Geneva and Detroit every year. We designed a skeleton, true to the exact format of the actual car in scale 1 to 1 (it was built in aluminum by professional smiths). We glued together cow intestines in layer upon layer (we had tried to get seal intestines from Greenland but the cost was considerable and availability in the quantities we needed finally wasn't possible to attain). There is power in materiality. The old fashioned, not too smart Volvo, the utmost token of a heavy carbon way of life, wrapped in the utmost and lightest survival garment. Superior in its solidity. But is it really? It may also seem like a mummy, a final wrapping of a way of life, similar to those wintering expedition ships in the Arctic, one of which features in Mary Shelley's *Frankenstein*, from which the representatives of the modern world see their kin in the shape of a monster – but indeed what they see is themselves writ large in the future.

And what can we expect of our current future? Perhaps we need to ask ourselves in the so-called developed world what a post-carbon society would look like? Including carbon-free technologies? The car is counter-intuitive, paradoxical, an oxymoron, this heavy thing clad in the super lightest of materials. Can the thin transparent bag of intestines hold the heavy burden of a carbon-laded part of humanity? Or is the Volvo, as we know it, ultimately the most vulnerable of all human designs, doomed to become one of the visible fragments of the strata we leave from our hubris existence called the Anthropocene?

We can collect the future in many ways. Collecting is also about managing ideas and impressions, using them to link phenomena, think, speak out, perform, act. This I would like to see as an act of "artistic research" – or scholarly art. It is art, but it also carries ideas and reflections that stem from scientific engagement in a broad set of issues and multiple fields of knowledge.

Seeking knowledge has a collecting side. It is also like developing a photograph. It is not enough to get it half done; it is not yet an image. We need to enhance the resolution, fix the details in full. Only from the finest nuances can empathy emerge. This is also the secret of loss: to be filled by it you must get a chance to see the personal, high-resolution fate. That is also the secret of the language of exhibition: through one single twenty-gram parka of intestines we can see the light from an Arctic heaven where all our billions of fates converge. A heavy Volvo may serve as its sadly co-produced counterpart from the fossil fueled moment of unequal planetary exchange.

27

MUSEUM AWAKENINGS

Responses to environmental change at the Swedish Museum of Natural History, 1965–2005

Ewa Bergdahl and Anders Houltz

> Had museums, like so many of their specimens, failed to adapt, they would be extinct – the dead bones of a former culture.
>
> Donald Squires, Natural Museums and the Community *(1973)*

Conflicting views on the museum's role in society and different conceptions of what a museum is and should be hamper museums in their ambitions to articulate and address the issue of climate change in exhibitions. As we intend to show, this dilemma has deep historical roots. This article uses the Swedish Museum of Natural History (SMNH) in Stockholm as a case to discuss the ways in which museums of natural history have responded (or not) to the challenges posed by human impact on environment during the recent decades when environmental questions became a significant topic of political and public debate.[1] Has the museum articulated its agency as a creator and conveyer of messages, and to what extent has it included ambiguous and contradictory narratives in its representations? How has the museum positioned itself in current global efforts towards achieving sustainable development and environmental awareness, and how can its positions be understood in a historical and social context?

The SMNH can trace its origin to the 1819 fusion of the zoological collections of the Royal Academy of Sciences with significant private collections, but we argue that the institution became what can be described as a museum in a modern sense as late as 1965.[2] Previously a research institute with an authority based on extensive collections, it then parted from the Academy of Sciences and was confronted by the obligation to actively and seriously communicate and interact with the public.

In this chapter we focus on three exhibition productions over four decades, where the museum has dealt explicitly with environmental issues. The first, *Are We Poisoning Nature?* (1966), was triggered by Rachel Carson's book *Silent Spring,* and was the museum's first real attempt to address current environmental debate topics. It was followed by *Sweden Turning Sour*

[1] Peter Davis, *Museums and the Natural Environment: The Role of Natural History Museums in Biological Conservation* (University of Leicester Press, 1996), 41–43.

(1985), focusing the 1980s debate on acidification. The third exhibition *Mission: Climate Earth* (opened in 2004, and still standing in 2015), was an early response to the reports on climate change by scientists and environmental activists in the first years of the new millennium.

The environment a political issue

Although we often think of the 1960s as the birth of an environmental consciousness, different aspects of human damage to nature had been discussed since at least the intense industrialization period of the late nineteenth century.[3] Sanitary consequences of industrial enterprises, the contamination of streams and water sources and the possibilities to protect *nature*, in its pristine state, were all discussed, although as separate and mainly local questions. In this, as in other questions, Swedish development followed the pattern of earlier industrialized nations.

With the economic boom and industrial expansion of the post-World War II decades, however, earlier warnings were drowned by the wheels of progress. Swedish industry exported products and raw materials on an unprecedented scale and living standards increased year by year.

Awareness of the limitations of natural resources was weak and so was knowledge about environmental threats, among the general public and politicians alike.[4]

When the biologist Rachel Carson's *Silent Spring* was published in the United States in September 1962, the impact was immediate. The book became an unexpected bestseller and soon reached an international audience. Chemical pesticides had been celebrated for decades as the final solution to problems ranging from malaria to pine weevils, but Carson turned the negative effects of biocides in industry, farming and forestry into headline news.[5]

The importance of Carson's controversial book is well known. A translation into Swedish was published rapidly in March the following year. It sold in large numbers and was discussed in meetings, newspapers and parliamentary debates. In Sweden as well as in other countries it served as an eye-opener to a wide audience – in fact the book received a response in Sweden that exceeded its attention in the United States.[6] The emerging environmental movement had found its bible. Carson pointed to the consequences of chlorine, arsenic, strontium and not least DDT, but the Swedish debate instead focused an issue that was not in fact mentioned by Rachel Carson: mercury pollution. The debate about mercury, fueled by *Silent Spring*, became the breakthrough that ushered in modern Swedish environmental protection.[7] Mercury was one of the biocides most frequently used to exterminate vermin in agriculture and forestry, and the issue became a hot political topic for the parliament and government, which had appointed an environmental commission for biological balance in

2 For the early history of SMNH see Gunnar Broberg, 1989; Gunnar Brusewitz, 1989; Naturhistoriska riksmuseets historia, 1916.
3 Sverker Sörlin, *Naturkontraktet. Om naturumgängets idéhistoria* (Stockholm: Carlssons förlag, 1991), 174.
4 Ibid., 180.
5 Rachel Carson, *Silent Spring* (Boston, MA: Houghton Mifflin, 1962), 13–32.
6 Andrew Jamison, "The Making of the New Environmentalism in Sweden," in *The Making Of The New Environmental Consciousness: A Comparative Study of the Environmental Movements In Sweden, Denmark, And the Netherlands*, ed. by Andrew Jamison et al. (Edinburgh University Press, 1990), 13–65.
7 Lars J. Lundgren, "Miljöpolitiken," in *Vad staten vill: Mål och ambitioner i svensk politik*, ed. Daniel Tarschys and Marja Lemne (Hedemora: Gidlunds förlag, 2013), 285.

1960. A few years later, in 1967, this would result in the formation of the governmental department Naturvårdsverket (The Environmental Protection Agency), which meant that environmental issues had been established as a political area in its own right for the first time.

The rise of environmental politics coincided with the emergence of a revised national cultural policy, which strongly emphasized culture as a tool for the development of the welfare state. The cultural program launched in 1961 by the Social Democrat government stated that culture was a democratic right and that the overarching aim of cultural policy was to make culture available to everybody. Art, theatre, music and museum exhibitions were to be distributed to the citizens regardless of geographic or social position. This meant new assignments for existing cultural institutions, among them museums, but also the emergence of new organizations for the distribution of culture. An important aspect of this was to reach out to children and youth, and museums were conceived of as a resource for schools in social sciences and humanities as well as in the natural sciences.[8]

Museum crisis

In marked contrast to the old and traditional European natural history museums – founded on collections from the eighteenth and nineteenth centuries aimed at scientific, systematic purposes – comparable institutions in the United States had been created with a more explicit aim to address a public audience. The case of SMNH is a good example of both the traditional, European-style outline and, from the 1960s onwards, a gradual reconfiguration influenced by what may be termed the American model.[9]

In 1916 the museum had left its crammed but centrally located premises in Stockholm for a new, imposing and spacious building north of the city. In doing so, it not only distanced itself from the public in a geographical sense, but it also consolidated its identity as first and foremost a scientific research institution, regardless of the fact that the move also meant ample space for exhibits.[10]

In the early 1960s, after four decades, the museum was in urgent need of renewal. Still formally a department under the Royal Academy of Sciences, the institution had stagnated to varying degrees in all of its capacities and was hampered by internal conflicts and insufficient funding. The organizational structure from 1916 remained intact and so did, to the most part, the exhibitions.[11] The *collections on display*, as they were characteristically termed, were organized as they had been for nearly half a century, in halls that were unheated and badly lighted. "Don't forget to bring a torch if you visit the SMNH" the newspaper *Stockholms-Tidningen* commented tartly in 1961.[12] Apart from the annual visits of generations of school classes, the visiting numbers were decreasing during the 1940s and 1950s.[13] But also

8 Helene Broms and Anders Göransson, *Kultur i rörelse: En historia om riksutställningar och kulturpolitiken* (Stockholm: Bokförlaget Atlas, 2012), 18–20.
9 Wolfgang Clausewitz, "Natural History Museums and the Public – a Critical Situation in Europe," in *Natural History Museums and the Community*, ed. by Kjell Engström and Alf Johnels, (Oslo: Universitetsförlaget, 1973), 43–47.
10 Jenny Beckman, *Naturens Palats: Nybyggnad, vetenskap och utställning vid Naturhistoriska riksmuseet 1866–1925* (Stockholm: Atlantis, 1999), 214–219.
11 Engström, I väntan på något bättre, 31–40.
12 "Museum i skumrask," Stockholms-Tidningen 1961-11-13.
13 Annual Museum Reports of the Royal Swedish Academy of Sciences, 1940–1959.

the museum's scientific activity was showing signs of stagnation. Research in systematics and taxonomy, once the pride of the institution, had by then lost its forefront position to the universities, where the so-called *white*, or laborative, biology had emerged.[14]

A state commission on the museum's future recommended that all research activities should be taken over by the university.[15] This deathblow to the institution was narrowly avoided, largely thanks to the undisputed uniqueness of its collections. Instead, a new organization was presented in the summer of 1965, but formulated in a way that was nearly as radical. The existing seven departments (vertebrates, invertebrates, insects, paleozoology, botany, paleobotany and mineralogy) were all merged into one single research department, and, combined with a new "museum department," responsible for exhibitions and educational activities as well as the administration of the whole organization. Previously, each department had been taking care of its own exhibitions, or collections on display, in addition to its research, and the central administration had been placed at the Academy of Sciences. With the new organization, the museum, with its own board responsible to the Ministry of Education, was once and for all separated from the academy. It can be argued that the reorganization marked the birth of this museum in the modern sense of the word.[16]

The change of direction clearly echoed the new cultural politics implemented by the Social Democrat government four years earlier. According to its 1965 directives, the museum's main task was "to promote interest in knowledge of and research concerning the plant and animal world, the structure and history of the earth, and the biology and natural environments of mankind."[17] The assignment was not, in other words, primarily to gather knowledge and conduct research about nature, but to promote interest in these matters. In addition, the interactions of mankind were explicitly mentioned as a responsibility for the museum.

"Are we poisoning nature?"

The topic of the first proper exhibition by the new Museum Department, and indeed by the museum as an autonomous institution, was chosen carefully. It was an indication of direction both to the museum staff, to the research community, to the politicians and, last but not least, to the public. The newly assigned museum director and head of department, Kjell Engström, and his associate, Tom Lötmarker, had traveled extensively to natural history museums in the United States and were eager to address the public in new and more direct ways.[18] The choice to focus the controversial pesticide issue signaled a will to engage in contemporary debate and to take the new museum directives seriously. It also expressed a marked distance to the existing collections on display, which were characterized by a detached positivist scientific position and systematics in a traditional Linnaean sense.[19]

14 Bergdahl, Interview with Kjell Engström, October 23, 2012.
15 Tunlid, *Riksmuseiutredningen, Naturhistoriska riksmuseets framtida ställning och organisation*, 112.
16 Tony Bennett, *The Birth of the Museum: History, Theory, Politics* (London: Routledge, 1995), 25–33.
17 Kjell Engström, "Aims of the Exhibition and Education Activities at the Museum of Natural History," in *Natural History Museums and the Community*, ed. by Kjell Enström and Alf Johnels (Oslo: Universitetsförlaget, 1973), 104.
18 Bergdahl, Interview with Kjell Engström, September 12, 2012.
19 Bengt Hubendick, "Gammalt och nytt inom biologin," *Göteborgs Handels- och Sjöfartstidning, 1964–12–14*.

Museum awakenings **221**

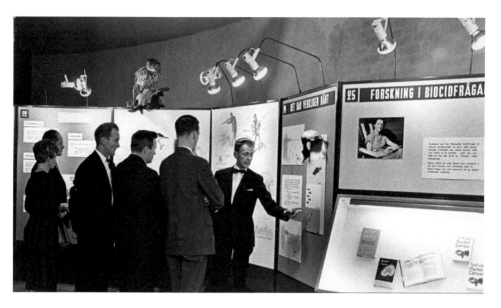

Figure 27.1 Director Kjell Engström guides visitors in the *Are We Poisoning Nature?* exhibition, Swedish Museum of Natural History, 1996. Photo: Swedish Museum of Natural History.

The exhibition dealt with a hot topic, but it also managed to direct attention towards recent research conducted by the museum's own scientists. A research group focused on biocides had been formed a few years earlier, and its attempts to trace certain biocides in the biological collections of the museum had proved successful beyond expectation. Suddenly the long series of collection specimens gained new relevance, and the results of the research group received attention well outside the research community. Particularly, studies of the spread of mercury in bird populations were groundbreaking and offered important scientific facts to support the prohibition advocates.[20] The successful biocide group overshadowed the traditional taxonomists, but it also placed the museum's research in the center of debate, conveniently aided by the new exhibition.

Are We Poisoning Nature? opened in May 1966 and was the first exhibition ever on environmental questions, not only at the SMNH but in Sweden as a whole. It was a low-budget production, funded within the regular museum budget, with a small contribution from the Museum Friends Association. It consisted of some thirty numbered screens with text and illustrations, but very few displayed objects. The simple production was convenient for transportation, and the exhibition went on a successful tour for a number of years after it had been displayed at the museum.[21]

Public and media attention was considerable, and the exhibition was commented on in several newspapers. Sweden's most prominent daily, *Dagens Nyheter*, stated that the exhibition "shows the complicated dilemma caused by the biocides through partly frightening examples, but does not provide conclusive answers about the extent of damage caused by the uses

20 Alf Johnels, "Natural History Museum Collections: A Basis for Future Research," in *Natural History Museums and the Community*, ed. by Kjell Engström and Alf Johnels (Oslo: Universitetsförlaget, 1973), 48–58.
21 The travelling exhibition was attended by ca 160 000 visitors during nearly five years. Engström, "Museum I skumrask… " 22.

of toxic substances."[22] The *Svenska Dagbladet* went further and criticized the question mark of the exhibition title for its "remarkable caution." since the fact that biocides do damage nature was beyond doubt.[23]

An examination of the content gives some support to this critique. The exhibition message was somewhat ambiguous; the texts raised plenty of questions and provided generous amounts of facts and statistics, but avoided making conclusions and formulating critical allegations. It was left to the visitors to draw their own conclusions. The exhibition content rested largely on the authority of the museum's own research, for instance in its thorough display of the effects of mercury emissions on birds. The presence of another authority was apparent: the two final panels of the exhibition were devoted to an homage to Rachel Carson (who had passed away in 1964) and her writings, displaying a portrait of the author as well as several editions of *Silent Spring*.

The debates on pesticides had considerable effects during the late 1960s. One substance after another was limited or prohibited: mercury, DDT, PCB and cadmium. While *Are We Poisoning Nature?* was on tour, museum staff made efforts to keep its content updated about ongoing developments. Somewhat unexpectedly, the museum found itself in the midst of an emerging popular movement, strongly connected to the 1960s radicalism. The earlier environmental debate had been mostly academic, and narrowly focused on preserving nature intact. In the 1960s, awareness about the interplay between humans and the environment increased; humans entered the equation not just as agents, threatening or saving nature, but also as potential victims. The environmental movement engaged young activists who used demonstrations and radical methods beyond the bounds of the parliamentary system.[24] In this context, *Are We Poisoning Nature?* held a modest standpoint indeed, but it was backed by the acknowledged expert authority of the museum, which made it hard to ignore.

"Sweden turning sour"

Are We Poisoning Nature? had been a success, and paved the way for the production of other temporary and traveling exhibitions at the SMNH. In part, this strategy served to conceal the fact that the efforts to renew the permanent exhibitions – to replace the collections on display with thematic basic exhibits – had turned out to be a slow and difficult process. This was mainly due to the acute pervasive needs of renovation of the interiors, which meant a considerable state investment. The financial problem was finally solved in 1984. After twenty years of annual requests, the renovation of the interiors started.[25] But the renewal plans also roused disputes on what the content and messages of such exhibitions should actually be, and the question was further complicated by upset reactions against the dismantling of the old displays. In a letter to the museum in 1986, even the National Board of Antiquities criticized the dismantling of the displays from 1916 on heritage grounds: "The display cases are original

22 Dagens *Nyheter,* May 20, 1966, www.dn.se/.
23 "Expo på Naturhistoriska…," *Svenska Dagbladet,* May 22, 1966, www.svd.se /.
24 Urban Emanuelsson, *Ett sekel av svensk naturvård*, Nationalencyklopedin, 2009. Visited May 26, 2013 www.ne.se/static
25 The Government Budget for 1986 designated 50 million kronor during five years for renewal of the SMNH exhibitions; Ewa Bergdahl, Naturhistoriska riksmuseet utställningsverksamhet 1965–1933, internal PM number 10, SMNH April 4, 2013 (unpublished), 27.

to the buildings and their open, slender construction is in natural unity with the set interior architecture."[26]

At the same time, and two decades after the previous occasion, the museum once more engaged in an exhibition dealing explicitly with environmental issues.[27] *Sweden Turning Sour* (Sverige surnar till), which opened in 1985, was not exclusively produced by the SMNH, but involved about twenty independent or governmental organizations. The production was coordinated by the relatively small museum of forestry in Gävle, Silvanum, tightly connected to the forest industry. This, too, was a traveling exhibition, but it did not commence in Stockholm but rather on a large hunting and fishing fair in the city of Jönköping, and was displayed at the SMNH in February the following year.[28]

The situation had changed in many ways since the 1960s. The environmental movement had broadened its scope, and gained increasing support across the political spectrum. Popular resistance against nuclear power had decided the outcome of the general elections in 1976, replacing the Social Democrat government with a coalition led by the Centre Party, which was strongly profiled towards environmental issues. A 1980 referendum over the nuclear issue resulted in a compromise, stating a gradual out-phasing of Swedish nuclear power, and the next year a new political party, the Swedish Green Party, entered the scene.

Sweden Turning Sour focused on another dominant environmental issue of the early and mid-1980s besides nuclear power – the acidification of land and water. Compared to the pesticide debates of the 1960s, acidification was a more distinctly international issue, since pollution and industrial emissions are transported over vast distances without regard to national borders. The concerns about acidification certainly had to do with domestic industry, but much of the attention was directed towards the effects of industries abroad on nature in Sweden. Heavy industries in the Eastern-bloc countries and coal plants in Germany featured as major threats in the debate.

This perspective was clearly present in the exhibition, where the symbolic *Mother Svea*, draped in the national colors, blue and yellow, was suffering from pollution and turning gradually more sour. A map showed arrows of pollution invading the Swedish borders from all sides, but only a few arrows illustrated the effects of Swedish emissions on the neighboring countries. Acidification was presented as an international problem, but from a national perspective.

The exhibition coincided with the 1987 publication of the Brundtland Report, *Our Common Future*, from the United Nations World Commission on Environment and Development (WCED). The report established the expression "sustainable development." and its targets were environmental multilateralism and the interdependence of nations. However, in comparison to the Brundtland Report, *Sweden Turning Sour* expressed a "one-way version" of the multilateral perspective.

The exhibition consisted mainly of a series of screens, but this time with some displayed objects and some props, most notably the sectioned body of a rusty car, registration number SUR 085. The color scheme was blue and yellow, to connect to the Swedish flag. The expertise of SMNH did not play a central role – as could be expected in a cooperation project involving several actors.

26 Ibid, 27.
27 Other exhibitions had dealt with environmental issues, but as one theme among several.
28 Bo Thunberg ed., *Sverige Surnar Till: En fakta-och idétidning till vandringsutställningen* (Stockholm, 1985) 1–31.

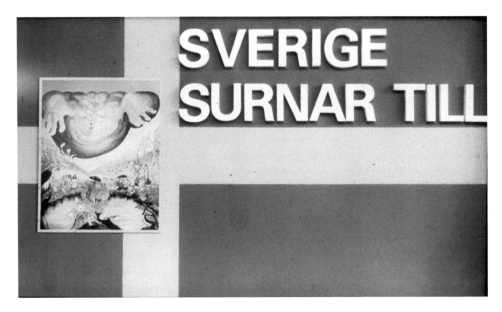

Figure 27.2 Flag poster, *Sweden Turning Sour* exhibition, Swedish Museum of Natural History, 1987. The colors of the Swedish flag (blue and yellow) influenced the exhibition design. Photo: Swedish Museum of Natural History.

The main actor in the exhibition narrative was industry, both as the cause of the problem and as the provider of possible solutions. Industry was also present as a contributor in a material sense; the project was funded by all of the involved organizations, but also through sponsoring. Under the headline "There are possibilities," the sponsoring companies were given space to present their various technological solutions to acidification. The message of the exhibition as a whole was rather shattered, reflecting the many different voices, and the response in mass media was limited. In April 1986 the Chernobyl nuclear accident in Ukraine occurred, and all media and political attention was once more directed towards nuclear hazards. Both the debate on acidification and the exhibition, still traveling from one location to another, were drowned in the nuclear flood.

Mission: Climate Earth

In 2002, the museum started planning the exhibition *Mission: Climate Earth* (Uppdrag: KLIMAT), its third major exhibition on environment. In contrast to its predecessors, this was not a traveling exhibition; new political goals for culture placed less emphasis on outreach to various groups of the population and this meant less interest in traveling exhibitions. *Mission: Climate Earth* was planned as a temporary exhibition but was later incorporated among the permanent exhibitions of the museum.[29]

The exhibition was conceived of at a stage when public awareness about the climate issue was still limited and the scientific debate between protagonists and skeptics still active. This was the first exhibition ever in Sweden on climate change, and internationally an early

29 Bergdahl/Houltz, interview with Claes Enger, SNMH, November 25, 2013.

Museum awakenings 225

attempt to grasp the climate issue in a museum context. This placed the museum in a somewhat awkward position, since it meant taking a stand in what was then still an unresolved scientific controversy. Furthermore, to deal with the climate issue, the museum was largely

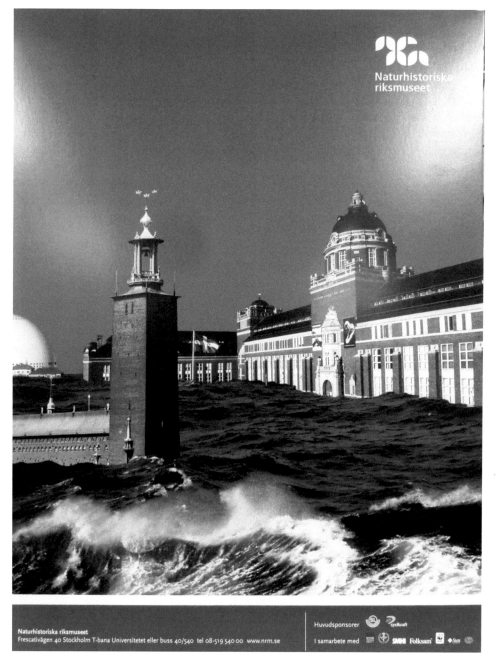

Figure 27.3 A poster presenting the *Mission: Climate Earth* exhibition, showing well-known Stockholm locations flooded by high waters, Swedish Museum of Natural History, 2014. Photo: Ewa Bergdahl. See Plate 31.

dependent on the authority of external scientists. While *Are We Poisoning Nature?* had been safely supported by the results of the museum staff researchers, there was no comparable in-house expertise to rely on this time.[30]

The decisive factor for the project's realization was probably the fact that it was initiated by the museum board chairman, the politician Anders Wijkman, a Christian Democrat strongly engaged in environmental policy questions. The solution to the potential credibility dilemma was to tie the exhibition message to the authority of the *Third Assessment Report* from The United Nation's Intergovernmental Panel on Climate Change (IPCC), published in 2001, the year before the exhibition plans were launched. Making the connection to the IPCC report explicit was also a firm condition in order to gain the support of the National Environmental Protection. Thus, the report was used as a fundamental authority comparable to Rachel Carson's book four decades earlier. A scientific reference group was organized with members from the Swedish Meteorological and Hydrological Institute, the Environmental Protection Agency, the World Wildlife Foundation and Stockholm University.[31] Still, in comparison to the report, the exhibition went one step further. While the IPCC stated that, "most of the observed warming is likely (greater than 66 percent probability, based on expert judgment) due to human activities," the exhibition presented human impact on climate change as a given fact.[32]

The exhibition was inaugurated in September 2004.[33] It was prominently located in one of the halls opening from the museum entrance vestibule. Much of the content was devoted to explaining what climate is and the mechanisms affecting weather conditions. Meteorology was central to the narrative, but space was also devoted to effects of climate change on human conditions, by, for instance, comparing the ecological footprints of a teenage girl in Cambodia with one in Sweden. The perspective of the exhibition was global, placing the future of the local or national society in relation to that of the whole planet. In one of the interactive stations, visitors were invited to "create their own clouds" by letting off steam through a hand-operated device – a subtle argument for the anthropogenic character of climate and weather conditions.

The exhibition team aimed to avoid "doomsday prophesies," to remain on firm, scientific ground and deliver the message that human action can make significant change.[34] This urge for action was a central theme, not least expressed in the exhibition title, *Mission: Climate Earth*. On the other hand, the exhibition's central feature was a spectacular film display named "The eye of the storm" (*Stormens öga*). The display, which showed dramatic weather sequences and devastating scenarios using strong visual, audio effects, and even a wind-machine to give the impression of storm, appealed more to the visitors' feelings than their intellect.

30 Interview with Stefan Claesson, SNMH, November 25, 2013.
31 *Uppdrag: KLIMAT: En utställningskatalog i samarbete mellan Forskning & Framsteg och Naturhistoriska riksmuseet*, Stockholm, 2004, 4.
32 IPCC, *Third Assessment Report* (TAR), 2001. Later IPCC reports confirm the connection between human agency and climate change more directly.
33 For an interesting analysis, see Anna Samuelsson, "*I naturens teater*: Kultur – och miljösociologiska analyser av naturhistoriska utställningar och filmer" (diss., Uppsala University, 2008), 230–268.
34 Interview with Claes Enger, SMNH, November 25, 2013.

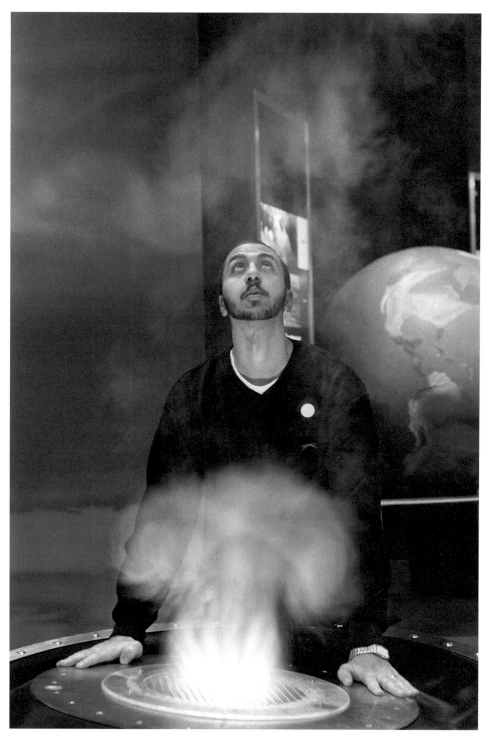

Figure 27.4 Create your own cloud interactive in the *Mission: Climate Earth* exhibition, Swedish Museum of Natural History, 2004. Photo: Mikael Axelsson, SMNH. See Plate 32.

The ambivalence between keeping a moderate and trustworthy tone on the one side and the need to communicate the urgency of the situation through spectacular displays on the other was clearly noticeable. The newspaper *Aftonbladet* commented the displays: "Through interactive computer stations and dystopian texts ('present day climate change may be the gentle beginnings of a major change in a hundred years') the exhibition tries to frighten visitors into action, as it seems."[35]

The ambitions of the marketing division of the museum to produce effective and eye-catching promotion also came into conflict with the moderate ambitions of the exhibition producers, resulting in an advertising campaign where well-known Stockholm locations were flooded by high waters. Similarly, the exhibition team were upset when one of the major sponsors, the local traffic company SL, placed a fake bus shelter demolished by ice at the bus stop near the museum entrance.[36] *Mission: Climate Earth* has slowly been incorporated in the permanent range of exhibitions and can still be visited in 2016.

Conclusions

Temporary exhibitions like the ones discussed in this chapter stand out in contrast to the museum's major permanent exhibitions, which were gradually modernized both in design and content from the mid-1980s. The first one to open was *Polar Regions* in 1989, followed by *4½ Billion Years – The History of Life and Earth* in 1996, and *Life in Water* in 1997. While the temporary exhibitions have been clearly polemical about controversial topics, the permanent exhibitions, striving for objective timelessness, have largely failed to articulate their debt to contemporary issues. For instance, the 1989 polar exhibition emphasized the problems of whaling and seal hunting, which was a hot political topic at the time both in Sweden and internationally, but this theme was downplayed in later versions.

All three temporary exhibitions are characterized by a direct address towards the visitor by using the word "we" in the texts and including the visitor in the story. A good example is *Are We Poisoning Nature?*, where even the title uses this mode, in marked contrast to the permanent exhibitions, where such formulations are avoided. In the temporary exhibitions, humans are very clearly presented as actors and the interplay between man and nature is accentuated. This, again, is in contrast to the permanent exhibitions, which are less articulate about human agency and yet somehow still rest on the traditional notions of human superiority over nature.

Additionally, even though the three exhibitions stress the importance and sometimes harmful consequences of human actions, they do not dare to question the current political system. They advocate improvements *within* the system but not radical changes of it. The exhibitions identify important and current problems without designating any villains or blaming anybody. Causes are described but presented in a neutral way.

SMNH is the biggest museum and one of the largest research environments of natural sciences in Sweden. However, the relationship between the exhibition activities and the research has always been complicated. In the 1960s, the museum had the precedence of interpretation by right of its research profile. In the 1980s by contrast, environmental issues had

35 Peter Lindgren, "Vilka Minnen ger vi Barnen?" *Aftonbladet,* March 31, 2005. www.aftonbladet.se/kultur/huvudartikel/article10569608.ab/
36 Bergdahl/Houltz, interview with Claes Enger, SMNH, November 25, 2013.

become established in public discussions and involved numerous actors and authorities, and this development has constantly increased since then. A gradual change in this respect is notable in the three exhibitions. The first one was almost entirely based on the results of the museum's research staff. It dealt with a limited number of pesticides and their consequences and was more easily correlated to the current research at the museum. A development where environmental issues have become more complex and interdisciplinary-dependent made it impossible to cover the whole problem, which was apparent in both of the later exhibitions.

Another gradual change can be noticed in the way in which the exhibitions have been funded. There is a clear development from simple productions, financed by the museum's own means, to more elaborate and expensive projects, funded by external sponsors. The attitude towards private sponsoring changed radically during the 1980s and 1990s and opened new funding opportunities, but it is also obvious in the two later exhibitions that the economic contributions have affected the contents in various ways. This is evident, for example, in the large space given to the sponsors, presenting their technical solutions and products.

A clear shift in geographical perspective is noticeable, from a local view on environmental issues in *Are We Poisoning Nature?*, to a widening view with a more national touch in *Sweden Turning Sour* and finally, in *Mission: Climate Earth*, to a totally global perspective on the environment problem. These changes correspond to the different contents of the exhibitions, from place-bound pesticide deposits, to far-reaching air pollution, to the global effects of the climate changes of today. But the change also reflects the transformation of the world and how we understand it into a more global community where mankind has been given the opportunities to grasp the whole globe and been exposed to the complexity of the current existence.

Dealing with the Anthropocene period poses new challenges to the exhibition media. A simplified evolutionary perspective is no longer sufficient, since humans have changed the rules of existence. The continuity of evolution is no longer the one and only model of explanation. Creating an exhibition today about the climate changes in the world requires embracing discontinuity, as well as bringing together a holistic and system-critical approach throughout, and dealing with the role of humans as the earth's totally predominant species.

28

RISING SEAS

Facts, fictions and aquaria

Susanna Lidström and Anna Åberg

> Although only a fortunate few can ever visit the deep sea, the precise instruments of the oceanographer, recording light penetration, pressure, salinity, and temperature, have given us the materials with which to reconstruct in imagination these eerie, forbidding regions.
>
> *Rachel Carson,* The Sea Around Us *(1951)*[1]

Understanding the oceans on a human scale

In 2008 the BBC aired a new series titled *Oceans*, intended, as stated by explorer Paul Rose in the introduction to each episode, to "understand the earth's oceans and put them on a human scale." The series follows a team of ocean explorers that includes, in addition to two oceanographers, a marine archaeologist and an "environmentalist," the grandson of Jacques-Yves Cousteau. The BBC team included both human and scientific perspectives on the ocean as well as acknowledgment of the popular history of deep-sea exploration. Throughout the series, these different themes are pursued in tandem with each other as dives in search of rare and spectacular marine species and phenomena are accompanied by investigations of shipwrecks and discussions about effects of climate change on marine environments.

In sharp contrast to the BBC's preceding series about the sea, *Blue Planet* (2001), *Oceans* was very inclusive of the human dimensions of the marine world, manifest in explorations of past shipwrecks, in the present through the dives designed for the camera, and in the reflective discussions and commentaries from the team. The previous series portrayed the world's oceans as unknown and alien environments with little or no human presence (all humans were behind cameras). It was narrated through the iconic voice of David Attenborough accompanied by dramatic music characteristic of classic nature documentaries.

1 Rachel Carson, *The Sea Around Us, Oxford* (Oxford: University Press, 1951). From the "Sunless Sea" chapter.

The shift in the perspectives between *Blue Planet* and *Oceans* captures a change in our understanding of the global ocean from a foreign, distant world untouched by human activities, to a place where they have, and have had for some time, far reaching and increasingly alarming impacts. Anthropogenic effects, including warming temperatures, species loss and changing chemical composition of the sea water, are attracting increasing concern worldwide. Even so, as *Blue Planet* illustrates, there is a continuing tradition of showcasing and narrating the ocean as a foreign place, stimulating emotions of wonder, amazement and awe, rather than an emphasis on the prosaic and sometimes dangerous activities of humans in the oceans' history.

The depiction of the ocean as a relatively unexplored alien world of wonders and strange creatures is likewise the prevailing narrative in most aquaria around the world. The introduction to *Oceans* states that the seas "cover 2/3 of our planet ... but the secrets of our oceans have remained largely undiscovered." Maritime biologist Tooni Mahto, one of the team members, comments that "if you don't dive into the Red Sea, all you see is that [pointing to the surface] ... you see blueness. To understand anything about what happens in our planet's oceans, you have to get in" (Episode 3). Aquaria enable visitors to at least vicariously explore the world beneath the surface, a part of the planet otherwise invisible and inaccessible to most of us, and view marine habitats and species from multiple angles and perspectives, including tunnels that give the experience of being "in" the water and technologies that visualize tiny details as well as large patterns.

As concerns about human impacts on ocean environments gather pace, especially in relation to climate change, aquaria are complementing the old narrative of the wonder and strangeness with stories about human-ocean relations. How can aquaria showcase relationships between humans and a changing sea? There is a challenge in combining the already vast scales of the ocean, and in showing global currents, the high and deep seas, and complex marine ecosystems, with the slow and barely visible processes of a changing climate, such as acidification and rising sea levels and temperatures. While such processes can be visualized indirectly, through maps, mathematical models and illustrations or demonstrated through their effects on specific species or ecosystems, such as bleached corals, it remains difficult to create a story that truly engages the viewer on a scale that is at the same time planetary and personal.[2]

The narrative about the wondrous ocean differs structurally as well as in its emotional components from stories about climate change, most of which so far, at least in the context of science and natural history museums, seem to rely on graphs, charts, data and predictions, evoking feelings of alarm and concern. Aquaria, on the other hand, are centered around living animals, often involving some that can be touched and "interacted" with. Live animal interactions play on emotions of fascination and curiosity. While climate exhibits in museums increasingly recognize and incorporate human aspects and stories in addition to the "cold facts" of the science, aquaria likewise are beginning to move towards more human-oriented stories, as scientific reports of human impact on the sea contradict and undermine narratives about the oceans as a world apart from human societies. In addition, as a crucial factor in the Earth climate system, as a climate regulator, through rising sea levels and in many other aspects, oceans are also central to climate exhibits. This chapter explores this

[2] Ursula Heise, *Sense of Place and Sense of Planet: The Environmental Imagination of the Global* (Oxford: Oxford University Press, 2008).

increasingly central intersection between aquaria and climate change exhibits, to unpack ways in which oceans and climate change interact in aquaria as well as other natural history and science museums. To examine different forms and shapes that this intersection may take, and highlight key concerns, we consider two case studies to illustrate our main points; one, an aquarium affiliated with a natural science institution and the other, a modern video installation about climate change. While our examples are from the United States, we have noted similar trends in Europe and other places. Further studies including cases allowing an international and comparative perspective would deepen this analysis.

The science aquaria: a sea of facts and figures

Several aquaria in the southern parts of the United States that depict habitats in the Gulf of Mexico, for example the Aquarium of the Americas in New Orleans, feature (scaled down) oil platforms in their tanks. Historian of technology, Dolly Jørgensen has suggested that such features are in fact the typical modern aquarium representation of the Gulf of Mexico. Rather than place the oil industry in opposition to the Gulf's ecosystem, aquaria have integrated the oil industry into their displays. Offshore oil structures are presented to visitors as an integral – and even necessary – part of nature in aquarium exhibits and education material.[3]

Jørgensen identifies these representations as "hybrid spaces," displaying "man's built environment and technological artifacts alongside and integrated with nature."[4] As Jørgensen shows, the motivations and interests behind exhibiting such hybrid spaces in this region may be traced to different corporate, social and economic interests, which may explain some of their popularity. However, looking at aquaria from a broader perspective, such hybrid spaces that show ocean environments as mixed human and natural worlds are unusual.

Rather than stories about human impact on the sea, the most common narrative in aquaria worldwide is about a strange, alien world, still comparatively unexplored. This narrative is recognized from depictions of marine environments and creatures in popular nature documentaries about the sea, such as *Blue Planet* or the French documentary *Océans* (2009), and in feature films such as *Le Grand Bleu* (1988), *Finding Nemo* (2003), or *Life of Pi* (2012). In some cases the link between film and aquarium is especially strong, as in *Finding Nemo*; ironically, many children visit aquaria with the main purpose to "see Nemo," not recognizing that they are seeing him in the very environment that in the film he is trying to escape or be saved from. In aquaria, these stories of wonder and amazement are typically accompanied by information from the natural sciences – scientific species names, taxonomic classifications, habitats, natural history – designed to inform and educate the visitor, often pitched at school children who form an important part of the aquarium's audience.

An example of this kind of aquarium, especially focused on informative oceanography and marine biology and ecology, is Birch Aquarium in La Jolla, California, "the interpretative center" of Scripps Institution of Oceanography (SIO), part of University of California, San Diego. Birch Aquarium consists of one main exhibit, the *Hall of Fishes*, made up of small tanks showcasing certain species, microhabitats and research projects (by SIO scientists),

3 Dolly Jørgensen, "Mixing Oil and Water: Naturalizing Offshore Oil Platforms in Gulf Coast Aquarium," *Journal of American Studies* 46, no. 2 (2012): 462.
4 Jørgensen, "Mixing Oil and Water," 469.

ordered so that they take the visitor on a journey along the west coast of North America, from north to south, ending in Baja California – which visitors can look out across from the aquarium's patio. This exhibit takes up about half of the aquarium, and includes its main attraction, a 70,000 gallon kelp forest tank, showing an important marine ecosystem just off the coast of La Jolla. The other half of the aquarium is divided between several newer and temporary exhibits on different topics, including, in 2013, an outdoor interactive exhibit about renewable energy, a collection of seahorses, a shark tank, a set of tide pools and, finally, a climate change exhibit.

Feeling the Heat: The Climate Challenge opened at Birch Aquarium in 2007 (dedicated by Al Gore) and, to date, remains open. The exhibit promises to provide "the facts on the world's hottest topic." Reflecting research pursued at SIO (oceanography, earth and atmospheric sciences), *Feeling the Heat* is constructed around a natural science understanding and depiction of climate change, focusing on facts, data and graphs. The first object that meets the visitor is a sign proclaiming that "the evidence is everywhere." This is followed by a statement from the Intergovernmental Panel on Climate Change (IPCC) confirming that "[w]arming of the climate system is unequivocal, as is now evident from observations of increases in global average air and ocean temperatures, widespread melting of snow and ice, and rising global average sea level." After this comes one of the largest objects in the exhibit, a graph showing how the level of CO_2 in the atmosphere has changed over the past 650 000 years, highlighting the sharp post-Industrial Revolution increase (Figure 28.1).

Other prominent objects in the exhibit include the famous Keeling Curve of carbon levels at Mauna Loa Observatory in Hawaii (Charles David Keeling, a scientist at SIO, began the observations in 1958); satellite images showing the decrease of Arctic sea ice from 1979 to 2012; detailed images illustrating predicted sea level rises based on different levels of future carbon emissions; a map showing the distribution of Argo robots (floating robots that roam

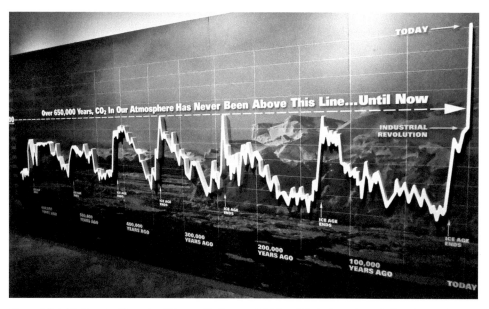

Figure 28.1 Feeling the Heat: the Climate Challenge exhibition, Birch Aquarium, 2007. Photo: Susanna Lidström and Anna Åberg. See Plate 33.

the oceans at various depths recording data), and an actual Argo robot with information about how it works. There are also two small aquaria showing contrasting examples of coral reefs, one healthy and one bleached, and a video where an SIO scientist explains climate science.

The texts that accompany the graphs and illustrations are both factual and alarmist. But they are alarmist without being emotional, such as this commentary about predicted future sea level rise. It begins with a quote from the IPCC, followed by a statement that elaborates on the figures behind the prediction:

> Many millions of people are projected to be flooded every year due to sea-level rise Global average sea level rose 4–8 inches in the 20th century. That same rate is projected to continue under a lower emissions scenario, but will nearly triple with continued high CO_2 emissions. As significant as these changes will be, they could be dwarfed by rapid changes in Greenland and Antarctic ice flows.

Several stations also include figures that look alarming, but actually mean little. The most striking is a ticking clock showing the amount of CO_2 that has been emitted since the Industrial Revolution (at the time of our visit 2,835,092.1 tons). This looks like a large amount, but its meaning for most of us would change little if it was halved, as it is exhibited without any frame of reference or comment.

The texts are also assertive. There is little room for the uncertainty present in the kinds of predictions of complex systems that inform the exhibit, even when the general trends are conclusive. The mission to convince visitors that may be in doubt regarding climate change prior to their visit is present throughout the exhibit. For instance in this text, about "Forecasting the Future":

> Scientists use climate models to simulate the Earth's climate system and project how the climate will respond to factors such as increasing greenhouse gases. Models are refined until they accurately reproduce past and present climates. Then the models are used to evaluate future scenarios with the confidence that they describe the real world faithfully.

In most places, more careful words would be chosen to describe the validity and accuracy of complex climate models,[5] but here it seems there is no room for anything that may invite doubt, in the context of North American climate controversy that surrounds Birch and SIO.[6] The mission to convince is also present in the promotional video for the exhibit, available on the aquarium's website, showing visitors commenting positively on the exhibit, and closing with one woman's comment that it is an important exhibit for everyone to come and see, "whether they believe in it or not."

After having walked through this sea of figures, graphs and data, the visitor encounters a final graph, asking "What Future Will We Choose?" before entering the last room of the

5 Paul Edwards, *A Vast Machine: Computer Models, Climate Data and the Politics of Global Warming* (Cambridge, MA: MIT Press, 2010).
6 Naomi Oreskes and Erik Conway, *Merchants of Doubt: How a Handful of Scientists Obscured the Truth on Issues from Tobacco Smoke to Global Warming* (New York: Bloomsbury, 2010).

exhibit, smaller than the previous spaces, focusing on what visitors can do when they return home in response to what they have learned. Suggestions include saving energy by switching to low energy light bulbs, changing window panes and other home appliances, choosing an electric car, and recycling and reducing waste. These suggestions focus on exchanging existing appliances for more environmentally friendly alternatives, rather than about changing habits. They also address individuals, rather than societies or cultures, apparently aiming to leave the visitor with a sense of agency. There is little discussion or acknowledgment about complex choices, larger societal or cultural changes, or global relations. Visitors leave, presumably, with a positive feeling of having been informed, and now motivated to make small changes in their lives that will contribute to a positive future.

While *Feeling the Heat* communicates a strong scientific message about climate change, the exhibit almost entirely lacks a human dimension. In the entire exhibit, there is no picture of a human being that brings to mind questions about distribution of resources or global inequality, for example. Humans in this exhibit are either polluters, as in the description of cities as human volcanoes, or scientists, as in the picture of Charles David Keeling next to the graph showing the Keeling Curve. Neither is there any reference to a long-term relationship between humans and climate, nor to a relationship of mutual influence between humans and the natural environment in a broader sense.

Visualizing slow violence: affect, fictions and futures

In relation to climate change, multiple narratives about humans and the oceans are making themselves known. Climate science does not report the wonders of coral reefs, but instead shows bleached reefs, disappearing fish and changing sea levels. While these are frightening concerns, and some of them are already becoming tangible through lifestyle changes among human populations living in or close to affected areas, they are also difficult to visualize, and the threats of climate change to the oceans can be difficult to grasp. The slow moving threats of many environmental disasters and the challenges in turning them into narratives that work within the framework of contemporary media have been highlighted by literary scholar Rob Nixon in *Slow Violence and the Environmentalism of the Poor*:

> How can we convert into image and narrative the disasters that are slow moving and long in the making, disasters that are anonymous and star nobody, disasters that are attritional and of indifferent interest to the sensation-drive technologies of our image-world? How can we turn the slow emergencies of slow violence into stories dramatic enough to rouse public sentiment and warrant political intervention, these emergencies whose repercussions have given rise to some of the most critical challenges of our time?[7]

This problem is facing those who aim to engage in and inform people about climate change. One attempt to visually show the slow disaster unfolding around us is the documentary *Chasing Ice* (2012), in which we follow photographer James Balog on the mission of photographing melting sea ice in the Arctic. In the film, photographs, taken over the course of

7 Rob R. Nixon, *Slow Violence and the Environmentalism of the Poor* (Cambridge, MA: Harvard University Press, 2011): 3.

several years, are sped up to show the movement of glaciers, and they communicate a devastating image of loss. The visual imagery is striking, but in order to achieve that effect, the spatial and temporal relationship between the viewer and the natural processes on display are modified, simplified, and mediated. There are no simple solutions for Nixon's questions. All we can do is to consider carefully how climate imagery might be both effective and authentic in "human-scaled" museum exhibits.

Another example illustrating the challenges of exhibiting climate change and communicating the urgency of this (mostly) slow threat is from the American Museum of Natural History (AMNH) in central New York. In the temporary exhibit *Climate Change: The Threat to Life and a New Energy Future*, one of the objects was a model that showed what a future flooded lower Manhattan might look like (see "Object In View" following this chapter). The intent was to communicate the potential consequences of a rise in sea levels. Manhattan was a familiar environment for the audience.

The model, however, was later re-evaluated for two significant shortcomings. It showed the consequences of a sea level rise of 1 and 5 meters to Manhattan as it looks today, but unless the audience read the text it was not clear that these levels of flooding would unfold over centuries, and that, over this period of time, the inhabitants of one of the richest cities in the world would surely have the time to adapt and defend themselves from the flooding, either by building barricades or simply moving away. The visual imagery failed to convey the time scale of the planetary processes and human responses brought on by climate change, and this is, as one of the curators Edmond Mathez comments, "Indeed … among the most challenging concepts to communicate." New York is indeed a part of the world where rising sea levels would cause problems, but the city itself and many of the inhabitants have access to financial and technological resources needed to adapt. Thus, the model overlooked the possibility to make a statement about different abilities of rich and poor to respond to climate change (see below). Interesting to note is that the problem, according to Mathez, lay particularly in the visualization. The text that accompanied the model explained the time scale and the fact that it was not an actual image of the future, but this needs to be in some way conveyed also through the visual model. Further, part of why the model was deemed problematic is because it did not show a believable image of the future. But what is a believable image of the future? And are *believable* images what we need?

A problem facing aquaria and other institutions when exhibiting slow change and the future of oceans pertains to the imperative of being scientifically correct, which is a difficult task when faced with the future. As already discussed, the image shown of the ocean in many exhibits communicates a story of wonder and awe, a narrative that also inspires affect, in the sense that the audience is moved by its perceived beauty and splendor. This positive affective story is easier to communicate, partly because the evidence is clearly in the present (in the form of living animals etc.). When exhibiting predictions, on the other hand, the museum must choose a future scenario to endorse – how does one go about that when scientific evidence of the future is a contradiction in terms? Institutions such as SIO and AMNH have a responsibility to provide scientifically correct information to the public as well as a reputation of scientific quality to uphold and, traditionally, that kind of mission can be seen as an opposite to the kinds of "emotional" exhibits that would cause audiences to act, but which climate science and politics seems to call for.

One might also discuss the role of museums in this regard in a more fundamental sense. To what extent should museums engage in public opinion and political action? This issue,

already discussed to a large extent in museums and other institutions, is challenged by global environmental change, with climate change and the manifold related concerns at the forefront. Concerns about how to visualize climate change and the possibility to inspire people to action is intertwined with a discussion about the role of museums in society. This role is also connected to the organizational form of each museum, leaving different spaces where museums can operate.

Negotiations of how to engage as well as inform, while keeping to scientific accuracy, takes another form in museums and other institutions that focus on art. Contemporary art is becoming increasingly involved with climate change. Through projects such as the Cape Farewell project and the Canary project, climate exhibits such as the EXPO 1 at Museum of Modern Art (MoMA), New York, or the ambulating Carbon 12 exhibit, and even aid efforts after the devastation of Hurricane Sandy, artists and curators have collaborated, acting to support communities and making art that visualizes different aspects of the climate changes and their impact on society. Within the contemporary art world, the goal to evoke affect and spur to action is unproblematic. Although some of these projects include cooperation with scientists, straightforward claims of scientific accuracy and clarity are not a necessary part of these exhibits. Instead, the audience is encouraged to engage their own interpretations and emotions.

The MoMA exhibition EXPO 1, in 2000, included a video installation called *The Drowning Room*, which shows an unnerving future scenario, where the human world has had to adapt to the rules of the sea. *The Drowning Room* is a short film by Reynold Reynolds and Patrick Jolley, capturing an everyday scene in a household that is under water.[8] The film shows a small apartment where a family of three is gathered around dinner. The food is whole fish, and the actors dig into the meal with animalistic fervor, while seemingly breathing water as if it was air. The atmosphere is both domestic and threatening at the same time. The grainy images and dulled sound of the film gives a claustrophobic impression of being trapped under water, and the actions of the characters, while familiar to us, have a violent undertone. This violence develops over time in the film; the protagonists grow more and more antagonistic and animal-like. As the action progresses from the dinner into hands-on fighting between the family members, the audience is caught between discomfort and revulsion (Figure 28.2).[9]

This underwater world is far from the beautiful, wondrous world of aquaria. Here humans are the animals on display, life is harsh and unforgiving, impossible even, and survival is for the fittest. The anxiety of being caught in a situation out of one's control is overwhelming, adding to the oppressive atmosphere. The actors seem at times lost in their new world, as if they are slightly confused over being there, adding to the feeling of an animal trapped in a cage.

If this is a future vision of human life on the planet warmed by climate change, who would not want to prevent it? Scientifically, the scene is, of course, impossible, to the same extent that the earlier mentioned model of New York does not present a believable future, but the threat of having your home submerged under water is not a complete fiction, and the creators of the film extrapolate the slow threat of the rising sea levels, in itself too slow for most of us to notice, to make us see the threat as imminent. A link can be made to the much-publicized underwater cabinet meeting held by the president of the Maldives in 2009

8 www.momaps1.org/expo1/image/the-drowning-room/
9 Thank you to Reynold and Patrick for letting us use the still from their film.

Figure 28.2 Still from *The Drowning Room*, by Reynold Reynolds and Patrick Jolley, 2000. Image courtesy of Reynold Reynolds and Patrick Jolley.

to draw attention to the threat posed to his country by rising sea levels. Compared to the New York model, in the context of the EXPO 1 exhibit the extrapolation of the science is not problematic in the same sense. Through *The Drowning Room*, we may not experience how the actual rise of sea levels will affect us, but we experience feelings of anxiety, lack of control and depression of being forced into a new lifestyle that is repulsive. The lack of a demand to show a scientifically believable future as well as a different audience leads to a greater freedom of expression.

Nevertheless, the strong emotions evoked by *The Drowning Room* do not necessarily lead to motivation for political or even private action on environmental issues. Indeed, if audiences feel too emotionally manipulated or that the displays in exhibits are too removed from a reality they can connect to, it may even evoke counter-reactions.[10] The lack of a clear message can, in this sense, be paradoxically both an asset and a liability.

A future life aquatic: constructing an environmental imagination of the sea

What then is a "successful" marine climate exhibit? One that is definitely scientifically correct? One that draws audiences toward political action? The exhibits at Birch and MoMA

10 Alexa Weik von Mossner, *Moving Environments: Affect, Emotion, Ecology, and Film* (Waterloo, ON: Wilfrid Laurier University Press, 2013).

illustrate both problems and possibilities in visual representations of rising seas, and the different expectations on an exhibit depending on host institution and expected audience. Considering these disparate exhibits together provides a starting point for discussing possible avenues for visualizations of climate and marine change.

Is it a problem that Birch Aquarium does not have a single human in their exhibit? Or that modern art exhibits showcase scenarios that are so extreme that they risk alienating rather than engaging visitors? Should we settle for the current division between nature and culture, and just let the contemporary art exhibits, with less pressure to get the scientific facts right, deal with the cultural side, and let aquaria deal with the important, scientific stuff?

We think not. For many reasons, discussed throughout this book, we think that climate change, marine science and culture need to go together. To separate scientific facts from cultural and historical human presence, as in *Feeling the Heat*, even while including graphs showing the steep incline of CO_2 emissions by humans, undermines the mission to create a sense of agency and responsibility in the visitor, where they feel included in the scenario on display. In Birch Aquarium, the scientific imperative dominates the exhibit, and few links are made that connect the scientific graphs on display to the lived realities of different groups of humans around the world, whether it is the American consumer or the climate refugee. Writing humans and culture out of the story does not reflect reality, but misrepresents how humans live in and are a part of their environments, locally and globally. We would argue that the exclusion of stories that reflect a long-term historical relationship between humans, climate and oceans narrows the perspective presented to the audience and presents climate change as a problem for natural scientists, rather than a cultural challenge in a much wider and deeper sense. We also suggest that this may alienate audiences, who are not included in "solutions" in any encompassing way, leaving them without a sense of agency beyond changing their light bulbs. To strengthen connections between science, culture and policy to understand changing climate and oceans, cultural narratives beyond scientific ones need to be part of the picture, from the beginning and everywhere, to show that these are social and cultural challenges, not only problems "in nature," not even in the farthest corner of the deep sea. Humans are more than scientists, saviors or villains, as the editors highlight in the introduction to this book. We are active agents in our environments in much more nuanced ways than such categories reflect, and this includes the ocean.

Today, we have more science to help us construct an imagination of the sea than in 1951 when Rachel Carson wrote the epigraph at the beginning of this chapter. But how do we make that imagination explicitly *environmental*? How can we develop a sense of the ocean as an environment that is coproduced by human societies and natural resources and conditions, just like environments on land? The oceans today are not just eerie and forbidding regions, but areas that, despite the fact that they may never have seen a human being, feel the effects of human activities around the globe. To use marine science and knowledge to showcase this increasingly human and troubling side of marine environments, not as a new phenomenon, but as the result of centuries of human-ocean interactions, is an emerging challenge that increases in importance as the sea continues to warm.

29
OBJECT IN VIEW

The model of flooded New York

Edmond Mathez

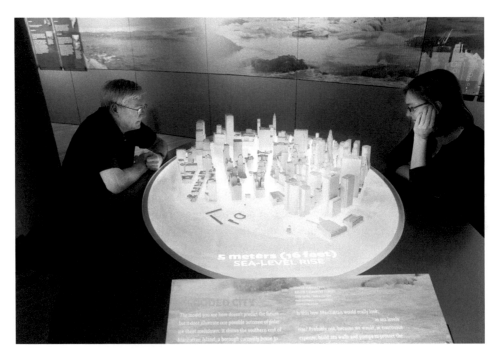

Figure 29.1 Model of Manhattan, flooded, in the *Climate Change: The Threat to Life and a New Energy Future* exhibition, American Museum of Natural History, 2008. Photo: Denis Finnin. See Plate 34.

In October 2008, the American Museum of Natural History opened a temporary exhibit entitled *Climate Change: The Threat to Life and a New Energy Future*. The exhibit concerned the issue of climate change, covering not just the science but also consequences, adaptation efforts, and energy solutions. The curatorial team consisted of myself, a geologist and

curator/professor at AMNH, and Michael Oppenheimer, a climate scientist and professor at Princeton University. Subsequent to its opening in New York, the exhibit traveled to about a dozen venues worldwide.

Among the features of the exhibit was a three-dimensional model of southern Manhattan showing the city as it is now and then the areas that would be flooded by three-meter and five-meter rises in sea level. While the model served as a reasonable object to communicate the potential for catastrophic sea level rise, it had two serious shortcomings. The first was that the visitor would have had to have read the caption to realize that a three-meter rise in sea level is not imminent, but like most other serious consequence of global warming will likely occur gradually over many decades or, in the case of a five-meter rise, over several centuries. This speaks to a fundamental aspect of the climate system, namely that many of the changes that we are forcing on that system will take centuries or even millennia and longer to play out, timescales that are generally difficult to comprehend. In other words, Earth marches to its own drummer, and at a beat unfamiliar to us humans. Indeed, the scales of time and space of planetary processes are among the most challenging concepts to communicate.

The caption made another important point that flooding of Manhattan is ultimately unlikely to occur because the city would surely adapt, for example, by building sea walls or other infrastructure to protect itself. Herein lies the second shortcoming. Of all places, one of the major financial centers on the planet will surely adapt, but what about the poor parts of the world that are similarly threatened? The model offered an extraordinary opportunity to juxtapose the differing abilities of rich and poor to adapt to climate change, but it did not do so.

This illustrates one of the difficulties inherent in exhibit-making: It is difficult to anticipate in advance all the messages conveyed—or in this case not conveyed—by specific exhibit elements (to a lesser extent, this is also true of their primary messages). Only after instillation of the model did we curators, who were ultimately responsible for the exhibit messages, realize our omission. More broadly, this tale is a metaphor for how global society thinks of climate change. We seldom think of it as a threat separating rich and poor, and thus as a threat to all of us.

30
WHEN THE ICE BREAKS

The Arctic in the media[1]

Miyase Christensen and Nina Wormbs

Introduction

The climate change "debate" on a global level has been partly twisted into a distorted representation by journalists operating within norms of objectivity, broad political and economic contexts and institutional restraints. To the extent that our primary sources of information are the mainstream media, such skewed representations lead not only to a grossly problematic understanding of climate change in the public realm, but to public policies premised upon misinformed decision-making and, ultimately, to increased risks for our collective future. Mediated pro and con arguments have planted doubts and uncertainties in our minds over decades. Meanwhile, climate change has remained on the world political agenda and thus in the news, with ups and downs. Or is it the other way around: because it has been on the news, climate change has been on the world political and social agenda? There is clearly a feedback loop between the two and the dynamics are complex.

What we know with certainty, however, is the fact that the planet is warming and that human activities are the primary reason. The Fifth Assessment Report of the Intergovernmental Panel on Climate Change (IPCC), released in September 2014 in Stockholm, confirmed that scientific fact with certainty. The report further stressed that only with radical cuts in emissions can we have influence on the ever-worsening progress of climate change's effects. Yet, based on what we see in the media, we know that even at this point in time, the political will to tackle this planetary problem that threatens our future is unlikely to be forthcoming.

The Arctic is clearly at the center of these developments. The IPCC report emphasized that the Arctic sea-ice cover is very likely to continue to follow a downward slide. The Arctic

1 This chapter is based on research presented in four chapters in Miyase Christensen, Anika E. Nilsson and Nina Wormbs, eds, Media and the Politics of Arctic Climate Change: When the Ice Breaks (London: Palgrave and Macmillan, 2013): "Globalization, climate change and the Media: An Introduction", by M. Christensen, A. E. Nilsson and N. Wormbs; "Arctic Climate Change and the Media: The News Story that Was" by M. Christensen; "Eyes on the Ice: Satellite Remote Sensing and the Narratives of Visualized Data" by N. Wormbs; and "Changing Arctic – Changing World" by M. Christensen, A. E. Nilsson and N Wormbs.

sea ice has already decreased significantly, both in thickness and extent, hitting a record low of 24 percent Arctic Ocean coverage in 2012—after the record low of 29 percent in 2007, which made the headlines. The 2007 coverage was 39 percent below the 1979–2000 average, and the media started to incorporate increasingly more dramatic imagery and narratives such as starving polar bears, disappearing local cultures and global disasters. As the Yale Forum on Climate Change and the Media note in relation to the latest storms in Great Britain, "historic" and "epic" are terms commonly being used to describe what the BBC has called "weeks and weeks and weeks" of continuous furious rains and flooding.

There is no doubt that the Arctic of today, both in the mediated public and political realms, has gained new meaning and significance. It is the bellwether of climate change, an ever-changing *present* showcase for ominous *future* scenarios. It is also a region potent with commercial possibilities, and thus a hotbed of contested interests. Rich resources becoming available, new shipping routes and opportunities arising, and questions related to sovereignty and rights have all become part of the media discourse. Media stories have pointed to the Northern Sea Route, which connects Asia and Europe by way of the northern Russian coast, as the "New Panama Canal", with the North Pole at the center of this New World. In 2012 we witnessed the deliberately spectacular voyage of the Chinese icebreaker, *Snow Dragon*, from Akureyri, Iceland, across the Arctic Ocean to Shanghai. Through such narratives and debates, the northern polar region has morphed into occupying a status of *center* from formerly being on the planetary *margins*. A new Arctic cartography, illustrated in photograph-like images originating from satellite data, has entered our social imaginary.

The Arctic sea-ice minima of 2007 and 2012, combined with alarming messages from the IPCC, have made it clear that a fundamental change in our public understanding of climate change is necessary. Due to variability, the rate of change follows slower pace at times. Yet, at other times, the change can be fast and furious, catching us inadequately prepared to handle its consequences. 2013 did not bring yet another Arctic sea-ice minimum, and fed into denials of global climate change as well as the credibility of climate science and scientists. However, for the Arctic, the record sea-ice lows in 2007 and 2012 also have brought a shift in our understanding: continued shrinkage is seen as inevitable, and so are major regional and global transformations. In that sense, Arctic climate change has become a *meta-event* of the evolving global climate.

As we will explore below, our society is a media-centric one where policy, politics, culture, economics and science—to name but a few areas—are interlinked through the media. The constant co-production of media and society means that media are both produced by and producing society and social norms. Arrows of simple cause and effect are not particularly interesting to draw. However, this does not make it less interesting to study, just more complex.

Mediating Arctic climate change

In what follows, we discuss how climate change in the Arctic is portrayed in "quality press"[2] and what the consequences of the reporting might be for climate policy and for

2 That is, newspapers in national circulation distinguished by their "seriousness" (formerly referred to as broadsheets in the UK).

the general perception of the Arctic as part of the global climate system. We focus on a media event: the Arctic sea-ice minimum of 2007. This was also a climate–change event, constructed as such through the media but only detectable with the help of modern science and technology. That year the sea ice only covered 4.28 million square kilometers compared to 5.57 million two years before. It was also the year when IPCC released their fourth assessment report asserting with the wording "very likely" that climate change was the cause of human activity and the year that the IPCC, together with Al Gore, received the Nobel Peace Prize. This affected reporting on climate change and the public perception of the issue, as we discuss below. The volume of reporting is significant, but more important is the nature of reporting and the qualitative dimensions of what stories have been told (Figure 30.1).

Before we discuss how the sea-ice minimum was displayed both in text and images in print media in three countries, let us say a few words about our theoretical scope and methodological considerations.

Media events, mediatization and the reading of news

The ways in which questions of climate change and ecosystems research are taken up within the scientific community and policy circles are marked by a variety of approaches. For the general public, mass media, particularly television and daily newspapers, constitute major sources of information about scientific issues including climate-related questions, although the significance of online sources has increased considerably. As covered extensively in media and communication studies literature, media's role in the coverage of scientific and policy-related issues is far from truly balanced and is governed by various factors, some of which will be discussed shortly. And, as has been documented in an increasing number of publications, media coverage of scientific issues is not a direct reflection of scientific debates and discourses but rather part and parcel of a complex web of power geometries (inter- and intra-institutional), professional/social interactions between policymakers, scientists and media actors, and journalistic norms and routines.

The new commercial possibilities that have been highlighted above are but one aspect through which the Arctic has become a unique showcase for global climate change over the past few years. The region also gained visibility through mediated images of polar bears on small remnants of sea ice and dramatic footage of calving glaciers. Images of the Greenland ice sheet moving into the sea chunk by chunk are used by scientists and environmental organizations in their efforts to raise awareness about the consequences of climate change. In the late summer of 2007, at the time of the "sea-ice minimum," satellite technology played a key role in providing dramatic and influential images of the impacts of global warming in the Arctic. An overarching consideration that frames our discussion in this chapter is that certain phenomena can be constructed as media events, the process of which can be analyzed discursively. We argue that the sea-ice minimum was a media event and that as such its construction was also sociopolitical.

In making the assertion that the sea-ice minimum was a "media event," we construe "media event" in the broader sense of a phenomenon, a moment, a "happening" that draws significant media attention to the level of occupying considerable space in various forms and outlets of media. There are many examples of such media events in politics, ranging from the assassinations of John F. Kennedy and Martin Luther King in the 1960s to the more recent

meta-event of the Arab Spring.[3] Public debate about global climate change has also been closely linked with certain events, including the 1988 drought in North America and James Hansen's testimony to the Congress the same year that together linked scientific and popular understandings of climate change and set the stage for moving international climate politics forward at the time. More recent examples are Hurricane Katrina in 2005 and the 2003 heat-wave in Europe that killed almost 15,000 in France alone. As events that led to extensive media coverage of a range of issues on a global scale, they made apparent the fact that adaptation to climate change was an issue of societal significance and would also be a challenge in rich countries with well-developed institutions.

While events such as Hurricane Katrina or 9/11 have an unexpectedness and immediacy that allow "breaking news" style reportage, media institutions and journalists also act as agents by lifting socially constructed moments (for example the Copenhagen COP15 of the UN Framework Convention on Climate Change) to varying degrees and ranks of an event through their coverage. A similar dynamic applies to slower processes in nature such as retreating Arctic sea ice. These only become events when they are constructed and mediated as such. An example is when press releases conveying satellite data are made public and in a broader social and political context that grabs—and further fuels—media attention.

In understanding media events, the level and intensity of coverage is an important factor, but qualitative elements also factor in and should be accounted for to grasp the overall picture presented and the long-term impact of the coverage.

The climate debate on the whole embodies a truly longitudinal, meta character unlike other events of more momentous nature. As such and recognizing the need to use a multi-disciplinary approach to understand climate change in its totality, we propose a conceptual framework within which to approach climate change as a *meta-event* that extends into the future, with the Arctic sea-ice minimum constituting a very significant *moment* along the way. As a meta-event, climate change is much more than the sum of its moments. It is like other phenomena that are produced socially and through the media, and absorbed as meta-events such as the Arab Spring.

Displayed events

Text and frames

In our research, our choice and analysis of media stories was less quantitative in nature and more qualitative. A great number of news articles were surveyed and a few were chosen as examples of how different narratives could be brought out depending on the choice of image and story. With the discursive power of the media in mind, we studied how Arctic climate change has been treated in the quality press between 2003 and 2010. We paid particular attention to representations of the 2007 sea-ice minimum, following the release of data from satellite observations, in three daily newspapers: *The New York Times* (United States), *The Guardian* (United Kingdom) and *Dagens Nyheter* (Sweden). The discussion focuses both on the broader frames and issues in the news stories and on the particular question of a change of media attitude in understanding climate-change indicators, such as the changes in the Arctic sea ice.

3 Christensen, Nilsson and Wormbs, Media and the Politics of Arctic Climate Change, 2013.

Our selection of newspapers was based on the assumption that such major media outlets are indicators of larger media trends. The purpose of including newspapers from three different countries (representing three different political and cultural climates) is to produce more comprehensive and comparative knowledge on a question with global significance.

In order to locate relevant articles, we conducted a search on the websites of all three newspapers. First, we searched for articles including the term "climate change" between the dates of 1 January 2003 and 31 December 2010 (inclusive). The time period covers roughly the four years preceding and four years following the 2007 satellite observations of the Arctic sea-ice minimum.[4] 2013 is also the year when the decline in ice in the Arctic area started to accelerate sharply. It is important to note that the year 2001 was also significant in the climate-change debate. The climate-change issue (including the earlier conceptualization terms such as "greenhouse effect") gained political significance in the British press in 1985, with other milestone moments and discursive shifts in the late 1980s and throughout the 1990s, as well as a decline between 1991 and 1996. In 2001, the release of the IPCC's Third Assessment Report linked climate change with human impact, which caused a jump in the news stories addressing the issue, and the coverage increased steadily from that point onwards.

While the results of this study reveal that the discursive constellation of climate change + Arctic + sea ice was framed in relation to political, economic and scientific issues, in many cases bridges were built between two or more frames and the melting ice in the Arctic and its consequences were addressed as both a global and local risk category (what we call scalar transcendence) and in relation to multiple complex questions such as political action, scientific un/certainty and wildlife (topical multiplicity).

Certain patterns and discursive trends were clearly discernible within the sample group analyzed here. It is worth mentioning that this study is an effort to examine relatively longer-term discursive elements surrounding the Arctic and climate change, rather than a focus on short-term dynamics, and it would not be far-fetched to suggest that these news pieces do have a certain degree of representative power in talking about the recent, qualitative trends in the quality press coverage of the questions identified in this chapter.

We can then conclude our discussion of these media stories with a few remarks. The analysis here (particularly in comparison to earlier studies on similar questions) reveals that there is a mediated return to science and scientific truth, this time with a positive tone about the success of scientific quests, which proved that the planet is indeed warming. Unlike the earlier news stories from the 1980s and portions of the 1990s which 1) placed a strong emphasis on scientific controversy and uncertainty; and 2) cast "climate change" in scientific isolation (that is, a battle fought among science geeks) rather than its sociopolitical significance, the growing scientific certainty, from 2003 onwards, about Arctic climate change as a bellwether for global warming was linked with sociocultural, economic and political frames. Stories that brought in the uncertainty factor were few and far between (and mostly linked with the extreme politics of those such as Sarah Palin and George W. Bush).

Considering the overall tone, it is possible to suggest that an emphasis on science and scientific truth (that climate change is a reality) was discernible in most stories. The quote

4 The satellite data were made public in September 2007. Therefore, in actual terms, the period preceding, as included in this study, is around four years and eight-and-a-half months, while the period following is three years and three-and-a-half months. However, for the sake of a more clear-cut periodic categorization, full four years were used to divide the news stories into two groups (i.e., 2003–2006 and 2007–2010).

below from President Obama ("Obama's revolution on climate change." 21 December 2008, *Guardian*) provides a good example:

> "Today, more than ever before, science holds the key to our survival as a planet and our security and prosperity as a nation," Obama announced. "It's time we once again put science at the top of our agenda and … worked to restore America's place as the world leader in science and technology."

The issues at stake were covered with respect to their complexity and transgeographic significance. Scientific frames that sent a strong message often provided entry points in terms of building linkages between environmental change and political and social dimensions.

Finally, while Arctic climate change was not cast as a "tipping point" (explicitly in those terms) save for two examples, it is clear from the narrative buildup and terminological character of the majority of the pieces (for example expressions such as "a profound transformation of the planet") that the accelerated sea-ice retreat was framed as that "magic moment when an idea, trend or social behavior crosses a threshold, tips, and spreads like wildfire."[5] The gradual shrinkage of the polar ice has provided a new and important gateway to understand the meta-event of global climate change in the concrete and tangible context of the Arctic region.

Images and context

In the investigation of the importance of images for displaying the sea-ice minimum we carried out yet another search. We chose larger groups of articles both through searches of news about the event itself, but also through some of the agencies that provide the scientific images supporting the scientific finding of the sea-ice minimum. Examples of such agencies are the National Air and Space Agency (NASA), the European Space Agency (ESA), the National Oceanic and Atmospheric Administration (NOAA) and the National Sea and Ice Data Center (NSIDC).

Articles discussing the sea-ice minimum were using different types of illustrations to add to the news in the text. As already mentioned, the news of the minimum itself was used to also tell other stories, such as those of the local, or of specific species. However, the illustrations could sometimes evoke perhaps unexpected notions and feelings and thereby result in associations, which carried with them narratives that were not core in the written text. At other times, the illustration was instead the central part of the news story and the text and the image wove the same narrative, supporting each other. The news story of the sea-ice minimum was actually originally built on the availability of satellite imagery that could show how the sea ice had decreased over time. It was a way of illustrating what no human eye could see.

In a story featured by the *Telegraph* on September 22, 2007 two images were put together displaying the extension of the ice in 2005 and 2007 respectively. The ice was displayed on a spherical Earth map against a black background and it was unclear to the reader exactly how the image had been made. The orientation of the image, which was from NASA, was

5 Malcolm Gladwell, *The Tipping Point: How Little Things Can Make a Big Difference* (New York: Little, Brown and Co., 2000).

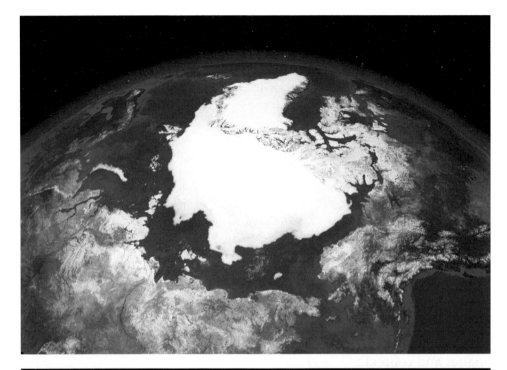

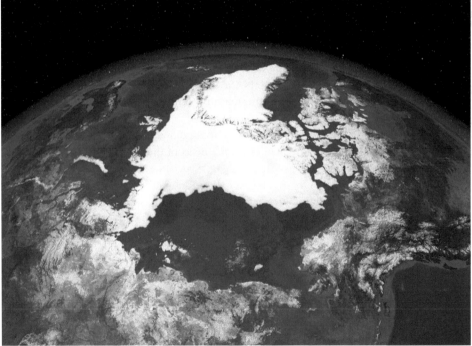

Figure 30.1 "Arctic sea ice melts to all-time low" (2005 and 2007). NASA/Goddard Space Flight Center Scientific Visualization Studio. Next Generation Blue Marble data courtesy of Reto Stockli (NASA/GSFC). See Plate 35.

North America at the bottom and the North Pole at the center and the difference in ice extension was clearly discernable. The reader was shown what could have been pictures from space, covering that particular part of the globe; the fact that the caption read "photograph" underscored that understanding (Figure 30.1).

National Geographic News used a quite different image in an online article on September 17, 2007. The image was from ESA with Europe at the bottom rather than North America. Here it was clear to the reader that the image was put together like a mosaic from a number of images, sequentially collected by an orbiting satellite. The hole over the North Pole, which is due to lack of data as a consequence of polar orbits, was even black and void of information. However, onto this rather transparent map two lines were drawn to show the positions of the Northwest and Northeast Passages. This is noteworthy. An economic and historic route was merged with a scientific image thereby conveying a cause and effect. By showing the sea routes in the mosaic of the satellite images, a socio-economic future was implied, however in the guise of science (Figure 30.2).

Figure 30.2 "Satellites witness lowest Arctic ice coverage in history," 2007. Source: ESA. See Plate 36.

The ESA image in its original framing on the ESA webpage had the title "Satellites witness lowest Arctic ice coverage in history." And even though it was clear that this was not a human eye, the reference to the witness is a striking metaphor also alluding to the saying *seeing is believing*. However, the NASA image also made a non-explicit reference to the idea of a witness, solely by displaying the ice extent on a sphere against a black background. The image resembled a picture taken by a distant observer in outer space. By now we have many such pictures, but there are a few that have been culturally more influential than others. The still most famous picture of the Earth is the AS17-148-22727, or the original Blue Marble. It was taken by chance on the Apollo 17 mission in 1972 with a Hasselblad camera but very soon acquired great status. As Robert Pool and Denis Cosgrove have argued, the Blue Marble illustrated like few other photographs that the most important outcomes of the journeys to the moon were new ways of looking at the Earth.[6] Not only did the image convey a fragile sphere in hostile dark space, but the orientation of the picture, with Africa in the center and the Old World hardly visible, showed forcefully that there is indeed no center on a sphere—it is a matter of perspective and an argument in a more global framing of the human condition.

Looking again at the two images illustrating the sea-ice minimum we might deduce that the one from ESA was indeed close to data and transparent for the reader, and therefore convincing. However, the one from NASA did a quite different job of placing the Arctic on the three-dimensional globe and thereby making the periphery more central. If the message was that shrinking sea ice is a global problem, that was an easier conclusion for the reader of the NASA image to reach.

A moral story/the moral of the story

News media are indispensable to the construction of public understanding regarding the relationship between human life and the natural and built environment. In spite of recent debates on the linkages between volume of coverage and individual-public understanding towards particular issues, it is reasonable to suggest that the media matter a great deal for how society understands climate change today, including its multiple social and cultural dimensions. However, important ethical and moral dimensions, especially those that include responsibility for the future—rather than value-neutralism—have appeared to be missing, particularly in the US media. There are many reasons for this. First, global climate change as a scientific concept has for long been too abstract and complex for the purposes of news-making. Journalists prefer "morality plays" with clear and concrete winners and losers, rights and wrongs. Second, and as we discussed earlier, journalistic norms of balance, truth and objectivity have been impediments to capturing the scientific discussions accurately. Finally, a concept such as climate change makes for a better media story if it involves controversy (i.e. drama). In the absence of concrete story elements that can portray the moral dilemmas of climate change, the rights and wrongs have become projected onto the practice of science.

Environmental disasters in the late 1980s provided dramatic moments for the media to generate alarmist discourses raising questions about the linkages between such events and global warming/climate change. Morality was also apparent in the coverage of climate

6 Robert Poole, *Earthrise: How Man First Saw the Earth* (New Haven, CT: Yale University Press, 2008); Denis Cosgrove, "Contested Global Visions: One World, Whole Earth, and the Apollo Space Photographs," *Annals of the Association of American Geographers* 84, no. 2 (1994): 270–294.

politics. For example, reporting on international protocols such as Kyoto involved casting of key political figures and heads of states such as Bush along the lines of "good guys" versus "bad guys."

The visible impacts of climate change in connection with the 2007 sea-ice minimum provided a new moral dimension, one that went beyond local disasters and challenged previous perceptions of our planet as being ultimately resilient and impervious to human damage. Parallels could be drawn with the discovery of the ozone hole over Antarctica in the mid-1980s, which shattered the old conviction that human pollution was irrelevant on the global scale. It may be going too far to claim that Arctic sea-ice minima instigated a moral turn, on the whole, in the international news coverage of climate change. Yet, it clearly provided that concreteness and high-drama moments that the media crave, including the tragic sublime embodied in the form of giant chunks of ice crumbling into the sea and starving polar bears left with nothing but a piece of ice to float on. Combined with clear messages from the IPCC and the scientific community that Arctic change was a testimony to human impact on the global climate, it became easier for journalists to cover both the local and global dimensions of climate change—including the high social, cultural and economic stakes—which had been largely missing from the stories published throughout the 1980s and 1990s. Climate change could simply no longer be regarded as a mere question of datasets and scientific turf wars. The multi-topical dimensions of global climate change, ranging from energy, food and health to local communities and farmland and to vulnerable populations and need for adaptation, had become all too apparent.[7] Similarly, the impacts on Arctic landscapes and people documented in the Arctic Climate Impact Assessment from 2005, and the rapidly declining Arctic sea ice charted in 2007 also played a significant role. Covering this multiplicity and its corresponding geographic consequences necessitated dedicating human resources such as reporters and commentators capable of dealing with such scientific, political and economic complexity. As evinced by the media coverage, quality press (as well as small media and local groups) responded to this challenge. More voices could be heard, including voices of those directly affected by climate change, not least in the Arctic, resulting in increasing attention to the ethical dimension of climate change. Some of those voices gained power from the increasing scientific attention to Arctic climate change.[8]

The general trend of peaks and dips in the overall coverage of climate change continues, with the issue almost falling off the map in the United States in 2010. While such shrinkage in volume is no small feat and has significant implications for issue-visibility in the public domain, online media and alternative platforms have also become increasingly important to the public for access to information. In qualitative terms, news media have improved their reporting on the issue with environmental journalists particularly grasping and conveying the significance of climatic change. This should give us hope. Future studies will reveal how the media story of the Arctic is being told.

Whether the moral trend will be sustained and effective (despite routine drops in media attention) and how it links with civic action and political intervention remains to be seen.

[7] S. Solomon, D. Qin, M. Manning, Z. Chen, M. Marquis, K.B. Averyt, M. Tignor and H.L. Miller, eds, *Contribution of Working Group I to the Fourth Assessment Report of the Intergovernmental Panel on Climate Change* (Cambridge, United Kingdom and New York, USA: Cambridge University Press, 2007).

[8] Annika E. Nilsson, "A Changing Arctic Climate: Science and Policy in the Arctic Climate Impact Assessment," in *Climate Governance in the Arctic*, ed. Tim Koivurova and Nigel Bankes. (New York: Springer, 2009), 77–95.

31
DISPLAYING THE ANTHROPOCENE IN AND BEYOND MUSEUMS

Libby Robin, Dag Avango, Luke Keogh, Nina Möllers and Helmuth Trischler

As global warming and climate change affect communities in different ways, museums become places for personal reflection on the future of the planet. The public is thirsty for clear information and nuanced discussions on environmental change at both local and global scales, but there are few opportunities for serious conversations about these issues that include diverse audiences. Museums focus on the material world: objects, artworks and historical collections. Such materiality can be helpful in environmental discussions, which are often abstract and filled with modeling that is beyond the mathematical literacy of the general public. Objects speak directly to people of all ages.[1]

This chapter explores some of the ways museums have engaged with the ideas of the Anthropocene and how the display of objects and cultural heritage can help foster conversations in times of rapid environmental change. The way the planet works is often explained through complex science and technical language. The "fast and furious" commercial media that Christensen and Wormbs explored in the previous chapter, snatch simplistic sound bites and images from all over the globe without context. Through museums of all sorts, it is possible to sponsor a "third way," something neither too technical nor too simplistic, which is suitable for the interested general public. The exhibition is a form of *slow media*; and the museum can be a secular cathedral or forum for thoughtful reflection.[2] By analogy with the slow food movement, the slow medium of a museum gallery offers room to explore the complexities of a rapidly changing world on a personal scale. The very pace of a museum visit and the process of engaging with physical objects and artwork is itself helpful in coping with the stress of accelerating change in the twenty-first century, a "no analogue" time, when we have moved beyond the conditions of the Holocene, the geological epoch of the last 10,000 years.[3] Change has become so widespread that a new geological epoch, the

1 Jane Bennett, *The Enchantment of Modernity: Crossings, Energetics, and Ethics* (Princeton, NJ: Princeton University Press 2001); Jane Bennett, *Vibrant Matter: A Political Ecology of Things*, (Durham, NC: Duke University Press, 2010). Parts of this chapter appeared in Libby Robin *et al.* "Three Galleries of the Anthropocene," *The Anthropocene Review* 1(3) (2014): 207–224.
2 S. David, J. Blumtritt and B. Köhler, *The Slow Media Manifesto.* (2010) Online: http://en.slow-media.net/manifesto

Anthropocene, has been proposed.[4] Time spent with well-chosen displays, perhaps enhanced by casual companionship with other visitors in that gallery space, can give people room to respond to a spectacle where they can "reshape media content as they personalize it for their own use."[5]

The big narrative of the Anthropocene is that human activities are shaping the way the planet works. The geological concept held immediate appeal for global change scientists more broadly: oceanographers, glaciologists, environmental physicists, soil scientists and earth scientists were all discovering patterns of unprecedented change in their respective long-term data sets.[6] The *metaphor* of the Anthropocene has also proved attractive to artists and humanists, who explore how people respond emotionally to our changing Earth.[7]

There are debates about when the Anthropocene began: was it the agricultural revolution, the Industrial Revolution, the atomic bomb or even the Stone Age that made humans a planetary force that can be read in the rocks in the deep future?[8] Whichever origin story they prefer, most proponents agree that there has been an acceleration of change from the 1950s onwards, the "Great Acceleration," called by some the "second stage" of the Anthropocene. The 1950s may even be designated the "first stage" by the International Stratigraphic Commission, as they need to identify *material* change in the lithosphere (rocks) to mark and adopt formally a new stratigraphic epoch.[9] Such change may be provided by the nuclear signatures in soils and sediments from the Atomic Age around 1950.

Museums are also concerned with the material world: they have collections and galleries that explore the meaning of objects. This chapter explores some possibilities for using a museum context to help understand and critique the ideas put forward as the Anthropocene. A museum gallery offers audiences concrete ways to think about this concept, which is abstract in both space and time. In the exhibitions and displays documented here, the Anthropocene idea has moved beyond stratigraphy and natural science, and considers the moral and ethical context for global dynamic change.

3 Will Steffen *et al.*, "The Trajectory of the Anthropocene: The Great Acceleration," *The Anthropocene Review* 2(1) (2015): 1–18, note that the Holocene is the time when most present world civilizations emerged.
4 Paul J. Crutzen, "Geology of Mankind," *Nature*, no. 415(2002): 23; Paul J. Crutzen, and Eugene F. Stoermer "The 'Anthropocene'" *Global Change Newsletter* 41(2000): 17–18.
5 Anders Ekström *et al.*, *History of Participatory Media 1750–2000* (London: Routledge, 2011): 1.
6 Jan Zalasiewicz *et al.*, "Are We Now Living in the Anthropocene?" *GSA Today (Journal of the Geological Society of America)* 18, no. 2 (2008): 4–8; Jan Zalasiewicz *et al.*, "The Anthropocene: A New Epoch of Geological Time?" *Philosophical Transactions of the Royal Society A* 369. (2011): 835–841; Jan Zalasiewicz, and Mark Williams, "The Anthropocene: a comparison with the Ordovician–Silurian boundary," *Rendiconti Lincei: Scienze Fisiche e Naturali*, (2013); Jan Zalasiewicz, *et al.*, "When did the Anthropocene begin? A mid-twentieth century boundary level is stratigraphically optimal," *Quaternary International* (online 12 January) (2015).
7 Brendon Larson, *Metaphors for Environmental Sustainability: Redefining our Relationship with Nature* (New Haven, CT: Yale University Press, 2011); Whitney J. Autin and John M. Holbrook, "Is the Anthropocene an Issue of Stratigraphy or Pop Culture?" *GSA Today* 22, no. 7 (2012): 60–61.
8 Libby Robin, "Histories for Changing Times: Entering the Anthropocene?," *Australian Historical Studies*, 44(3) (2013): 329–340; Jed O. Kaplan, *et al.*, "Holocene Carbon Emissions as a Result of Anthropogenic Land Cover Change," *The Holocene* 21, no. 5 (2011): 775–791; Crutzen, 2002; Joseph Masco, "Bad Weather: On Planetary Crisis," *Social Studies of Science* 40, no.1 (2010): 7–40; C.E. Doughty, "Preindustrial Human Impacts on Global and Regional Environment," *Annual Review of Environment and Resources* 38 (2013): 503–527.
9 Zalasiewicz and Williams, 2013; Zalasiewicz *et al.*, 2015; Steffen *et al.*, 2015; Will Steffen *et al.*, "The Anthropocene: From Global Change to Planetary Stewardship," *Ambio*, 40(7) (2011): 739–761.

We first consider the 2014–2016 exhibition "*Welcome to the Anthropocene: The Earth in Our Hands*" [*Willkommen im Anthropozän: Unsere Verantwortung für die Zukunft der Erde*] hosted by the Deutsches Museum in Munich, a traditional science and technology museum, the first major exhibition on this subject in the world. Then we turn to the north and consider the Anthropocene as a whole landscape spectacle of *in situ* industrial heritage in Svalbard. This is not so much an exhibition but a place that has been transformed slowly over a century or more and is now an attraction for climate-change science and heritage tourism. Here the objects of a hybridized local landscape promote reflections on the Anthropocene, a quasi-museum, but also a tourist site because of the changing sensibilities of our times.

A museum for the Anthropocene?

How did the Deutsches Museum in Munich become the host for the first large-scale special exhibition solely dedicated to the Anthropocene? Of primary importance were the objects and collections of the world's largest science and technology museum, which provided suitable real display items for explaining the technical and scientific dimensions of climate change and other biophysical changes at the end of the Holocene. It harbours technical measuring devices that can measure in nanoseconds and in eons, and at micro and macro-scales in air, water and earth. But a good exhibition also needs stories and a human touch, and here its important partnership with the Rachel Carson Center for Environment and

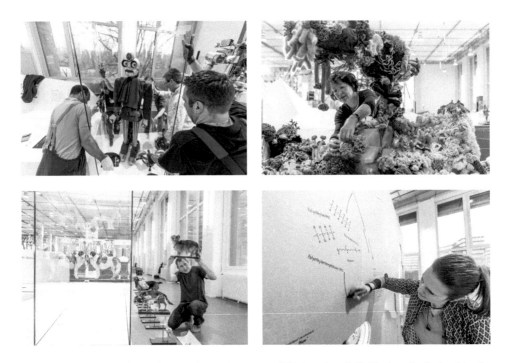

Figure 31.1 Installing the *Welcome to the Anthropocene* exhibition. (top left) Placing the "robot" in the *Humans and Machines* exhibit. (top right) Curating the crochet coral reef, *Evolution*. (bottom left) Lining up the dogs, *Evolution*. (bottom right) Calligrapher creating the wall. Deutsches Museum, 2014. Photos: Axel Griesch. See Plate 37.

Society (RCC), an international research center of environment and society came into play.[10] The scholarly partnership between the RCC and the Deutsches Museum proved a way to deliver research stories to diverse public audiences.

The Deutsches Museum was founded to promote the principles of science and engineering in the early twentieth century. German engineers sought social acknowledgment for their creativity and innovation, reinforcing their role in steering and planning a new modern society.[11] It opened permanent galleries on "Museum Island" (by quirk, formerly "Coal Island') in the Isar River in central Munich in 1925. Its galleries presented progressive histories of scientific and technological development, starting with older, simpler versions and ending with the newest and most "advanced" technology. The successive lines of objects in the exhibitions reinforced a message of linear advancement, the progressive view typical of engineering at that time. The museum drew on traditional basic sciences and industry support. Exhibitions ranged from large engineering installations and stories of transportation to the innovative design in household appliances. Neither the environment nor the social context of the new technologies was included in such exhibits. Nature was not a subject of its inquiry or display.

Over the century, the Deutsches Museum has "greened" and now includes a range of exhibitions and collections including those that engage with environmental issues and other aspects of technology in society. In 1992, the year of the United Nations Conference on the Environment at Rio, the Deutsches Museum opened a gallery *Environment [Umwelt]*. Following the museum's original mission to trace "development," the new notion of *sustainable development* inspired a gallery that took in very different ideas, including population growth, fossil-fuel use, the hole in the ozone layer, recycling, and water and air pollution. In general, this exhibition relied not so much on the objects of the collections of the history of technology, but on models, texts and images for its storylines. The environment was framed as a story of decline with technical innovations offering alternative pathways towards a more sustainable future.

Each of the themes in *Environment* was presented through objects, images, text and media installations that conveyed a message that through harnessing technology, humans have caused problems, but also that new and emerging technologies might offer solutions. By making *causation* the focus, instruments used to analyse and measure the environment became its objects. The exhibition was otherwise carried by images and text, which was reworked in 1998 and moved to a different place within the museum, but the basic storyline reflected the museum's approach to the environment. *Environment* still stands at the time of writing (2015).

Triggered by scientific findings and public discussion on climate change resulting particularly from the IPCC reports, the Deutsches Museum presented a special exhibition on *Climate: The Experiment with the Planet Earth* in 2002. This dealt mostly with the scientific background on climate change. Sub-themes included worldwide networks for measuring

10 Luke Keogh and Nina Möllers, "Pushing Boundaries – Curating the Anthropocene at the Deutsches Museum," in Fiona Cameron and Brett Neilson (eds), *Climate Change and Museum Futures*, Routledge Research in Museum Studies (New York: Routledge, 2015), 78–89.
11 Wilhelm Füssl, The Deutsches Museum and Its History. In Wolfgang M. Heckl (ed.), *Technology in a Changing World: The Collections of the Deutsches Museum*, tr. Hugh Casement and Jim O'Meara (München: Deutsches Museum, 2010): xv.

and gathering data, meteorology, historical technological ideas for influencing climate and natural catastrophes resulting from climate change. The exhibition also included a historical review of human reactions to climate variability in the past and present. The underlying idea was that nature and technology could no longer be viewed separately, but were interdependent:

> Weather and climate, one might think, are not suitable topics for a museum of technology, as they concern nature. ... Nature and culture, however, may no longer to be neatly separated from each other, which is why the prominent symbol of technological culture, the steam engine, is chosen as the opening of this climate exhibition in the museum of technology.[12]

A new philosophy for *Welcome to the Anthropocene*

Climate change, more than any other issue before it, brought into sharp focus the ability of the human species to influence planetary systems as a whole, but this is only one of many anthropogenic changes affecting the Earth's systems in the twenty-first century. As well as the carbon cycle, humans have significantly altered the nitrogen, phosphorous and sulfur cycles, changing sediment movement and water vapor flow from land to atmosphere (through landcover change). There has been a Great Acceleration of global changes, both physical and social, since around 1950.[13] For example, population, wealth and energy usage have all risen exponentially in this period. Financial and business institutions have become globalized, and so have people, who move faster and more often around the world. Some say that humanity is driving the sixth major extinction event in Earth's history.[14]

Humanities scholars have cautioned that an overarching concept such as Anthropocene, with its scientific basis, lacks cultural diversity and might even reinforce regimes of power and capital that have brought us to this point. The Deutsches Museum recognized that cultural diversity provides an important creative friction in a globalized world and that a museum was well positioned to display this.[15] The museum exhibition constantly critiqued the "we": might a species-level understanding of humanity downplay the challenges of environmental justice, where the fossil-fuel-prints of the few drive adverse changes for the many?[16] Finding material representation for unequal consumption patterns and the distribution of resources and wealth was by no means easy, but was a priority for the exhibition team.

12　Walter Hauser, ed. *Klima – Das Experiment mit dem Planeten Erde* (English translation NM) (München: Deutsches Museum, 2002): 9.
13　Steffen *et al.*, "Trajectory of the Anthropocene."
14　A.D. Barnosky *et al.*, "Has the Earth's Sixth Mass Extinction Already Arrived?" *Nature* 471 (2011): 51–57.
15　Anna Lowenhaupt Tsing, *Friction: An Ethnography of Global Connection.* (Princeton, NJ: Princeton University Press, 2005); x. Andrea Witcomb, "Migration, Social Cohesion and Cultural Diversity: Can Museums move beyond Pluralism?," *Humanities Research*, XV(2) (2009): 49–66; Nigel Clark, *Inhuman Nature: Sociable Life on a Dynamic Planet* (London: Sage, 2011); Sabine Wilke, "Anthropocene Poetics: Ethics and Aesthetics in a New Geological," *Rachel Carson Center Perspectives* 3 (2013): 67–74; Andreas Malm and Alf Hornborg, "The Geology of Mankind? A Critique of the Anthropocene Narrative," *The Anthropocene Review* 1 (2014): 62–69.
16　Rob Nixon, *Slow Violence and the Environmentalism of the Poor* (Cambridge, MA: Harvard University Press, 2011); Wade Davis, "The Naked Geography of Hope: Death and Life in the Ethnosphere," *Whole Earth,* Spring (2002): 57–61; Gaston Gordillo, "Ships Stranded in the Forest," *Current Anthropology* 52 (2011): 141–167.

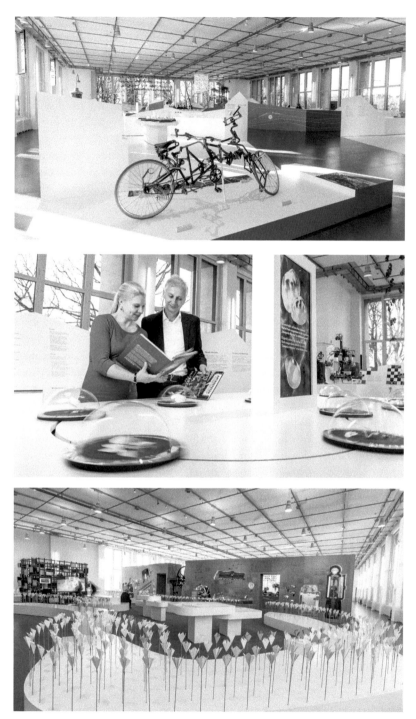

Figure 31.2 Three dimensions of the *Welcome to the Anthropocene* exhibition. (top to bottom) Artistic interpretation: Victor Sonna's recycled art bike "Guernica," *Cities exhibit*. Publications: Catalogue and graphic novel, with curators Nina Möllers and Helmuth Trischler. Participation: *Field of Daisies*, 2014. Deutsches Museum. Photos: Axel Griesch. See Plate 38.

Accepting that humans have fundamentally altered the way natural systems work and have shaped global climate change closes the bifurcation between the natural and the cultural: in the Anthropocene natural and cultural systems are interdependent. As chemists Will Steffen and Paul Crutzen and historian John McNeill noted: "Humanity is, in one way or another, becoming a self-conscious, active agent in the operation of its own life support system."[17] This new period also reshapes our understanding of humanity, as historian Dipesh Chakrabarty notes: "To call human beings geological agents is to scale up our imagination of the human."[18]

Drawing on insights from a wide range of scholarly disciplines, the members of the Deutsches Museum exhibition team decided to use the concept of an "usworld" (translated from the German *Unswelt*) advocated by the geologist Reinhold Leinfelder.[19] Such a notion of "us" makes it difficult to separate nature and culture, and forces thinking with a hybrid nature-culture world. An *usworld* challenges how we know ourselves. Although as a species we have become a geological force, as individuals we are pro-active actors on this stage. The Anthropocene is not just about irreversible environmental changes, it is also a historical phenomenon. Anthropocene changes have accelerated over a period that showcases many of the great innovations and thinking about human freedom. The usworld approach blends nature, culture, technology and society into a single hybridized perspective, an Anthropocene imaginary, compatible with the original mission of the Deutsches Museum and also with the expectations of its twenty-first century visitors.

As literary theorist Sabine Wilke has argued, a critical Anthropocene approach must engage with frameworks and insights from postcolonial theory and environmental justice and continuously expose the ideological underpinnings of the Anthropocene narrative as it develops.[20] Just as surely as "data" are added from the physical sciences, insights about meaning, value, responsibility and purpose structure this new epoch.[21] The geological time depth of the Anthropocene can provoke new scales for imagining the material conditions of human life: it brings Big History to this history museum.[22] Elizabeth Ellsworth and Jamie Kruse work with a group of artists and scholars to explore the geologic in contemporary life, unpacking the "geological turn" and human responses to it. Inspired by the work of Jane Bennett, they use materiality – the Earth's surface itself – to:

> recalibrate infrastructures, communities, and imaginations to a new scale – the scale of deep time, force, and materiality. …[W]e are not simply "surrounded" by the geologic. We do not simply observe it as a landscape or panorama. We inhabit the geologic.[23]

17 Will Steffen, Paul J. Crutzen and John R. McNeill, "The Anthropocene: Are Humans Now Overwhelming the Great Forces of Nature," *Ambio* 36, no. 8 (2007): 614–621; quote 619.
18 Dipesh Chakrabarty, "The Climate of History: Four Theses," *Critical Inquiry* 35 (2009): 197–222; quote: 206.
19 Reinhold Leinfelder, Christian Schwägerl, Nina Möllers, and Helmuth Trischler, "Die menschengemachte Erde: Das Anthropozän sprengt die Grenzen von Natur, Kultur und Technik," *Kultur und Technik* 2 (2012): 12–17.
20 Wilke, "Anthropocene Poetics."
21 Elizabeth DeLoughrey, Jill Didur and Anthony Carrigan (eds), *Global Ecologies and the Environmental Humanities: Postcolonial Approaches* (London: Routledge, 2015).
22 David Christian, "A Single Historical Continuum," *Cliodynamics* 2 (2011): 6–26.
23 Elizabeth Ellsworth and Jamie Kruse, "Evidence: Making a Geological Turn in Cultural Awareness," *Making the Geological Now: Responses to the Material Conditions of Contemporary Life*, ed. Elizabeth Ellsworth and Jamie Kruse (Brooklyn: Punctum, 2013), 25; see also Bronislaw Szerszynski, "The End of the End of Nature: The Anthropocene and the Fate of the Human," *Oxford Literary Review* 34, no. 2 (2012): 165–184.

Since we inhabit the geologic, then the gallery of the Anthropocene aspires to place people in their own strata.

Practicalities

Welcome to the Anthropocene: The Earth in Our Hands,[24] opened to the public on 5 December 2014. It displays the effects of humanity as a biological and geological actor and the extent of planetary changes in the three-dimensional space of a gallery, so that the visitor actually *experiences* the Anthropocene, while learning about the current state of scientific knowledge and debate. The Anthropocene here is a complex and often ambivalent story of destruction and re-shaping, threaded through feedback loops; nature and culture is an integrated and hybrid system. Practical examples include an installation about the spread of invasive species and how they remake ecosystems, and an experiential section that deliberately disrupts preconceived ideas about what constitutes "nature."

The curators instigated an internal survey to find out what their audience already knew about the Anthropocene, and to get a sense of how to "pitch" the text-based panels. They drew on the views of over 100 patrons in a two-month period in late 2012. While 80 percent of those interviewed supported the idea that the museum should engage with "controversial topics," an even greater number (86 percent) had not previously heard of the Anthropocene. Many were interested in the environment, and saw the impacts of industry as bad for the environment; almost half of the patrons said that industry could not solve environmental problems.[25]

Informed by the survey, the curators "pitched" the Anthropocene as a holistic, systemic, and reflective concept, enabling the inclusion of a range of global-scale environmental problems in an open-ended format that enabled visitors to engage actively. The Anthropocene brands the exhibition and also frames the responses of the visitors.

The exhibition covers 1,450 square meters (ca. 15,600 square feet) and is structured in three parts. The first section provides a comprehensive introduction into the Anthropocene both as a geological hypothesis and new conceptual framework. The introduction includes a range of technological objects that highlight the eras of industrialization (from the late 1800s, building on Paul Crutzen's narrative of the origins of the Anthropocene) and the Great Acceleration from the 1950s. The second part of the exhibition consists of six thematic areas, islands that are jig-saw fragments of a whole, which present selected phenomena of the Anthropocene. They explore systemic connections, global and local interdependencies, and temporal dimensions. The themes covered are urbanization, mobility, nutrition, evolution, human-machine interaction and "nature." Connecting these themes is a geological layer of materiality that embeds visitors in the *strata* of their creation. The third and final part of the exhibition discusses the future in the Anthropocene. It looks at past visions of the future, emphasizing their transformative potential while simultaneously highlighting their fragility and ambivalence. It then discusses possible scenarios of the future for people to consider in a more relaxing space; the final installation invites people to listen to possible scenarios and

24 German title, "Willkommen im Anthropozän: Unsere Verantwortung für die Zukunft der Erde."
25 Henrike Bäuerlein and Sarah Förg, "Vorab-Evaluation zur Sonderausstellung, Anthropozän – Natur und Technik im Menschenzeitalter," August–September, Internal Report (Munich: Deutsches Museum, 2012).

to plant their own possible scenario in an evolving field of paper daisies (Figure 31.2). Thus, each individual visitor has the opportunity to offer a personal reflection on their aspirations for the Anthropocene.

As an epoch, the Anthropocene encompasses the entire globe throughout Earth history. As a new epoch and a philosophical framework, it weaves connections between many disparate phenomena, often previously unconnected. The challenge for a museum is to research, shape and represent the Anthropocene epoch even as it unfolds. While exhibitions are always selective representations of specific interpretations of our world, the uncertainty that surrounds the Anthropocene challenges traditional perceptions of museums as authorities and mediators of knowledge, and demands space for raising questions and reflecting on uncertainty. Museums of science and technology, like the Deutsches Museum, can no longer represent themselves as mere purveyors of authentic knowledge. *Welcome to the Anthropocene* created a space – literally and figuratively – for free thinking, discussion and imagining a new concept, drawing on abstract and academic ideas and creating ways for the public to participate.

Traditional museum objects were not easy to incorporate in such an exhibition. When it came to pinpointing the stories and finding an "Anthropocene moment" (or even origin story), it became messy. In the end, the curators elected to live with the complex messiness and concentrate rather on the networks, systems of interconnections and chaos. Since the world in the Anthropocene is no longer ordered, the exhibition explored the navigation of chaos. In translating the Anthropocene into a three-dimensional gallery, the exhibition explored the systems of the Anthropocene and their interrelationships and feedbacks. An exhibition space affords visitors multi-perspective and nonlinear opportunities: they make their own paths, touring where they want to, forming their own experiences, and coming up with different interpretations. Part of the idea of the landscape of paper flowers folded by individuals was to capture the diversity of visitor experience.

The gallery was not only based on intense research provided by the curatorial team and the Rachel Carson Center which resulted in various publications.[26] It also became a springboard for follow-up projects. One of these projects resulted in a cabinet-like exhibition added to the gallery: the *Cabinet of Curiosities for the Anthropocene*, which opened in July 2015. Based on a collaboration with the Center for Culture, History and Environment at the University of Madison-Wisconsin and the Environmental Humanities Lab at the KTH Royal Institute of Technology in Stockholm, scholars and artists were invited to an Anthropocene slam to suggest objects with the aim to create the cabinet of curiosities.[27] The outcome of the slam was then "translated" into the cabinet which combines exhibits on wondrous and curious relics with films and sound bites to display the different forces that shape relationships between environment and society.

26 Foremost the catalogue: Nina Möllers, Christian Schwägerl, and Helmuth Trischler (eds), *Welcome to the Anthropocene. The Earth in Our Hands* (Munich: Deutsches Museum, 2015); see also e.g. the graphic novel: Alexandra Hamann, Reinhold Leinfelder, Helmuth Trischler, and Henning Wagenbreth (eds), *Anthropozän. 30 Meilensteine auf dem Weg in ein neues Erdzeitalter* (Munich: Deutsches Museum, 2014).

27 For documentation of the Slam see http://nelson.wisc.edu/che/anthroslam/, and Robert Emmett and Gregg Mitman (eds.), *Environmental Futures* (Oxford: Oxford University Press, forthcoming).

Anthropocene in museums **261**

Figure 31.3 Various elements of the *Welcome to the Anthropocene* exhibition. (top left) Engine block inside object shelf. (top right) Brussels sprout growing in shopping trolley. (bottom left) The digital media cube. (bottom right) Planting a tree. Deutsches Museum, 2014. Photos: Axel Griesch. See Plate 39.

Pyramiden, industrial heritage and the new tourism of climate change

Moving beyond museum walls to the "spectacle,"[28] we now consider the Anthropocene *in situ* at Pyramiden, a coal-mining settlement within the Arctic Circle, recently refashioned for climate-change science and polar tourism. This is a museum without walls, a gallery on a landscape scale that provokes thought about the Anthropocene at the extremes of the inhabited world.

Background

In the high latitudes of the Arctic, one degree of global warming makes for greater and faster changes than at temperate latitudes. The "polar effect" has fueled climate-change tourism, with people anxious to see glaciers "before they melt" and extreme environments remote

28 Anders Ekström, *et al.*, *History of Participatory Media 1750–2000*. (London: Routledge, 2011).

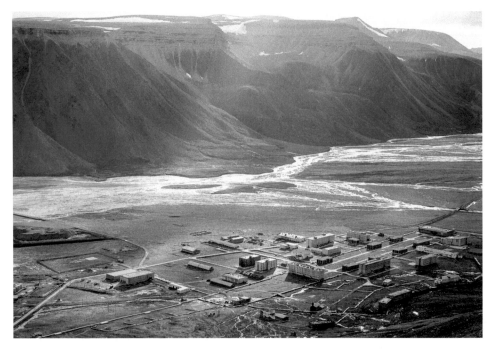

Figure 31.4 Pyramiden: a coal-mining town within the Arctic Circle, 2012. Photo: Dag Avango. See Plate 40.

from people, yet disproportionately affected by their activities. The Ilulissat Glacier in Greenland, for example, has become an iconic place for visiting American politicians, a place that signifies "climate change" as surely as an image of a polar bear on a sea-ice floe. The United States and other members of the Arctic council wish to mitigate the consequences of climate change in the Arctic, protect the environment and support climate science. At the same time, however, they want to protect their traditional interests in resources and sovereignty there.[29] At Svalbard, Russian and Norwegian actors combine these seemingly contradicting policy goals, by transforming coal mines into industrial heritage sites. Could abandoned Arctic resource extraction sites become resources for a more sustainable economy in the Arctic, based on tourism?

Norwegian and Russian companies started coal mining at Svalbard (also called Spitsbergen) in the early twentieth century. At this time the energy extraction boom drove an international debate about the legal status of Svalbard itself. The archipelago had been recognized as an international space – an unoccupied "no-man's land" – until it emerged as potentially profitable. Promised wealth from the primary energy source of the industrialized

29 See for example Norwegian Ministry of Foreign Affairs, "The High North. Visions and Strategies. Meld," St. 7 (2011–2012) (Oslo: Norwegian Ministry of Foreign Affairs, 2011); Norwegian Ministry of Justice, Stortingsmelding Nr. 22 (2008–2009) Svalbard. (Oslo: Norwegian Ministry of Justice, 2009); Vladimir Putin (Approved 20 February 2013), "Development Strategy of the Arctic Zone of the Russian Federation and National Security until 2020" (Unofficial translation (2013) by the Embassy of the Russian Federation at Stockholm).

world at the time – coal – increased interest (particularly among northern states) in staking a nationalist claim for influence in this windy, cold and remote territory. Norway first demanded sovereignty, but was opposed by Sweden and Russia because of their respective economic and political interests. The coal mines became part of this conflict, not just because of the resources, but also because these nations could use their existing mines as "effective occupation," a precursor to claiming sovereignty.[30]

Pyramiden was established initially by a Swedish company that built a few huts there in 1910, with a plan to supply coal to the Swedish steel industry, and support nationalist interest in Spitsbergen, aiming to block Norway's claim to sovereignty. In the end, the mining town was not built and in 1920, Norway was granted sovereignty over Svalbard (Spitsbergen) through a treaty. In the following years, the world economy slumped, and most companies left Svalbard, Pyramiden's Swedish founders. The huts were abandoned.

In the years that followed, the extraction of energy resources became a project of Norwegian and Soviet nationalist interest. The only remaining coal mines at Svalbard were run by state-supported companies. The Norwegians wanted to maintain their sovereignty by effective occupation, and the Norwegian economy could use the energy. The Soviet Union was first and foremost interested in it because the rapidly industrializing Murmansk region needed coal, which in turn made this part of the Arctic of strategic importance for the Soviet Union.[31] Each operated several mining towns on Svalbard at this time, including Pyramiden, which the Soviet Union had bought from its Swedish owners in 1927. The Soviet company Trust Arktikugol developed an elaborate mining settlement, soon the most splendid on Svalbard. The new owners brought their settlement housing materials and elegant and ambitious architectural designs. There was nothing comparable among Norwegian mining settlements in Svalbard until the 1980s. The settlement at Pyramiden from the 1960s was more than an extraction site for energy resources; it was a signal of strong Soviet intentions for Svalbard.[32]

When the Soviet Union fell, the new Russian government had little interest in Pyramiden. Trust Arktikugol had closed down the town in 1998. Over the following years, the settlement infrastructure slowly deteriorated, becoming a victim of melt water and looters.

At the same time, an increasing number of Norwegians came to question the Svalbard coal-mining industry, because the mines were unprofitable and hard to rationalize with Norway's own policy for protecting the environment at Svalbard or its international status as a leader in environmental thinking. In 2001, the Norwegian government passed a new environmental law, limiting the possibilities for mining in Svalbard. Meanwhile the last Russian mine operating in Svalbard, Barentsburg, was running out of coal. The Trust Arktikugol saw two possibilities: either to open another town to mine coal, or instead to repurpose the existing mining towns. Since any plan for a new coal venture would contravene

30 Dag Avango, *Sveagruvan: Svensk Gruvhantering mellan Industri, Diplomati och Geovetenskap* (Stockholm: Jernkontoret 2005); Dag Avango and Sander Solnes, Registrering av kulturminner i Pyramiden. Registrering utfört på oppdrag fra Sysselmannen på Svalbard (Longyearbyen: Governor of Svalbard, 2013); Roald Berg, *Norsk utenrikspolitikks historie. Norge på egen hånd 1905–1920*. Bd 2 (Oslo: Universitetsforlaget 1995).
31 Dag Avango, Louwrens Hacquebord and Urban Wråkberg, "Industrial Extraction of Arctic Natural Resources since the Sixteenth Century: Technoscience and Geo-Economics in the History of Northern Whaling and Mining," *Journal of Historical Geography* 44 (2014): 15–30.
32 Norwegian Commissioner of Mines, unpublished reports 1934–1966.

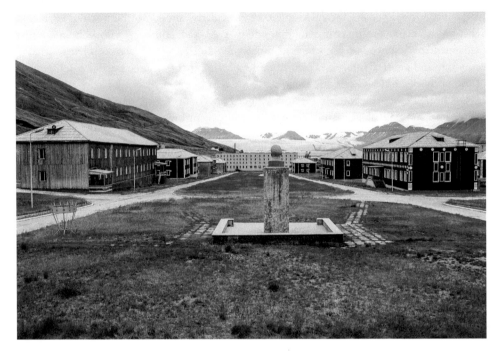

Figure 31.5 Ukraine grass planted in Pyramiden, 2012. Photo: Dag Avango.

new Norwegian environmental regulations, new towns were out.[33] Instead, the Trust Arktikugol moved to re-develop their coal-mining settlements into hubs for Arctic tourism, conservation and science.

The Russian state restarted its activities at Pyramiden around 2010. In cooperation with the governor of Svalbard, the Trust Arktikugol carefully renovated parts of the settlement and in the spring of 2013, it reopened the hotel. The company promoted Pyramiden as an industrial heritage site with a unique Soviet character.

Pyramiden's facelift also opened a window of opportunity to the Norwegian authorities. During the Cold War years, the Norwegian governors of Svalbard had held back from intervening in Russian activities on Svalbard, but now Norway was free to demand that the Trust Arktikugol abide by Norwegian laws in Svalbard.[34] Norwegian regulations require companies to protect buildings and material remains that are older than 1946 as "cultural heritage."

The Norwegian governor responded to Russia's new concept for Pyramiden by calling on the Trust Arktikugol to make an area plan. The company contracted a Norwegian firm to do this, whilst the governor enrolled heritage professionals (including one of us DA) to identify structures that should be protected as heritage. Based on the November 2013 report, parts of Pyramiden were declared "cultural heritage." This Soviet industrial town thus became a heritage site protected under Norwegian law.[35]

33 Åtland and Pedersen, 2008.
34 Jörgen Holten Jörgensen, *Russisk svalbardpolitikk. Svalbard sett fra andre siden* (Trondheim: Tapir akademisk forlag 2010).
35 Irene Skauen Sandodden, [unpublished] Plan for arkeologiske registreringen i Pyramiden planområden (June 28, 2013, Governor of Svalbard archive, Longyearbyen); Avango and Solnes, *Registrering av kulturminner.*

The leading Norwegian mining company on the archipelago (SNSK) had for a number of years developed plans to establish a museum and a "knowledge center" in one of its abandoned mines near the Norwegian administrative capital Longyearbyen, as a "Corporate Social Responsibility," giving something back to the mining community on which the company has been dependent.[36] For the company there were also other strategic values in re-using abandoned mines as heritage and for museum exhibitions. At a time when public opinion and politicians in mainland Norway question the value of SNKS's mining operations, the company turned to history to emphasize its role in maintaining Svalbard as a part of Norway.

The abandoned coal mines at Svalbard are evocative remains of former and contemporary boom and bust cycles of Arctic extraction, motivated by resource needs, quick profits and geopolitical interests, a fossil-fuel landscape which is refashioned to serve new futures in the Arctic, including tourism. Re-using the settlement suits both Norwegian and Russian Arctic policy makers. The interested parties can see how these places enable them to continue to control resource use, to maintain influence or sovereignty and to protect the environment. Supporting science, particularly climate science, in this far northerly place is itself a sustainable development for both nations.

By defining abandoned mining sites such as Pyramiden as industrial heritage, and bases for climate-change science and polar tourism, both Norway and Russia can showcase their global environmental and cultural credentials, while keeping a close eye on a region that is increasingly strategically important as the climate warms and the Arctic sea ice melts. Visitors coming to this spectacle can see the hybridity of the worlds of nature and culture, of energy landscapes and their post-fossil-fuel uses. They stay in a comfortably refurbished Soviet hotel, repurposed after the Cold War to meet the needs of new generation climate-change scientists, measuring change in the Arctic.

Reflections: foregrounding the cultural in the Anthropocene

The Anthropocene poses a challenge to humanity and to planet Earth. It is also a challenge for the museum world to engage with this on a human scale and within the space of a gallery, even one beyond a museum building. Yet objects, collections and heritage landscapes offer a new perspective on the Anthropocene. Traditional (and often cherished) museum frameworks that compartmentalize knowledge into disciplines, cultures and periods of time are no longer useful. Nonetheless, because they are collecting institutions, museums are in the position to connect the deep past through the Anthropocene present to the deep future through objects and collections.

The original idea of a museum was that it was a house for collections. The nature of collections has changed over time, and so has the idea of the "house." In the rapidly changing times of the Anthropocene world, the museum gallery takes on new forms. We see gardens that are set out like museum cabinets and museums that include indoor forests.[37] Communities demand spaces that work for their traditional needs, leading to different sorts of

36 Sture Norske Spitsbergen Kulkompani (SNSK) www.snsk.no/corporate-social-responsibility.5550233.html, (accessed May 13, 2015).
37 Libby Robin, "The Red Heart Beating in the South-eastern Suburbs: The Australian Garden, Cranbourne," *reCollections* 2 (2007).

museums, and sometimes to significant new sorts of spaces within them, for example, the living *marae* (meeting house) in Te Papa, the National Museum of New Zealand in Wellington, is used for museum, community and religious purposes.

Museums that seek to explore big abstract ideas like the Anthropocene find themselves pushing the edges of the classic museum form, which is a gallery or room that places objects and visitors in conversation with each other. A science and technology museum offers a unique place for discussions of the unintended and far-reaching consequences of the Industrial Revolution.

Pyramiden takes the idea of the museum form itself to another level again. It is a global museum of a local place, a place where ideas of change, where international debates have focused on the local and specific circumstances, yet they also resound with issues affecting other polar places and regions (including in Antarctica). Pyramiden is only accidentally a "gallery of the Anthropocene," and its hybrid nature/culture is historical rather than artful. In Pyramiden, the actors have all come from somewhere else and re-made the place according to different nationalist and contemporary visions. Now it is a place where visitors and scientists come to explore ideas about climate change at the far northern edge of the inhabitable world.

For museum and heritage professionals the industrial museum and the industrial heritage landscape taken together showcase very different ways for exploring big ideas and grand timescales in stories of the Industrial Revolution. For those already engaged with the Anthropocene concept, these examples demonstrate how the cultural sector might further enliven public discussions about the future of the planet.

32
DEAR MATAFELE PEINAM

Kathy Jetñil-Kijiner

Performed at the opening of the United Nations Climate Summit, New York.
23 September 2014.

dear matafele peinam,

you are a seven month old sunrise of gummy smiles
you are bald as an egg and bald as the buddha
you are thighs that are thunder and shrieks that are lightning
so excited for bananas, hugs and
our morning walks past the lagoon

dear matafele peinam,

i want to tell you about that lagoon
that lucid, sleepy lagoon lounging against the sunrise

men say that one day
that lagoon will devour you

they say it will gnaw at the shoreline
chew at the roots of your breadfruit trees
gulp down rows of your seawalls
and crunch your island's shattered bones

they say you, your daughter
and your granddaughter, too
will wander rootless
with only a passport to call home

dear matafele peinam,

don't cry

mommy promises you

no one
will come and devour you

no greedy whale of a company sharking through political seas
no backwater bullying of businesses with broken morals
no blindfolded bureaucracies gonna push
this mother ocean over
the edge

no one's drowning, baby
no one's moving
no one's losing
their homeland
no one's gonna become
a climate change refugee

or should i say
no one else

to the carteret islanders of papua new guinea
and to the taro islanders of the solomon islands
i take this moment
to apologize to you
we are drawing the line here

because baby we are going to fight
your mommy daddy
bubu jimma your country and president too
we will all fight

and even though there are those
hidden behind platinum titles
who like to pretend
that we don't exist
that the marshall islands
tuvalu
kiribati
maldives
and typhoon haiyan in the philippines
and floods of pakistan, algeria, colombia
and all the hurricanes, earthquakes, and tidalwaves
didn't exist

still
there are those
who see us

hands reaching out
fists raising up
banners unfurling
megaphones booming
and we are
canoes blocking coal ships
we are
the radiance of solar villages
we are
the rich clean soil of the farmer's past
we are
petitions blooming from teenage fingertips
we are
families biking, recycling, reusing,
engineers dreaming, designing, building,
artists painting, dancing, writing
and we are spreading the word

and there are thousands out on the street
marching with signs
hand in hand
chanting for change NOW

and they're marching for you, baby
they're marching for us

because we deserve to do more than just
survive
we deserve
to thrive

dear matafele peinam,

you are eyes heavy
with drowsy weight
so just close those eyes, baby
and sleep in peace

because we won't let you down

you'll see

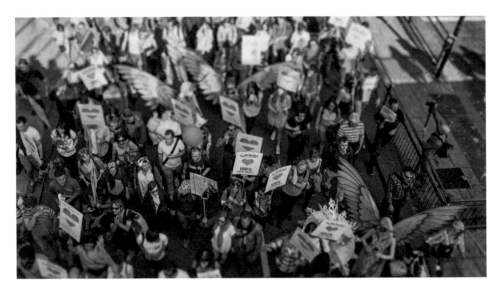

Figure 32.1 People's Climate March, London, with hummingbirds, September 21, 2014. Photo: Antonio Acuña, Flickr, https://flic.kr/p/p3EdaY. See Plate 41.

BIBLIOGRAPHY

Aboriginal Studies Department. *Women's Work: Aboriginal Women's Artefacts in the Museum of Victoria.* Melbourne: Museum of Victoria, 1992.
Abram, David. "Storytelling and Wonder." In *Encyclopedia of Religion and Nature* 1. London: Thoemmes, 2005.
Abram, David. *Becoming Animal: An Earthly Cosmology.* New York: Pantheon, 2010.
Aitken, Richard, Julie Collett, Thomas Darragh, A., Jennifer Jones-O'Neill, and Gordon Morrison. *Capturing Flora: 300 Years of Australian Botanical Art.* Ballarat, Australia: Art Gallery of Ballarat, 2012.
Aldridge, Steven, and Laurel Miller. *Why Shrinkwrap a Cucumber?: The Complete Guide to Environmental Packaging.* London: Laurence King Publishing Ltd., 2012.
Allen, Anne. "Architecture as Social Expression in Western Samoa: Axioms and Models." *Traditional Dwellings and Settlements Review* 5, no. 1 (1993): 33–45.
Annual Museum Reports of the Royal Swedish Academy of Sciences, 1940–1959.
Appadurai, Arjun. *The Future as Cultural Fact: Essays on the Global Condition.* New York: Verso, 2013.
Asma, Stephen T. *Stuffed Animals and Pickled Heads: The Culture And Evolution Of Natural History Museums.* New York: Oxford University Press, 2001.
Autin, Whitney J. and John M. Holbrook. "Is the Anthropocene an Issue of Stratigraphy or Pop Culture?" *GSA Today* 22, no. 7 (2012): 60–61.
Avango, Dag. *Sveagruvan: Svensk Gruvhantering mellan Industri, Diplomati och Geovetenskap.* Stockholm: Jernkontoret, 2005.
Avango, Dag, and Sander Solnes, Registrering av kulturminner i Pyramiden. Registrering utfört på oppdrag fra Sysselmannen på Svalbard, report (online). Longyearbyen: Governor of Svalbard, 2013.
Avango, Dag, Louwrens Hacquebord and Urban Wråkberg. "Industrial Extraction of Arctic Natural Resources since the Sixteenth Century: Technoscience and Geo-Economics in the History of Northern Whaling and Mining." *Journal of Historical Geography* 44 (2014): 15–30.
Barker, Holly. *Bravo for the Marshallese: Regaining Control in a Post-nuclear, Post-colonial World.* California: Wadsworth Publishing, 2012.
Barker, Lady. *Station Life in New Zealand.* London: Macmillan & Co., 1883 (and facsimile edition, Auckland: Wilson & Horton, n.d.).
Barnosky, A.D., N. Matzke, S. Tomiya, G.O.U. Wogan, B. Schwartz, T.B. Quental, C. Marshall, J.L. McGuire, E.L. Lindsey, K.C. Maguire, B. Mersey, E.A. Ferrer. "Has the Earth's Sixth Mass Extinction Already Arrived?" *Nature* 471 (2011): 51–57.

Bäuerlein, Henrike and Sarah Förg. "Vorab-Evaluation zur Sonderausstellung 'Anthropozän – Natur und Technik im Menschenzeitalter'." August–September, Internal Report. Munich: Deutsches Museum, 2012.
Beattie, James. "Environmental Anxiety in New Zealand, 1840–1941." *Environment and History* 9 (2003): 379–392.
Beckman, Jenny. *Naturens Palats: Nybyggnad, vetenskap och utställning vid Naturhistoriska riksmuseet 1866–1925*. Stockholm: Atlantis, 1999.
Beckwith, Sandra. *Royal Botanic Gardens Melbourne: Master Plan*. South Yarra, Victoria: Royal Botanic Gardens Melbourne, 1997.
Beeton, Isabella. *Mrs Beeton's Garden Management: The Art of Gardening*. Ware: Wordsworth Editions Ltd., 2008.
Beets, Jim. "Declines in Finfish Resources in Tarawa Lagoon, Kiribati, Emphasize the Need for Increased Conservation Effort." *Atoll Research Bulletin*. 490 (2001): 1–14.
Bennett, Jane. *The Enchantment of Modernity: Crossings, Energetics, and Ethics*. Princeton, NJ: Princeton University Press, 2001.
Bennett, Jane. *Vibrant Matter: A Political Ecology of Things*. Durham, NC: Duke University Press, 2010.
Bennett, Jill and Saskia Beudel, *Curating Sydney: Imagining the City's Future*. Sydney: University of New South Wales Press, 2015.
Bennett, Tony. *The Birth of the Museum: History, Theory, Politics*. London: Routledge, 1995.
Berg, Roald. *Norsk utenrikspolitikks historie. Norge på egen hånd 1905–1920*. Bd 2. Oslo: Universitetsforlaget, 1995.
Bergdahl, Ewa. Riksmuseets Pedagogik 1916–1965, Internal PM number 8, SMNH 2012-07-11 (unpublished).
Bergdahl, Ewa. Naturhistoriska riksmuseets utställningsverksamhet 1965–1933, Internal PM number 10, SMNH 2013-04-30 (unpublished).
Bergdahl, Ewa. Riksmuseets utställningar 1916–1965, Internal PM number 7, SMNH 2012-07-09 (unpublished).
Bird Rose, Deborah. *Reports from a Wild Country: Ethics for Decolonisation*. Sydney: UNSW Press, 2004.
Bird Rose, Deborah. "Val Plumwood's Philosophical Animism: Attentive Interactions in the Sentient World." *Environmental Humanities* 3 (2013): 93–109.
Bolton, Lissant. "The Object in View: Aborigines, Melanesians, and Museums." In *Museums and Source Communities*, edited by Laura Peers and Alison K. Brown, 42–54. London: Routledge, 2003.
Botanic Gardens Conservation International. "Towards a New Social Purpose: Redefining the Role of Botanic Gardens." Richmond, UK: Botanic Gardens Conservation International, 2010.
Brenstrum, Erick. *The New Zealand Weather Book*. Nelson: Craig Potton Publishers, 1998.
Broberg, Gunnar. "The Swedish Museum of Natural History." In *Science in Sweden*, edited by Tore Frängsmyr, 148–176. Canton: Science History Publications, 1989.
Broms, Helene and Anders Göransson. *Kultur i rörelse: En historia om riksutställningar och kulturpolitiken*. Stockholm: Bokförlaget Atlas, 2012.
Brusewitz, Gunnar. "Riksmuseet genom tiderna." In *Naturen berättar: Utveckling och forskning vid Naturhistoriska riksmuseet*, edited by Kjell Engström, 9–30. Stockholm: Naturhistoriska riksmuseet, 1989.
Buckland, David and Chris Wainwright, eds. *Unfold: A Cultural Response to Climate Change*, 2010.
Burnham, Jack. "Systems Esthetics." *Artforum* 7, no. 1 (1968): 30–35.
Buschmann, Rainer. "Exploring Tensions in Material Culture: Commercializing Ethnography in German New Guinea, 1870–1904." In *Hunting the Gatherers: Ethnographic Collectors, Agents and Agency in Melanesia, 1870s–1930s*, edited by Michael O'Hanlon and Robert L. Welsch. 55–79. Oxford: Berghahn Books, 2000.
Cameron, Fiona. "Ecologizing Experimentations: A Method and Manifesto for Composing a Posthumanist Museum." In *Climate Change and Museum Futures*, edited by Fiona Cameron and Brett Nielson, 16–33. New York: Routledge, 2015.

Cameron, Fiona. "We are on Nature's Side? Experimental Work in Rewriting Narratives of Climate Change for Museum Exhibitions." In *Climate Change and Museum Futures*, edited by Fiona Cameron and Brett Neilson, 51–77. New York: Routledge, 2015.

Cameron, Fiona and Ann Deslandes. "Museums and Science Centres as Sites for Deliberative Democracy on Climate Change." *Museums and Society* 9 (2011): 136–153.

Cameron, Fiona and Brett Nielson. *Climate Change and Museum Futures*. New York: Routledge, 2015.

Cameron, Fiona, Bob Hodge and Juan Francisco Salazar. "Conclusion: Climate Change Engagement – a Manifesto for Museums and Science Centers." In *Climate Change and Museum Futures*, edited by Fiona Cameron and Brett Nielson, 248–268. New York: Routledge, 2015.

Campbell, John R. *Traditional Disaster Reduction in Pacific Island Communities*. GNS Science Report, 2006/38. Accessed December 11, 2013. Available online: http://unpan1.un.org/intradoc/groups/public/documents/apcity/unpan029291.pdf

Carson, Rachel. *Silent Spring*. Boston, MA: Houghton Mifflin Company, 1962.

Carter, Melissa. "North of the Cape and South of the Fly: The Archaeology of Settlement and Subsistence on the Murray Islands, Eastern Torres Strait." Unpublished PhD thesis, James Cook University, 2004.

Catala, Rene L.A. "Report on the Gilbert Islands: Some Aspects of Human Ecology." *Atoll Research Bulletin* 59 (1957): 1–256.

Chakrabarty, Dipesh. "The Climate of History: Four Theses." *Critical Inquiry* 35 (2009): 197–222.

Christensen, Miyase, Annika E. Nilsson and Nina Wormbs, eds. *Media and the Politics of Arctic Climate Change: When the Ice Breaks*. London: Palgrave Macmillan, 2013.

Christian, David. "A Single Historical Continuum." *Cliodynamics* 2 (2011): 6–26.

City of Melbourne, Climate Change Adaptation Strategy, 2009. Available online: www.melbourne.vic.gov.au/AboutCouncil/PlansandPublications/strategies/Documents/climate_change_adaptation_strategy.PDF

Clark, Nigel. "Wild Life: Ferality and the Frontier with Chaos." In *Quicksands: Foundational Histories in Australia and Aotearoa New Zealand,* edited by Klaus Neumann, Nicholas Thomas, and Hilary Ericksen. Sydney: UNSW Press, 1999: 133–152.

Clark, Nigel. *Inhuman Nature: Sociable Life on a Dynamic Planet*. London: Sage, 2011.

Clarke, Phillip A. *Aboriginal Plant Collectors: Botanists and Australian Aboriginal People in the Nineteenth Century*. Kenthurst: Rosenberg Publishing, 2008.

Clausewitz, Wolfgang. "Natural History Museums and the Public – a Critical Situation in Europe." In *Natural History Museums and the Community*, edited by Kjell Engström and Alf Johnels, 43–47. Oslo: Universitetsförlaget, 1973.

Clifford, James. *Routes: Travel and Translation in the Late Twentieth Century*. Cambridge, MA: Harvard University Press, 1997.

Cole, Chris. "Landscape Succession Plan – Framework." At *BGANZ Plants Forum: Putting the Botanic Back into Botanic Gardens*. Royal Botanic Gardens, Melbourne, Australia, 2013.

Cosgrove, Denis. "Contested Global Visions: One World, Whole Earth, and the Apollo Space Photographs." *Annals of the Association of American Geographers* 84, no. 2 (1994): 270–294.

Council of Heads of Australian Botanic Gardens. "National Strategy and Action Plan for the Role of Australia's Botanic Gardens in Adapting to Climate Change." Canberra: Council of Heads of Australian Botanic Gardens, 2008.

Cowie, Robert. H., Neal L. Evenhuis, and Carl C. Christensen. *Catalog of the Native Land and Freshwater Molluscs of the Hawaiian Islands*. Netherlands: Backhuys Publishers, 1995.

Craik, Kenneth H. and George E. McKechnie. "Editor's Introduction: Personality and the Environment." *Environment and Behavior* 9 (1977): 155–168.

Crane, Peter R., Stephen D. Hopper, Peter H. Raven and Dennis W. Stevenson. "Plant Science Research in Botanic Gardens." *Trends in Plant Science* 14 (2009): 575–577.

Crate, Susan and Mark Nuttall. *Anthropology and Climate Change*. Walnut Creek, CA: Left Coast Press, 2009.

Crépeau, Pierre. *Pointing at the Wind: The Weather-vane Collection of the Canadian Museum of Civilization.* Hull: Canadian Museum of Civilization, 1990.

Cronon, William. "Caretaking Tales: Beyond Crisis and Salvation." In *The Story Handbook: Language and Storytelling for Land Conservationists.* San Francisco, CA: Center for Land and People of the Trust for Public Land, 2002: 87–93.

Crouch, Joe, Ian McNiven, Bruno David, Cassandra Rowe and Marshall Weisler. "Berberass: Marine Resource Specialisation and Environment Change in Torres Strait during the Last 4000 Years." *Archaeology of Oceania* 42 (2007): 49–64.

Crutzen, Paul J. "Geology of Mankind." *Nature* 415, no. 6867 (2002): 23.

Cullen, Heidi. *The Weather of the Future: Heat Waves, Extreme Storms, and Other Scenes from a Climate-Changed Planet.* New York: Harper, 2011.

Cuthill, James. *A Treatise on the Cucumber and Melon.* London: Groombridge and Sons, Paternoster Row, 1870.

D'Arcy, Paul. *People of the Sea: Environment, Identity and History in Oceania.* Honolulu, HI: University of Hawaii Press, 2008.

Dagens-Nyheter. May 20, 1966. Available online: www.dn.se

Daniels, Stephen and Georgina. H. Endfield. "Narratives of Climate Change." *Journal of Historical Geography* 35 (2009): 215–404.

Davenport, W.A. "Marshall Islands Cartography." *Expedition* 6 (1964): 10–13.

David, S., J. Blumtritt and B. Köhler *The Slow Media Manifesto.* (2010). Available online: http://en.slow-media.net/manifesto

Davis, Peter. *Museums and the Natural Environment: The Role of the Natural History Museums in Biological Conservation.* Leicester: University of Leicester Press, 1996.

Dawson, Ashley. "Putting a Human Face on Climate Change." In *Climate Change and Museum Futures*, edited by Fiona Cameron and Brett Neilson, 207–218. New York: Routledge, 2015.

Delay, J., Mark Merlin, Juvik, J., Perry, L., and Castillo, M. (n.d.). *Rare and Unusual Plants: Island of Hawaii.* Lyon Arboretum Special Report, 2005.

DeLoughrey, Elizabeth, Jill Didur and Anthony Carrigan, eds. *Global Ecologies and the Environmental Humanities: Postcolonial Approaches.* London: Routledge, 2015.

Derrida, Jacques, and Maurizio Ferraris. *A Taste for the Secret.* Cambridge: Polity Press, 2001.

Despret, Vinciane. "Sheep Do Have Opinions." In *Making Things Public. Atmospheres of Democracy*, edited by Bruno Latour and Peter Weibel: 360–370. Cambridge, MA: MIT Press, 2006.

Dibley, Ben. "Prospects for a Common World: Museums, Climate Change, Cosmopolitics." In *Climate Change and Museum Futures*, edited by Fiona Cameron and Brett Neilson, 34–50. New York: Routledge, 2015.

Diego de Prado, Don, Luis Vaes de Torres. *The Discovery of Australia: Discovery Made by Pedro Fernandez De Quiros in the Southern Land, and Afterwards Completed for Him by Don Diego De Prado Who Was Afterwards a Monk of the Order of S. Basil.* Translated by George F. Barwick (1922): 1607.

Director of National Parks. "Australian National Botanic Gardens Climate Change Strategy." Canberra, Australia: Commonwealth of Australia, 2010–2015.

Dixon, John, and Kevin Durrheim. "Displacing Place Identity: A Discursive Approach to Locating Self and Other." *British Journal of Social Psychology* 39 (2000): 27–44.

Drew, Joshua. "The Role of Natural History Institutions and Bioinformatics in Conservation Biology." *Conservation Biology* 25, no. 6 (2011): 1250–1252.

Drew, Joshua, Christopher Philipp and Mark Westneat. "Shark Tooth Weapons from the 19th century reflect shifting baselines in central Pacific predator assemblies." *PloS One* 8 (2013): e59855.

Edgar, William. "Engineering: From the Depths to the Heights." *The Institute of Mechanical Engineers*, May 26, 2004.

Edwards, Paul. *A Vast Machine: Computer Models, Climate Data and the Politics of Global Warming.* Cambridge, MA: MIT Press, 2010.

Ekström, Anders, Solveig Jülich, Frans Lundgren, and Per Wisselgren. *History of Participatory Media 1750–2000.* London: Routledge, 2011.

Ellsworth, Elizabeth and Jamie Kruse. "Evidence: Making a Geological Turn in Cultural Awareness." In *Making the Geologic Now: Responses to the Material Conditions of Contemporary Life*, edited by Elizabeth Ellsworth and Jamie Kruse, 6–26. Brooklyn, NY: Punctum, 2013.

Emanuelsson, Urban. *Ett sekel av svensk naturvård*. Nationalencyklopedin, (2009). Available online: www.ne.se/static, visited 2013-05-26.

Emmett, Robert and Gregg Mitman, eds. *Environmental Futures*. Oxford: Oxford University Press, forthcoming.

Engström, Kjell. "Aims of the Exhibition and Education Activities at the Museum of Natural History." In *Natural History Museums and the Community*, edited by Kjell Engström and Alf Johnels, 103–108. Oslo: Universitetsförlaget, 1973.

Engström, Kjell. "Museum i skumrask … Riksmuseet och dagens krav på aktiv museiverksamhet." In *Naturen berättar: Utveckling och forskning vid Naturhistoriska riksmuseet,* edited by Kjell Engström, 31–40. Stockholm: Naturhistoriska riksmuseet, 1989.

Faison, Maya. "The Unfamiliar and the Unpredictable," blog post, "Rethinking Home," posted Jan 29, 2014. Available online: www.amnh.org/our-research/anthropology/projects/rethinking-home/blog

Farbotko, Carol. "Wishful Sinking: Disappearing Islands, Climate Refugees and Cosmopolitan Experimentation." *Asia Pacific Viewpoint* 51, no. 1 (2010): 47–60.

Ferm, Deane W. and Debra Campbell. *Smithfield, 1840–1990: Maine's Only Leap Year Town*. Smithfield, Maine, 1990.

Field Museum. Engaging Chicago Communities in Climate Action. Accessed April 14, 2015. Available online: www.fieldmuseum.org/science/research/area/science-action/communities/engaging-chicago-communities-climate-action

Foderaro, Lisa. "A Lawyer Quit her Job to Start a Climate Museum in New York." *New York Times*, August 21, 2015. www.nytimes.com/

Foerstel, Lenora. "Margaret Mead: From a Cultural/Historical Perspective." *Central Issues in Anthropology* 8 (1988): 25–31.

Foerstel, Lenora and Angela Gilliam. *Confronting Margaret Mead: Scholarship, Empire, and the South Pacific*. Philadelphia, PA: Temple University Press, 1994.

Fort, Tom. *Under the Weather*. London: Arrow Books, 2006.

Franco, R. and S. Mageo Aga. "From Houses without Walls to Vertical Villages: Samoan Housing Transformations." In *Home in the Islands: Housing and Social Change in the Pacific*, edited by J. Rensel and M. Rodman. Honolulu, HI: University of Hawai'i Press, 1997: 175–193.

Füssl, Wilhelm. The Deutsches Museum and Its History. In Wolfgang M. Heckl, ed. *Technology in a Changing World: The Collections of the Deutsches Museum*, tr. Hugh Casement and Jim O'Meara, xiv–xvi. Munich: Deutsches Museum, 2010.

Futerra Sustainability Communications: *Branding Biodiversity: The New Nature Message*. Available online: www.futerra.co.uk/downloads/Branding_Biodiversity.pdf

Garran, Andrew, ed. *Picturesque Atlas of Australasia: Our Country, as It Was and as It Is*. Sydney: Picturesque Atlas Publishing C., 1888.

Gladwell, Malcolm. *The Tipping Point; How Little Things Can Make a Big Difference*. New York: Little, Brown and Co., 2000.

Gleeson, Ben. "Terra Nullius in Australian Environmentalism and Agriculture: Implications for Ecologically-based Intra-action within a Living-landscape." *PAN: Philosophy, Activism, Nature* 11 (2015): 63–73.

Griffiths, Tom. *Hunters and Collectors: The Antiquarian Imagination in Australia*. Cambridge and New York: Cambridge University Press, 1996.

Grimble, Arthur. "From Birth to Death in the Gilbert Islands." *The Journal of the Royal Anthropological Institute of Great Britain and Ireland* 51 (1921): 25–54.

Grimble, Arthur. In Maude, H.C. and H.E. Maude, H.E. (1981). "Tioba and the Tabiteuean Religious wars." *The Journal of the Polynesian Society* 90 (1923): 307–336.

Gudger, Eugene. "Wooden Hooks Used for Catching Sharks and Ruvettus in the South Seas: A Study

of their Variation and Distribution." In *Anthropological Papers of the American Museum of Natural History* 28 (1923): 199–348.

Guldi, Jo and David Armitage. *The History Manifesto*. Cambridge: Cambridge University Press, 2014.

Gurian, Elaine. "Blurring of the Boundaries." *Curator* 38, no. 1 (2005): 31–37.

Gurian, Elaine. "A Savings Bank for the Soul: About Institutions of Memory and Congregant Spaces." In *Civilizing the Museum: The Collected Writings of Elaine Heumann Gurian*, 88–97. London and New York: Routledge, 2006.

Haddon, Alfred C. *Reports of the Cambridge Anthropological Expedition to Torres Straits, vol. 1: General Ethnography*. Cambridge: Cambridge University Press, 1935.

Hage, Ghassan. "'On the Side of Life' – Joy and the Capacity of Being." In *Hope: New Philosophies for Change*, edited by M. Zournazi, 150–171. Annandale, NSW: Pluto Press, 2002.

Hamann, Alexandra, Reinhold Leinfelder, Helmuth Trischler, and Henning Wagenbreth, eds. *Anthropozän. 30 Meilensteine auf dem Weg in ein neues Erdzeitalter*. Munich: Deutsches Museum, 2014.

Hamil, Denis. "Staten Island Man Loses Home to Sandy, Pledges Year to Jesus as Thanks for his Family's Life." *Daily News*. May 4, 2013. Available online: www.nydailynews.com/new-york/amazing-act-charity-article-1.1335346

Hansen, Christine. "Telling Absence: Aboriginal Social History and the National Museum of Australia." Unpublished PhD thesis, School of History, Australian National University, 2010.

Haraway, Donna. *When Species Meet*. Minneapolis, MN: University of Minnesota Press, 2008.

Hastrup, Kirsten and Karen Fogg Olweg, eds. *Climate Change and Human Mobility: Global Challenges to the Social Sciences*. Cambridge: Cambridge University Press, 2012.

Hauser, Walter, ed. *Klima – Das Experiment mit dem Planeten Erde* (English translation NM). München: Deutsches Museum, 2002.

Hawkins, B., S. Sharrock and K. Havens. "Plants and Climate Change: Which Future?" Richmond, UK: Botanic Gardens Conservation International, 2008.

Head, Lesley and Mark Gibson. "Becoming Differently Modern: Geographic Contributions to a Generative Climate Politics." *Progress in Human Geography* 36 (2012): 699–714.

Heise, Ursula. *Sense of Place and Sense of Planet: The Environmental Imagination of the Global*. Oxford: Oxford University Press, 2008.

Helgen, Kristofer, C. Miguel Pinto, Roland Kays, Lauren E. Helgen, Mirian T. N. Tsuchiya, Aleta Quinn, Don E. Wilson, and Jesus E. Maldonado. "Taxonomic Revision of the Olingos (Bassaricyon), with Description of a New Species, the Olinguito." *ZooKeys* 68, no. 324 (2013).

Henare, Amiria. *Thinking Through Things: Theorizing Artefacts Ethnographically*. London: Routledge, 2007.

Holland, Peter. *Home in the Howling Wind: Settlers and Environment in Southern New Zealand*. Auckland: Auckland University Press, 2013.

Holmes, Tiffany. "Eco-visualization: Promoting Environmental Stewardship in the Museum." *The Journal of Museum Education* 32 (2007): 275–285.

Horhardt, Emil, ed. *Climate Change and the Humanities*. Santa Barbara, CA: Cloudripper Press, 2015.

Houlihan, Michael, "Planning for Impact: a Case Study." in Carol A. Scott, ed. *Museums and Public Value: Creating Sustainable Futures*, 65–80. Farnham: Ashgate, 2013.

Hubendick, Bengt. "Gammalt och nytt inom biologin." *Göteborgs Handels-och Sjöfartstidning*, 1964.

Hulme, Mike. "Geographical Work at the Boundaries of Climate Change." *Transactions of the Institute of British Geographers*, 33, no. 1 (2007): 5–11.

Hulme, Mike. *Why We Disagree about Climate Change: Understanding Controversy, Inaction and Opportunity*. Cambridge: Cambridge University Press, 2009.

Hulme, Mike. "Reducing the Future to Climate: A Story of Climate Determinism and Reductionism." *Osiris* 26, no. 1 (2011): 245–266.

Humboldt, Alexander von. "Geographie des Plantes Equinoxiales." In *Essai sur la Geographie des Plantes*, Paris: A.v. Humboldt & A. Bonpland, 1805.

Hume, Audrey Noel. *Archaeology and the Colonial Gardener*. Williams, VA: Colonial Williamsburg Foundation, 1974.

Hume, Phillip E. "Addressing the Threat to Biodiversity from Botanic Gardens." *Trends in Ecology and Evolution* 26, no. 4 (2011): 168–74.
IPCC, *Third Assessment Report* (TAR), Cambridge University Press, 2001. Available online: www.grida.no/publications/other/ipcc_tar/
IPCC. Intergovernmental Panel on Climate Change Fifth Assessment Report, 2013. Available online: www.ipcc.ch
Iyer, Pico. *The Global Soul: Jet Lag, Shopping Malls, and the Search for Home*. New York: Vintage, 2011.
Jackomos, Alick and Derek Fowell. *Living Aboriginal History of Victoria: Stories in the Oral Tradition*. Cambridge and Melbourne: Cambridge University Press and the Museum of Victoria Aboriginal Cultural Heritage Advisory Committee, 1991.
Jamison, Andrew. "The Making of the New Environmentalism in Sweden." In *The Making Of The New Environmental Consciousness: A Comparative Study of The Environmental Movements in Sweden, Denmark, And The Netherlands*, edited by Andrew Jamison, Ron Eyerman, Jacqueline Cramer and Jeppe Læssøe, 13–65. Edinburgh: Edinburgh University Press, 1990.
Janes, Robert. *Museums in a Troubled World: Renewal, Irrelevance or Collapse?* New York: Routledge, 2009.
Jimeno, S. and A. Rafael. *A Profile of the Marshallese Community in Arkansas*, Vol. 3. Little Rock and Fayetteville, AR: Winthrop Rockefeller Foundation and University of Arkansas, 2013.
Johannes, R.E. and Being Yeeting. "I-Kiribati Knowledge and Management of Tarawa's Lagoon Resources." *Atoll Research Bulletin* 489 (2001): 1–24.
Johnels, Alf. "Natural History Museum Collections: A Basis for Future Research." In *Natural history Museums and the Community*, edited by Kjell Engström and Alf Johnels, 48–58. Oslo: Universitetsförlaget, 1973.
Jones, Jonathan. "Science Museum: Close Your Climate Change Show." *The Guardian*, Nov. 18, 2009.
Jones, Patrick. "Gifting Economies." *Arena Magazine* 119 (2012): 23–27.
Jönsson, Bror Fredrik, ed. *Uppdrag: klimat – en utställningskatalog i samarbete mellan Forskning & Framsteg och Naturhistoriska riksmuseet*. Stockholm: Naturhistoriska riksmuseet, 2004.
Jørgensen, Dolly. "Mixing Oil and Water: Naturalizing Offshore Oil Platforms in Gulf Coast Aquarium." *Journal of American Studies* 46, no. 2 (2012): 461–480.
Jörgensen, Jörgen Holten. *Russisk svalbardpolitikk. Svalbard sett fra andre siden*. Trondheim: Tapir akademisk forlag, 2010.
Junior Naturalist, The. Journal of the Hawthorn Junior Field Naturalists Club of Victoria, Jan. 1969: 4.
Kaeppler, Adrienne. *The Pacific Arts of Polynesia and Micronesia*. Oxford: Oxford University Press, 2008.
Kahn, Brian. "Climate Change is Getting its own Museum." *Climate Central*, Aug. 14, 2015.
Kaplan, Jed O., Kristen M. Krumhardt, Erle C. Ellis, William F. Ruddiman, Carsten Lemmen and Kees Klein Goldewijk. "Holocene Carbon Emissions as a Result of Anthropogenic Land Cover Change." *The Holocene* 21, no. 5 (2011): 775–791.
Karp, Ivan and Corinne Katz, "The Interrogative Museum." In Raymond Silverman, *Museum as Process: Translating Local and Global Knowledge*: 279–288. Oxford and New York: Routledge, 2015.
Keats, John. *John Keats Selected Letters*. Edited by Robert Gittings. Oxford: Oxford University Press, 2002.
Kelsey, Elin and Clayron Hanmer. *Not Your Typical Book about the Environment*. Toronto: Owlkids Books, 2010.
Keogh, Luke and Nina Möllers. "Pushing Boundaries – Curating the Anthropocene at the Deutsches Museum." In Fiona Cameron and Brett Neilson, eds. *Climate Change and Museum Futures*: 78–89. Routledge Research in Museum Studies. New York: Routledge, 2015.
Kirksey, Eben, Nick Shapiro and Maria Brodine. "Hope in Blasted Landscapes." *Social Science Information* 52, no. 2 (2013): 228–256.
Kirsch, Stuart. "Lost Worlds: Environmental Disaster, 'Culture Loss,' and the Law." *Current Anthropology* 42, no. 2 (April 2001): 167–198.
Kirshenblatt-Gimblett, Barbara. *Destination Culture: Tourism, Museums, and Heritage*. Oakland, CA: University of California Press, 1998.

Klein, Naomi. *This Changes Everything: Capitalism vs. The Climate*. New York: Simon & Schuster, 2014.
Kolbert, Elizabeth. "Lines in the Sand." *The New Yorker,* May 27, 2013.
Kolbert, Elizabeth. *The Sixth Extinction,* London and New York: Bloomsbury, 2014.
Krmpotich, Cara and Laura Peers, *This is Our Life: Haida Material Culture and Changing Museum Practice*. Toronto: UBC Press, 2013.
Kuchment, Anna. "Museums Tiptoe around Climate Change." *Dallas Morning News*, June 15, 2014.
Kungl. Vetenskapsakademien. *Naturhistoriska riksmuseets historia: Dess uppkomst och utveckling*. Stockholm: Almqvist & Wiksell, 1916.
Kuruppu, Natasha and Diana Liverman. "Mental Preparation For Climate Adaptation: The Role of Cognition and Culture in Enhancing Adaptive Capacity Of Water Management In Kiribati." *Global Environmental Change* 21, no. 2 (2011): 657–669.
Laade, Wolfgang. "Notes on the Clans, Economy, Trade and Traditional Law of the Murray Islanders, Torres Strait." *Journal de la Société des Océanistes* 29 (1973): 151–167.
Lampert, R.J. "An Archaeological Investigation On Ocean Island, Central Pacific." *Archaeology & Physical Anthropology in Oceania* 3, no. 1 (1968): 1–18.
Larson, Brendon. *Metaphors for Environmental Sustainability: Redefining our Relationship with Nature*. New Haven, CT: Yale University Press, 2011.
Lazarus, Heather. "Sea Change: Island Communities and Climate Change." *Annual Review of Anthropology* 41 (2012): 285–301.
Leinfelder, Reinhold, Christian Schwaägerl, Nina Möllers, and Helmuth Trischler. "Die Menschengemachte Erde: Das Anthropozän sprengt die Grenzen von Natur, Kultur und Technik." *Kultur und Technik* 2 (2012): 12–17.
Leonard, David L. "Recovery Expenditures for Birds Listed Under the US Endangered Species Act: The Disparity Between Mainland And Hawaiian Taxa." *Biological Conservation* 141 (2008): 2054–2061.
Lindgren, Petter. "Vilka Minnen Ger Vi Barnen?" *Aftonbladet*. March 31, 2005. Available online: www.aftonbladet.se/kultur/huvudartikel/article10569608.ab/.
Lockwood, Leslie, Jan Wilson and Murray Fagg. *Botanic Gardens of Australia: A Guide to 80 Gardens*. Sydney, London, Auckland, Cape Town: New Holland Publishers, 2001.
Loumala, Katherine. "Some Fishing Customs and Beliefs in Tabiteuea. (Gilbert Islands, Micronesia)." *Anthropos* 75 (1980): 523–558.
Loumala, Katherine. "Sharks And Shark Fishing in the Culture of the Gilbert Islands, Micronesia." In *The Fishing Culture Of The World*. Budapest: Akademiai Kaido. Vol. 2 (1984): 1203–1252.
Low, Chris and Elizabeth Hsu. "Introduction." *Journal of the Royal Anthropological Institute* 13 (supplement, 2007): S1–S17.
Lucas, A.M., Sara Maroske and Andrew Brown-May. "Bringing Science to the Public: Ferdinand Von Mueller and Botanical Education in Victorian Victoria." *Annals of Science*, 63 no. 1 (2006): 25–57.
Lundgren, Lars J. "Miljöpolitiken." In *Vad staten vill: Mål och ambitioner i svensk politik,* edited by Daniel Tarschys and Marja Lemne, 281–346. Hedemora: Gidlunds förlag, 2013.
Lynas, Mark. *High Tide: How Climate Crisis Is Engulfing Our Planet*. London: Harper Perennial, 2004.
Lythberg, Billie, Jennifer Newell and Wayne Ngata. "House of Stories: The Whale Rider at the American Museum of Natural History." *Museums and Society* 13, no. 2 (2015): 195–202.
Mabey, Richard. *Turned Out Nice Again: Living with the Weather*. London: Profile Books, 2013.
Macalister, Terry. "Shell Sought to Influence Direction of Science Museum Climate Programme." *The Guardian*, May 31, 2015. Available online: www.theguardian.com/business/2015/may/31/shell-sought-influence-direction-science-museum-climate-programme
Maldonado, Jesús E. *et al.*, "Taxonomic Revision of the Olingos (*Bassaricyon*), With Description Of A New Species, The Olinguito." *Zoo Keys* 324, no. 1 (2013): 1–83.
Malm, Andreas and Alf Hornborg. "The Geology of Mankind? A Critique of the Anthropocene Narrative." *The Anthropocene Review* 1 (2014): 62–69.
Marris, Emma. *Rambunctious Garden: Saving Nature in a Post-Wild World*. New York: Bloomsbury USA, 2011.

Maude, H. C. and H. E. Maude (1980). "Tioba and the Tabiteuean Religious Wars." *The Journal of the Polynesian Society* 90 (1923): 307–336.

Maunder, Michael. "Botanic Gardens: Future Challenges and Responsibilities." *Biodiversity and Conservation* 3 (1994): 97–103.

Maunder, Michael. "Beyond the Greenhouse." *Nature* 455 (2008): 596–597.

Mayer, Jane. "Covert Operations: The Billionaire Brothers Who are Waging a War Against Obama." *New Yorker,* Aug. 30, 2010.

McCalman, Iain. Presentation at the Symposium "Collecting the Future: Museums, Communities and Climate Change" at the American Museum of Natural History, New York, Oct. 2, 2013.

McMillan, Thomas. *Plain and Practical Hints on the Cultivation and Management of the Melon, Cucumber, Gourd and Vegetable Marrow.* Melbourne: Slater, Williams, and Hodgson, 1856.

Mead, Margaret and Franz Boas. *Coming of Age in Samoa.* New York: Penguin, 1973.

Medlock, Kathryn. "The Thylacine Trade." Paper presented at the Collecting the Future: Museums, Communities and Climate Change Conference, American Museum of Natural History, New York, Oct. 3, 2013.

Message, Kylie. *Museums and Social Activism: Engaged Protest.* Hoboken, NJ: Taylor and Francis, 2013.

Ming, Tien L., Ezra M. Markowitz, Peter D. Howe, Chia-Ying Ko and Anthony A. Leiserowitz, "Predictors Of Public Climate Change Awareness And Risk Perception Around The World." *Nature Climate Change,* 27 July (2015): 1014–1020.

Möllers, Nina, Christian Schwägerl and Helmuth Trischler, eds. *Welcome to the Anthropocene. The Earth in Our Hands.* Munich: Deutsches Museum, 2015.

Mortreux, Colette and Jon Barnett. "Climate Change, Migration And Adaptation in Funafuti, Tuvalu." *Global Environmental Change* 19, no. 1 (2009): 105–112.

Mouffe, Cantall and Ernesto Laclau. "Hope, Passion, Politics." In *Hope: New Philosophies for Change,* edited by M. Zournazi, 122–149. Annandale, NSW: Pluto Press, 2002.

Mueller, Baron Ferdinand von. *The Objects of a Botanic Garden in Relation to Industries: A Lecture Delivered at the Industrial and Technological Museum Melbourne.* Melbourne, 1871.

Murdoch, G.M. "Gilbert Islands Weapons and Armour." *The Journal of the Polynesian Society* 32, no. 3 (1923): 174–175.

Nabhan, Paul. "Restoring and Re-storying the Landscape." *Restoration and Management Notes* 9, no. 1 (1991): 3–4.

Neistchmann, Bernard. "Traditional Sea Territories, Resources and Rights in the Torres Strait." In *A Sea of Small Boats,* edited by John Cordell. Cambridge: Cultural Survival, 1989.

Newell, J.E. "The Legend of The Coming of Nareau from Samoa to Tarawa, and His Return to Samoa." *The Journal of the Polynesian Society* 4, no. 4 (1895): 231–235.

Newell, Jennifer. "Weathering Climate Change in Samoa: Cultural Resources for Change." In Tony Crook and Peter Rudiak-Gould, eds. *Appropriating Climate Change: Pacific Reception of a Global Prophecy.* The Hague: De Gruyter Open, forthcoming.

Nilsson, Annika E. "A Changing Arctic Climate: Science and Policy in the Arctic Climate Impact Assessment." In *Climate Governance in the Arctic,* edited by Tim Koivurova and Nigel Bankes, 77–95. New York: Springer, 2009.

Nixon, Rob. *Slow Violence: The Environmentalism of the Poor.* Cambridge, MA: Harvard University Press, 2013.

Norwegian Commissioner of Mines, unpublished reports 1934–1966.

Norwegian Ministry of Foreign Affairs. *The High North Visions and Strategies, Meld St.* 7, 2011–2012. Oslo: Norwegian Ministry of Foreign Affairs, 2011.

Norwegian Ministry of Justice. Stortingsmelding Nr. 22, 2008–2009, *Svalbard.* Oslo: Norwegian Ministry of Justice, 2009.

Novak, Barbara. *Nature and Culture: American Landscape and Painting 1825–1875.* New York: Oxford University Press, 2007.

Nunn, Patrick D. *Climate, Environment and Society in the Pacific During the Last Millennium.* Amsterdam, London: Elsevier, 2007.

Nunn, Patrick. D. "The End of the Pacific? Effects of Sea Level Rise on Pacific Island Livelihoods." *Singapore Journal of Tropical Geography* 34, no. 2 (2013): 143–171. doi: 10.1111/sjtg.12021

O'Hanlon, Michael. "Introduction." In *Hunting the Gatherers: Ethnographic Collectors, Agents and Agency in Melanesia, 1870s–1930s*, edited by Michael O'Hanlon and Robert L. Welsch, 1–34. Oxford: Berghahn Books, 2000.

Oldfield, Sara. *Botanic Gardens: Modern-Day Arks*. London, Cape Town, Sydney, Auckland: New Holland Publishers Ltd., 2010.

O'Neill, Saffron and Sophie Nicholson-Cole. "Fear Won't Do It: Promoting Positive Engagement with Climate Change through Visual and Iconic Representations." *Science Communication* 30 (2009): 355–79.

Oram, Emma L. *Vintage Script-Editors* (blog). Available online: http://vintagescript.blogspot.com/2012_02_01_archive.html

Oreskes, Naomi and Erik Conway. *Merchants of Doubt: How a Handful of Scientists Obscured the Truth on Issues from Tobacco Smoke to Global Warming*. New York: Bloomsbury, 2010.

Pascoe, Gwen. *Long Views and Short Vistas: Victoria's Nineteenth-Century Public Botanic Gardens*. North Melbourne: Australian Scholarly Publishing, 2012.

Patton, Paul. "Politics." In *Understanding Derrida*, edited by Jonathan Roffe and Jack Reynolds, 26–34. Continuum: New York, 2004.

Peers, Laura and Alison K. Brown. "Introduction." In *Museums and Source Communities*, edited by Laura Peers and Alison. K. Brown, 1–16. London: Routledge, 2003.

Peers, Laura. "'Ceremonies of Renewal': Visits, Relationships, and Healing in the Museum Space." *Museum Worlds: Advances in Research* 1 (2013): 136–152.

Phillips, Jock. "Forecasting the Weather and Telling the Time." In *The Amazing World of James Hector*, edited by Simon Nathan and Mary Varnham, 85–87. Wellington: Awa Press, 2008.

Pile, Steve and Nigel Thrift. "Conclusions: Spacing and the Subject." In *Mapping The Subject: Geographies Of Cultural Transformation*, edited by Steve Pile and Nigel Thrift, 371–380. London: Routledge, 1995.

Plumwood, Val. "Shadow Places and the Politics of Dwelling." *Australian Humanities Review*, no. 44 (2008): 139–150.

Plumwood, Val. "Nature in the Active Voice." *Ecological Humanities* 46 (2009): 1–10. Accessed online March 17, 2015. www.australianhumanitiesreview.org/archive/Issue-May-2009/plumwood.htm

Poliquin, Rachel. *The Breathless Zoo: Taxidermy and the Cultures of Longing*. University Park, PA: Pennsylvania State University Press, 2012.

Poole, Robert. *Earthrise: How Man First Saw the Earth*. New Haven, CT: Yale University Press, 2008.

Prest, John. *The Garden of Eden: The Botanic Garden and the Re-Creation of Paradise*. New Haven, CT and London: Yale University Press, 1981.

Price, Sally. *Primitive Art in Civilized Places*. Chicago, IL: University of Chicago Press, 1989.

Primack, Richard B. and Abraham J. Miller-Rushing. "The Role of Botanical Gardens in Climate Change Research." *New Phytologist* 182 (2009): 303–313.

Puig de la Bellacasa, Maria. "Nothing Comes Without Its World: Thinking With Care." *The Sociological Review* 60, no. 2 (2012):197–216.

Putin, Vladimir (approved February 20, 2013). "Development Strategy of the Arctic Zone of the Russian Federation and National Security until 2020." (Unofficial translation (2013) by The Embassy of the Russian Federation at Stockholm).

Quinnell, Michael. "'Before It Has Become Too Late': The Making and Repatriation of Sir William MacGregor's Official Collection from British New Guinea." In *Hunting the Gatherers: Ethnographic Collectors, Agents and Agency in Melanesia, 1870s–1930s*, edited by Michael O'Hanlon and Robert L. Welsch, 81–102. Oxford: Berghahn Books, 2000.

Rayner, Steve. "Domesticating Nature: Commentary on the Anthropological Study of Weather and Climate Discourse." In *Weather, Climate, Culture*, edited by Sarah Strauss and Ben Orlove, 277–290. Oxford: Berg, 2003.

Reichard, Sarah Hayden, and Peter White. "Horticultural Introductions of Invasive Plant Species: A

North American Perspective." In *The Great Reshuffling: Human Dimensions of Invasive Alien Species*, edited by Jeffrey A. McNeely, 161–170. Gland, Switzerland and Cambridge: IUCN Biodiversity Policy Coordination Division, 2001.

Restani, Marco and John M. Marzluff. "Funding Extinction? Biological Needs and Political Realities in the Allocation Of Resources To Endangered Species Recovery." *BioScience* 52, no. 2 (2002): 169–177.

Riksmuseiutredningen, Naturhistoriska riksmuseets framtida ställning och organisation: betänkande, 1962.

Roberts, Bev. *The Australian Garden*, edited by Helen Vaughan. South Yarra, Victoria: Royal Botanic Gardens Board Victoria, 2007.

Robin, Libby. "Collections and the Nation: Science, History and the National Museum of Australia." *Historical Records of Australian Science* 14, no. 3 (2003): 251–289.

Robin, Libby. "A Report of the Historical, Cultural and Biological Significance of the National Historical Collection's MacKenzie Wet Specimens." Consultancy for the National Museum of Australia, May–June 2005: 1–21.

Robin, Libby. "Dead Museum Animals: Natural Order or Cultural Chaos." *reCollections: A Journal of Museums and Collections* 4, no. 2 (2009): 17 pages.

Robin, Libby. "Weird and Wonderful: The First Objects of the National Historical Collection." *ReCollections: Journal of the National Museum of Australia*, Sept. 2006, vol. 1(2): 115–129.

Robin, Libby. "The Red Heart Beating in the South-eastern Suburbs: The Australian Garden, Cranbourne." *reCollections* 2, no. 1 (2007), review.

Robin, Libby, Dag Avango, Luke Keogh, Nina Möllers, Bernd Scherer, Helmuth Trischler, "Histories for Changing Times: Entering the Anthropocene?" *Australian Historical Studies* 44, no. 3 (2013): 329–340.

Robin, Libby, Sverker Sörlin and Paul Warde. *The Future of Nature: Documents of Global Change*. New Haven, CT: Yale University Press, 2013.

Robin, Libby. "Three Galleries of the Anthropocene." *The Anthropocene Review* 1, no. 3 (2014): 207–224.

Robson, Merryl K. *Keeping the Culture Alive: An Exhibition of Aboriginal Fibrecraft Featuring Connie Hart, and Elder of the Gunditjmara People with Significant Items on Loan from the Museum of Victoria*. Hamilton: Aboriginal Keeping Place and Hamilton City Council, 1986.

Romm, Joe. "Smithsonian Stands by Wildly Erroneous Climate Change Exhibition Paid for by the Kochs." March 23, 2015, climateprogress.org.

Rudiak-Gould, Peter. *Climate Change and Tradition in a Small Island State: The Rising Tide*. New York: Routledge, 2013.

Sachs, Aaron. *The Humboldt Current*. New York: Viking, 1966.

Salazar, Juan. F. "The Mediations of Climate Change: Museums as Citizens' Media." *Museum and Society* 9 (2011): 123–135.

Salmond, Amiria. "Digital Subjects, Cultural Objects: Special Issue Introduction." *Journal of Material Culture* 17, no. 3 (2012): 214.

Samuelsson, Anna. "I naturens teater: Kultur – och miljösociologiska analyser av naturhistoriska utställningar och filmer." Unpublished Ph.D. thesis. Uppsala University, 2008.

Sandin, S.A., Jennifer E. Smith, Edward E. DeMartini, Elizabeth A. Dinsdale, Simon D. Donner, Alan M. Friedlander, Talina Konotchick, Machel Malay, James E. Maragos, David Obura, Olga Pantos, Gustav Paulay, Morgan Richie, Forest Rohwer, Robert E. Schroeder, Sheila Walsh, Jeremy B. C. Jackson, Nancy Knowlton, and Enric Sala. "Baselines and Degradation of Coral Reefs in the Northern Line Islands." *PloS One 3, no. 2* (2010): e1548.

Sear, Martha. "Stilled Lives." *The Museum* 4 (2013–2014): 14–19.

Schulman, Leif and Susanna Lehvävirta. "Botanic Gardens in the Age of Climate Change." *Biodiversity Conservation* 20 (2011): 217–220.

Shankman, Paul. *The Trashing of Margaret Mead: Anatomy of an Anthropological Controversy*. Madison, WI: University of Wisconsin Press, 2009.

Sherratt, Tim, Tom Griffiths and Libby Robin, eds. *A Change In The Weather: Climate And Culture In Australia*. Canberra: National Museum of Australia, 2005.

Shiva, Vandana. *The Violence of the Green Revolution: Third World Agriculture, Ecology and Politics.* London: Zen Books, 1991.

Silverman, Raymond, ed. *Museum as Process: Translating Local and Global Knowledge.* Oxford and New York: Routledge, 2015.

Smith, Bridie. "Tweets All Part of Growth and Change." *The Age,* February 26, 2013.

Smith, David F. *Natural Gain in the Grazing Lands of Southern Australia.* Sydney: UNSW Press, 2000.

Sodikoff, Genese Marie. "The Time of Living Dead Species: Extinction Debt and Futurity in Madagascar." In *Debt: Ethics, The Environment, and the Economy,* edited by Peter Y. Paik and Merry Wiesner-Hanks, 140–163. Bloomington, IN: Indiana University Press, 2003.

Solomon, S. et al., Contribution of Working Group I to the Fourth Assessment Report of the Intergovernmental Panel on Climate Change. Cambridge and New York: Cambridge University Press, 1996.

Solomon, S., D. Qin, M. Manning, Z. Chen, M. Marquis, K.B. Averyt, M. Tignor and H.L. Miller, eds. Contribution of Working Group I to the Fourth Assessment Report of the Intergovernmental Panel on Climate Change. Cambridge and New York: Cambridge University Press, 2007.

Sörlin, Sverker. *Naturkontraktet. Om naturumgängets idéhistoria.* Stockholm: Carlssons förlag, 1991.

Spennemen, Dirk. "Marshallese Dress." In *Essays on the Marshallese Pasti.* Albury, New South Wales, 1998. Available online: http://marshall.csu.edu.au/Marshalls/html/essays/es-ed-1.html

Steffen, Will. "Commentary: Crutzen and Stoermer on the Anthropocene." In *The Future of Nature: Documents of Global Change,* edited by Libby Robin, Sverker Sörlin and Paul Warde, 483–490. New Haven, CT: Yale University Press, 2013.

Steffen, Will, Wendy Broadgate, Lisa Deutsch, Owen Gaffney, and Cornelia Ludwig. "The Trajectory of the Anthropocene: the Great Acceleration." *The Anthropocene Review* 2, no. 1 (2015): 81–98.

Steffen, Will, and Paul J. Crutzen and John R. McNeill. "The Anthropocene: Are Humans Now Overwhelming the Great Forces of Nature." *Ambio* 36, no. 8 (2007): 614–621.

Stege, Kristina and Jennifer Newell. "Thinking about the Sea in a Changing World: Views from the Marshall Islands." Conference paper presented at the European Society for Oceanists, Brussels, June 28, 2015.

Stockholms-Tidningen. "Museum i skumrask." Nov. 13, 1961.

Strauss, Sarah and Ben Orlove, eds. *Weather, Climate, Culture.* Oxford: Berg, 2003.

Svenska Dagbladet. "Expo på Naturhistoriska riksmuseet belyser biocidproblemet." May 22, 1966. Available online: www.svd.se/.

Svenska Dagbladet 1985-06-14. "Hela Europa kan bli en öken."

Sweatman, John, Jim Allen and Peter Coris. *The Journal of John Sweathman: A Nineteenth Century Surveying Voyage in North Australia and Torres Strait.* St. Lucia: University of Queensland press, 1977.

Symes, Peter. "Rethinking Botanic Gardens in the Face of Climate Change – Perspectives on Planning, Landscape Design, and Implementation." In BGANZ Congress, (2009): 22–49.

Szerszynski, Bronislaw. "The End of the End of Nature: The Anthropocene and the Fate of the Human." *Oxford Literary Review* 34, no. 2 (2012): 165–184.

Tapsell, Paul. "The Flight of Pareratutu: An Investigation of Taonga from a Tribal Perspective." *Journal of the Polynesian Society* 106, no. 4 (1997): 323–374.

Taylor, Charles. "Modern Social Imaginaries." *Public Culture* 14, no. 1 (2002): 91–12.

The Guardian. "Cucumbers in Space: Astronaut's Horticultural Mission." June 6, 2011. Available online: www.theguardian.com/science/2011/jun/06/cucumbers-in-space-japanese-astronaut-mission.

Thoday, Peter. *Two Blades of Grass: The Story of Cultivation.* Wiltshire, UK: Thoday Associates, 2007.

Thomas, Nicholas. *Entangled Objects: Exchange, Material Culture, and Colonialism in the Pacific.* Cambridge, MA: Harvard University Press, 1991.

Thomas, Nicholas. "The Museum as Method." *Museum Anthropology* 33, no. 1 (2010): 6–10.

Thunberg, Bo, ed. *Sverige Surnar Till: En fakta-och idétidning till vandringsutställningen.* Stockholm, 1985.

Tsing, Anna Lowenhaupt. *Friction: An Ethnography of Global Connection.* Princeton, NJ: Princeton University Press, 2005.

Tunlid, Anna. "Den Nya Biologin: Forskning och politik i tidigt 1960-tal." In *Vetenskapens sociala strukturer: Sju historiska fallstudier om konflikt, samverkan och makt*, edited by Sven Widmalm, 99–135. Lund: Nordic Academic Press, 2008.

Tupuola-Plunkett, Anne-Marie. "Home is Transient and Fluid," blog text. Text available on the "Rethinking Home" blog. Available online: www.amnh.org/our-research/anthropology/projects/rethinking-home/blog.

Van der Veken, Sebastiaan, Martin Hermy, Mark Vellend, Anne Knapen and Kris Verheyen. "Garden Plants Get a Head Start on Climate Change." *Front Ecol. Environ* 6 (2008): 212–216.

Van Dooren, Thom. *Flight Ways: Life and Loss at the Edge of Extinction.* New York: Columbia University Press, 2014.

Van Dooren, Thom. "Banking the Forest: Loss, Hope and Care in Hawaiian Conservation." In *Defrost: New Perspectives on Temperature, Time, and Survival*, edited by Joanna Radin and Emma Kowal (MIT Press, forthcoming).

Van Hooidonk, Ruben, Jeffrey Allen Maynard, Derek Manzillo and Serge Planes. "Opposite Latitudinal Gradients in Projected Ocean Acidification and Bleaching Impacts on Coral Reefs, "Opposite Latitudinal Gradients In Projected Ocean Acidification And Bleaching Impacts On Coral Reefs." *Global Change Biology* 20, no. 1 (2014): 103–112.

Viska, John. "Handle with Care: Collectable Glass for the Garden." *Australian Garden History* 23, no. 4 (2012): 5–10.

Vivanco, Luis A. *Reconsidering the Bicycle: An Anthropological Perspective on a New (Old) Thing.* New York: Routledge, 2013.

Von Humboldt, Alexander. *Personal Narrative of Travels to the Equinoctial Regions of the New Continent during the Years 1799–1824.* Translated by Helen Maria Williams. London: Longman, Rees, Orme, Brown, and Green, Paternoster Row, 1826.

Von Mossner, Alexa Weik. *Moving Environments: Affect, Emotion, Ecology, and Film.* Waterloo, ON: Wilfrid Laurier University Press, 2013.

Watkins, Thomas. *The Art of Promoting the Growth of the Cucumber and Melon: In a Series of Directions for the Best Means to Be Adopted in Bringing Them to a Complete State of Perfection.* London: Harding, St James Street, 1824.

Walter, Richard. "Lapita Fishing Strategies: A Review of the Archaeological and Linguistic Evidence." *Pacific Studies* 13, no. 1 (1989): 127–149.

Wehner, Kirsten. "Exhibiting Australia: Negotiating National Identities at the National Museum of Australia." Unpublished PhD thesis, New York University, 2007.

Weik von Mossner, Alexa, ed. *Moving Environments: Affect, Emotion, Ecology, and Film.* Waterloo, ON: Wilfrid Laurier University Press, 2013.

Weir, Jessica. "Connectivity." *Australian Humanities Review* 45 (2008). Available online: www.australianhumanitiesreview.org/archive/Issue-November-2008/weir.html

Wilke, Sabine. "Anthropocene Poetics: Ethics and Aesthetics in a New Geological." *Rachel Carson Center Perspectives* 3 (2013): 67–74.

Wilson, Alexander T. "Isotope Evidence from Past Climatic and Environmental Change." In *Climate and History: Studies in Interdisciplinary History*, edited by Robert I Rotberg and Theodore Rabb, 215–232. Princeton, NJ: Princeton University Press, 1981.

Witcomb, Andrea. "Migration, Social Cohesion and Cultural Diversity: Can Museums move beyond Pluralism?" *Humanities Research*, XV(2) (2009): 49–66.

Witzell, Wayne. *Synopsis of Biological Data on the Hawksbill Turtle, Eretmochelys Imbricata* (Linnaeus, 1766). Rome: Food and Agriculture Organisation of the United Nations, 1983.

Wolfgang-Hagen, Hein. *Alexander von Humboldt: Life and Work.* Ingelheim am Rhein: C.H. Boehringer Sohn, 1987.

Wood, David. "On being Haunted by the Future." *Research in Phenomenology* 36, no. 1 (2006): 274–298.

Worster, Donald. *The Wealth of Nature: Environmental History and the Ecological Imagination.* New York: Oxford University Press, 1993.

Wright, Duncan. "Mid Holocene Maritime Economy in the Western Torres Strait." *Archaeology of Oceania* 46 (2011): 23–47.
Yanow, Dvora. "Space Stories: Studying Museum Buildings as Organizational Spaces While Reflecting on Interpretive Methods and their Narration." *Journal of Management Inquiry* 7, no. 3 (1998): 215–239.
Yuen, Eddie. "The Politics of Failure have Failed: The Environmental Movement and Catastrophism." In *Catastrophism: The Apocalyptic Politics of Collapse and Rebirth*, edited by Sasha Lilley, David McNally, Eddie Yuen and James Davis, 15–43. Oakland, CA: PA Press, 2012.
Zalasiewicz, Jan, Mark Williams, Alan Smith, Tiffany L. Barry, Angela L. Coe, Paul R. Bown, Patrick Brenchley, David Cantrill, Andrew Gale, Philip Gibbard, F. John Gregory, Mark W. Hounslow, Andrew C. Kerr, Paul Pearson, Robert Knox, John Powell, Colin Waters, John Marshall, Peter Rawson, and Philip Stone. "Are We Now Living in the Anthropocene?" *GSA Today (Journal of the Geological Society of America)* 18, no. 2 (2008): 4–8.
Zelig, Eva and Stephanie L. Pfirman. "Handling a Hot Topic: Global Warming: Understanding the Forecast." *Curator: The Museum Journal* 36 no. 4 (1993): 256–271.
Žižek, Slavoj. "Censorship Today: Violence, or Ecology as a New Opium for the Masses, part 2." Lacan, last modified 2007. Available online: www.lacan.com/zizecology2.htm
Zournazi, Mary. *Hope: New Philosophies for Change*. Annandale, NSW: Pluto Press, 2002.

EXHIBITIONS CITED

American Museum of Natural History. *Global Warming: Understanding the Forecast*. New York, NY, USA, 1992.
American Museum of Natural History. *Climate Change: The Threat to Life and a New Energy Future*. New York, NY, USA, October 2008–August 2009.
American Museum of Natural History. *Our Global Kitchen: Food, Nature, Culture*. New York, NY, USA, November 2012–August 2013.
American Museum of Natural History. *Water H20-Life*. New York, NY, USA, November 2007–May 2008.
Birch Aquarium. *Feeling the Heat: The Climate Challenge*. San Diego, California, USA, 2007.
Birch Aquarium. *Hall of Fishes*. San Diego, California, USA, opened 1992.
Deutsches Museum, *Welcome to the Anthropocene: The Earth in Our Hands*. (Wilkommen im Anthropozän: Unsere Verantwortung für die Zukunft der Erde) Munich, Germany, 2014–2016.
Espace Foundation EDF, *CARBON 12*, Paris, France, May–September 2012.
Harvard Museum of Natural History, *Climate Change: Our Global Experiment*. Cambridge, MA, USA, 2015.
Hood Museum (The), *Thin Ice: Inuit Traditions within a Changing Environment*, Dartmouth, NH, USA, January–May 2007.
Immigration Museum, Victoria, *Waters of Tuvalu: A Nation at Risk*. Melbourne, Australia August–November 2008.
Maine State Museum. *12,000 Years in Maine*, Augusta, ME, USA.
MIT Museum. *Rivers of Ice: Vanishing Glaciers of the Greater Himalaya*, Cambridge, MA, USA, April 2012–March 2013.
Museum of Modern Art (MoMA), *EXPO 1*, New York, NY, USA, May–September, 2013.
Museum of New Zealand Te Papa Tongarewa, *Awesome Forces*, Wellington, New Zealand, opened 1998, updated 2009–2010.
Museum of New Zealand Te Papa Tongarewa, *Blood Earth Fire: Whangai Whenua Ahi Ka. The Transformation of Aotearoa New Zealand*. Wellington, New Zealand, opened 2009.
Museum Victoria, *Keeping Culture Strong: Women's Work in Aboriginal Australia*, Melbourne, Australia, 1992.
National Library of Australia, *National Treasures from Australia's Great Libraries*, Canberra, Australia, 2011.
National Museum of Australia, *Tangled Destinies*, Canberra, Australia opened 2001, renamed as *Old New Land*, 2011, updated 2013.

National Museum of Australia, *Landmarks: People and Places across Australia*, Canberra, Australia opened 2001, renamed as *Old New Land*, 2011, updated 2013.
New Zealand Maritime Museum, *Blue Water Black Magic*, Auckland, New Zealand, opened 2009.
Science Museum, *Prove it! All the Evidence you need to Believe in Climate Change,* London, UK. 2009–2010.
Swedish Museum of Natural History, *Are We Poisoning Nature?* (Förgiftar vi naturen?) Stockholm, Sweden, 1966.
Swedish Museum of Natural History, *Sweden Turning Sour* (Sverige surnar till). Stockholm, Sweden, 1985.
Swedish Museum of Natural History, *Polar Regions*, (Polartrakerna) Stockholm, Sweden, 1989.
Swedish Museum of Natural History, *4½ Billion Years – The History of Life and Earth*, Stockholm, Sweden, 1996.
Swedish Museum of Natural History, *Life in Water*, Stockholm, Sweden, 1997.
Swedish Museum of Natural History, *Mission: Climate Earth* (Uppdrag: KLIMAT), Stockholm, Sweden, 2004.
Swedish Museum of Natural History, *Changing Matters – The Resilience Art Exhibition,* Stockholm, Sweden, April–September 2008.
University of Alaska Museum of the North. *Then and Now: The Changing Arctic Landscape*, Fairbanks, AK, 2010–2011.
Wellington Museum of City and Sea, *Wahine Disaster.* Wellington, New Zealand, 2009.
Yale Peabody Museum of Natural History. *Seasons of Change*, New Haven, CT, opened 2012.

INDEX

Figures are indicated with *italic* page numbers. Tables are indicated with 't'. To find names that start with 'The', look under the second word in the name.

4½ Billion Years-The History of Life exhibition, 228

Aboriginal artefacts, 62–6; remains 63, 89–90
Aborigines Act (1886), 64
Abram, David, 117, 174, 178
acidification of oceans, 68, 80, 168–9, 223–4
activist archives, 196–205
Adams, Ansel, 201–2
Adkin, Leslie, 133
affect: of climate change, 7, 15, 100; of objects and exhibitions, 5, 7, 95, 97, 98, 100, 235–8; and the practice of care, 152; subdued, 36, 201, 202; of weather 129
affective response: of museum audiences, 95, 97-8, 100; of curators, 88, 95
agriculture, 13, 108, 112, 116, 171–80; ecological farming 173; stump-jump plough, *115,* 115–17
āiga (Samoan extended family), 38
Alele Museum (Marshall Islands), 43, 71
Altered Landscape photography collection, 197, 202
American Alliance of Museums, The (formerly American Association of Museums), 6, 9, 35
American Museum of Natural History (AMNH), 9, 24, 46–7, 49, 57, 107, 114; *Climate Change: The Threat to Life and a New Energy Future* exhibition, 106, 236, 240–1; collection database, *58*; *Global Warming: Understanding the Forecast* exhibition, 6; Hall of African Peoples, 58; Hall of Pacific Peoples, 36, 40, 45, 53, 55–6, 59; *jaki-ed* mats, 50–2; Olinguito, 154; *Our Global Kitchen Food, Nature, Culture,* 111–14; Paikea the whale rider, *21, 44–9, 45, 47, 48*; Rethinking Home: Climate Change in New York and Samoa project, 35–40; *Science on a Sphere* exhibition, 107–8; South Seas Hall, 45; *Water: H₂O=Life* exhibition, 106–8, *108, 109,* 113–14

A angu people (Australia), 178–9
anatomy, comparative 89
ancestral materials, 3, 34, 44–9, 122, 127
animal-objects, 85–100; Mackenzie's menagerie, 89–91; national narratives on, 92–4
anorak, Inuit, *214*
Anthropocene age 14, 15, 23–31, 197–205, 253, 256–66; ark 189–91; defined 14, 197; *see also Welcome to the Anthropocene: The Earth in Our Hands* exhibition (DM)
Aotearoa (New Zealand), 128–38, 185; settlers, 130–3
Apelu, Lumepa, 35, 36,37
Apollo 17 Mission, 250
Appadurai, Arjun, 4, 6
aquaria, 230–9
Arctic, 106, 110–11, 213–16, 235–6, 242–51;

Arctic Climate Impact Assessment 251; ice levels images, *248, 249*; media coverage 243–4, 245–7, 251; polar bears 244; Pyramiden, 261–6, *262,* 264; rich resources of 243; sea ice 110, 244, 247–50, 251
Are We Poisoning Nature? exhibition (SMNH), 217, 220–2, 221–4
Armitage, David, 48–9
art, 208, 235–8; and the Anthropocene, 196–205
art museums, 70, 196, 205
artefacts. *see* objects
atolls, 40, 42, 43, 53, 67–9, 74, 80–1
Attenborough, David, 25–6, 230
Aua (PNG), 71
Aureed (Torres Strait), 121
The Australia Landscape (UK), *190*
Australian Botanic Garden Sydney, 183
Australian food production systems, 179
The Australian Garden (UK), *189*
Australian Institute of Anatomical Research, 89–91
Australian Institute of Anatomy, 86, *93,* 94–6; animal-objects and ecological museology, 85–100; origins of collection, 89–91
Australian Institute of Anatomy exhibit (NMA), *93, 97*
Australian Institute of Marine Science, 160, 161, 169
Australian National Botanic Gardens, 183, 186
Autagavaia, Mata'afa, 36
aute (mulberry), 131
Autofriedhof, 83
Awesome Forces exhibition (TP), 136
Ayers Rock (Uluru), 178–9

baidam (shark), 123
Baker, Carolyn, 177
Balog, James, 235–6
Bandolin, Gunilla, 14, 215
Bani, Dimple, 126
Barker, Mary Anne, 132–3, 136
Barnicoat, John, 132
Barrett, Charles, 63
Barthes, Roland, 206
basket-making, 64–5
baug (small hawksbill turtle), 119
Bazin, André, 206
Beattie, James, 133
Beeton, Isabella, 192
"behind the scenes" visitors, 59, 60
Bell, Daniel, 214
Bennett, Jane, 258

Bernard, Henry, 161
bicycles, *101,* 101–4, *103,* 104
Bierstadt, Albert, 199
biocides, 218, 221–2
biodiversity, 79–81, 112, 115, 145–52, *see also* extinction
biodiversity banking, 89, 145–52
Birch Aquarium (USA), 232–3, 239; *Feeling the Heat: The Climate Challenge* exhibition, 233–5
Black, George Murray, 89
Blake, Sir Peter, 138
bleached corals, 166, *167,* 168
Blood Earth Fire: Whangai Whenua Ahi Ka. The Transformation of Aotearoa New Zealand exhibition (TP), 136
Blue Marble (photo), 250
Blue Planet (documentary), 230–2
Blue Water Black Magic exhibition (New Zealand), 138
Boas, Franz, xxiv, 24, 60
Bolin, Bert, 15
Bonpland, Aimé, 198
botanic gardens and conservation, 181–91
Botanic Gardens Australia and New Zealand Inc., 185
Botanic Gardens Conservation International, 183–4, 188
Box, Richard, 203–4
Brand, Stewart, 28
Breakthrough Institute, 28–9
British Museum (UK), 9, 123–5
Brown, Thomas, 140
Brundtland Report, 223
Burke Museum (USA), 43
Burrell, Harry, 89, 93
Burtynsky, Ed, 108
Buschmann, Rainer, 71

Cabinet of Curiosities for the Anthropocene exhibition, 260
Cadi Jam Ora, 181
Cameos: Connie Hart's Basket, 62–6; Museums Connect, 32–3; Vulnerable Volvo, The, 213–16
Cameron, Fiona, 87
Canadian Museum of Civilisation, 137
The Canary Project, 14, 206–9, 237
The Canary Project Works on Climate Change, 206, 209
Canterbury (New Zealand), 133, 136
Cape Farewell (art project), 6, 106, 237
car cemetery, *83*
carbon dioxide, 27–8, 108, 116–17, *233,* 233–4

Carson, Rachel, 202–3, 218, 222, 230
Carteret Islands (PNG), 268
Center for Art+Environment (USA), 197, 200–1, 204
Center for Culture, History and Environment (USA), 260
Central Valley (USA), 110
chainsaws, 25–7; lyrebird mimicry, 25–6
Chakrabarty, Dipesh, 258
chameleons, Jackson's, 147
change, as challenge to museums, 14–16
Chasing Ice (documentary), 235–6
chemical pesticides 218, 222
Chernobyl accident, 223
Mt Chimborazo (Ecuador), 198
Church, Frederic, 199; *Heart of the Andes*, 199, *200*
Church, James, 196–7.
citizen science projects, 106, 188
Clark, Nigel, 117
Clarke, Harry, 102–4, *103, 104*
Cliett, John, 203–4
Clifford, James, 46
climate: social meanings of, 3, 128–38
climate and culture, 6–8, 67–76
climate change (science and culture) 35–8, 36, 38, 159–70, 171, 217–29; 208, 235, 239, 241–2, 250–1; contemporary art and 235–8; COP talks 5, 106; media coverage *see* media 5–6; political inertia on, 27; portrayal in media, 242–51; stories for living with, 2, 4–5, 25–7, 34–49, 105–14, 171–80
climate change museums, 8
Climate Change: Our Global Experiment exhibition (HMNH), 105
Climate Change: The Threat to Life and a New Energy Future exhibition (AMNH), xxiv, 106, *211*, 236, 240–1
climate change tourism, 261–2
Climate Commission (Australia), 85
Climate Museum (USA), 8
climate skepticism, 3, 5–6, 208, 224–5, 242–3
Climate: The Experiment with the Planet Earth exhibition (DM), 255–6
climate *vs.* weather, 128–30
ClimateWatch (citizen science program), 188
Cloud (artwork), *131*
cloud interactive exhibit, *227*
coal mining, 262–5
Cobb, Victor, 96
collecting, 11, 265, ethnographic 11, 62–3, 122; for the future 13, 14, 71, 137, 169, 205, 216, 265; as knowledge seeking, 182, 216; biological 77–81, 98, 100, 154, 161, 169, 182
collections, 2–5, 13–14, 56–60, 100, 154–265; botanical, 182–3; in digital form, 55–6, 57–60, *58,* 169–70; human *vs.* non-human, 89–97; as places, 56–60
Collingullie Public School, *177*
Colonial Geological Survey, 136
Colonial Museum (New Zealand), 61, 70–1, 134, *see also* Te Papa Tongarewa, Museum of New Zealand
combative approaches in exhibitions, 3, 95, 228, 231, 234
Commonwealth Scientific and Industrial Research Organisation (CSIRO) (Australia), 115–17
Comstock Lode (USA), 200
community engagements with museums, 3–5, 33, 34–49, 52, 53–61, 55–6, 67–76, 171–80
Connie Hart's Basket, 62–6
conservation, 79, 145–52, 155, 159–70, 186; botanic gardens and, 181–91; biodiversity banking projects, 145–52; of "flagship" species, 153–5; Hawaiian 148; Olinguito, 155; Royal Botanic Gardens Melbourne plan, 186
Cook, James, 121, 159, 160
Cooktown Botanic Garden (Australia), 182
Cooper Sailor, Grace, 65
coral and reefs, 12–14, 42, 67–8, 72, 79, 81, 119, 159–70, 160, 161–3, *164, 167*, 234–5, 254; archives 168; bleaching, 166, 168; crocheted, *14, 254*; digital collection of, 169–70; islands 67; reef-growing (Scleractinia) 161; taxonomy 161–2, 163
Coral Geographic (database), 162
Coral Triangle, 163
coralline osteoporosis, 169
Cordell Bank Underwater Reef Installation, *12*
corporate funding of museums, 9–10
Cosgrove, Denis, 250
Crate, Susan, 6
crocheted coral reef, *14, 254*
crocodiles, 122–3, 126
Cronon, William, 176
crown-of-thorns starfish, 165–6, 169
Crutzen, Paul, 15, 25, 197, 258
CSIRO (Australia), 115–17
cucumbers and straighteners, 192–5, *193*
Cullen, Heidi, 129
cultural collections and global citizens, 49, 53–5
cultural diversity, 6, 79, 81, 256
cultural heritage, 15, 53–56, 58–60, 63, 65, 70–6,

252–9, 264; Aboriginal, 63, 65; managing objects, 53–61
culture: and aquaria, 238–9; and climate, 6–8; distributed by museums, 219–20; *vs.* nature, 12–13, 77–81, 258
curation, evolving role of, 2–3, 10–11, 25, 62, 252
Cutts, Charles, 196, 197
cycling and public health issues, 104
cyclones, 40, 130, 169–70; Evan, 33, 35, 38; Giselle, 134; Samoa, 35; Sandy, 33, 35, 38

Dabangai (Torres Strait), 119
d'Albertis, Luigi, 70
dams, 108, 110; Three Gorges Dam (China), 108
Darwin, Charles, 159, 161, 163–5
Dauar (Torres Strait), 119
Davidson, Bruce, 116
Davidson, Joseph, 133
Dawson, Ashley, 35
de Brum, Tony, 40–2
De Maria, Walter, 203–4
de Prado y Tovar, Don Diego, 121
de Torres, Luis Vaes, 121
Dear Matafele Peinam (poem), 267–70
DeChristopher, Tim, 176
decolonizing and opening museums, 11–12, 21–81
Deep Rooted (artwork), *30*
deforestation, 133–4, 155, 188
Deiro, Guido, 203
Deliverance Island (Torres Strait), 126–7
Derrida, Jacques, 148, 151
Deutsches Museum (DM), 24, *254,* 254–6, *257, 261; Cabinet of Curiosities for the Anthropocene* exhibition, 260; *Climate: The Experiment with the Planet Earth* exhibition, 255–6; *Environment* gallery, 255; *Welcome to the Anthropocene: The Earth in Our Hands* exhibition, 254, 259–60
dialogical approaches, 39, 179
diasporas, 34, 43, 53–5, 72, 81
Dibley, Ben, 49
digitized collections, 55–6, 57–60
dispossession of land, 27, 49, 55, 63
dog collar, *139,* 139–44
dog rescue story, *139,* 139–44, *141*
drought, 69, 113, 117, 133, 136, 144, 171
The Drowning Room exhibit, 237, 238, *238*
dugong, 119
Duke University, 24

Earth mastery, 28–9
EarthWatch (citizen science program), 188
Earthworks (USA), 203
eco-art. *see* art
ecological museology, 85–100; allowing constructive responses to climate change, 171–80; curatorial approaches to, 10–11
ecology, 160, 173, 184; restoration, 186–7
Eden Project (UK), 188–9
Edwards, Sharon, 65
eel: nets, 65; trap basket, 65, *66*
eight-furrow plough, *115*
El Niño Southern Oscillation, 136, 166, 168
Ellis, David, 134; *Wahine weather maps, 135*
Ellis, Erle, 28
Ellsworth, Elizabeth, 258
emotional manipulation of public, 238
endangered species, 147, 148, 150, *see also* biodiversity; biodiversity banking; extinction; tree snails (Hawai'i), 145–52
energy, renewables, and exhibitions, xxiv, 106, 110, 114, 168, 170, 186, 211, 233, 235–6, 251, 256, 262–3, 265
Energy Quest, 106
Engaging Chicago Communities in Climate Action project, 106
Engström, Kjell, 220, *221*
entomology, 159, 160
Environment [Umwelt] gallery (DM), 255
environmental activism, 9, 44, 223
environmental humanities, 61, 260
environmental justice, 9, 23–31, 256, 258
Environmental Protection Agency (Sweden), 226
environmental time, envisaged, 29–30
ethics, 8–10, 13, 242–51
ethnographic museums, 2, 55, 57, 70–1, 90
European Space Agency (ESA), 247, 249–50
"eventism" in the media, 244–5
evolutionary "hierarchies," racial, 91–2
exhibitions, 5–6, 6–7, 10, 72, 97–8, 105–14; *4½ Billion Years-The History of Life,* 228; *Are We Poisoning Nature?,* 217, 220–2; *Awesome Forces,* 136; *Blood Earth Fire: Whangai Whenua Ahi Ka. The Transformation of Aotearoa New Zealand,* 136; *Blue Water Black Magic,* 138; *Cabinet of Curiosities for the Anthropocene,* 260; *Climate Change: Our Global Experiment,* 105; *Climate Change: The Threat to Life and a New Energy Future,* 106, 240–1; *Climate Earth,* 218; *Climate: The Experiment with the Planet Earth,* 255–6; *The Drawing Room,* 237, 238; *Energy*

Quest, 106; *Engaging Chicago Communities in Climate Action* project, 106; *Feeling the Heat: The Climate Challenge,* 233–5; *Global Warming: Understanding the Forecast,* 6, 8; *Keeping Culture Strong: Women's Work in Aboriginal Australia,* 63; *Life in Water,* 228; *Mission: Climate Earth,* 224–8; narrative approach, 110; *National Treasures from Australia's Great Libraries,* 116; *Our Global Kitchen: Food, Nature, Culture,* 111–14, *112*; *Polar Regions,* 228; Science on a Sphere, 107, 108; *Sunlight-Ihi Kōmaru,* 134; *Sweden Turning Sour,* 217–18, 222–4; *Thin Ice,* 213; University of Alaska Museum, 105–6; *Wahine Disaster,* 134, 136; *Water: H₂O=Life* exhibition (AMNH), 106–8, *108, 109,* 113–14; *Waters of Tuvalu: Nation at Risk,* 74; *Welcome to the Anthropocene: The Earth in Our Hands,* 254, 259–60

EXPO 1 (MOMA), 237, see also *The Drowning Room*

extinction, 13, 76, 77, 79, 89, 100, 145–52, 168–9, 187, 190, 256; see also biodiversity; birds 148; coral, 168–9; cultural, 70–1, 76; debt, 151; great K-T, 169; Thylacine as icon of, 93; plants, 148, 185, 187, 190; predators, 150; sixth, 256; snails, 148, 149

Faison, Maya, 38, *39*
fale samoa, 32–3, *33, 36–7, 37*
Faletalimālō, 33
Farbotko, Carol, 73
Feeling the Heat: The Climate Challenge exhibition (USA), 233–5
Field Museum of Natural History (Chicago), 79; *Engaging Chicago Communities in Climate Action* project, 106
Fiji, 67
Finding Nemo (film), 232
fire, 85, 171
fishhook, 65, 75
'flagship' species for conservation efforts, 153–5
flooded city model, 236, *240,* 240–1
floods, 13, 19, 33, 38, 113, 117, 133–4, 136, 139–40, 142–3, 234, 236, 240–1, 243, 268; and food security, 113, 117; *Mission: Climate Earth* poster, *225*; Nelson the Newfoundland's rescue story, 139–44; in New Zealand, 133–4, 136
Fly River (PNG), 70
Flying Ace and the Storm of the Century (performance), 7

Fonoti, Dionne, 38
food: production 112–13, 117, 175–79, security 13, 113; waste 113
food and water exhibitions, 105–14, *112,* 117, 171–80
Forest Gallery (Melbourne Museum), 191
Förgiftar vi naturen? exhibition (SMNH), *221*
fossil fuels, 67, 111, 197, 216, 265; industry funding of museums, 5–6, 9
fossil studies (artwork), *209*
Frankl, Viktor, 176–7
frigate birds *(womer),* 12–13, 126
Furukawa, Satoshi, 195
future collections, 13–14, 71, 137, 169, 205, 216, 265

Ganges River (India), 110–11
gardens and conservation, 181–91
Garnett, William, 202
gatau waru (dry turtle), 119
Gell, Rob, 74
genetic diversity, 112
Gibson, Ross, 10
Gilbert Islands (Kiribati) and sharks, 77, 80–1
Gilmartin, Red, 161
Gleeson, Ben, 171
global citizens and cultural collections, 49, 53–5
global media coverage of climate change events, 5–6, 242–51
Global Seed Vault (Norway), 112
global warming, 6, 8, 67, 110, 113, 116, 166, 208, 233, 241–2, 246, 250, 252, see also climate change; Arctic and, 136, 244, 246, 261–2; coral bleaching, 166; and food waste, 113; news media and, 250; Pacific nations and, 67; *Water: H₂O=Life* exhibition, 110
Global Warming: Understanding the Forecast exhibition (AMNH), xxiv, 6, *8*
Goemu clan (Torres Strait), 126–7
Gore, Al, 244
Gould and Curry Mill, Virginia City (artwork), *201*
The Great Acceleration, 23–4, 202, 253, 256; Anthropocene age, 53–4, 202, 259; portable chainsaw and, 25, 27
Great Barrier Reef, 159–70; loss of coral cover, 169
The Great Divergence, 23
Great Ideas Consortium (USA), 24
greenhouse gases, 29, 108, 110–13, 137–8, 166, 168, 234
Greenland, 216, 234, 244, 262

292 Index

Griffiths, Tom, 11, 61
Grimble, Arthur, 77
Guernica (artwork), *257*
Guldi, Jo, 48–9
Gunning, Tom, 206

habitat degradation and loss, 25–6, 86, 100, 119, 150–1, 155, 186–7, 204, 287; aquaria and, 231–2; botanic gardens and, 186–7; Hawai'i and, 147–8, 150–1; marine turtles and, 127; Olinguito and, 155
Haddon, Alfred C, 121
Hadfield, Mike, 145, 147–9
Hage, Ghassan, 152
Hall of African Peoples (AMNH), 58
Hall of Pacific Peoples (AMNH), 36, 40, 45, 53, 55–6, 59
Hansen, James, 245
Haraway, Donna, 145, 152
Harrison, Helen and Newton, 205
Harry Clarke's high-wheeler bicycle, *101*, 101–4
Hart, Connie, 64–5, *66*
Harvard Museum of Natural History (HMNH), 105
Hautere (Solander Island), (Aotearoa New Zealand), 131
Hawai'i, 145, 147–50, 152; *see also* University of Hawai'i; endangered tree snails, 145–52, *147*
hawksbill turtle, 119
Hayden, Ferdinand, 199
Hayden Reichard, Sarah, 183
Heart of the Andes (Church), 199, *200*
Heizer, Michael, 203
Henare, Amiria, 46
herbarium collections, 190
heritage, cultural. *see* cultural heritage
Higginbotham, William John, 140, *141*
high-wheeler bicycles, *101*, 101–4, *103*
A History of the Future (artwork), *209*
Hoddle, Robert, 141
Hoegh-Guldberg, Ove, 166
Holland, Peter, 133
Holmgren, David, 176
Holocene, 28, 54, 171
homes, 32–3, 35–40; Māori "House of Stories," 46, 48–9
Hood Museum (USA), 213–15
hope: projects of, 86, 145–52, 181–91
Horkheimer, Max, 214
Hsu, Elizabeth, 137
Hulme, Mike, 3, 28, 129, 138

human impact *vs.* control, 28–9
human *vs.* non-human collections, 89–97
human-animal histories, 122–7
humanities, 24–5, 31, 61, 170, 219, 256, 260
Humboldt, Alexander von, 198–9, 205; volcano cross-section, *198*
Hurley, Frank, 70
hurricanes, 40, 131, 237; Katrina 245; Sandy 6, 35, 38

Iama (Torres Strait), 121
ice coverage (Arctic), *249*
Ilulissat Glacier (Greenland), 262
imaging, 207, 247–50
Immigration Museum (Australia), 11–12, 74–5
Indonesian reefs, 162–4, 166
Industrial Revolution, 6, 25, 233–4, 266
industrialization, 61, 116–17, 171–9, 185, 195, 215, 218–19, 259
inhabitability, 68–9, 73
Initiative Gaia, Hong Kong Jockey Club, 8
Intergovernmental Panel on Climate Change, 6, 15, 226, 233–4, 244, 246
International Agenda for Botanic Gardens in Conservation, 184
International Coral Reef Society, 165
International Geosphere Biosphere Program, 15
International Stratigraphy Commission, 31, 253
International Union for Conservation of Nature, 155, 184, 187
Inuit, 110, 213–15; seal intestine anorak, *214*
irrigation, 108, 113, 196
Israeli *vs.* Palestinian social inequality, 26–7

Jackson, William Henry, 199
jaki-ed mats, *50*, 50–2, *51*
Janes, Robert, 8–9, 179
Jeffray, James, 25
Jenkins, William, 202
Jetñil-Kijiner, Kathy, *19*, 44
Jockey Club Museum of Climate Change (Hong Kong), 8
Johns, Reynell Eveleigh, 62, 64–5
Jolley, Patrick, 237
Jones, Patrick, 176
Jørgensen, Dolly, 232

Kaiga Tuvalu organization (Australia), 74
kaigas (shovelnose rays), 122–6; mask, *123, 124, 125*
Kalaw Lagaw Ya (language) 119

kapu waru (good turtle) 119
karar (strong turtleshell) 119
Keane, Basil, 131
Keats, John, 208
Keeling Curve, 233, 235
Keeping Culture Strong: Women's Work in Aboriginal Australia exhibition (MV), 63
Kenyon, A S, 65
Kew Gardens (UK), 183
King, Clarence, 200
Kings Park, Perth (Australia), 183
Kiribati, 12, 49, 67, 77–8, 80, 268; shark-tooth weapon, *80*; warrior, *78*
Kirksey, Eben, 148, 149
Kirshenblatt-Gimblett, Barbara, 5
kitchen garden, primary school, *177*
Knox, Elizabeth, 86, 95
Kolbert, Elizabeth, 27
Krmpotich, Carla, 49
Krupnik, Igor, 213
Kruse, Jamie, 258
KTH Royal Institute of Technology (Sweden), 260
Kuduma of Nagir, 120
Kunsthistorisches museum Wien 70

La Niña, 85, 136, *see also* El Niño
Lacey, Jacklyn, 36
Lake Condah Aboriginal community (Australia), 64
land dispossession. *see* dispossession of land
land-based art of Anthropocene age, 196–205
Lee, James, 182
Lehvävirta, Susanna, 184
Liberty Science Center (USA), 106
Life in Water exhibition (SMNH), 228
liveability, 68–9, 73
living collections and botanic gardens, 181–91
lodestone objects, 34–5, 38
London Missionary Society (LMS), 122
Longyearbyen (Norway), 265
Los Angeles Aqueduct, 202
Lötmarker, Tom, 220
Low, Chris, 137
Lynas, Mark, 28, 71
lyrebirds, mimicking chainsaw, 25–6

Mabey, Richard, 128
Mabuiag (Torres Strait), 119, 123
Mabuiag Island clan totemic animals, 126t
MacGregor, William, 70
Mackenzie, Colin, 89–96, 100

Madagascar corals, *164*
Mahto, Tooni, 231
Main, George, 48
Majuro (Marshall Islands), *68, 69*
malaria, 71
Maldives, 237–8
Manhattan flooded model, 236, *240*, 240–1
Māori culture and peoples, 45, 131–3, 135, 137; calendar *(maramataka), 135*; Paikea the whale rider, 44–9; settlement of Aotearoa New Zealand, 130–2
maramataka (Māori calendar), *135*
marine climate exhibits, 230–9
marine turtles, 118–19; Torres Strait history and, 118–27
Marshall Islands, 11, 17–19, 42–3, 67, 71, 72; Compact of Free Association with USA, 43; *jaki-ed* mats, 50–2; land tenure, 72; *meto* navigation charts, 40–4, 49; photos, *19, 68, 69, 74*
Marshallese Educational Initiative, 42, 43
masks, 120–1; kaigas, *123, 124, 125*; Torres Strait Islander, 120–7
Massie, Miranda, 8
materiality, 36, 171–80, 216; storytelling and, 5
Mathews, Freya, 174
Mathez, Edmond, 106, 236
Mauna Loa Observatory (Hawai'i), 233
Maunder, Michael, 187, 188–9
McCalman, Iain, 48–9
McCormick, Daniel, 204
McFarlane, Samuel, 122
McNeill, John, 197, 258
Mead, Margaret, xxiv, 35, 53, 203
media and its depictions of climate change, 5–6, 27, 55, 235, 242–51
Melbourne, Australia, 139, 142–4; floods (1881), *140*; Swanston Street, *143*
Melbourne Immigration Museum, 11, 74–5
Melbourne Museum, 191, *see also* Museum of Victoria
mercury, 218–19, 221
Message, Kylie, 9
meteorology, 133, 226, 256
methane, 108, 113, 168
meto navigation charts, 40–4, *41*, 49
Mer (Torres Strait), 199
Mexican clay water pipe, *109*
migration, 11, 43, 54–6, 71, 74–6, 132, 186
Millennium Seedbank (Norway), 183
Miller-Rushing, Abraham J, 189–90
mining, 200, 262–5

294 Index

Mission: Climate Earth exhibition (SMNH), 218, 224–8, *227*; poster, *225*
Missionary Museum of London, 70
MIT Museum (USA), 106
mobility, 104, *see also* bicycles
Möllers, Nina, 257
Mollison, Bill, 176
MOMA (Museum of Modern Art), 237
Moody, John, 42
Moran, Thomas, 199
Motusaga, Faanu, 36
Mouffe, Chantal, 151
Mt Chimborazo (Ecuador), 198, *198*
Museo de Zoología, Quito (Ecuador), 154
Museo Ecuatoriano de Ciencias Naturales (Ecuador), 154
museology. *see* ecological museology
Museum Friends Association (SMNH), 221
Museum of Samoa, 35, *37, 39*
Museum of Victoria (MV) (Australia), 63–5, *75*, *see also* Melbourne Museum
museums: Anthropocene age explored, 196–205, 252–66; changing role of, 1–16, 219, 265–6; decolonizing and opening, 11–12, 21–81; ecologizing, 87–100; encouraging reflection and discussion, 3, 6, 9, 25, 49, 229, 242, 252-56, 265-66; engaging with communities, 3–5, 33, 34–49, 52, 53–61, 55–6, 67–76, 171–80; ethical considerations, 8–10, 67-76; exploring implications of climate change for human societies, 7–8, 171–80, 213–19; focusing on the future, 13–14, 157–209; and social responsibility 39–40; and stories, 4–5, 7, 11, 15, 34–49, 100, 110, 171–80, 231–2, 254–5, 265; reinventing nature and culture, 12–13, 83–155; representing change and uncertainty, 211–70; role in addressing climate change in the Pacific, 34–49, 67–76; roles in society, 217–29; temporary *vs.* permanent exhibitions, 228–9; *see also* exhibitions; collecting; collections
Museums and Social Activism (book), 9
Museums Connect project, 32–3, 35–40
Museums in a Troubled World (book), 8–9, 179
Mutitjulu Primary School (Australia), 179

Nabhan, Gary, 176
Naga of Nagir, 120–1
Nakba (catastrophe, Palestine) 26–7
narrative. *see* stories
National Air and Space Agency (NASA), 247, 250

National Board of Antiquities (Sweden), 222
National Endowment of the Humanities (USA), 57
National History Museum (Austria), 70
National Library of Australia, 116
National Museum of Australia, 24, 86–7, 90, 92–3; *Food Stories* project, 117, 175–9; Nelson the Newfoundland's dog collar, 140–1; *Paddock Report,* 172–5; stump-jump plough, 117; *Tangled Destinies* gallery, 92–7
National Museum of Australian Zoology, 89–91, 92
National Museum of Natural History (Smithsonian) (USA), 9, 154
National Treasures from Australia's Great Libraries, 116
natural selection, 164
Nature Conservancy, The, 204
nature *vs.* culture, 12–13, 77–81, 258
Naturhistoriska Riksmuseet. *see* Swedish Museum of Natural History (SMNH)
Nelson the Newfoundland, *139,* 139–44, *141*
Nevada Museum of Art (USA), 196–7; *Altered Landscape* project, 197, 201, 202
"New Museums", 39
New York, 35, 38; flooded model, 236, *240,* 240–1
New Zealand (Aotearoa), 130–4, 185; weather as culture, 128–38; Wellington sign, *129*
Newell, Jennifer, 32
Ngata, Wayne, *4,* 46
Ngunnawal people (Australia), 117
Nixon, Rob, 6, 235
Noah, Timothy, 23
Nona, Denis, 126
non-human *vs.* human collections, 89–97
North Pole, 110, 243, 249, *see also* Arctic
Norway and Pyramiden, 261–5
nuclear testing, 43
Nunn, Patrick, 67, 68
Nuttall, Mark, 6
NZL 32 (yacht), *137*

Obama, Barack, 247
objects, 2, 5, 35, 53–61, 70, 72; Aboriginal, 62–4, 179; as agents of meaning, 11, 34; animal-objects, 85–100; aura, 207; balancing histories with communities of origin, 58; curatorial engagements with, 88; as extractions out of time, 206–9; impact of encounters with, 60–1; relations between, 70
objects in view: The Canary Project, 206–9;

cucumber straighteners, 192–5; Harry Clarke's high-wheeler bicycle, 101–4; *jaki-ed* mat, 50–2; Nelson the Newfoundland's dog collar, 139–44; New York flooded model, 240–1; Olinguito, 153–5; photographs and fossils 206–9; shark teeth, 77–81; stump-jump plough, 115–17
O'Brien, Mary, 204
oceans, 168–9, 230–2, 235–8, *see also* aquaria
Oceans (documentary), 230–1
olai (large hawksbill turtle), 119
Old New Land, 97
Old New Land gallery (NMA), 94, *see also Tangled Destinies*
Olinguito (mammal), *153,* 153–5; skins, *154*
op le masks, 120
open-shelving of objects, 59
opening and decolonizing museums, 11–12, 21–81
Oppenheimer, Michael, 241
Orpheus Island (Australia), 166
O'Sullivan, Timothy, 200–2; *Gould and Curry Mill, Virginia City, 201*
Our Global Kitchen exhibition (AMNH), 111–14, *112*
ozone hole, 251, 255

Pacific Ethnology Collection (AMNH), 40–8, 50–2, 53, 55–7
Pacific Island communities, 67–9, 70–4, 76, *see also* Aotearoa New Zealand, Fiji, Gilbert Islands, Hawai'i, Kiribati, Marshall Islands, Papua New Guinea, Samoa, Solomon Islands, Tokelau, Tuvalu, Vanuatu; role for museums within, 71–4; *Waters of Tuvalu: Nation at Risk* exhibition, 74–6
The Paddock Report (website), *172,* 172–4
Paddock Report project (NMA), 172–5
Paikea the whale rider, *21,* 44–9, *45, 47, 48*
paleo-fatalism and paleo-hubris, 28–9
Palestinian *vs.* Israeli social inequality, 26–7
Papua New Guinea (PNG), 67, 70–1, 268
Papua New Guinea National Museum, 71
Peers, Laura, 49, 70, 72
penny-farthing bicycles, *101,* 101–4, *103*
People's Climate March, London (2014), *270*
permaculture gardens, 175–6, 178
permanent *vs.* temporary exhibitions, 228–9 +
pesticides, 218, 222
Pfirman, Stephanie L, 6
PHARMAZIE exhibition (DM), *157*
Philippine reefs, 162, 164

Phillip, Chris, 79
photographs, power of, 200–4, 206–9, 250; and the Anthropocene, 200–4, 206–9
phytoplankton, 169
Pickard, Jeremy, 7
Pitt Rivers Museum (UK), 2–3, 49
places, collections as, 56–60
platypus studies, 89, 93
plough, stump-jump *115,* 115–17
Plumwood, Val, 87, 173–4, 179
poetry: *Dear Matafele Peinam,* 267–70; *Tell Them,* 17–19
polar bears, 110, 243–4, 251, 262; exhibit (AMNH), *211*
polar effect, 261–2, *see also* Arctic
Polar Regions exhibition (SMNH), 228
Pool, Robert, 250
post-carbon society, 216
Price, Sally, 70–1
Primack, Richard B, 189–90
privilege, curators', 57
public involvement with botanic gardens, 188–9, 191
public responses to exhibitions, 1–2, 4–6, 97–8, 105–06, 113–14
Puig, Maria, 152
Pykare, Shelby, 36
Pyramiden (Norway), 261–6, *262, 264*

Queensland Museum (Australia), 70–1

Rachel Carson Centre for Environment and Society (Germany), 254–5
Raiders of the Lost Ark (film), 63
rain, 128, 131, 143
Rancière, Jacques, 206
rats, 147, 150
reefs. *see* coral and reefs
relational museums, defined, 2–3
Rethinking Home: Climate Change in New York and Samoa project (AMNH), 35–40
Reynolds, John, *131*
Reynolds, Reynold, 237
rising sea levels. *see* sea level rises
Robin, Libby, 24, 59, 90, 185
Robley, Horatio, 45
Rose, Deborah Bird, 85, 178
Rose, Paul, 230
Royal Academy of Sciences, 217
Royal Botanic Gardens (Melbourne, Australia), 183, 186, 188
Royal Botanic Gardens (UK), 183, *190*

Royal Botanical Gardens (Sydney, Australia), *181*
Royal Botanical Gardens (Victoria, Australia), 183, 186, 188
Royal Horticultural Society (UK), *189*
Royal Tasmanian Botanical Gardens, 182
Ruffle, Harry, 28
Russia and Pyramiden, 263–5

Sacred Demise: Walking the Spiritual Path of Industrial Civilizations' Collapse (book), 177
salvage paradigm, 70–1
sam (cassowary) 126
SAM3 (artist), 29–30, *30*
Samoa, 32–3, 35–40, 41, 49
Schulman, Leif, 184
science museums, 7, 9, 106, 232
"Science on a Sphere" display, 107–8, *108*
Scripps Institution of Oceanography, 232–3
sea ice, 110, 235–6, 242–4, 247–51, *248*
sea level rises, 67, 71, 234; *Climate Change: The Threat to Life and a New Energy Future* exhibition, 236, 241; Maldives, 237–8
seal intestine anorak, *214*
Sear, Martha, 86, 94–5
seas. *see* aquaria; oceans; sea level rises
seedbanks, 111–12, 186, 190
shark fishing, 77–81
sharks, 77–81
shark-tooth weapon, *80*
shell, turtle, 119–27
shipwrecks, 230
Shiva, Vandana, 116
shovelnose rays *(kaigas)*, 122–4, 126
Sierra Club, 201–2
Sierra Nevada (USA), 196, 201–2, 205
skaigas (shovelnose rays), 122–4, 126
slow change, challenges of exhibiting, 236
slow media, 5–6, 15, 48, 59, 252–3
slow violence, 6, 169, 235–8
Smith, David, 116
Smith, Mike, 93
Smith, Richard and Clarence, 116
Smithson, Robert, 203
Smithsonian (National Museum of Natural History) (USA), 9, 24, 154
snails, endangered, 145–52
Snow Dragon (ship), 243
social inequality, 11, 23–5, 29; Palestinian *vs.* Israeli, 26–7
social meanings of climate, 3, 128–38
social stratification in storytelling, 29
Soviet Union and Pyramiden, 261–3

Solander Island (New Zealand), 131
Solomon Islands 67, 268
Sonna, Victor, *257*
Sörlin, Sverker, 14, 215
South Pole, 110
South Seas Hall (AMNH), 45
Spitsbergen. *see* Svalbard (Norway)
Springdale, Arkansas (USA), 42, 52
Squires, Donald, 217
Stähle, J H, 64
starfish, crown-of-thorns, 165–6, 169
State Library of Victoria (Australia), 63
Steffen, Will, 197, 203, 258
Stege, Kristina, 42, 43, 44, *50,* 50–2
Stege, Mark, 44
Stephanie Alexander Kitchen Garden Foundation (Australia), 175–6
Stephenson, George, 194
Sterling, Eleanor, 49
Stevenson, Robert Louis, 41
Stockholm Resilience Centre (Sweden), 214
Stoermer, Eugene F, 25
stories, *see also* objects in view; about the ocean, 230–9; in exhibitions, 105, 110; museums as places of, 4–5, 7, 11, 15, 34–49, 100, 171–80, 231–2, 254–5, 265; for dealing with climate change, 2, 4–5, 25–7, 23–25, 31, 34–49, 87, 94, 105–14, 171–80; social stratification within, 29
Strong family (farmers), 172–3
Stuckenberger, Nicole, 213
stump-jump plough, *115,* 115–17
Sunlight-Ihi Kōmaru exhibition (Aotearoa New Zealand), 134
surlal season 118, 119, 120, 126
sustainability, 75, 104, 114, 176, 217, 255
Svalbard (Norway), 112, 262–4, 265
Sweden Turning Sour exhibition (SMNH), 217–18, 222–4, *224*
Swedish Museum of Natural History (SMNH), 217–29; *4½ Billion Years-The History of Life* exhibition, 228; *Are We Poisoning Nature?* exhibition, 217, 220–2; *Climate Earth* exhibition, 218; *Life in Water* exhibition, 228; *Mission: Climate Earth* exhibition, 224–8; *Polar Regions* exhibition, 228; *Sweden Turning Sour* exhibition, 217–18, 222–4

Tangled Destinies gallery (NMA), 92–5, *93, see also Old New Land* gallery
taonga (Māori treasures), 46, 48
Tapsell, Paul, 48

Tapungao, Tito, 74
taxonomy, 160–3
Te Kane a Takirou (Māori meeting house), 44
Te Manawa, Museum of Science, Art and History (New Zealand), 134
Te Papa Tongarewa, Museum of New Zealand, 130, 135–8, 266; *Cloud* (artwork), *131*
tekoteko (gable figure), 44–5
Tell Them (poem), 17–19
Tempest Williams, Terry, 176
temporary *vs.* permanent exhibitions, 228–9
Thaiday Snr, Ken, 126
theatre in museums, 7
Thin Ice, 213
Thomas, Nicholas, 70, 87, 88
Three Gorges Dam (China), 108
Thylacine, 80, 93, 97
Tiapapata Art Centre, *33*
tiltil (Marshallese embroidery), 52
time and climate change, challenges in presenting, 236
Timor Leste, 188
Tipoto, Alick, 126
Toi Hauiti, *4, 21*, 44, 46, *48*; and Paikea (*taonga*), 44–9
Tokelau, 67
Torres, Luis Vaes de, 121
Torres Strait (Australia), 118-127
Torres Strait Islander peoples, 13, 71, 90, 118–27; masks, 120–7, *123, 124, 125*; relationship with marine turtles, 118–20; turtle shell masks, 120–7
totemic animals, Mabuiag Island clans, 125–6, 126t
translocation of species, 187
tree snails, endangered Hawaiian, 145–52, *150*; environmental chambers for, *146*
Trischler, Helmuth, *257*
Trust Arktikugol, 263–4
Tuamotu Archipelago, 67
turtle shell masks, 120–7
turtles, 118–20
Tudu (Torres Strait), 121
Tuvalu, 73–6
Tuvalu Community Exhibition, *75*
typhoons, 67–8

UC Santa Cruz Arboretum, 205
Ujae Atoll (Marshall Islands), 74
ula sisi seed necklace, 36
Uluṟu National Park, 178–9
uncertainty and change, as challenges to museums, 14–16
UNESCO Convention on the Means of Prohibiting and Preventing the Illicit Import, Export, and Transfer of Ownership of Cultural Property, 71
uninhabitability, 68–9, 73
United Nations Convention on Biological Diversity, 184
University of Alaska Museum, 105–6
University of Alaska Museum (USA), 105–6
University of California Berkeley Sagehen Research Station, 205
University of Hawai'i, snail ark, 145, 147–50, 152
Urban Forest Strategy, 144
usworld / *Unswelt* (concept), 258

Vaeua, Erynn, 38, *39*
Vanuatu, 71, 163
vehicles, abandoned, *83*
Veron, Charlie, 159–70, *162, 164, 167*
Vivanco, Luis, 102
volcano, Mount Chimborazo, *198*
Volvo installation, 213–16, *215*
Voyager Maritime Museum (New Zealand), 138

Wahine Disaster exhibition (New Zealand), 134–6
Wahine weather maps (artwork), *135*
waka (canoes), 131
Wallace, Alfred, 159
Wara, Billy, 179
Waria, Ned, 125–6
Warne, Kennedy, 28
waru (turtle), 119
water, 106–9, 110–11, 113–14; Urban Forest Strategy, 144
Water: H$_2$O=Life exhibition (AMNH), 106–8, *108, 109*, 113–14
water pipe, clay, *109*
Waters of Tuvalu: Nation at Risk exhibition (Melbourne Immigration Museum), 74–6, *75*
Watt, James, 25, 197
weather on exhibit, 128–38; *vs.* climate, 128–30; Māori understandings of, 131–2; at Te Papa Tongarewa, 135–6
Weiner, Norman, 203
Welcome to the Anthropocene: The Earth in Our Hands exhibition (DM), *14, 254, 254, 257*, 259–60, *261*
Wellington (New Zealand), 128, 134; sign, *129*
Wells, John W, 161–2

Western Pacific Warm Pool, 168
Westneat, Mark, 79
whare korero (Māori house of stories), 46
Wharekaponga, Owen, 47
White, Peter, 183
Wijkman, Anders, 226
Wilke, Sabine, 258
Willkommen im Anthropozän exhibition *see* Welcome to the Anthropocene
Wilson, Alexander, 132
wind, in New Zealand, 130–4, 136–8
WithOneSeed project (Australia), 188
wombat, preserved, *99*
women's creative work, 43, 51–2, 63–5, 213
womer (frigate birds), 12–13, 126
Wood, Lowell, 28
World Commission on Environment and Development, 68
World Resilience Conference (2008), 214
world views, altered through object encounters, 60–1
Worster, Donald, 171
Wuvulu (PNG), 71

Yale Forum on Climate Change and the Media, 243
Yale Peabody Museum of Science (USA), 105
Youssef, Aiman, 37
Yuen, Eddie, 27, 31
Yulara Primary School (Australia), 178

Zalasiewicz, Jan, 30–1
Zelig, Eva, 6
Žižek, Slavoj, 208
zoos, 98, 188, 217
Zournazi, Mary, 151